media
spectacles

media spectacles

edited by

MARJORIE GARBER

JANN MATLOCK &

REBECCA L. WALKOWITZ

Routledge . New York & London

Published in 1993 by

Routledge
29 West 35 Street
New York, NY 10001

Published in Great Britain by

Routledge
11 New Fetter Lane
London EC4P 4EE

Copyright © 1993 by Routledge

Printed in the United States of America on acid free paper.

Library of Congress Cataloging-in-Publication Data

Media spectacles / edited by Marjorie Garber, Jann Matlock and Rebecca L.
 Walkowitz.
 p. cm.
 Includes bibliographical references.
 ISBN 0-415-90750-0 HB — ISBN 0-415-90751-9 PB
 1. Mass media—United States. I. Garber, Marjorie
 II. Matlock, Jann. III. Walkowitz, Rebecca, L., 1970– .
 P92.U5M444 1993
 302.23'0973—dc20 93-3460
 CIP

British Library Cataloguing-in-Publication Data

Media Spectacles
 I. Garber, Marjorie
 302.23

ISBN 0-415-90750-0 HB
ISBN 0-415-90751-9 PB

Contents

CONTENTS

Acknowledgments

The editors take pleasure in thanking the many friends and colleagues who contributed generously of their time, thought, and effort to bring this book about. We want in particular to express our gratitude to Norman Bryson, David Halperin, Alice Jardine, and Susan Suleiman, each of whom was instrumental in helping to frame the questions about media spectacles, politics, gender, race, and sexuality addressed in the essays collected here.

Provocative and fruitful conversations with Henry Louis Gates Jr., Phillip Brian Harper, Elizabeth Honig, Judith Alexa Jackson, David Scott Kastan, David Kennedy, Ruth Perry, Judith R. Walkowitz, Daniel J. Walkowitz and Patricia J. Williams contributed immeasurably to our sense of the complexity and interrelationship of these issues. Karen Friedland of the Center for Literary and Cultural Studies played a crucial role in coordinating logistical arrangements for the volume. Christina Carlson, J.D. Connor, Frédéric Cousinié, Paul Franklin, Brian Martin, Rajath Shun, Kristi Schutjer, and Herrick Wales also provided important support and assistance. William Germano's interest in the project and his clear sense of the centrality of these questions to the field of cultural studies were invaluable throughout.

Introduction

The caricature of the scholar has long been that of a preoccupied idealist or pedant isolated in his or her ivory tower, but it is mokre nearly true to say that scholars have always looked simultaneously at their books and at the world around them. Education and intellectual life are intrinsically charged with political and ethical choices. Yet for academics who emphasize the link between their intellectual and political endeavors, this double gaze frequently reveals a double bind: either they are not political enough, or they are too political.

Political and academic institutions have often tried to trammel intellectuals who articulate their ideas as interactions with contemporary culture and society. Recent attacks on multiculturalism in the curriculum and on its proponents, for instance, greatly resemble the efforts of McCarthyism and Hollywood blacklisting in the 1950s. Surely, these kinds of efforts are not uniquely modern, nor are they uniquely American, as government crackdowns in China, among many examples, attest. Ironically, however, many of the American critics who applaud dissident intellectuals in China are quick to attack politically-engaged scholars here. Moreover, what is certainly true as well, and what many of the essays in this collection additionally address, is the extent to which public figures, even as they condemn the visibility of politics in academia, often call on the humanities—its literary texts or presumed historical truths—to establish their own authority.

Much of this dialogue between politicians and scholars, and about politics and its relation to scholarship, has taken place in the media, as soundbites or short quotations exchanged on the evening news or in daily articles. Indeed,

many of our contributors suggest, the media have been complicit in these debates, framing the questions but often denying their own participation in them. The essays in this collection perform, variously, the practice of academic scholarship not apart from or alongside cultural conflicts, but in the midst of them. The contributors represent fields as diverse as history, political science, art history, law, philosophy, English literature, comparative literature, African-American studies, Latin American studies, women's studies, and film studies. These scholars use the methods of their disciplines to rethink epistemological and political crises. In the process of doing so, they have come to question and cross the boundaries of disciplinary study.

Watching the evening news and reading the national newspapers in the last few years, academics have seen themselves and their colleagues prominently featured in headlined stories and front-page articles about debates in the humanities. In recent books and essays, a number of scholars have addressed these issues and marked this "watching" as the event that mobilized their analyses and provoked them to join the media spectacle. As Gerald Graff remarks in Beyond the Culture Wars, the same conflicts over race, gender, sexuality, and ethnicity that have informed debates in the universities have been depicted in popular films, such as JFK and Thelma and Louise, and in political controversies like the Clarence Thomas confirmation hearings. This volume addresses these and other spectacles of social and cultural conflict. Produced by academics from a broad range of disciplines, Media Spectacles suggests how our watching ourselves in the media, and how our watching the media itself, might be related to watching politics, watching borders, watching sex, and watching AIDS.

Most of the "media spectacles" discussed in this volume had already been authorized by the media as spectacular. The press of 1991–92 spent nearly as much time discussing its own representations of the Gulf War, the Clarence Thomas confirmation hearings, the William Kennedy Smith trial, the Rodney King beating, and Dan Quayle's attack on Murphy Brown, as it did reporting the political events themselves. Nevertheless, as anyone who watched the media in the last two years knows, more people were watching "real" politics

and "real life" on television than ever before—whether in the guise of the television "documentaries," like "Rescue 911," or the new "Courtroom Television" that brought live interventions into America's private dramas. TV movies-of-the-week based on the likes of the Amy Fisher ("Long Island Lolita") sex scandal followed a fictional television anchorwoman, Murphy Brown, responding to the very real Vice President's assault on single mothers. At a certain point, one began to wonder if Dan Quayle was a fiction too.

These media spectacles were chosen by contributors in an effort to give serious thought to a series of disruptive events that had jostled our lives in indirect and direct ways. This volume seeks, however, to do far more than provide another account of how the media produced our illusions and realities in the 1990s. Each author has chosen to examine events or texts that he or she believes significant for today's crises in meaning, identity, and politics, articulating the ways these analyses might carry over to other work in cultural studies and cultural criticism. Watching politics, Michael Rogin, Marjorie Garber, Rebecca L. Walkowitz, and Elaine Scarry examine a broad range of materials, from newspaper articles and Freud's case studies to Shakespeare and situation comedy.

In the volume's first essay, Michael Rogin demonstrates that the spectacle of Oliver Stone's *JFK*, as it described and enabled a "breakdown in the distinction between history and fiction," produced confusion for academics, politicians, and journalists alike. Moreover, Rogin argues, *JFK* reveals not so much about covert plots of presidential assassination as its own discreet politics of sexual paranoia. Demonstrating the intertextuality of Shakespeare in the Clarence Thomas confirmation hearings and the film *JFK*, Marjorie Garber offers a model for reading our dependencies on the "classics." Moreover, Garber suggests, these dependencies reveal a political investment in the classics and in their interpretation. To control that interpretation may be, as in the Thomas hearings, to mobilize their cultural authority for political power plays. Traditional humanities become, then, not just relevant to "real life," but part of politics itself—whether in the canon debates, squabbles over "political correctness," or contests over authority and truth in the U.S. Senate.

Rebecca L. Walkowitz demonstrates how the rhetoric of Dan Quayle's

"family values" campaign and of traditional journalism produced a fiction of objective authority masquerading as universal truth. And Elaine Scarry interprets U.S. constitutional law and contract theory to argue that a mimesis of political and ethical deliberation in the media undermined and displaced the population's right to authorize the Gulf War.

K. Anthony Appiah, Doris Sommer, and Svetlana Boym turn to how national, racial, and ethnic borders negotiate and transform our understanding of what we see. K. Anthony Appiah looks at the shifting representation of black and gay characters in popular film, and interrogates the difference and distance between representation and experience. Doris Sommer addresses a variety of texts, from newspapers to novels to film, suggesting the political, legal, and cultural implications of mistranslation. Svetlana Boym offers a trenchant reading of French philosopher Jean Baudrillard to ask if the Soviet Coup really happened and how it was articulated both among Soviet intellectuals and in translation through the Soviet and American media.

Watching sex, Jann Matlock addresses theories of naming to reconsider debates about exposing the identity of rape victims. Barbara Johnson, watching sexuality in film and literature, interrogates the critical relation between her sexuality, her reading strategies, and the reading of sexuality as such. Lee Edelman's analysis of President Bush's visit to Japan introduces psychoanalytic interventions to elucidate political criticism. Like Johnson, Edelman examines how presumptions about sexuality and its categories inflect interpretation. Diana Fuss, calling on contemporary film theory and psychoanalytic criticism, narrates a pathology of perversion implicit in the representation of homosexuality in *The Silence of the Lambs* and the Jeffrey Dahmer case. Watching AIDS, Andrew Parker locates metaphors of monstrosity in a contemporary film aesthetic that turns on the anxieties produced along boundaries of national and sexual borders. Katharine Park, in an analysis of religious rhetoric during medieval plagues and the current AIDS epidemic, shows how historical analogy produces powerful tools for understanding contemporary debates and media discourse. And in a poignant, personal analysis of the "Magic" Johnson phenomenon, Douglas Crimp examines media discourse to weigh political strategies in the representation of AIDS.

In an era of global technology, instant news, infomercials, electronic town meetings, and made-for-TV "documentaries," the borderlines between news and analysis, news and entertainment, news and fiction are constantly shifting. The essays collected here offer a provocative commentary on these shifts and on the ongoing performance and production of media spectacles.

Watching Politics

1

Body and Soul Murder: *JFK*

Michael Rogin

I

The cover of the April 1992 issue of the *American Historical Review*, professional journal of the American Historical Association, features a picture of Oliver Stone and Kevin Costner on the set of a Hollywood movie, *JFK*. The cover advertises three essays that approach history, the professional province of the *AHR*, through film, that were not refereed like all other submissions to the journal but solicited, and that, insofar as they address the film that occasioned them, are the product not of years of research and reflection but of weeks.[1] The dissolution of professional norms in the face of mass culture, the breakdown of the distinction between history and fiction—these trends that have caught up the *American Historical Review*—lie behind the two developments in American politics, one old and one new, that came together with the election of a Hollywood actor, Ronald Reagan, as president of the United States: the conflation of politics and conspiracy, and the confusion between politics and the fiction-making visual media.

These apparent boundary collapses have obscured a more important splitting, however, in the unprecedented attention given *JFK* by news commentators, reporters, and others who don't usually write about movies. One discourse, the dominant one, appeared in opinion journals and news media; it addressed *JFK*'s claim that a military-industrial complex conspiracy killed the president to stop him from withdrawing from Vietnam. The other discourse, the marginal one, engaged gay activists and the gay press. It recognized that at the political and emotional center of *JFK*'s plot is the homosexual plot to

3

kill Kennedy. The mainstream political debate, by its total silence on *JFK*'s homophobia, marginalized the gay discourse at the heart of the film.

In the weeks following the film's release, *JFK* was the target—to cite only those commentators I came across in the periodicals I normally read—of William Pfaff, Tom Wicker, David Corn, Terrence Rafferty, Leslie Gelb, Stephen E. Ambrose, Anthony Lewis, William Manchester, Janet Maslin, Christopher Hitchens, Alexander Cockburn, and Stuart Klawans. The *New York Times* and the *Washington Post* targeted *JFK* on their news, editorial, and entertainment pages. Nonetheless, four books making Kennedy the victim of one conspiracy or another made the *Times* best-seller lists the first week in February; the number one nonfiction best-seller was by Jim Garrison, the former New Orleans district attorney who is the hero of Oliver Stone's movie. Those books were all off the best-seller lists by the first week in May, but they had been replaced by two others. One, like *JFK*, implicated high Washington officials in the assassination. The other, the number one nonfiction paperback best-seller, addressed a subject to which I will return, the fate of the president's brain. As professionals attacked *JFK*'s conspiracy theory, while millions of Americans rushed to see the film and buy the books, the gulf between the political class and the apparently prepolitical mass public could not have seemed wider.[2]

Fairly quickly, however, respectable defenders of *JFK* began to appear. *Nation* columnists had criticized the movie, but it was defended on the editorial page. The *Nation* sponsored a sold-out forum in New York in which Stone, Norman Mailer, and Nora Ephron (the screenwriter for *Silkwood* and director of the recently released *This Is My Life*) all defended the film; the *Nation* printed Ephron's remarks in its pages. The *Nation* did not go far enough for *Tikkun*, however, which advertised its own forum on *JFK*, in conjunction with the Academy Awards, on the *Nation*'s back cover. *Tikkun* would explain "why left columnists at *The Nation* seem as threatened by the film as many rightists, why so many progressive people need to distance themselves from the issues raised by the film." Stone and others, in letters to the *Nation*, repeated that accusation. *Tikkun* and the director should not have worried so much, for the *American Historical Review* appeared a month after the *Tikkun* forum, with two

of its three "progressive people" on the side of the "powerful cinematically . . . surprisingly accurate" *JFK*.[3]

Further to confuse the film/history boundary, Jack Valenti, president and chief executive of the Motion Picture Producer's Association and former top aide to the president implicated in Stone's conspiracy, Lyndon Johnson, bitterly attacked *JFK*. Valenti compared Stone's film to Leni Riefesnstahl's *Triumph of the Will*, not only because both films corrupted the young, but also because the "contents" of both "were mostly pure fiction." This bizarre claim about Riefenstahl's documentary, which showed nothing that did not happen, came strangely from a man who had moved from Washington to Hollywood. Warner Brothers chairman Robert A. Daly responded to Valenti by endorsing at the same time Stone's "wonderful movie" and Valenti's loyalty to LBJ. "I hope that anybody who worked for me for all those years would be that loyal," concluded Daly, inadvertently exposing in his effort homosocially to unite Stone, Valenti, and LBJ what barely a single word on either side of the political debate addressed, what might be called the silence of the wolves. For, to turn now to the other discourse, according to David Ehrenstein in the national gay magazine *The Advocate*, *JFK* is "the most homophobic film ever to come out of Hollywood."[4]

JFK is not alone. Three of the five best picture nominees at the 1992 Academy Awards were homophobic at their core: A homosexual rape at age 11 is the buried trauma for the protagonist of *Prince of Tides*. The serial killer in *Silence of the Lambs* is a man trapped in a woman's body, a transvestite aspiring to be a transsexual, who is sewing himself a new body covering by stripping his female victims of their skins, and who dances long-haired and naked over one of his women with his male sexual organ hidden between his legs, or, as we now say, occluded. *Silence of the Lambs* received the Best Picture and four other awards; *JFK* was nominated for eight awards and the winner of two. Moreover, *Basic Instinct*, the top grossing film in the weeks surrounding the award ceremony ($15 million gross in its first week of release) features three bisexual women and one lesbian as its menaces.[5]

It may be, as John Weir suggests, that homosexuals have replaced Communists as villains, with the end of the Cold War, in Hollywood thrillers and

political movies. Reds were often coded queer in cold war films, but their disappearance as political subversives coincides with the shift from covert to overt homosexuality on the movie screen. Other traditional American villains have also lost pride of place in Hollywood. The films that dominated the Academy Awards in 1990 and 1991 attended sympathetically, by their own lights, to the two peoples that, from the first settlements in the new world, "had never been included in the original *consensus universalis*." The glorification of unthreatening African and Native Americans, in *Driving Miss Daisy* and *Dances with Wolves*, contrasts with the threat of homosexual invasion.[6]

Weir's article on Hollywood homophobia did break into the mass circulation press; I saw it in the *New York Times* and the *San Francisco Chronicle*. Perhaps as a condition, however, Weir perpetuated the split of the sexual from the political discourse, for he claimed that the homosexuality of recent film villains was entirely separable from the film plots. Not only does Catherine Trammell's lesbianism in *Basic Instinct* "[explain] nothing about her," but "Clay Shaw's sexuality is incidental to the plot of *JFK*. It makes nothing happen." That is a demonstrably false claim; Shaw's sexuality makes everything happen. Or so, to come out of the closet, I argued as the third commentator on *JFK* in the *American Historical Review*. "When *JFK* creates a fascist, homosexual prisoner named Willie O'Keefe to give Garrison the evidence that Clay Shaw was involved with Lee Harvey Oswald," claims another *AHR* contributer, "one can see that Oliver Stone is doing no more than finding a plausible, dramatic way of summarizing evidence that comes from too many sources to depict on the screen." One sees, on the contrary, that although this observer is atypical in noticing the homosexuality, he has protected himself from Stone's visual assault, like most other viewers, by keeping his distance from the film. I propose now, in a substantially expanded revision of my contribution to the *American Historical Review*, to restore the connection insisted upon in *JFK* between homosexuality and conspiracy, male bodies and (to quote the other contributor to the *AHR* forum) the "sore on the body politic."[7]

II

"Treason doth never prosper, what's the reason? For if it prosper, none dare call it treason." These lines, quoted by Stone's Garrison, call Richard Hofstadter from his grave, for they are featured in his classic book *The Paranoid Style in American Politics* (1965). The couplet forms the epigraph for *None Dare Call It Treason*, John Stormer's right-wing Republican exposé, published the year after Kennedy's death, of the communist takeover of Washington.[8] Stone's conspiracy is anticommunism. As *JFK* unfolds, it reveals that an omnipresent "they" killed not only John Kennedy but also Robert Kennedy and Martin Luther King, Jr., that "they" seized power in a "coup d'etat," and that Lyndon Johnson was an "accomplice after the fact." Stone's assassins murdered Kennedy to stop him from withdrawing from Vietnam, making peace with Cuba, and ending the Cold War. But "they" killed a president who (as the movie does not say) had increased military spending, heated up Cold War rhetoric, intensified the American intervention in Vietnam, and sponsored, until his own assassination, death plots against Fidel Castro.

Resembling traditional American conspiracy theories, Stone's demonology makes an easy target for those defending the allegedly beleaguered political elites smeared by *JFK*. From their perspective—William Pfaff's, for example—Oliver Stone is a New Left McCarthyite. But such a view is maliciously ahistorical. Kennedy was no New Left hero, for neither civil rights activists in the early 1960s (since his Justice Department and FBI worked against them) nor for the antiwar movement that emerged after his death. Stone, in turn, is a product not of the rise of the New Left but of its demise.[9] Blaming the New Left counterposes *JFK*'s paranoia to a rational governing class, making it impossible to understand either the power of the movie or where it goes wrong. If we accept the invitation to enter the Kennedy assassination from Garrison's point of view (I refer to the film's Garrison, Kevin Costner), then we can trace the path from legitimate political disorientation to the moment when Garrison, to use the words he rejects about himself, becomes "paranoid" and goes "crazy."

Since the publication of Edward Jay Epstein's *Inquest* a quarter century ago, reasonable people have had to doubt the Warren commission, lone assassin,

"magic bullet" (as Garrison calls it) version of the killing of Kennedy. (Stone's defenses of his movie, in responses to the *Nation*, the *New York Times*, and Valenti, focus entirely on the deficiences of the Warren Commission.)[10] In the first portion of *JFK*, a disorienting montage draws the viewer into the evidence of other assassins, other bullets, other places from which Kennedy may have been shot. Rarely have the camera shot and the gun shot been more aligned, with the viewer at once behind the telephoto lens and, like Kennedy, its target.

Reasonable people have also had to acknowledge for a quarter-century the power of secret government in the United States, hidden both in its unaccountable decision making at the top and its covert operations on the ground. The achievements of that government, many of which are, by the same technique of discontinuous assault, detailed in the film, include the recruitment of Nazis to work for the CIA in the Cold War; the CIA-sponsored coups against Jacobo Arbenz in Guatamala and Muhammad Mussaddiq in Iran; the FBI, Military Intelligence, and CIA operations against domestic dissent; Watergate; Iran-Contra; the Reagan/Bush covert underwritings of Manuel Noriega and Saddam Hussein.

It is plausible, moreover, to link the Kennedy assassination to secret government interventions during the Cold War. Since the Watergate burglars were anti-Castro Cubans implicated in Kennedy's plots to kill Castro, President Nixon justified the Watergate cover-up on national security grounds, to keep secret the Kennedy-Cuba connection.[11] Nixon imagined Lee Harvey Oswald as Castro's avenger. Left versions of the assassination propose other ties: to anti-Castro Cuban exiles, to the Cuban exile/Mafia/Kennedy tangle; to elements in the national security bureaucracy; to the family of deposed South Vietnamese president Ngo Dinh Diem, murdered in the Kennedy-sponsored coup. The scenarios bewilder by their number and believability. Evidence for the withholding within government of information that might shed light on Kennedy's death is overwhelming. To attend seriously to Cold War politics and the Kennedy assassination is to risk being thrown back into the paranoid position (to use psychoanalyst Melanie Klein's term) of helpless, suspicious disorientation.[12]

The widespread feeling that America began to fall apart after Kennedy was killed prolongs national mourning; conversely, the extraordinary fixation on

JFK is evidence of the public malaise. But the unresolved assassination, combined with Kennedy's complicity with the forces suspected of doing him in, has blocked a national mourning of the president as he actually was, encouraging the regression from what Klein calls the depressive position, where loss can be acknowledged and overcome, to idealization, splitting, and paranoia.

A plausible version of the assassination like Don DeLillo's *Libra* (1988) makes sense of the chaos surrounding Kennedy's death. In the name of sanity-restoring fidelity to history, however, *Libra* must offer not only a bewildering, fragmentary, self-reflexive story, but also one that presents itself as fiction. *JFK* refuses the fictional label by insisting it has discovered the truth. But that rejection of fictional narrative entails another, of form as well as content, for Stone replaces a convincing, novelistic plot-as-story with a mysterious, fragmentary plot-as-conspiracy.

The elements of a plot in both those senses are set in New Orleans. Stone, however, provides no characters whose actions connect his sordid New Orleans revelations to the Washington scene of the crime. Graphic language and images of some men dominating others, rather than a political drama, link invisible Washington power to New Orleans sex. Denying charges of homophobia, the director insists that the homosexual conspirators, Clay Shaw and David Ferrie, are "fringe players," not "masterminds," that "the villainy lies in Washington, not in New Orleans," and that "the chief villains are heterosexual."[13] But the allegedly chief Washington villains are invisible, save for tantalizing brief mug shots and half-obscured nameplates, while the "fringe players" dominate the action. (In the exception that helps explain the rule, a Washington messenger turns one of Garrison's staffers into a tool of the cover-up, preparing for a scene that will discredit the Mafia assassination theory [that contaminates Kennedy] by putting it into the renegade's mouth.)

Stone has no problem finding anticommunist Kennedy haters, among both Bay of Pigs veterans and homegrown right-wingers. He accepts their view of Kennedy, inverts it, and makes it the instrument of the president's death. But to give the assassination its cosmic political significance, as the coup d'etat source of all that has gone wrong in the country, Stone (himself a Vietnam veteran) also needs a group at the top who feared Kennedy was withdrawing

from Southeast Asia. That wish structures the film from the beginning, when the missile crisis is announced in a fiction-presented-as-fact 1962 television broadcast as a secret Kennedy/Khrushchev arrangement, provoking charges that Kennedy is "soft on communism." The *None Dare Call It Treason* crowd may have so deluded itself; Stone shares their fantasy. Since it is hard to give verisimilitude to a Kennedy plan to withdraw from Vietnam and end the Cold War, *JFK's* political content and filmic method come to mirror the conspiracy the movie is supposedly exposing. As narrative history fails Stone, his plot splits in two: idealization of the beautiful "dying king" on the one hand, demonization of a homosexual band on the other. Historical confusion and emotional ambivalence threaten disintegration; homosexual conspiracy, the source of chaos in *JFK's* diegesis, is the source of order in its underlying structure. Sexual anxiety overwhelms politics, in *JFK's* paranoid style, as a homosexual primal horde slays the young father-king.

Although Garrison complains that "the government considers you children" and keeps its citizens from the truth, his Americans are never adults; they are Hamlets, "children of the slain father-leader whose killers still possess the throne." Stormer's *None Dare Call It Treason* dedication—"to Holly, May her future be as bright as mine was at age 5"—speaks equally to the cry of betrayed innocence that drives *JFK*. Stone's film is "Dedicated to the young." The beautiful object of the viewer's desire, in the nostalgic newsreel footage we watch along with Garrison, Kennedy is felled by the perverted desire of David Ferrie and Clay Shaw. Homosexual panic displaces politics in *JFK*. Stone's Kennedy is at once the "father-leader" whose killing unleashes chaos and the beautiful young man (synecdochical and desired object for Garrison and the male viewer) endangered by erotic attraction.

With David Ferrie, the pilot linked to the CIA and to Operation Mongoose's anti-Castro plots, homophobia and conspiracy each first enter the movie, joined together on Ferrie's body. An announced "alleged homosexual incident," preceding even the report of his anti-Castro activities, frames our first view of Ferrie. His flimsy story supposedly makes Garrison suspect a conspiracy, but what fills the screen is the queer's nervous, flitty manner. That a middle-aged degenerate drove to Dallas with "a couple of young friends"

only to hunt birds (the assassination will be called a "turkey shoot") raises sexual as much as political suspicion.

The two come together again in the figure of Willie O'Keefe, the attractive, corrupted, imprisoned homosexual prostitute. (Unlike Ferrie and Shaw, this figure, played by Kevin Bacon, is Stone's invention, or rather a "composite" of discredited Garrison witnesses.) In the conspiratorial connections with which O'Keefe floods Garrison, sexual and political perversions are entirely intertwined. O'Keefe first met Shaw "for sexual purposes," he tells Garrison. Shaw introduced him to the "butch-John," Ferrie, and he first met Oswald at Shaw's gay masquerade ball. There we watch a Camelot parody in which Shaw as Louis XVI simulates anal penetration of O'Keefe as Marie Antoinette. O'Keefe's memories or fantasies are illustrated as documentary truth not only in the masquerade ball but also in the conspiracy to which it leads. Oswald, two Cuban exiles, a hysterical Ferrie, and a very queer Shaw talk about killing Kennedy. In the "homosexual underground," O'Keefe explains to Garrison, no one wants to be what he seems. Garrison doesn't understand that disguise is the essence of the queer world. The district attorney's lack of understanding—or is it Kevin Costner's?—is perhaps intended to deflect attention from the entire overlap between Stone's homosexual underground and *JFK*, between Shaw playing Louis XVI and Costner playing Garrison, for example. Masquerade is only one practice *JFK* shares with its conspirators; wisdom received through assault is, as we shall see, the other. "You don't know shit," O'Keefe tells Garrison, "because you've never been fucked in the ass." When the interview is over, the male prostitute propositions the district attorney; the camera shows O'Keefe watching Garrison's rear as Garrison exits the room. His interrogation and trial of Clay Shaw—"the guy's a fag"—now organizes Stone's conspiracy.

Clay Bannister, the single nongay white male among the New Orleans principals, is presented as a tough guy who, according to his sidekick, "never kissed anybody's ass." But "he kissed" Clay Shaw's. Ferrie, terrified and cracking, complains that that "cocksucking faggot has got me by the balls." "All I wanted in the world was to be a Catholic priest," he cries to Garrison. "I had one terrible fucking weakness. And they defrocked me. They'll get you too. They'll destroy you" like they did the president. Homosexual blackmail, perverted sexual prac-

11

tices, and murder merge together in Ferrie's confession, entirely invented by Stone. "The Warren Commission was bunk. It fucked us all up," according to the director, and the principle of its defenders is "cover your ass." "We lost our innocence" on November 22, 1963, Norman Mailer has claimed in his defense of *JFK*. "The murder of President Kennedy," according to Stone," put an abrupt end to a period of innocence." Although Mailer compares the United States to a "battered wife" since the Kennedy assassination, the film exposes what lost innocence Mailer and Stone have in mind. Kennedy was killed, *JFK* comes pretty close to saying, because he refused to submit to homosexual domination, to, as O'Keefe puts it, be fucked in the ass.[14]

When Garrison's wife accuses him of caring more about Kennedy than his own family, she points to the absence of heterosexual desire that feeds the gay threat. In what is intended to be her least sympathetic moment, but that actually speaks the film's truth by denying it, she accuses her husband of persecuting Shaw "because he is a homosexual." (From one side, *JFK* inherits Stone's misogyny; from the other, it derives from *No Way Out*, the 1987 espionage thriller in which the character played by Kevin Costner is framed for murder by a queer in love with the real killer, his State Department boss.) Homosexual panic may not be the universal ground of paranoia, as Freud argued in the Daniel Paul Schreber case, but it organizes *JFK*.

Schreber believed that his doctor, Geheimrat Professor Dr. Paul Flechsig, was transforming him into a woman "for the purpose of sexual abuse"— "unmanning me and allowing my body to be prostituted like that of a female harlot," as Schreber puts it; he is O'Keefe's Marie Antoinette to Shaw's Louis XVI. But Paul Flechsig and Shaw/Ferrie, "little men" inside the heads of their victims, Schreber and Stone's Kennedy, turn out to be the instruments of a higher power. Invisible rays emanating from God were invading Schreber's body, replacing his male organ with female genitalia. Invisible rays in *JFK* radiate out from Washington through the bodies of Shaw, O'Keefe, and Ferrie. An omnipotent force not only slays the president; its instruments also penetrate and violate the vulnerable presidential body over and over again, first in the incessantly repeated footage of the shooting, fictional and documentary, then in the horrifying climax of the film with which I'll conclude, the

exploded, dissected, opened up body, head and brain (in close-up) of the murdered president. Kennedy's body is subjected to power exercised from a distance, such that invisible rays or souls, in Schreber's language, produce catastrophic bodily effects. Stone's Kennedy is the victim of what Schreber calls soul murder.[15]

Sensory overload, the disruption at once of narrative continuity and the boundaries of fiction and fact, characterizes Stone's film technique, his gift of enlightenment through visual assault. After a documentary opening (Eisenhower's military-industrial complex speech, footage of Kennedy in which, since the president is already dead in viewer time, history enters the psyche as myth), the first fictional scenes are in black and white to extend the documentary effect: the false newscast on the missile crisis, which I've already noted, is followed by the first action, a woman being thrown from a car and crying, "They're going to kill Kennedy." On the model of the use of None Dare Call It Treason, the opening of Kiss Me Deadly (1955), an anticommunist, black and white, Cold War film, is borrowed for Stone's inversion. Color succeeds black and white for most of the balance of the film, but Stone reverts to black and white psuedodocumentary and genuine color newsreel footage, overwhelming the viewer's ability to sift history from the director's fiction. Rapid cutting inside flashbacks, as with O'Keefe, establishes eyewitness authority for the conspiracy, giving point of view interior monologues the status of fact.

The homosexual scenes have pride of place in this visual disorientation, for they carry the weight of emotional disturbance. Montages of mouths and body parts; a transvestite bacchanale; the seduction scene between Shaw and O'Keefe; the strange movements of Ferrie and Shaw; and, in a shot sequence that will be doubled by close-ups of the dead Kennedy's head and brain, the bald head of Ferrie's corpse, surrounded by what is now revealed as the queer's everyday wig lying among his transvestite hairpieces—all these scenes and shots overwhelm visual and narrative coherence. As Stone blends the camera shot and the gunshot, so his rapid cutting, body dismemberments, sudden close-ups, and charged bodily accessories join the filmic to the sexual fetish. (Here the fetish stands in not only for the threatened male member, disavowing the existence of the already castrated sex to which passive homosexual desire points, but also

for the fearfully present patriarchal phallus aimed at men.) Cinematic form enforces the disorienting fragmentation; homophobia is its content. Fragmentary details pregnant with meaning are the building blocks both of the content of political demonology and of Stone's paranoid film style.

Flooding the screen, the director returns to the preillusionistic beginnings of motion pictures (though he does so with the montage techniques of D. W. Griffith and Soviet cinema rather than with the primitive cinema of attractions, brief spectacles that often reminded viewers of their spectator position). Unlike classic narrative films, Stone's images disperse rather than tell a story. But, unlike primitive cinema, Stone puts spectacle in the service of narrative. Intentionality at the top organizes the charged data of Stone's animistic universe. Homosexual contagion produces a panic attack, relieved by establishing a centralized military-industrial plot, just as Schreber is relieved to discover God behind Flechsig. As Leo Bersani quotes Pynchon, it would be scarier if there were no "hidden orders behind the visible."[16] Conspiracy supplies the formal and final causes (in Aristotle's classification) that restore psychopolitical order.

"Seeking other orders behind the visible," the definition of paranoia in *Gravity's Rainbow*, Garrison goes to Washington. But whereas the fragments are disturbingly visible, the unity can only be told. *JFK* suffers from the same split found in Schreber's memoirs, between endless speech—Schreber's "basic language"—and the overwhelming, preverbal bodily experiences—Schreber's imaginary, which Stone makes visible on-screen and which words proliferate in a failed effort to reach. What Jacques Lacan says of Schreber applies as well to Stone, that his "delusion displays all the wealth of its tapestry around the power of creation attributed to speech, of which the divine rays are the hypostasis."[17]

By speech in *JFK*, I refer to the three ever-lengthier monologues, culminating in the longest uninterrupted soliloquy in Hollywood history. For Stone's visual bludgeoning establishes not order but disintegration, softening up viewers for the invisible rays. Thus the Abraham Zapruder film of Kennedy's assassination is shown over and over, frame by frame, as if it held the key to the plot, but only words keep Zapruder from turning into *Blow-Up*, Michelangelo Antonioni's 1969 film in which murder remains mysterious because the

picture keeps the secret of whether it has a secret at all. Coherence is supplied by the monologues. These voice-overs, spoken from within the diegesis and illustrated by streams of juxtaposed images, offer the structure for which the viewer, even more than before entering the theater, now longs. But the monologues cannot make actual connections, any more than could a traditional filmic narrative, for those would be vulnerable to exposure as fiction.

An assistant district attorney first lays out the New Orleans connections, as Stone begins with the least disjunction between film plot and conspiracy narrative, organizing the local homosexual actions the film has already displayed. It is two hours into the movie before New Orleans sexual depravity acquires its Washington direction. *JFK*'s Deep Throat authorizes the conspiracy, his monologue supported by flashbacks that are keyed to "X's" subjective account but shown as historical truth. Norman Mailer calls "X's" lecture to a passive, grateful Garrison an "expository" "installation." But the scene succeeds, according to Mailer, overcoming the risk of being "analagous to approaching the bed of one's beloved with a dildo larger than oneself."[18] Urging Garrison to bring Shaw to trial without knowing how everything fits together, this paternal dildo prepares us to experience Shaw's acquittal as evidence that the conspiracy goes on. Since we are never told the charges against Shaw, and he plays no role in Garrison's soliloquy, the film's climax divides between Garrison's thirty-five minute speech to the jury and close-ups of Shaw's guilty-as-queer face and body.

JFK is its own evidence for homosexual panic, but there is no reason to practice new-critical self-denial when the author of a text interprets his own dream. Interviewed in the *Advocate*, Stone denied that his film is organized around homosexual conspiracy. His defense of his film practice suggests the opposite. Depicting Ferrie and Shaw in drag was not homophobic, insists Stone, producing a picture of each in drag to prove they knew each other. Suppressing the Mardi Gras masquerade that is probably the source of these pictures, Stone continues, "It's not about being gay; it's about the connections that being gay makes." Or, as the actual judge at Shaw's trial put it, "Queers know queers," and gayness itself is *JFK*'s evidence of conspiracy.[19]

More revalatory still are Stone's free associations. He reports his interest

in directing *The Mayor of Castro Street*, the proposed film about assassinated San Francisco gay supervisor Harvey Milk, so long as the movie does not censor Milk's "promiscuity." The director objects not only to "censorship" of *JFK* and *Silence of the Lambs*—he finds neither film homophobic—but to the censorship that keeps "homosexual love scenes" offscreen. "That's an issue worth fighting for." Perhaps Stone's interest in Milk's promiscuity, like his interest in Shaw's, is a deflection from the presidential promiscuity suppressed in *JFK*. Stone's obsession with homosexual practices seems more than a displacement, however. He must refuse to acknowledge any gay experiences, Stone tells the interviewer, because otherwise, "I'll really be in deep shit." Question: "With whom?" Answer: "With the government. They'll really be on my ass." Stone's only use of the words "shit" and "ass" in the interview, opening up into government penetration, inadvertantly repeats the fantasy of the film. Then the director turns his vulnerability from the government to Queer Nation, the gay group that has protested *JFK*. If he admitted he'd had a homosexual experience, complains Stone, Queer Nation "would just call me a closet fascist. They'd see me as the Clay Shaw of this generation," that is, not just any closet fascist but the fag who links homoerotic desire to presidential assassination. Is the man who makes that connection Shaw, or is it Stone?[20]

The possibility of being confused with Shaw works Stone up into a pitch of self-pity and accusation. "I'm tired of having my neck in the guillotine," he complains. Sometimes a neck is only a neck and decapitation does not, as Freud wrote, equal castration. But when Stone has filmed Clay Shaw as Louis XVI fucking O'Keefe as Marie Antoinette, and just worried about being confused with Shaw, then the director is not worried about just any neck in the guillotine but his own as Louis XVI's/Kennedy's/Shaw's. Having made himself the victim (unconsciously Clay Shaw), Stone makes Queer Nation his persecutor: "Queer Nation is like a Nazi group."[21]

Stone's Nazification of Queer Nation, echoing Valenti's Nazification of Stone, returns us to the link between politics and sex severed, I've suggested, in all the attention to the film. Demonology imagines that a secret power is exercised on the body; thus sexual fantasy has always been part of the American paranoid style. In Maria Monk's antebellum, anti-Catholic, nonfic-

16

tion best-seller, for example, priests kidnap and engage in criminal intercourse with nuns.[22] Women's liberation, calling into question the rape-and-rescue erotics of female victimization, may contribute to the shift from heterosexual to homosexual sadomasochism. Other "postfeminist" movies (like *Basic Instinct* and *Fatal Attraction*) target threatening women; this one simply blocks them out. But the wish that women go away returns to haunt male connections. Moreover, although the story presents homosexual contagion as the cause of the assassination, the spectacle presents it as the consequence, since we meet the primal horde knowing that Kennedy is dead. Homosexual contagion is at once source and result of the killing, making the spread of alternative sexualities, and perhaps AIDS and (as I'll sugggest in conclusion) abortion as well, more disasters for which Kennedy's death is to blame.

American male impotence as the tragedy of Vietnam is explicit in Stone's *Born on the Fourth of July*(1989), and almost as close to the surface in George Bush's Vietnam syndrome. If the white male authority as victim was the dominant political discourse of the Reagan/Bush regime, climaxing in the acquittal of the forces of law and order who beat Rodney King, Stone is, as he boasts in his interview, no detached radical but part of the mainstream.

Stone's Kennedy and Vietnam, however, are not simply responses to sexual disarray, and the sexual politics of *JFK* is perhaps more the product of Washington men than feminists and gays. The film illustrates with particular, sensate force how disorienting powerlessness invades the psyche, threatening to turn men into receptacles for sadomasochistic possession. For just that reason *JFK* deserves the attention it received, neither as a political understanding of the assassination and its aftermath nor as a McCarthyite assault on vulnerable elites, but rather for making us experience how politically produced paranoid anxieties, somatized on the visually produced mass body, turn into paranoid analysis.

That is brought home by the visual climax of the film to which I have already referred, but referred inadequately, by withholding the final stage of Schreber's transformation. For Schreber accepts his violated, feminized body when he realizes that God is turning him into a woman to make him the redeemer, to "restore mankind to their lost state of bliss," in his doctor's

words, to give the "young" back their "innocence," to recall Stone/Mailer. Terrified of a brain operation in *Sleeper* (1973), Woody Allen complains that the doctors are depriving him of his "second-favorite organ." Schreber relinquishes Allen's favorite organ to give birth to "a new race of men." His castration, in Freud's penis = baby equivalence, is in the service of childbirth. We witness that birth in close-up in *JFK*, the ceasarian extraction of Woody Allen's second favorite organ (a decapitation = castration, penis = baby = brain substitution), the delivery of the president's brain from his head.[23]

"No one with a brain is going to walk out of *JFK* and think that gays are all President killers," Stone protests. There is no negative in the unconscious, said Freud, and the director's free association—this time from brain to gay— points to the deep meaning of the autopsy. If we understand the fetish—the part standing in for the whole—as substituting not for the missing female penis but for the whole maternal body, if the phallus is itself a fetish replacing the lost maternal connection, then the homosexual fetishes that populate *JFK* have their telos in the scene of birth. Schreber's belief that God deals best with corpses, because He mistakenly believes that living bodies have designs on him (that is, that the attraction might be going from Schreber to God rather than the other way around) is borne out by the necrophiliac treatment of Kennedy's dead body. But is the result the new birth, the second coming, that Schreber imagined?[24]

From one point of view this final body and soul murder is an abortion, a stillbirth, for the brain that could prove the existence of conspiracy is mangled and hidden away. Here the autopsy illustrates Schreber's fear that "my soul was to be murdered and my body used like a strumpet," his soul handed over to Flechsig and his body "transformed into a female body ... for sexual misuse." But from another perspective Stone, making visible the murdered brain, is participating in his own Operation Rescue. If anal penetration is, as O'Keefe says, the source of enlightenment, then this stillbirth is its product, the martyred fetus on display that will lead us back to its progenitor. In Schreber's language, "the tendency ... to unman a human being who has entered into permanent contact with rays ... is connected to the basic plan ... that in the case of world catastrophes ... the human race can be re-

deemed." Stone is giving birth to his own redeemed race, the young to whom he dedicates the film and for whom Warner Brothers (part of Time Warner, the news as well as film production company) is preparing educational kits on the Kennedy killing, built around *JFK*, for distribution in the schools.[25]

Stone's educational attention to Kennedy's brain has already borne fruit, thirty years after the assassination, in the memoir by one of the doctors present in the Dallas emergency room. Meanwhile, rays have been emanating from another news source, the tabloid *Sun*. "JFK's brain found in Cuba," runs the February 2, 1992 headline. Prostrated like the makers of Hollywood political thrillers by communism's collapse, Fidel Castro is using Kennedy's brain in "voodoo rituals . . . to help him ward off evil spirits." Only if "the panic-stricken tyrant" possesses the murdered president's brain, reports the *Sun*, does Castro believe God will answer his prayers.[26]

NOTES

I am indebted to conversations about *JFK* with Jim Breslin, Cathy Gallagher, Richard Hutson, Meta Mendel-Reyes, Kathleen Moran, and Françoise Vergès; to materials and insights about the film supplied by Carol Clover, Paul Hoch, Laura Mulvey, and Rebecca L. Walkowitz; and to participants in the "Politics and Spectacle" film conference, Graduate Program in Film, University of California, Berkeley, Feb. 22, 1992; the conference in honor of John Schaar, University of California, Santa Cruz, May 7–8, 1992; and the Center for Literary and Cultural Studies, Harvard University, "Dissident Spectators, Disruptive Spectacles," May 15–16, 1992.

1. Marcus Raskin, "*JFK* and the Culture of Violence"; Michael Rogin, "*JFK*: The Movie"; Robert A. Rosenstone, "*JFK*: Historical Fact/Historical Film"; all in *American Historical Review* 97 (Apr. 1992): 487–511.

2. Tom Wicker, *Sunday Times* (London), Jan. 26, 1992, 10; *New York Times*, Dec. 23, 1991, A1, 14; *New York Times*, Dec. 24, 1991, C9, C12; Janet Maslin, *New York Times*, Jan. 5, 1992, H13; Anthony Lewis, *New York Times*, Jan. 9, 1992, A23; William Manchester, *New York Times*, Feb. 5, 1992, A22; Terrence Rafferty, "Smoke and Mirrors," *New Yorker*, Jan. 13, 1992, 73–75; Stuart Klawans, "*JFK*," *Nation* 254 (Jan. 20, 1992): 62–63; David Corn, "X-Men and *J.F.K.*," *Nation* 254 (Jan. 27, 1992): 80; *Alexander Cockburn*, "In Defense of the Warren Commission," *Nation* 254 (March 9, 1992): 294–95, 306; Stephen E. Ambrose, "Writers on the Grassy Knoll: A Reader's Guide," *New York Times Book Review*, Feb. 2, 1992, 1, 23–25; Gray I. Zirbel, *The Texas Connection* (New York: Warner Books, 1992); Charles A. Crenshaw with Jens Hansen and J. Gary Shaw, *JFK: Conspiracy of Silence* (New York: NAL-Dutton, 1992); *New York Times Book Review*, May 3, 1992, 32, 34; Tom

Prasch, "Everybody Must Get Stoned: '60s Revisionism, *JFK*, and the Critics," *Ryder* (Bloomington, Ind.), April 2–6, 1992, 32–33, 36.

3. Nora Ephron, "The Tie That Binds," *Nation* 254 (April 6, 1992): 453–55; "*Tikkun* Forum," *Nation* 254 (April 30, 1992): 431; Oliver Stone, John M. Newman, Philp Green, letters, *Nation* 254 (May 18, 1992): 650, 676–78; Raskin, "*JFK* and the Culture of Violence," 487.

4. "Valenti Denounces Stone's *J.F.K.* as a 'Smear,' " *New York Times*, Apr. 2, 1992, B1, B4; David Ehrenstein, "*JFK*—A New Low for Hollywood," *Advocate*, Jan. 14, 1992, 78–79.

5. John Weir, "Gay-Bashing, Villainy and the Oscars," *New York Times*, March 29, 1992, 17, 22–23.

6. Ibid., 17; Hanna Arendt, *Crises of the Republic* (New York: Harcourt, Brace, 1971), 90.

7. Weir, "Gay-Bashing," 23; Rosenstone, "*JFK*," 508, and Raskin, "*JFK*," 488.

8. Richard Hofstadter, *Paranoid Style in American Politics* (New York, 1965), 110–11; John A. Stormer, *None Dare Call It Treason* (Florissant, Mo.: Liberty Bell Press, 1964). Right-wing conspiracy fantasies, and perhaps the *None Dare Call It Treason* lines as well, enter *JFK* by way of Col. L. Fletcher Prouty. A retired Air Force intelligence officer who was an adviser on the film set and the model for "Mr. X" (see below), Prouty is connected to the racist and anti-Semitic Liberty Lobby. See Sara Diamond, " 'Populists' Tap Resentment of the Elite," *Guardian* (New York), July 3, 1991, 4; Sara Diamond, "The Rights' Grass Roots," *Z*, Mar. 1992, 21; Chip Berlet, "The Author Replies," *Progressive*, Aug. 1992, 7; Robert Sam Anson, "The Shooting of *JFK*," *Esquire*, Nov. 1991, 100, 174–76. Thanks to Sara Diamond for these references.

9. William Pfaff, *International Herald Tribune*. (I am unable to recover this reference.) *Los Angeles Times* journalist Robert Scheer and California state assemblyman Tom Hayden, both prominent in the 1960s New Left, celebrated *JFK*. See Robert Scheer, "Pssst: Give Stone an Oscar," *Playboy*, Jan. 1992, 47–48; Tom Hayden, "Shadows on the American Storybook," *Los Angeles Times*, Dec. 30, 1991, 4.

10. Edward Jay Epstein, *Inquest: The Warren Commission and the Establishment of Truth*, intro. Richard Rovere (New York: Viking, 1966); Oliver Stone, *New York Times*, Feb. 3, 1992, A14; Oliver Stone, *Nation* 254 (May 18, 1992): 650; *New York Times*, April 2, 1992, B4.

11. See Fawn M. Brodie, *Richard Nixon: The Shaping of His Character* (Cambridge, Mass: Harvard, 1981), 493–96.

12. Melanie Klein, *Love, Guilt, and Reparation and Other Works*, intro. R. E. Money-Kyrle (New York: Free Press, 1975).

13. Jeff Yarbrough, "Heart of Stone," *Advocate*, April 7, 1992, 46.

14. Stone quoted in Clancy Sigal, "The Paranoid Myth of *JFK*," *Guardian* (Manchester, England), Jan. 17, 1992, 38; Stone quoted in Prasch, "*JFK* and the Critics," *Ryder*, Apr. 2–16, 1992, 29; *Nation* 254 (May 18, 1992): 650; Norman Mailer, "Footfalls in the Crypt," *Vanity Fair*, Feb. 1992, 129.

15. Daniel Paul Schreber, *Memoirs of My Nervous Illness*, trans. and ed. Ida Macalpine and Richard H. Hunter, intro. Samuel Weber (Cambridge, Mass: Harvard, 1988); Sigmund Freud, "Psycho-Analytic Notes on an Autobiographical Account of a Case of Paranoia (Dementia Paranoides)," in *Standard Edition of the Complete Psychological Works of Sigmund Freud*, ed. James Strachey, 24 vols. (London: Hogarth Press, 1953–74), 12:3–79. Quotes are from Schreber, 99, 83; Freud, 19.

Schreber may well have himself been subjected to the physically invasive educational and psychiatric reform practices of his father, an eminent educational reformer, and his doctor, a founder of German psychiatry. But if his theory of soul murder was an effort to make sense of what these authorities had done to him, that hardly makes his *Memoirs* an accurate account of his history. Rather it intensifies the parallel with *JFK*, an attempt to make sense of authoritarian intrusions into the body politic that is distorted by the very power it seeks to grasp. Subjecting Schreber's *Memoirs* and *JFK* to psychoanalytic interpretation will for some side with power against the flawed understandings in the texts. We can no longer read Schreber innocent of Freud, to be sure, and a line may well run from Schreber's father through Flechsig to the founder of psychoanalysis. But however one sorts out the problem of knowledge and power, Stone hardly shares Schreber's vulnerability. The texts remain, moreover, and sexual, bodily invasion from a distance is at the center of both. Cf. Morton Schatzman, *Soul Murder: Persecution in the Family* (New York: Random House, 1973); Friedrich Kittler, "Flechsig—Schreber—Freud: A Network of Discourses," unpublished ms. (I am grateful to Jann Matlock for the Kittler reference).

16. Leo Bersani, "Pynchon, Paranoia, and Literature," *Representations* 25 (Winter 1989): 101.

17. Ibid., 103; Schreber, *Memoirs*, 49–50; Weber, intro. to Schreber, *Memoirs*, xxviii; Jacques Lacan, "On the Possible Treatment of Psychosis," *Ecrits*, trans. Alan Sheridan (New York: Norton, 1977), 201–2.

18. Mailer, "Footfalls," 128.

19. Yarbrough, "Heart of Stone," 46, 47.

20. Ibid., 48–49.

21. Ibid., 49.

22. Maria Monk, *Awful Disclosure of the Hotel Dieu Nunnery of Montreal* (1836; rev. with appendix, New York: Arno Press, 1977).

23. Freud, "Paranoia," 16–17, 20–21; Schreber, *Memoirs*, 72–73.

24. Yarbrough, "Heart of Stone," 46; Freud, "Paranoia," 23–25.

25. Schreber, *Memoirs*, 72, 75; Freud, "Paranoia," 19; Alexander Cockburn, "Cockburn Replies," *Nation* 254 (May 18, 1992): 678.

26. *Sun*, Feb. 11, 1992, 15, 33.

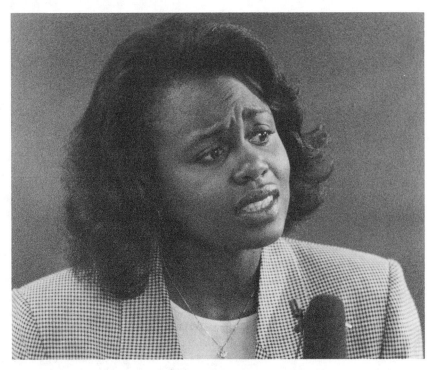

Anita Hill (AP/Wide World Photos)

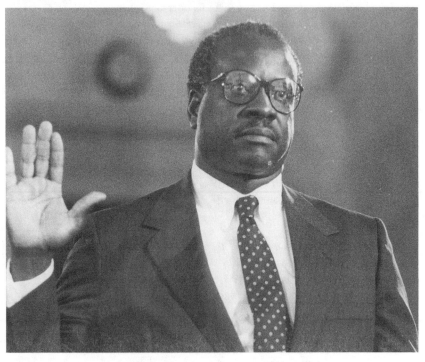

Clarence Thomas (AP/Wide World Photos)

2

Character Assassination:

Shakespeare, Anita Hill, and *JFK*

Marjorie Garber

"Great men are more distinguished by range and extent than by originality."

> —Ralph Waldo Emerson, "Shakespeare"

1st VOICE: Oh no!
2nd VOICE: Can't be!
3rd VOICE: They've shot the President!
5th VOICE: Oh, piteous sight!
1st VOICE: Oh, noble Ken O'Dunc!
2nd VOICE: Oh, woeful scene!
6th VOICE: Oh, traitorous villainy!
2nd VOICE: They shot from there.
1st VOICE: No, that way.
3rd VOICE: Did you see?
4th VOICE: Let's get the facts. Let's go and watch TV.

> —Barbara Garson, *Macbird*

In the fall of 1991, the televised Senate hearings on the confirmation of Clarence Thomas as justice of the U.S. Supreme Court yielded an unexpected and fascinating benefit for the student of literature and culture: the voice of Shakespeare ventriloquized, speaking through our nation's lawmakers and those called to testify before them.

Senator Alan Simpson of Wyoming, one of Judge Thomas's most ardent supporters, declared roundly as he addressed the assembled gathering that

"Shakespeare would love this. This is all Shakespeare. This is about love and hate and cheating and distrust and kindness and disgust and avarice and jealousy and envy." To reinforce his point, that the Bard had a word for it, he then went on to cite in defense of Clarence Thomas what he felt was a particularly apposite and telling passage:

> Good name in man and woman, dear my lord,
> Is the immediate jewel of their souls.
> Who steals my purse, steals trash; 'tis something, nothing;
> 'Twas mine, 'tis his, and has been slave to thousands;
> But he that filches from me my good name
> Robs me of that which not enriches him,
> And makes me poor indeed.

To underscore the depth of his feeling, Senator Simpson added "What a tragedy! What a disgusting tragedy!"—a remark I take to be a comment on the Thomas/Hill events, and not on the play from which he had just quoted.[1]

Let us pause for a moment to consider what any psychoanalytic critic would recognize as the overdetermined nature of this choice of text. For the quotation, as Simpson noted to his learned colleagues, comes of course from *Othello*, a play about a black man whose love for a white woman, Desdemona, leads his detractors to describe his passion—or rather, their fantasies about his passion—in the most graphic and vivid terms. It is not, that is to say, only a telling passage about sexual jealousy, but also a passage chosen from a play with a peculiar pertinence—or impertinence—to the events narrated in the Senate chamber.

Whether Senator Simpson had, in fact, the thematic relevance of *Othello* firmly in mind when he quoted from it, however, must remain a little in doubt. For the passage that he quoted in ringing tones is not, of course, the voice of the injured Othello, but rather that of his Machiavellian manipulator, Iago, the very man who sets in motion the plot against him, the man whose own "hate . . . and distrust . . . and jealousy and envy"—to quote the senator's eloquent peroration—lead him to falsify evidence and to twist the facts.

Needless to say, Iago has no use at all for "good name," nor for the quality he calls, in an equally famous interchange with another victim of his innuendo, "reputation."

The whole speech (*Othello* 3.3.155–61), as any student knows, is an example of the most blatant *hypocrisy*. The audacity of Iago in taking what he pretends to be the high road while secretly manipulating his dupes (Othello and the unsuspecting, gullible Venetians) is, in dramatic context, breathtaking. In his next lines Iago will invoke—and invent—the "green ey'd monster," "jealousy," which is the very quality that typifies *his*, and not Othello's, behavior throughout.

What is it that Senator Simpson thought he perceived in this dollop of the classics, this soupçon of Shakespeare, that somehow would make his point? Perhaps it is no accident that members of the Venetian senate are themselves called senators—"most grave senators" (*Oth.* 1.3.229). Yet Iago's audience, like that of Senator Simpson, is a wider one. By citing Shakespeare this "most grave senator" was in effect giving moral weight to his own position. Shakespeare said it: therefore it must be true. True, somehow, to human nature, whatever that is. Universally, transhistorically true.

This penchant for quoting Shakespeare out of context, as a testimony simultaneously to the quoter's own erudition and the truth of the sentiment being uttered, is itself a time-honored trick of American public oratory. In some quarters (although not on the fundamentalist Right) it has come to replace the Bible, since Shakespeare is regarded as both less sectarian and less sanctimonious. For many years one of the most quoted passages of Shakespeare in the *Congressional Record* was a set piece equally wrenched out of context, Polonius's advice to his son in *Hamlet*: "This above all: to thine own self be true, / And it must follow, as the night the day, / Thou canst not then be false to any man" (*Ham.* 1.3.78) That this is the same passage that begins "Neither a borrower nor a lender be" may testify to the Congress's ability to disregard, as well as to regard, the timeless "wisdom" of Shakespeare.

For Polonius, like Iago, is of course being presented in an ironic context. His utterances on this occasion are bromides, sententiae, used wisdom, the

Bartlett's Quotations of his day, spilled forth helter-skelter in a speech that many in Shakespeare's audience would have recognized as the mark of a puffed-up public man delighted with the sound of his own voice.

But let us return to Senator Simpson. For Senator Simpson emerged in the course of the hearings as in some sense the voice, and the guardian, of Shakespeare. When the chairman of the Judiciary Committee, Senator Joseph Biden, misattributed another quote to Shakespeare, Simpson quickly corrected him. "One of the things that has been indicated here," as Biden summarized the proceedings for his colleagues, "is this notion of maybe that the witness, Professor Hill, really was basically the woman scorned. . . . and that after being spurned she took up the role in the way that Shakespeare used the phrase, 'Hell hath no fury like' and that's what's being implied here."[2]

But the ever-vigilant Senator Simpson was on hand to set the record straight. "My friend from Wyoming," Biden reported genially, "in an attempt to save me from myself, has suggested to me that it was not William Shakespeare who said 'Hell hath no fury. . . .' I still think Shakespeare may have said it as well, but he says, 'William Congreve said it and the phrase was, "Heaven has no rage like love to hatred turned,/ Nor hell a fury like a woman scorned." 'I want the record to show that.'

Biden was good-natured enough to add a further self-deprecating quip: "I must tell you—I have my staff researching Shakespeare to discern if he said [anything like that]. Not that I think Mr. Congreve would ever plagiarize Shakespeare."[3] This last reference, of course, is to Biden's own history of quotation without citation from the political speeches of British politician Neil Kinnock.[4]

The Congreve passage comes from a play called *The Mourning Bride*, not necessarily standard American curricular fare even in Wyoming, which is why I am guessing that *Bartlett's Familiar Quotations*, not Congreve, was Senator Simpson's source.[5] And *Bartlett's Quotations*, the disjecta membra of famous, disembodied voices, is the repository of conventional wisdom, of what we, and our senators, purport to know about "human nature." This use of quotation from the literary classics—quotation, especially, from

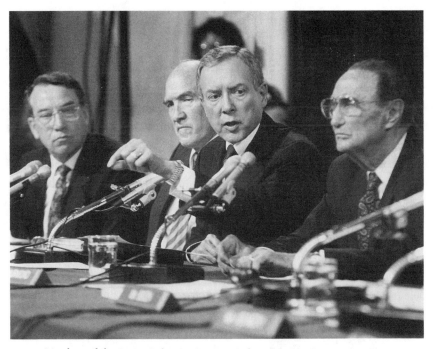

Members of the Senate Judiciary Committee, from left to right, Senator Charles Grassley, Senator Alan Simpson, Senator Orrin Hatch, and Senator Strom Thurmond. (AP/Wide World Photos)

Shakespeare—had, then, bipartisan appeal. Why did Biden think that "hell hath no fury like a woman scorned" was by Shakespeare? Because it was famous—and because he thought it was true. Indeed, many if not all of the most grave senators seemed to think it was true, was a given, was a foregone conclusion. If Anita Hill *was*, or could be said to be, a scorned woman, then it would be clear that she was animated and motivated by fury, had become, in effect, one of the Furies, who were themselves

regarded by the wise ancients as female. A "scorned" woman or a "spurned" woman? The senators seemed unsure as to the exact quotation—how many of them had read *The Mourning Bride* recently?—but the phrase echoed, ghostlike, thoughout the hearings. Hell had no fury like one of them; Shakespeare had—almost—said so.

Why Shakespeare? Well, for one thing Shakespeare is "safe"; neither too high nor too low. He is not an author whom Lynne Cheney or her colleagues at the National Endowment for the Humanities could have accused of being the property of narrow specialists,[6] but rather the abiding, ventriloquized voice of us all, of disembodied wisdom. Emerson wrote in 1850 about the way in which Shakespeare's works underlay political and moral thought in America and Europe: "literature, philosophy, and thought," said Emerson, "are Shakespearized. His mind is the horizon beyond which, at present, we do not see. Our ears are educated to music by his rhythm" (204).

Emerson's Shakespeare is enhanced rather than diminished by the fact that so little is known about his life. Like some of George Bush's political and judicial appointments, whose past opinions were nonexistent, retracted, or under erasure, he is therefore free to be everything, to know everything, to tell us what we want to know, or what we already think we know. "The wise Shakespeare and his book of life," "inconceivably wise," a "poet and philosopher" who teaches the king, the lover, the sage, and the gentleman—this is the Shakespeare whom Emerson calls a "genius" and a representative man (210–11). This is the Shakespeare whom Thomas Carlyle, in a book written a few years earlier, called a "Hero," an object of "Hero-Worship." "A thousand years hence," Carlyle wrote in 1840, "[f]rom Paramatta, from New York, wherever English men and women are, they will say to one another, 'Yes, this Shakespeare is ours; we produced him, we speak and think by him; we are of one blood and kind with him.' "[7]

We speak and think by him.

The power of this kind of disembodied, free-floating quotation is considerable. Sometimes the quotation itself can perform an implicit act of commentary, less overt than Senator Simpson's grumpy (and un-Shakespearean) offstage (but on-mike) complaint that people were afraid to tell the supposed

"truth" about Anita Hill because of "all this sexual harassment crap."[8] (The shift in tonal register in the learned senator's language from the earlier heights of "Good name in man and woman . . . is the immediate jewel of their souls" was, perhaps, not wholly lost upon a discerning audience). The faxes supposedly hanging out of his pockets were disjecta membra of another kind, foul papers that had come in over the transom.

Yet the Thomas hearings provided all too glaring evidence of how the Shakespeare quote, lifted out of context, could be like a double-edged sword, turning back upon the wielder. During the floor debate on the day of the Senate vote, Patrick Leahy, senator from Vermont, attempting to reclaim the high ground from the Republicans, noted that "Senator Simpson quoted Shakespeare the other day," and added, "let me paraphrase from *Hamlet*, 'Judge Thomas doth protest too much.' "[9] Leahy thus inadvertently cast himself as Queen Gertrude and Clarence Thomas as the Player-Queen whose overfervent claims of innocence and fidelity were—or so Hamlet remarks to the audience—themselves grounds for suspicion.

Notice the gender roles implicit in this allusion. Thomas, Senator Leahy's reference seemed subliminally to suggest, had appropriated to himself the "female" role, the role of impossible virtuousness and chastity. If he were in a locker room or a sports bar his language among men, Thomas asserted, would be as pure as tea party conversation with a roomful of Republican ladies. But the *Hamlet* context, of course, is doubled. The spectator who sees through this language of protesting too much is the very person whose own innocence the play within the play is set up to question. Was Senator Leahy, among the most staunch and, to my mind, admirable, of Anita Hill's supporters, subconsciously offering a comment on the Senate's own holier-than-thou position—on, for example, Orrin Hatch's horrified claim that any man who watched pornography or talked about his own body was a psychopathic monster?

But this may be, to cite the Bard once more, to consider too curiously. My favorite of all the Shakespeare citations in the Thomas hearings, however, has, apparently, very little of the subconscious or inadvertent about it. I refer to the accusation leveled by Thomas character witness J. C. Alvarez, who had

worked with him in the office of Education, at Anita Hill, whom Alvarez characterized directly as aggressive, aloof, and, above all, *ambitious*. Alvarez, whom right-wing columnist Peggy Noonan unforgettably described as "the straight-shooting Maybellined J. C. Alvarez," "the voice of the real, as opposed to the abstract, America," sneered self-righteously, "What is this country coming to when an innocent man can be ambushed like this, jumped by a gang whose ringleader is one of his own protégées, Anita Hill. Like Julius Caesar, he must want to turn to her and say 'Et tu, Brutus? You too, Anita?' "[10] Thus the voice of the real America spoke, not entirely surprisingly, in and through the voice of Shakespeare. Can it be a total accident that her cryptic initials, J. C., are the initials of the Shakespearean figure she is quoting, Julius Caesar? Caesar who became the most famous case of literal character assassination in ancient history, or, indeed, in Shakespeare's plays?

The phrase "Et tu, Brute"—you too, Brutus—is, as I pointed out in another context a few years ago, "a quotation of a quotation, a quotation which has *always* been in quotation, ultimately a quotation of nothing."[11] It has no source in ancient texts, though it is set off in Shakespeare's play as apparently "authentic" by the fact that the dying Caesar speaks it in Latin. It is in fact not a sign of authenticity but of its opposite, what I called "a back-formation from Elizabethan literary culture, a 'genuine antique reproduction.' "

"Et tu, Brute"—or, to quote the voice of America, J. C. Alvarez, more exactly, "Et tu, Brutus." That Ms. Alvarez has small Latin (and, I think it is fair to assume, perhaps even less Greek) makes her appropriation of Shakespeare, and Shakespeare's cultural power, even more striking. "You too, Anita." The bathos, as with Senator Simpson's rhetorical tumble into "sexual harassment crap," is imperceptible to the speaker. For she is speaking "Shakespeare"—never mind that the Shakespeare she speaks is, to a large extent, made-up. (Peggy Noonan, you may recall, contrasted J. C. Alvarez favorably with "the professional, movement-y, and intellectualish [Judge] Susan Hoerchner," who, said Noonan disparagingly, wore no makeup). Alvarez is speaking "Shakespeare," as "Shakespeare" has come to be spoken in the public sphere of American politics. Out of context, deprofessionalized, timeless,

transcendent, and empty, the literary version of the American flag, to be waved at the public in an apparently apolitical gesture toward universal wisdom.

Indeed, had Anita Hill wished to reply in kind, she too could have found prescient authorization and authority in the disembodied voice of Shakespeare. Turning to *Richard III*, his play of Machiavellian statecraft, she might have quoted a familiar passage from the episode known as Clarence's dream: "Clarence is come, false, fleeting, perjur'd Clarence, / That stabb'd me in the field by Tewksbury" (*Richard III* 1.4.56–57). The dreamer, and the speaker, in this case is in fact the Duke of Clarence himself, recalling a moment in his earlier career.

The saving remnant for the reader of Shakespeare is that the context is, in fact, so often telling, that the play's language does, so often, to quote Brutus on the spirit of Caesar, walk abroad, and "turn our swords / In our own proper entrails," stabbing or undercutting the speaker. Senator Simpson as Iago will long linger in my mind as one of the most revealing moments of the hearings. Honest, honest, honest Iago. The play's the thing.

Emerson himself was not immune to the nicking of this two-edged sword. Both his chapter titled "Shakespeare: Or the Poet" and the more general introductory essay, "Uses of Great Men," in *Representative Men* reproduce the same pattern of quotation undercutting the apparent argument of the text. The overtly presiding spirit of Emerson's essay is that of Hamlet. His observation that "literature, philosophy and thought are now 'Shakspearized' " is presented in the context of a praise of German Romantic Shakespeare criticism: "It was not until the nineteenth century, whose speculative genius is a sort of living Hamlet, that the tragedy of Hamlet could find such wondering readers" (204).

This privileging of *Hamlet* as the key text of the age is as expectable from Emerson as it is common to writers of the period. The same semi-autobiographical impulse that led him to claim that great geniuses all plagiarize from one another (a teaching that might have been some comfort to Senator Biden, had one of his staffers, or the staffers of the indefatigably learned

Senator Simpson, called it to his attention)—that same impulse to write *himself* into his praise of Shakespeare surfaces again in the "identification" with Hamlet and his problems.

Emerson tacitly casts himself as Hamlet when he tells the story of his visit to the theater to see a great tragedian play the part:

> and all I now remember of the tragedian was that in which the tragedian had no part; simply Hamlet's question to the ghost:
>
> "What may this mean,
> That thou, dead corse, again in complete steel
> Revisit'st thus the glimpses of the moon?" (207)

It needs no ghost come from the grave to tell us that the "dead corse" here is Shakespeare, or the avid questioner, Emerson; the "great" tragedian, a mere transitional object, is conveniently erased and forgotten, remains nameless in the essay, and will not be numbered among the "great men."

The question of "chararacter assassination" and the phrase itself did, of course, come up in the course of the Thomas hearings. Thomas's protest against what he viewed as racial stereotyping of black male sexuality, his suggestion that he was undergoing a "high-tech lynching," was reinforced by this declaration: "I would have preferred an assassin's bullet to this kind of living hell that they have put me and my family through."[12] And Senator Edward Kennedy spoke out sharply against the "dirt and innuendo" that had been cast upon Anita Hill: "We heard a good deal about character assassination yesterday, and I hope we're going to be sensitive to the attempts of character assassination on Professor Hill. They're unworthy. They're unworthy."[13]

For Kennedy the image of the assassin's bullet had, undoubtedly, a special and painful relevance. The difference (and the relationship) between assassination and character assassination, between the bullets that had killed his brothers and the innuendo aimed at him by the press, was doubly clear in his case, since his own "character" (and, indeed, the "question of character" raised by Thomas C. Reeves' moralizing JFK biography of that name) was implicitly

on trial or at least on view.[14] And ironically, the chief defense counsel for Judge Thomas, the point man for innuendo against Anita Hill, was also a key figure in the story of the Kennedy assassination and its aftermath.

To make the irony more precise, and to introduce what will be, inevitably, a strong and ghostly Shakespearean subtext to *that* story of character and assassination, we may note that the name of the counsel, the hard-nosed senior senator from Pennsylvania, was "Specter": Arlen Specter.

> What may this mean,
> That thou, dead corse, again in complete steel
> Revisit'st thus the glimpses of the moon?

Uncannily, this same Arlen Specter was the aggressive and ambitious junior counsel for the Warren Commission, the man who proposed the famous "magic bullet" theory that enabled the Warren Commission to claim that Lee Harvey Oswald had acted alone. In doing so he warded off any implications of the sort that Oliver Stone brings forward in his blockbuster film *JFK*: that "spooks" from the C.I.A. had foreknowledge of, much less any hand in, the assassination. Is this specter an "honest ghost"? Or a "damned ghost"? Or just "an affable familiar ghost"—the return of the repressed?

It will probably not surprise you at this point to learn that Stone's film contains not one or two but five Shakespeare quotations, all performing cultural work of a kind that should now be familiar. *Hamlet*, inevitably, is the play of choice for this dramatization of the moral musings of a man who regards himself as the conscience of the nation—whether that part is being played by Jim Garrison (Kevin Costner) or Oliver Stone. "One may smile and smile and be a villain," Garrison/Costner reflects, as he ushers the urbane and elusive Clay Shaw out of his office, shortly to charge him with conspiracy in the murder of JFK, whom he will characterize as a "slain king." In a long and (mostly) moving speech to the jury at the end of the film he tells them "we are all Hamlets, children of a slain father-leader whose killers still possess the throne." Since considerations of spurious "national security" have allowed the government to classify the relevant documents for a conspiracy trial, he tells the jury he himself will have "shuffled off this mortal coil" before they are

33

Senator Arlen Specter. An "honest ghost?" (AP/Wide World Photos)

unsealed, but he will urge his son to examine them when they are opened in fifty years. *Julius Caesar* too is, perhaps inevitably, invoked and cited, as Garrison asks a staff member whether he's read it; this is how a conspiracy works, he says, Brutus and Cassius and all the others united in a plot against the innocent leader. "Do you read Shakespeare?"

But the oddest and most piquant Shakespearean touch, as you will remember if you've seen the film, is the final epigraph, starkly lettered in white against a field of black: "What is past is prologue," it says. Not "what's past is prologue" (*Tempest* 2.1.253): "What is past is prologue." Is it that Shakespeare is not, on so solemn an occasion, to seem colloquial? Does misquotation here seem more authentic, more like a real quotation? Does it seem more like what Shakespeare—our Shakespeare—would have, should have, said?

The citation from *The Tempest*, itself a play of revenge, is spoken in the

voice of the usurping Duke of Milan, Prospero's brother. The context is his suggestion to Sebastian that he kill his own brother, the king, and rule Naples in his stead, appropriate enough, we might think, in a film that paints a dark picture of the motivations of Lyndon Johnson. But Stone preempts this scenario, disembodies the text, to make the line an ominous pledge: like Garrison he will continue to fight the good fight, seek the truth, uncover the character assassination of the single "patsy," Oswald, that is hiding the real story of the assassination of JFK by a megaconspiracy of agencies, generals, and politicians. What is past is prologue.

A very similar set of concerns was brought forward twenty-five years ago in Barbara Garson's play *Macbird*, the source of the stichomythic passage I have cited at the beginning of this essay. *Macbird*, a pastiche of parodied Shakespearean passages from plays like *Richard II*, *Henry V*, *Hamlet*, *Julius Caesar*, and *Othello* as well as *Macbeth*, was written, as is doubtless clear from this excerpt, in the chaotic time after the Kennedy assassination, and was published in Berkeley, California, in 1966, by an outfit calling itself the Grassy Knoll Press. It tells the story of the murder of Ken O'Dunc by the ambitious Macbird and Lady Macbird, who then escalate the war in Vietland and are finally defeated by Ken O'Dunc's surviving brothers Robert and Teddy "when burning wood doth come to Washington."

But the role played by Shakespeare in Stone's *JFK* is a slightly different one from the one he plays in *Macbird*. Stone's Shakespeare is present not overtly as analogue and pretext but covertly as a glancing subtext, as 1) a sign that educated discourse in this country is Shakespeare-literate, and 2) a ghostly evocation of Shakespeare as the cultural voice of revenge and retribution, of values and of conscience; and 3) as yet further evidence that Shakespeare quotation can be an uncanny, double-edged sword—if not a magic bullet.

Furthermore, as is perhaps needless to say, Garson's *Macbird* was a coterie production of the antiwar movement, while Stone's *JFK* is a $40 million film bankrolled by Time-Warner and ballyhooed on the pages of mass circulation magazines and newspapers from *Esquire* to *Newsweek* to the *New York Times*. And the questions raised in journal after journal have been: Is Stone, like Shakespeare's comic and self-important vicar, an "Oliver Mar-text"?[15] What

right does he have to make so public and political a statement of his own interpretation of historical events, and to buttress that opinion with manufactured footage, cross-cuts, grainy color and black and white reenactments of "historical events"—meetings between conspirators, the planting of Oswald's handprint on the rifle, admirals intervening at the autopsy of JFK—"events" that may never have occurred?

Here is Oliver's Stone's defense, or explanation: "I consider myself a person who's taking history and shaping it in a certain way. Like Shakespeare shaped *Henry V.*" "Like Hamlet we have to try and look back and correct the inaccuracies."[16] D.A. Jim Garrison may have suffered from hubris and made serious mistakes, but that "only makes him more like King Lear."[17] This is indeed the official story from Stone headquarters, that Stone is today's Shakespeare. Here is entertainment lawyer Bert Fields, whose firm represents the director:

> If you are doing what purports to be a book or film about history, it's hardly rare for an author or film maker to take a position. Look at *Richard III*. There was a violent controversy between those who believed Richard was a tyrant who murdered his two nephews. And those who think he was a wonderful king. Shakespeare represented one view, the view that was acceptable to his Queen. Nobody faulted Shakespeare.[18]

Leaving aside this last observation ("nobody faulted Shakespeare"), the argument seems fairly joined. *Newsweek*'s cover story decried "The Twisted Truth of 'JFK'" and sought to explain "Why Oliver Stone's new Movie Can't Be Trusted."[19] Headlines like "When Everything Amounts to Nothing[20]," "Oliver Stone's Patsy,"[21] and Stone's op-ed page challenge, "Who is Rewriting History?"[22] (all printed on the same day in the same newspaper) are obviously good publicity for the film, but they are also something more. A *New York Times* reporter named Michael Specter—no relation, presumably, to the senator from Pennsylvania—noted skeptically that many filmgoers seem to have "succumbed to Mr. Stone's Grand Unified Conspiracy Theory, a gaudy, frenetic fiction."[23] These ghosts are all around us.

"Stone has always required a hero to worship," wrote *Newsweek*'s arts columnist, David Ansen. "He turns the D.A. into his own alter ego, a true

believer tenaciously seeking higher truth. He equally idealizes Kennedy, seen as a shining symbol of hope and change, dedicated to pulling out of Vietnam and to ending the cold war."[24] . A hero to worship. Stone's heroes are not two but three: Jim Garrison, John F. Kennedy, and Shakespeare. And here he is in formidable company. Consider again the view of Shakespeare put forward by the man who popularized the term "hero-worship" (a term invented, it would seem, by David Hume[25]) one hundred fifty years ago, Thomas Carlyle. "How could a man delineate a Hamlet, a Coriolanus, a Macbeth, so many suffering heroic hearts, if his own heroic heart had never suffered?"[26]

Of Shakespeare's "Historical Plays" Carlyle asserts that "there are really, if we look to it, few as memorable Histories. The great salient points are admirably seized; all rounds itself off into a kind of rhythmic coherence; it is, as Schlegel says, *epic*." Art, not history, is thus the measure of "hero-worship"; to Carlyle, Shakespeare's "veracity" lies in his "universality."[27]

For Carlyle—as for Emerson—Shakespeare was cramped, even demeaned, by the material circumstances of cultural production in his time: "Alas, Shakespeare had to write for the Globe Playhouse; his great soul had to crush itself, as it could, into that and no other mould. It was with him, then, as it is with us all. No man works save under conditions. . . . *Disjecta membra* are all that we find of any Poet, or of any man."[28]

Disjecta membra. Familar quotations. Disembodied voices. In the Thomas/ Hill hearings, in Oliver Stone's *JFK*, in *Bartlett's Familiar Quotations*, everywhere in the corridors of power, Shakespeare authorizes a rhetoric of "hero-worship" and character assassination based upon this Orphic dismemberment of the text. "Et tu, Brutus?" "What is past is prologue." Perhaps it is well for us to remember in these times how uncannily the "familiar" can be defamiliarized—and that a "familiar" can also be a demon, a spirit, a specter, a "spook," or a ghost.

NOTES

1. Senator Alan Simpson, Hearing of the Senate Judiciary Committee on the Thomas Supreme Court Nomination, Saturday, October 12, 1991 (Washington: Federal News Service, Federal Information Systems Corporation [computer disc record]).

2. Senator Joseph Biden, Hearing of the Senate Judiciary Committee on the Thomas Supreme Court Nomination, Sunday, October 13, 1991.

3. Ibid.

4. "Great genial power, one would almost say, consists in not being original at all." The great man "steals by this apology—that what he takes has no worth where he finds it, and the greatest where he leaves it. It has come to be practically a sort of rule in literature, that a man having once shown himself capable of original writing, is entitled thenceforth to steal from the writings of others at discretion. Thought is the property of him who can entertain it and of him who can adequately place it. A certain awkwardness marks the use of borrowed thoughts; but as soon as we have learned what to do with them they become our own.

"Thus all originality is relative." Ralph Waldo Emerson, "Shakespeare," in *Representative Men* (1850) (Boston: Houghton Mifflin, 1903), 191, 198.

5. William Congreve, *The Mourning Bride* 3.1.457–58, in *The Complete Plays of William Congreve*, ed. Herbert Davis (Chicago: University of Chicago Press, 1967).

6. Lynne V. Cheney, *Humanities in America: A Report to the President, the Congress, and the American People* (National Endowment for the Humanities: Washington, D.C., 1988), 8–10.

7. Thomas Carlyle, *On Heroes, Hero-Worship, and the Heroic in History* (1840), ed. Carl Niemeyer (Lincoln, Neb.: University of Nebraska Press, 1966), 114.

8. Simpson, Hearing of the Senate Judiciary Committee, October 12, 1991. For an acute media analysis of Simpson on "this sexual harassment crap," see Anna Quindlen, "The Perfect Victim," *New York Times*, October 16, 1991, A25.

9. Senator Patrick Leahy, *Congressional Record*, Proceedings and Debates of the 102nd Congress, First Session, Washington, Tuesday, October 15, 1991, vol. 137, no. 147, S14650.

10. J. C. Alvarez, Hearing of the Senate Judiciary Committee on the Thomas Supreme Court Nomination, October 13, 1991.

11. Marjorie Garber, "A Rome of One's Own," *Shakespeare's Ghost Writers* (London and New York: Routledge, 1987), 55.

12. "Excerpt from Senate's Hearings in the Thomas Nomination," *New York Times*, October 13, 1991, 31.

13. "Excerpt from a Statement by Senator Kennedy," *New York Times*, October 14, 1991, A13.

14. Thomas C. Reeves, *A Question of Character: A Life of John F. Kennedy* (New York: The Free Press, 1991)

15. *As You Like It* 3.3.

16. Robert Sam Anson, "The Shooting of JFK," *Esquire*, November 1991, 102.

17. Ibid., 174.

18. Quoted by Bernard Weinraub, "Hollywood Wonders if Warner Brothers Let 'J.F.K.' Go Too Far," *New York Times*, December 24, 1991, C12.

19. *Newsweek*, December 23, 1991.

20. Vincent Canby, *New York Times*, Dec. 20, 1991.

21. *New York Times* editorial notebook, December 20, 1991.

22. *New York Times*, December 20, 1991.

23. *New York Times*, December 23, 1991, 1.

24. "A Troublemaker for Our Times," *Newsweek*, December 23, 1991, 50.

25. David Hume, *The Natural History of Religion* (1757), section 6, "Various Forms of Polytheism: Allegory, Hero-Worship," in *The Philosophical Works*, ed. T. H. Green and T. H. Grose (London, 1882), 4:328: "The same principles [on which human beings create divinities] naturally deify mortals, superior in power, courage, or understanding, and produce hero-worship, in all its wild and unaccountable forms."

3

Reproducing Reality: Murphy Brown and Illegitimate Politics[1]

Rebecca L. Walkowitz

It doesn't help matters when prime-time TV has Murphy Brown, a charac-
ter who supposedly epitomizes today's intelligent, highly paid, professional
woman, mocking the importance of fathers by bearing a child and calling it
"just another lifestyle choice."
 —Vice President Dan Quayle[2]

My complaint is that Hollywood thinks it's cute to glamorize illegitimacy;
Hollywood doesn't get it. . . . They ought to come with me out to where
the real America is.
 —Vice President Dan Quayle[3]

Throwing down the first gauntlet in what the *New York Times* came to describe
as a "cultural war" of politics, Vice President Dan Quayle launched the 1992
Republican campaign for "family values" with an attack on the popular fictional
television news anchor, Murphy Brown.[4] Brown, played by Candice Bergen
in a top-rated CBS sitcom called "Murphy Brown," became unexpectedly
pregnant in the 1991–92 season, and gave birth as a single parent in the last
episode, which aired on May 18. Quayle's speech, delivered before a club
gathering in California only two days later, followed shortly on the heels of
the Rodney King riots in Los Angeles. The vice president attributed the "lawless
social anarchy" of the King riots to a broader "poverty of values," encouraged
and exemplified by the Murphy Brown story line.[5] In an impressive rhetorical
maneuver, Quayle blithely exchanged "poverty" in Los Angeles for a "poverty
of values" in prime-time television, and thus moved from the material to

the abstract, ideological, and fictional. Moreover, through this displacement, Quayle avoided discussing either race or the urban environment, but rather universalized his topic and his analysis, making race, class and geography inadmissible to the contest over "real America" and its constituency.

Despite the instant and widespread attention given Quayle's remarks, the vice president's team swiftly retreated from its derision of Murphy Brown, ever-mindful of the sitcom's high ratings share (the network estimated 70 million viewers for the fall 1992 season premiere).[6] And in any case, Quayle's advisors told the media, Murphy Brown wasn't the issue: "The Vice President wanted to give a serious speech about the urban problem and focus on the poverty of values," William Kristol, Quayle's chief-of-staff, told Andrew Rosenthal of the *New York Times*.[7] Another aide insisted, "It was a pop-culture cite to make [the speech] interesting."[8]

Meanwhile, back at the White House, Quayle damage control was working overtime. Murphy Brown, White House spokesman Marlin Fitzwater soon found, was pregnant with unruly signification; with the spectacle of "illegitimacy" came an excess of additional political baggage. Brown, after all, had chosen motherhood over abortion, and the conservative spin doctors couldn't figure out whether to embrace her decision as "pro-life" or reject it for its affirmation of unwed motherhood.[9] On one level, the vice president might have chosen any popular cultural reference to draw attention to his speech and to create a segue from urban to moral poverty. Yet it is the argument of this essay that Quayle's choice made a difference; Murphy Brown's body—a distinctly gendered body—and her reproductive decisions mobilized the vice president's argument. The woman and the journalist, as middle terms, as media, cannot be merely looked through, but must also be looked at, as integral to the news spectacle itself.

The vice president's reference glanced specific and controversial issues— abortion, motherhood, families—both in the news and in the newsroom, a division that is dissolved to his discomfort in the "Murphy Brown" program. For the breakdown of barriers between politics *in* the media and politics *of* the media in the content of the sitcom is mirrored by an ironic and often titillating play between fictional and real-life news in its formal design; "Mur-

phy Brown" prides itself on the very confusion of fiction and real life. "Just mixing the real people with the fictional people is a real kick for us," sitcom creator Diane English has said.[10] And according to reports from the Quayle camp, the commingling of real and fictional women newscasters in a sitcom baby shower for Murphy prompted the reference to Murphy Brown in the vice president's speech.[11] Quayle chose a television program about the news media as his medium, locating the institution of journalism, the power of journalists, and their authority in the anxiety that provoked his attack. Thus the media's reproduction and representation of political rhetoric in the content of the news became intricately tied to debates about the sexual reproductive choices of newscasters in particular and the politics of women's reproductive choice more broadly. In this sense, Dan Quayle's attack on Murphy Brown, I will argue, points to a debate about the position of journalists within a news media that produces and patrols individual personality only to reinforce the fiction of universal authority.

Real pregnant newscasters, married or unmarried, have been a topic of some gossip and occasional serious concern in the national press.[12] Indeed, Diane English freely admits that a number of episodes related to Murphy Brown's pregnancy were inspired by conflicts and stories from real newsrooms. In one program, a news executive suggests that public scandal may force him to take Murphy off the air; this interchange was not unrelated, English says, to a run-in between "60 Minutes" executive producer Don Hewitt and his correspondent Merideth Vieira, who was expecting her second child.[13] Vieira in fact was removed from "60 Minutes."

The hiring and firing of women newscasters, their circulation and exchange from network to network, is evident enough. Jane Pauley, Deborah Norville, Paula Zahn, Connie Chung, Diane Sawyer, Mary Alice Williams, among others, have all been shifted on and off news programs. The reasons for these shifts vary from the specific quest for the "younger and blonder" to the more ambiguous reasons of "charisma" or "how settled a person feels" to the television audience.[14] Women newscasters must be sexy, but not stray to sexual, and the boundaries are not always clear. "If you were an anchor, they expected

42

you to be glamorous and appear on the cover of *Vogue*," said one former news correspondent.[15] In September 1987, Diane Sawyer graced the cover of *Vanity Fair*, with an accompanying article about her entitled "Diane Sawyer: The Glamour and the Mystery." Maria Shriver has appeared, complete with strapless gown, frolicking with husband Arnold Schwarzenegger also in *Vanity Fair*, and in a photo sequence in *Harper's Bazaar*. Yet these women must be careful not to transgress the boundaries of what *Time* magazine has termed "propriety and professionalism." When Merideth Vieira, then correspondent for CBS's "West 57th Street," posed in *Esquire*, she was criticized for showing too much thigh. "60 Minutes" star Mike Wallace, later to be (if only momentarily) Vieira's colleague, damned the *Esquire* spread as "about as appropriate as anchormen appearing in beefcake pictures."[16]

It may be beside the point for Wallace that anchormen never happen to be in beefcake pictures, but the comparative surveillance of women newscasters, whether fictional or real, is not without consequence. Many of the critics and journalists who tout "journalism," by definition, as an ungendered, objective, and universal mediation of truth are also those, such as Wallace, who delineate the very boundaries of what gets mediated. As a visual medium, television news anchors the authority of its journalism in personality and persons. The anchoring comes as much from behind the scenes as from the anchors themselves. Don Brown, executive vice president of NBC News, has said that his network has become more flexible as its "talent" base has diversified to include more women. "Talent . . . is more critical than ever, and if that talent happens to be a woman who happens to be pregnant," Brown says, the network must make sure "talent" stays, whoever he or she may be.[17] Although he may have the best of intentions toward progressive work policies for women and families, Brown's attempts to universalize the interests of the network and his "happens to be" grammar undermine the extent to which the regulation of various kinds of reproduction, in media form (women newscasters) and media content (the news), is never quite so accidental.

Murphy Brown was condemned by Quayle as a bad example for urban America, presumably for unwed girls who might become pregnant, who might "get in trouble," influenced by Murphy's impoverished values. The danger,

then, was not just unwanted pregnancy, but unruly behavior, a sexual auton-
omy unrestricted by marriage or conservative morality. Indeed, top news
anchor Connie Chung caused particular controversy not for getting pregnant,
but for *trying* to get pregnant, which doesn't quite fit into the ABC executive's
euphemistic "happens to be" formulation. In 1990, Chung and her husband,
news correspondent Maury Povich, announced that they would begin taking
an "aggressive approach to having a baby."[18] *Working Woman* described
Chung's decision as a "retreat to the bedroom." Other journalists at a conven-
tion in New York chanted "Ovulate! Ovulate!" at a video apology when she
canceled a speech as a result of her new relation to reproduction.[19] The
spectacle of Chung's sexual reproductive choices thus demeaned her status as
a serious journalist, a status that had up to then been confirmed as properly
sexy and respectable in a series of *People* magazine interviews over the years.[20]
Chung's fault, and the fault attributed to many of her women colleagues, does
not reside in the spectacle of journalists and their sexualities—which the news
media, on their own terms, create all the time—but in a spectacle that threatens
to uncover its own boundaries and constructions.

Chung's troubles with reproduction don't end, of course, with her personal
life. Her 1989 prime-time television program, "Saturday Night with Connie
Chung," upset many critics and journalists for mixing fact and fiction to
confusion. Chung initially described "Saturday Night" as a "new genre in
television news": it mingled dramatic re-creations of events with eyewitness
accounts and talk-show analysis. The program's producers said they saw these
techniques as a way to bring viewers closer to reality, to what they would not
ordinarily be able to see: "I saw this as a way to get to the big events that
happened off camera," said executive producer Andrew Lack in the *New York
Times*.[21]

"Saturday Night with Connie Chung" sparked heated reactions from both
its critics and its defenders. Some journalists complained that it brought
together too many different and conflicting visual cues from documentary,
Hollywood film, television news, and political analysis. Moreover, the partici-
pation and headlining of Chung added the authority of a news anchor to what
was often not considered real journalism. The *Los Angeles Times* argued in an

editorial criticizing the program that "In good journalism there is no room—and certainly no need—for recourse to the bogus, the dishonest, the illusionary."[22] Such methods are not necessary nor suitable, the newspaper asserted, yet again invoking language of worth and stability. On the other hand, but along the same rhetorical lines, an unidentified CBS executive supported the use of Chung's dramatic re-creations with the assertion that they are "at least classy, not sleazy."[23]

The most serious complaint against "Saturday Night with Connie Chung" and other information news programs of this sort is that they shift between various degrees of documentation and re-creation, between actors and witnesses, without giving viewers signals to let them know that the rules are changing. This anxiety is not unlike the one that fueled Dan Quayle's political and rhetorical slippage from "poverty" to the "poverty of values;" his transition from families to family morality, according to Quayle aides, was motivated by the sight of unseemly fiction (Murphy Brown as single mother) flirting with proper reality—namely other, real news anchors visiting the program. It is indeed true that these programs may confuse viewers about how they should understand and interpret the value of what they are seeing. This confusion, however, stems more from unfulfilled expectations about news and what it looks like than from a recent rash of visual manipulation. "Journalism" and "America"—whether we call them real or not—depend upon a "grounding" that is constructed by the very manipulations that journalists and politicians have come to decry.[24]

"Saturday Night" was not the first time that Chung was attacked for participating in unworthy journalism. In 1987, Chung hosted a program that *Washington Post* reviewer Tom Shales deemed excessively flashy for "crossing the documentary form with the Hollywood Squares." In the show, Chung discussed AIDS and its effect on sexual mores by running clips from popular television shows and rock videos. "Chung sullies her good name in the process. It will be hard to take her seriously for a while," Shales added.[25] This threat of minimized journalistic authority came with the "Saturday Night" program as well. Reviewers in the *Boston Globe* and the *New York Times* focused on a spread of glamorous portraits of Chung that appeared in the opening credits,

which, according to the *Globe*, prompted one network executive to ask, "Is this a news program or a date?"[26] Yet the very photos that lowered Chung's program into the blatantly sexual for the *Globe* became evidence for "stardom in accord with network fashion" in the *Times*. What makes a woman news anchor a star, a spectacle, is also what, it seems, reduces her very authority in and about the news.[27] Robert Goldberg in the *Wall Street Journal* lauded Chung for the "warm glow" she brought her program, but he too wondered whether "America's sweetheart" could command enough screen presence and seriousness to attract audiences to a prime-time news show.[28]

As the conflated debates about Chung's appearance, life-style, and work suggest, in television journalism the personalities of news correspondents come to stand metonymically for the form and content of their news programs. The policing of news anchors often implies and includes a critique of the kind of news they represent and how they represent it. Former Watergate reporter Carl Bernstein, writing about the state of journalism on the twentieth anniversary of the Watergate burglary and scandal, complained that the news media have "been moving away from real journalism toward the creation of a sleazoid info-tainment culture in which the lines between Oprah and Phil and Geraldo and Diane and even Ted, between the *New York Post* and *Newsday*, are too often indistinguishable."[29] Television personalities, on a first-name basis with American culture, occupy in Bernstein's description the same institutional authority as entire newspapers in the print medium. "Even Ted," presumably Ted Koppel of ABC, no longer upholds the boundary between "real journalism" and the "sleazoid." What has declined is not just the people ("even Ted") but also the form and content of what they represent. Thus Bernstein decries a "lack of information, misinformation, disinformation, and a contempt for the truth or reality of most people's lives" in the same sweep as he condemns coverage of "the weird and the stupid and coarse" in television programs about "cross-dressing in the marketplace; skinheads at your corner luncheonette; pop psychologists rhapsodizing over the airways about the minds of serial killers and sex offenders."[30]

Certainly, this connection between those who report, what they report,

and what is reported about them is not restricted to television news, even if it is most visually obvious in that medium. Carl Bernstein, himself the subject of various kinds of personal public attention over the years, with Bob Woodward was catapulted to professional fame through the popularity of their best-selling book, *All the President's Men*, and the subsequent film, starring Robert Redford and Dustin Hoffman.[31] The mythology surrounding Watergate—its glorification as journalism's "finest hour" and the sense, true or false, that it paved the way for a "permanently more powerful, more celebrated, and more aggressive press"—no doubt has contributed to Bernstein's stature.[32] Given his position as a presumed source of accurate information compared to, say, Dan Quayle, Bernstein and his definition of "real journalism" carries the power to authorize representation among journalists and politicians alike.

Yet Bernstein's rhetoric of "real" and "sleazoid" journalism, of proper and improper newscasters, operates along terms not so unlike Quayle's boundaries of representable reproductive behavior. News can be provocative, attract attention, even be "popular culture," Bernstein explains, but it has to be earned culture, "popular culture that stretches and informs its consumers."[33] Some manipulations in the course of journalism are deemed by him worse than others, depending on the value of the fictions produced. Bernstein himself reconstructed fact in *All the President's Men*, using dramatic, fictional narratives.[34] "Real journalism" and "real America" are not just about what's true, but what's true to whom. In the media, the right to define "news," to term an issue "fit to print," presumes the right to identify not just what viewers or readers *should* know, but what they *need* know.[35] "Real journalism" is a conflation, in Carl Bernstein's account, of the suitable and the necessary. Similarly, in political terms, "real America" refers to the individuals and experiences that need be counted, considered, deemed representative, true, as opposed to those, in Vice President Dan Quayle's estimation, that are irrelevant, "glamorized."

Bernstein defines his "real journalism" as a narrative about untrustworthy politics, with Watergate as the example par excellence, as opposed to narratives of impure sensationalism and celebrity, which, he argues, do not reveal "society's real condition."[36] The notion of discovering what others have hidden or cannot see is central to Bernstein's logic of investigative journalism, and

similar to Quayle's geography of the "real America." The "real America" is, according to the vice president, what the media don't get, what he must discover, what those who sit in "newsrooms, and sitcom studios and faculty lounges" have distorted and "mock."[37] Indeed, the "real journalism" and the "real America," while here defined by traditionally-opposed critics, one a journalist and one a politician, both emanate from the same set of fairly conservative moral gestures, whereby boundaries of fact and fiction, reality and fantasy, worthiness and unworthiness are used to regulate the authorization of individual experience.

The challenges to these regulations, to Bernstein's and to Quayle's, manifest themselves as undisciplined sexuality and reproduction in the media and in politics. Whether as "cross-dressing" and other "sleazoid" topics, or as Murphy Brown, what was once "journalism" or "America" is being infiltrated by what should not be represented. If the gender politics of the real television news-room has not always been a sustained topic of the national mainstream media, certainly the spectacle of Murphy Brown's fictional newsroom and its interchanges with Vice President Dan Quayle made it so. Murphy's unmarried pregnant body, alongside the bodies of real newscasters, confuses what is most dangerous and disruptive here. It's not so much the presence of real women newscasters, or the pregnant, but fictional, Murphy Brown, but the combination of the two in the same space. They begin to take on the same authority, and one category seeps into the next.

This confusion, not surprisingly, prompted many to wonder, after all, who's Murphy Brown? Most famously, Prime Minister Brian Mulroney of Canada, at a press conference to discuss a trade pact with President Bush, turned to his colleague to query the very same: "Who's Murphy Brown?"[38] Bush, only one day after Quayle's speech, was exasperated by the controversy, particularly when he had presumably "real" business to discuss. He finally told the press corps, "O.K., everybody give me a 'Murphy Brown' question. I've got one answer right here for you. What's your 'Murphy Brown' question?"[39]

This unruly spectacle in the news made, as I have suggested, for unruly representation. Was it Murphy Brown or 'Murphy Brown'? The character, the

woman, or the television show by the same name? Journalists, even "real journalists" from major newspapers, the guardians of fact, couldn't seem to make up their minds. In an early article, the New York Times described Quayle's target as "Murphy Brown" on first reference, a polite "fictional Ms. Brown" on the second, and "actress Candice Bergen" on the third. "Ms. Brown" seemed to be the favorite for all future references—she was a new mother after all. In a New York Times article later that summer about President Bush's attacks on the cartoon program "The Simpsons," Bart Simpson is merely "Bart" on second reference, not a more formal "Mr. Simpson," as is the newspaper's usual honorific for men.[40] One wonders whether the comparative respect shown Murphy Brown reflects deference to age or to beauty; perhaps it merely indicates the value with which the newspaper invested the Murphy Brown debate.

The displacement from fact to fiction mobilized a confusion of names, but also a confusion of category. Journalists were unsure whether this was entertainment news, or political news, or merely "information" news—not "real journalism," in Carl Bernstein's formulation, but true in any case. For politicians, if Dan Quayle wasn't talking about real single mothers, and he insisted he wasn't, then they had to come to terms with the policy implications of "family values." Quayle defined "family values" as those that the "real America" already possessed; they were universal, understood. Like the "real America," "family values" as an ideology was predicated on its stability and its precise definition, a definition Quayle and his compatriots claimed to possess. He knew, he told the Southern Baptist Convention in Indianapolis, what was "in the heart of America," where "the real America is."[41] It was this claim for "values," however, that allowed Quayle to disclaim responsibility for families and for the experience of families in urban America.

"Family values" as an ambiguous ideology was a blueprint for an equally ambiguous policy as well: "Marriage is probably the best anti-poverty program there is," the vice president asserted in the Murphy Brown speech.[42] Focusing on ideological and moral institutions, Quayle stressed in his comments to the press that he was attacking the "glamorization" of unwed motherhood, and not unwed mothers themselves: he was attacking a thing, an idea, a value,

and not a person.[43] Indeed, Quayle's language suggests that he objected not just to the presentation of an impoverished value—single motherhood—but to the excess of attention given it, to its glorification. It wasn't worthy, and it certainly wasn't worthy of a newscaster or news. Thus the conservative argument here adopted a logic much like that used to condemn artists in the censorship debates over pornography and sexuality: even as the attack on fictional television presumed to evaluate the accuracy and effect of representation, its rhetoric also condemned the value of such representation, deeming it dangerous fantasy and fiction, and thus not part of the "real America" that is authorized to exist. Murphy Brown was judged by Quayle at once empty of right values and overflowing in wrong influence.

On the season premiere of "Murphy Brown" in September 1992, the first episode to follow Quayle's remarks in May, the real producers of the sitcom took the opportunity to turn the tables. The sitcom characters were shown watching May's news clips of Dan Quayle discussing their very real Murphy Brown, as if the debate had taken place entirely within the sitcom world. Characters walked into their newsroom carrying copies of both real and fictional national newspapers from the spring controversy, headlined with the Murphy Brown story, disrupting boundaries of representation all the more. "Quayle to Murphy Brown: You Tramp," read a massive front-page headline in the *New York Daily News*. Where Dan Quayle used fiction to displace reality and to authorize his "family values," Murphy Brown manipulated her authority as a newscaster—as a journalist—and the titillation of real-life fiction to produce a sharp retort to the vice president's condemnation.

In her return, Murphy Brown made fiction look like fact; her persona as sitcom television anchorwoman took on all the cues of broadcast journalism. Certainly, in both literature and visual media, including television, fact has always been rendered through the manipulation of fictional narrative structures. Some journalists have argued that re-creation or docudrama is at times more mimetic than documentary because such genres often present a better overall sense of reality, a contiguity that is more "accurate" than a reproduction, such as a video eyewitness account, would be. Writing in the *Christian Science*

Monitor, one critic has insisted that television programs that use only documentary footage are often more manipulative than those that mix re-created fact with description and analysis. The best of these programs, he concluded, may or may not use "real" clips, but rather concentrate on "something truer than facts," what he termed putting realism "in the right context."[44] This is just the kind of reproduction that got Connie Chung in trouble.

It should come as no surprise, then, that Quayle's comments on Murphy Brown seemed more "real," easier to reconcile, placed within the television sitcom world than they did outside of it. Toward the end of the program, Murphy Brown, in her news anchor clothes, with pristine hairstyle and careful makeup, sits behind a news desk, poised for a program on "the American family and family values" to answer Quayle's attacks on single motherhood. Murphy Brown looks straight at the television audience, and the camera tightens to a familiar head-and-shoulder shot. She has become the authority, and she is telling the truth: "In searching for the causes to our social ills, we could blame the media, or the Congress, or an administration that has been in power for 12 years. Or, we could blame me."[45] Murphy Brown ends her report with the suggestion that the vice president "expand his definition" of families, and then she introduces several nontraditional real and diverse families gathered on set. The news broadcast breaks as Murphy Brown rises to stand next to the families, who are thanked in the sitcom credits for appearing on the program. Is Murphy Brown a real news anchor, or does she just function as one? "Fact or fiction?" asked Boston's local news anchor Liz Walker that night on the 11 o'clock broadcast. "Hard to tell," her co-anchor responded.[46]

"Fact or fiction?" The irony of Liz Walker's question comes with the "fact" that she was the target of much criticism only five years earlier when she announced that she was to become a single mother. Walker, Boston's first black female co-anchor, was accused of setting a bad example for urban teenagers, among whom pregnancy was increasing.[47] Walker's story re-emerged after the Murphy Brown incident, with speculation that it had formed the basis for the sitcom plot—speculation that the program's creators declined to confirm.[48] Asked the difference between her story and the one portrayed

51

by Candice Bergen on "Murphy Brown," Walker aptly responded: "I didn't have a laugh track in my life." What Walker clearly articulates is the distance between her subjective experience and our own as spectators in a media culture that blurs our ability to distinguish what we see, and to remember that there is a difference—particularly for Walker.[49] These real attacks on Liz Walker's morality recover and uncover the ground of Quayle's original displacement from race and class conflict to a vague "poverty of values." Walker's critics suggested that her actions would provide a bad model for minority youth, and thus the reproductive choices of a single woman journalist were, again, deemed responsible for the problems of urban poverty.

This *mise en abyme* of media, of network newscasters, women, and various kinds of reproduction, was just what made Quayle's reference to Murphy Brown so titillating for the spectator and so dangerous for conservative strategists. It becomes difficult to identify the origin of reproduction, when, for instance, real women news anchors begin copying Murphy Brown's clothing style.[50] After the fact, "Murphy Brown," the program, became if anything more popular and more invested with real authority than ever before. In the mainstream press, this investment in a fictional news anchor as an example of a single professional mother sparked an array of news stories about the diversity of real families. The *New York Times*, which a few months earlier had topped its front page with a photograph of Murphy Brown as new mother, ran a four-part cover series soon after the sitcom retort to Quayle entitled "The Good Mother."[51] Favorably, these articles restored real bodies and real lives to Quayle's empty discourse of values. But these articles also indicate the media's own interest in recouping the authoritative ground of real news and proper mediation. "The political morality play . . . does not begin to suggest the complexity, diversity and confusion of being a mother in 1992," the first paragraph of the opening article argued.[52] Although sitcom warfare no doubt simplified and distorted the experience of women, such performances, I would argue, are integral to the cultural and political landscape that they mediate and that inform them. The media, as a middle, will always, if only implicitly invoke itself in the spectacle. With great irony, Murphy Brown told her colleague, fielding a call from the *Washington Post*, "Tell them to go find

a real story."[53] What she knew, what Liz Walker and Connie Chung knew, and what Dan Quayle was to find out, was that the story was already there.

Notes

1. This essay could not have been completed but for timely transatlantic research provided by Brian Martin. For generous support, my thanks to Sheila Allen, Hannah Feldman, Becky Hall, Susan Glasser, Henry Turner, Daniel J. Walkowitz, Judith R. Walkowitz, and Jamie Zelermyer. For varied and, indeed, pregnant counsel, thanks to Marjorie Garber, who suggested the essay's title, and Jann Matlock.

2. Dan Quayle, quoted in John E. Yang and Ann Devroy, "Quayle: 'Hollywood Doesn't Get It,' " *Washington Post*, May 21, 1992, A17.

3. Dan Quayle, quoted in Michael Wines, "Views on Single Motherhood Are Multiple at White House," *New York Times*, May 21, 1992, B16.

4. Maureen Dowd and Frank Rich, "Taking No Prisoners in a Cultural War," *New York Times*, August 21, 1992, A11.

5. Douglas Jehl, "Quayle Deplores Eroding Values; Cites TV Show," *Los Angles Times*, May 20, 1992, A1.

6. A CBS estimation reported in *New York Times*, September 23, 1992, C20.

7. Andrew Rosenthal, "Quayle's Moment," *New York Times Magazine*, July 5, 1992, 33.

8. John E. Yang and Ann Devoy, "Quayle," A17.

9. Michael Wines, "Views on Single Motherhood," A1.

10. Neal Koch, "Everyone Has Advice for Murphy, Especially Real- Life TV Journalists," *New York Times*, September 29, 1991, H33.

11. Andrew Rosenthal, "Quayle's Moment," 34.

12. For general stories, see, for example, Susan Bickelhaupt, "TV Makes Room for Motherhood," *Boston Globe*, April 13, 1991, 8, and Jennet Conant, "Broadcast Networking," *Working Woman*, August 1990, 58–61.

13. Neal Koch, "Everyone Has Advice for Murphy," H33.

14. Jennet Conant, "Broadcast Networking," 58–61; Richard Zoglin, "Star Wars at the Networks," *Time*, April 3, 1992, 70–71.

15. Jennet Conant, "Broadcast Networking," 59.

16. Anastasia Toufexis, "The Girls of Network News," *Time*, March 7, 1988, 85.

17. Susan Bickelhaupt, "TV Makes Room for Motherhood," 8.

18. Ibid.

19. Gail Collins, "Chung's Choice," *Working Woman*, December 1990.

20. Gail Buchalter, "To Wake Up Its Sluggish *Early Today* Show, NBC Anchors Its

Hopes on Connie Chung," *People*, June 13, 1983, 34–35; Carol Wallace, "D.C. Newsman Maury Povich Anchors NBC's Connie Chung after a Longtime Cross-Country Romance," *People*, June 10, 1985, 150–55; Kristin McMurran, "Two Hearts, Beating in Prime Time," *People*, April 10, 1989, 116–21.

21. Bill Carter, "Stars to Re-Enact News on Chung Program," *New York Times*, September 19, 1989, C22.

22. "Just the Facts, Please," *Los Angeles Times*, November 24, 1989, B10.

23. Kevin Goldman, "TV Network News Is Making Re-Creation a Form of Recreation," *Wall Street Journal*, October 30, 1989, A1, A4.

24. A television reviewer for the *Wall Street Journal*, responding to criticism of "Saturday Night" that the use of actor James Earl Jones in a re-creation alongside interviews with historical witnesses constituted the show as entertainment, not documentary, wrote, "So maybe it's not traditional news. . . . James Earl Jones's portrait is wonderfully subtle . . . and the witnesses interject a solid grounding of fact." Robert Goldberg, "America's Sweetheart Nets Marlon," *Wall Street Journal*, October 9, 1989, A12.

25. Tom Shales quoted in "Connie Chung," *Current Biography Yearbook* (1989), ed. Charles Moritz (New York: H. W. Wilson, 1989), 107.

26. Bruce McCabe, "Looking for Redemption," *Boston Globe*, July 22, 1990, 2.

27. Walter Goodman, "Connie Chung's 'Saturday' Features James Earl Jones," *New York Times*, September 25, 1989, C18.

28. Robert Goldberg, "America's Sweetheart Nets Marlon," A12.

29. Carl Berstein, "The Idiot Culture," *New Republic*, June 8, 1992, 24.

30. Ibid., 25.

31. Speculation about Carl Bernstein's personal life ran rampant after the publication of *Heartburn*, a novel by his ex-wife Nora Ephron, which portrayed a fictionalized Bernstein as an adulterous husband. *All the President's Men*, when it appeared in 1974, was the fastest-selling nonfiction hardback in the history of American publishing. Michael Schudson, "Watergate: A Study in Mythology," *Columbia Journalism Review*, May/June 1992, 31.

32. Larry Martz, "For the Media, A Pyrrhic Victory," *Newsweek*, June 22, 1992, 32; Tom Mathews, "Watergate Blues," *Newsweek*, June 22, 1992, 24; Michael Schudson, "Watergate: A Study in Mythology," 30; James Mann, "Deep Throat: An Institutional Analysis," *The Atlantic*, May 1992, 106–12.

33. Carl Bernstein, "Idiot Culture," 25.

34. Michiko Kakutani, "Fiction and Reality: Blurring the Edges," *New York Times*, September 25, 1992, C1, C31.

35. Every *New York Times* banner is underwritten by the motto, "All the news that's fit to print."

36. Carl Bernstein, "The Idiot Culture," 25.

REBECCA L. WALKOWITZ

37. In a cover story in the *New York Times Magazine*, Dan Quayle equates and conflates "newsrooms, sitcom studios and faculty lounges," opposing them to "the heart of America," the real America, where, he seems to argue, his "family values" are to be found. Andrew Rosenthal, "Quayle's Moment," 13.

38. Prime Minister Mulroney quoted in John E. Yang and Ann Devroy, "Quayle," A1.

39. Michael Wines, "Views on Single Motherhood," B16.

40. At the Republican National Convention in Houston, Bush called for an America that looks a lot more "like the Waltons and a lot less like the Simpsons." In a following episode of the Simpsons, young Bart Simpson responded: "We're just like the Waltons. We're praying for the depression to end, too." This falls right along the "family values"-through-pop-culture strategy that Quayle began in May. Interestingly, the fictional television insists on its own relevance to reality, thus disrupting Bush's displacement away from reality and his control over fiction. Maureen Dowd and Frank Rich, "Taking No Prisoners," A11.

41. First reference from speech to Southern Baptist Convention in Indianapolis, quoted in Andrew Rosenthal, "Quayle's Moment," 13. Second reference to Michael Wines, "Views on Single Motherhood," B16.

42. Douglas Jehl, "Quayle Deplores Eroding Values," A1.

43. John E. Yang and Ann Devroy, "Quayle," A17.

44. Alan Bunce, "Can TV Tell Us What Is Real?" *Christian Science Monitor*, October 10, 1991, 14.

45. "Murphy Brown," CBS-TV, September 21, 1992.

46. Thanks to Jann Matlock who tracked this piece of Boston news banter. WBZ-TV, September 21, 1992.

47. Robert A. Jordan, "A Personal Decision," *Boston Globe*, June 27, 1987, 19; Marian Christy, "Liz Walker Talks about Her 'Real Riches,'" *Boston Globe*, March 22, 1989, 75.

48. Elizabeth Mehren, "Just like 'Murphy Brown,'" *Los Angeles Times*, June 22, 1992, F1.

49. In another angle on the "fact or fiction" question, one might look to the career of Candice Bergen herself, who portrays Murphy Brown. Apparently, Don Hewitt, executive producer of the highly successful news program "60 Minutes," had been trying to convince Bergen to become a correspondent on his show, joining such well-known journalists as Mike Wallace and Diane Sawyer. She declined, the *New York Times* reports, to continue her acting career. Neil Koch, "Everyone Has Advice for Murphy," H34.

50. In addition, when *W* magazine did a fashion spread on women anchors, it combined Jane Pauley, Kathleen Sullivan, and Murphy Brown. Harry F. Waters and Janet Huck, "Networking Women," *Newsweek*, March 13, 1989, 49.

51. Susan Chira, "New Realities Fight Old Images of Mother," *New York Times*, October

55

4, 1992, 1; Tamar Lewin, "Rise in Single Parenthood Is Reshaping U.S.," *New York Times*, October 4, 1992, 1; Erik Eckholm, "Finding Out What Happens When Mothers Go to Work," *New York Times*, October 6, 1992, 1; Felicity Barringer, "In Family-Leave Debate, a Profound Ambivalence," *New York Times*, October 7, 1992, 1.

52. Susan Chira, "New Realities," 1.

53. Murphy Brown, played by Candice Bergen, on "Murphy Brown," CBS-TV, September 21, 1992.

4

Watching and Authorizing
the Gulf War

Elaine Scarry

My comments about the Gulf War have four framing assumptions. The first assumption is that whatever deliberative processes we are expected to exercise are especially important at a moment of emergency. The argument is often made that in wartime or in the moment of a crisis the population's participation has to fall away because of the speed required for what is about to occur. But in social contract theory, as well as in specific constitutions such as our own U.S. Constitution and many others, it turns out that precisely the opposite is the case: the requirements for overt and explicit acts of deliberation and consent *increase* rather than *decrease* at times of war and do so not only in terms of the explicitness of the act of consent, but also in the breadth of distribution of the consensual act.

One of the complicating features of this increased requirement for deliberation is, of course, the fact that in an emergency it is hard enough to hold onto even the usual level of deliberation and consent, since it is hard to think in moments of panic. Therefore the requirement goes up at precisely the moment when it is difficult to carry out even the normal act of deliberation, let alone an extraordinary act. In order to protect against the phenomenon of panic, contracts often have built into them certain procedures to ensure that deliberative processes will remain intact. In our case, that is, in the United States, the Constitution requires both a congressional declaration of war (which, since World War II, we have not had: not in Korea, not in Vietnam, not in Central America, not even in Iraq, though here we at least had the shadow of one in the formal authorization of force), and the consultation of the population implied by the Second Amendment, which by ensuring the population's right

to serve in the military distributes to that whole population authorization for ratifying decisions that have been taken by the country's leadership. My second general framing thesis, then, is that with the loss of these two constitutional safeguards,[1] we have become a kind of military monarchy where the president acts alone and where neither the Congress nor the population has any part in military decisions.

A third framing assumption is the fact that to lose the exercise of military authority is to lose our civil authority as well. The history of military rights in this country shows that military rights and civil rights are closely entwined. For example, the Twenty-sixth Amendment, which lowered the voting age from twenty-one to eighteen, was argued primarily on the basis that the Vietnam generation had shown its authority to vote at eighteen both by going to Vietnam and by protesting Vietnam (remarkably, on the floor of Congress such protest was looked on as a politically responsible act).[2] More significant is the fact that the Fifteenth Amendment, which extended the vote to blacks, was urged primarily on the basis of the argument that 180,000 blacks had fought in the Union Army: this fact was used in arguments supporting the new amendment on the floor of Congress, as well as in Republican newspapers like the *Chicago Tribune* and the *New York Tribune* during the 1868 presidential campaign.[3] In fact, Lincoln's Emancipation Proclamation of 1863 had itself been a brilliant merging of two separate verbal acts, a proclamation of emancipation and a call to arms. This is the way the Emancipation reads:

> I do order and declare that all persons held as slaves . . . are and shall hereafter
> be free . . . and I furthermore declare and make known that each person of
> suitable condition will be received into the armed services of the United States,
> to garrison forts, positions, stations, and other places, and to man vessels of
> all sorts in said service.[4]

The Fifteenth Amendment reenacted in reverse the merged logic of self-authorization. As liberty in 1863 made inevitable the eligibility to bear arms, so eligibility to bear arms in 1869 made inevitable the liberty to vote. The history of the Nineteenth Amendment shows that civil and military rights are

again conflated in women's suffrage. The pageants advocating women's suffrage often focused on songs such as "Onward, Glorious Soldiers" whose chorus rang with the news that women were marching as to war.[5] Suffrage plays repeatedly depicted women as capable of bearing arms and of protecting themselves physically;[6] articles urging the suffrage coupled the contribution of women in World War I with the coming vote.[7]

The conflation of military and civil rights in the history of the Fifteenth, Nineteenth, and Twenty-sixth Amendments suggests that now the loss of military rights and responsibilities also carries with it a loss of civil rights. By the elimination of the draft, by the disappearance of the congressional declaration, by the existence of monarchic weapons that require only a presidential decision or what is effectively a standing army (as we had in the Gulf), what is lost is not only our authorization over our responsibility to other populations for the injury that may be inflicted on them; what is lost is ultimately our civic power as well. I keep saying that *we* have lost these rights, which perhaps sounds like a strange locution since women never had full military rights; but by the fact that one's brothers or father or sons had those obligations, women bore some of the weight of military decision making; now even the brothers, fathers, and sons are disengaged from all delibaraton. Men and women alike now stand disempowered.

So the result—this is my fourth framing thesis—is that the population has been infantilized and marginalized; the population can no longer exercise its deliberative obligations over these very grave military matters. We are instead often asked to perform a kind of *mimesis of deliberation* by debating what we think abut such things as Gary Hart's or Bill Clinton's personal sexual affairs, subjects that may well be someone's responsibility or concern but are certainly not the province of our own political decision making; such a matter may be the spouse's business or the lover's business or the child's business, but it does not seem to me that it is in any way the population's business. This kind of rotation of our deliberative energies onto decisions about how leaders should conduct themselves sexually has a very direct relation to a general inattention to political events. Here are two examples. When the *Miami Herald* broke the story about Gary Hart's affair, that story was immediately picked

up by the *New York Times* and by the *Washington Post*. But Jules Lobel points out that that same newspaper, the *Miami Herald*, during that same year had carried a story that

> revealed that Lieutenant Colonel Oliver North and the Federal Emergency Management Agency (FEMA) had drafted a contingency plan providing for the suspension of the Constitution, the imposition of martial law, and the appointment of military commanders to head state and local governments and to detain dissidents and Central American refugees in the event of a national crisis.[8]

One of these, the Gary Hart story, quickly spread throughout the whole country; it galvanized the population into a mimesis of deliberation. The other did not make it into the major newspapers at all and, according to Jules Lobel, rapidly disappeared even after it was briefly mentioned during the Iran Contra hearings. This inattention permitted the disappearance of key information at a moment when what was at stake was our own form of government: what was being discussed in FEMA's contingency plan was the dissolution of our country. I want to turn now to a second example were what was at stake was injury to another population. The displacement of actual deliberation by mimetic deliberation occurred during the 1980 campaign contest between Carter and Reagan. In the months immediately preceding that election contest, many voices in Central and South America repeatedly signaled the United States population that President Carter's human rights campaign was making a crucial difference for their lives, making a difference in the most concrete way a difference can be made: it diminished the degree to which they were tortured. Now, years later, those claims are taken very seriously by our population, a change that began immediately following the publication of Jacobo Timerman's book about torture in Argentina.[9] But at the time, that language of human rights was being dismantled even by the Left in the United States as a kind of hollow window dressing. In the months immediately preceding the election, the population's attention to Carter rotated away from the country's power to diminish pain and onto the question of personal style, and most revealingly, onto the style of Carter's brother, who was regarded by

the press (and hence eventually by the population) as a clown. The day-by-day comparison of the content of our own major newspapers with the content of *Le Monde*, the *Manchester Guardian*, and other European papers is very revealing. *Le Monde* wrote things such as this: "Throughout all of the Latin America the Right awaits passionately the defeat of Mr. Carter."[10] The newspaper also credited the timing of the Bolivian coup to the Republican nomination of Reagan: *Le Monde* speculated that the Bolivian Right saw Reagan's candidacy as a very hopeful sign that this troubling rights business would soon disappear. Our own papers, in contrast, became absorbed with personal stories about the Carter brothers, thereby deflecting attention from what Central and South Americans were saying about Carter's rights program, and making it seem to many voters that the election contest offered no choice between candidates. Subjects such as the quality of Carter's appointments of federal judges (and the implications of his choices for his eventual Supreme Court appointments) and Carter's positions on labor also fell outside the province of the population's exercise of responsibility.

One might debate for a long time how this phenomenon comes about. It may be that having been read out of military decision making, we permit all our ambient political attention to shift over onto these personal stories about lovers and brothers that are mimetic of that deliberation. Or it may instead be the case that these other private stores are somehow more susceptible to narrative, and therefore can engage us, and as a result we then become inattentive to the grave subjects that are our actual responsibility to oversee.

Now, the general thesis that we are inattentive to military matters is not wholly descriptive of the Gulf War, which the population sat watching in fascinated immobility. This illustrates what I would see as the second major axiom in the structure of lost military and civic responsibility. Either (this is axiom one) we are inattentive to military events or (axiom two), when we are attentive to them, we are attentive in a way that still deprives us of any authorization over them. The two constitutional gates that a president is required to go through—the congressional declaration of war and the act of calling on the population—were both absent during the Gulf War. Bush said, for example, during a December 1, 1990 press conference: "It's only the

President that should be asked to make the decision [whether to risk lives]. . . . And it's a tough question. But a President has to make the right decision."[11] Much could be said about this position, but I want to focus on the way it exemplifies what have become two key elements of presidential practice. First, presidents find that when they need moral authorization for their actions, it is easier to get it from the U.N. than to get it from Congress. Now, authorization from the U.N. was never meant to bypass our own contractual obligations. Yet both in the Gulf and in earlier wars,[12] it has been used as a way of bypassing the Congress. The second kind of presidential practice is to find some source of funding other than congressional (or internal) funding: in other words, a source that is external to the country. The Iran Contra affair was precisely the attempt to get private money to fund the president's war to make him independent of the people or of the Congress. So, too, the complaints about the failure of other countries to pay for the Gulf War should, I believe, *in part* be seen within this framework: getting Europe or Japan to contribute funds is a way of not having to sustain our own population's consent to a degree that would require us to give money. Dispersing the financial expense to an array of countries reduces the burden on any one of them but thereby also relaxes the necessity of examining, with full rigor, whether the war is worth waging. What it inhibits is not the infliction of injury but the practice of responsible deliberation.

In summary, then, the United States president does not need us or our representatives to authorize his war: he has the U.N. He does not need us to fight the war: the draft is gone and has been replaced by what would at an earlier moment have been called a standing army, or by weapons that require no army at all: nuclear arms are a monarchic or totalitarian weapon par excellence. Finally, he does not need us to fund the weapons because he will fund them from some international underworld or aboveworld; however difficult the project of raising money internationally, it appears to be easier than to get and maintain the population's assistance, as Vietnam shows. Thus, we are read out of the processes of *authorizing* the war, *fighting* the war, and *funding* the war; and therefore our consent and, incidentally, our dissent, become irrelevant (or almost irrelevant).

I say "almost" because clearly, the U.S. president still put a great deal of labor into image making about the Gulf, a labor that expressed his sense of the need to address himself to the people, the subject to which I now turn. There already exist rich analyses of the nature of spectacle in the Gulf War. Some sense of this richness can be suggested by taking as a sample the journal articles appearing on news stands and in book stores in the spring of 1992. Not surprisingly, some of the best have been by literary critics who are very practiced in looking at the nature of imagery and spectacle. A full volume of *Cultural Critique* is devoted to the Gulf War. The *South Atlantic Quarterly* has an article by Andrew Ross on image surfeit or—here he uses Susan Sontag's term—the "ecology of images," the need to begin to practice an "ethics of imagery." Simultaneously, an issue of the *London Review of Books* has a long article by Tom Mitchell comparing CNN's coverage of the Gulf War with the film *JFK*. In addition to their often intricate analyses, these articles make visible the stark facts about the spectacle, such as its scale: "one billion people in 108 nations," as reported by Mitchell, watched the CNN coverage.[13] This in turn means that as in Genet's play *The Balcony*, all possible political positions began to orient themselves in relation to the theatrical spectacle rather than to the reality of the events themselves. Andrew Ross describes the protest group, for example, that marched "not to the Pentagon, but to the TV network buildings."[14] As in Genet, the war's physical injuring quickly acquired as counterpart a contest of images or a "war of allegories." That play argues that when not only the government but the opposition to the government commits itself to theatrical spectacle, the possibility of opposition disappears and dissent becomes impossible. Genet is prescient of our present stance, even of our general habit of displacing civic deliberation with sexual curiosity. In the opening four scenes of *The Balcony*, members of the population voyeuristically and vicariously participate in the sexual lives of their leaders: one imitates a bishop, one imitates a general, one imitates a judge, one even imitates the beggarly population. Genet shows that by such acts they disempower them-selves, reinforcing the strength of the very leaders who hold them subject to their own fascination. During the Gulf War, most people found themselves in the extremely discomforting position of feeling compelled to watch the 7

to 11 prime-time television coverage of the war and yet knowing that such attention was not anything that could remotely be meant by an act of political responsibility. The nighttime spectacle enthralled and captured: it suspended, rather than incited, the population's capacity for deliberation and debate.

The Gulf War—to which the population was extremely attentive but over which we practiced no acts of authorization—was characterized by some features that are descriptive of almost all wars. It is true of most wars that a country will minimize the depiction of the injury it inflicts on the enemy population[15] and will simultaneously maximize its depiction of the injury the enemy inflicts (at least at the moment it seeks to justify its own entry into the war). I want to look at each of the two separately for a few moments. First, there were no bodies of the enemy, no photographs of bodies, no verbal narratives about bodies, no verbal counts of bodies. If just one person were killed for each sortie, that would be over 10,000 people; it is extremely unlikely that only one person was killed with each flight. Mitchell points to one brief moment when dead Iraqi civilians were pictured and another when the bruised faces of U.S. soldiers were shown; this caused such turmoil among viewers that the subject had to be put to the side.[16] The body disappears, the vulnerable human body that can be injured, the bodies of the Iraqi population. Various of these critics have shown that the body reappears in some other form. Jonathan Goldberg, for example, describes the way the idea of a woundable population is replaced with the image of a single leader, whose body is eroticized and imagistically sodomized.[17] Andrew Ross stresses the way the inattention to Iraqi soldiers had as its counterpart the obsessed attention to the spreading oil slick in the Gulf as billions of gallons of Kuwaiti oil floated there. Pictures of populations and persons were thus displaced by grotesque puddles of oil toward which the United States could "justly" feel disgust and aversion: "for Western audiences, many of the diabolic features attached to the pseudo-biological 'Arab threat' " became summarized by that slick.[18] Ross does an ingenious riff on the picture of the United States "generating a ton of toxic waste every minute in peacetime," now suddenly becoming "Captain Planet" responsible for the ecological well-being of all the earth's inhabitants.

The critiques of spectacle in the Gulf War do not, however, inhibit the

ongoing production of the spectacle: images keep pace with, even outpace, the critiques that can be made of them. In the spring of the *Cultural Critique*, *London Review*, and *South Atlantic Quarterly* articles, a startling new image appeared in an issue of the *Economist* magazine,[19] one that seemed to inaugurate, or at least participate in, a new genre of advertising. At once *Vogue*like and high tech, it is a lavishly beautiful image: the blue and lavender and grey of the sky merge with the plane, an the plane merges with the bombs it carries, and the bombs unfold back into the plane, and the plane back into the sky. It is an image of serenity. In its elegant, self-echoing design, the explosives seem to be only the fins of the aircraft, as in turn the explosives themselves have yet more delicate fins, so that what seems to float there before us is the materialization of the sky folding and unfolding into itself in a pure principle of suspension and flight. Superimposed over the image is a tonally distinct narrative. It begins with masculine swagger: "YOU'RE CARRYING 4 TONS OF EXPLOSIVES AND PEOPLE ARE SHOOTING AT YOU. No problem. You're in a F/A-18 Hornet." Abruptly the text veers to history: "In Operation Desert Storm, two McDonnell Douglas F/A-18s were able to engage and shoot down two enemy MiGs, even while loaded down with several tons of bombs and missiles. Then the F/A-18 pilots went on to complete their real mission: Bombing an Iraqi airfield." Now the text turns once more, this time to corporate history: "The F/A-18 Hornet is just one in a long line of McDonnell Douglas success stories—from the dependable Delta Rocket to the fearsome Apache. It's this record of proven performers that has made us a world leader in aerospace technology." One of the many striking things about this sequence of sentences is the way the bombs become a kind of precious, encumbering cargo. Remarkable and twice repeated is the fact that this plane got through despite the complication that "you're carrying four tons of explosives" and, again, "even while loaded down with several tons of bombs and missiles." The grammar of "even while" and "even though" makes the cargo seem wholly independent of the other plane's aggressive actions. The encumbering weight might be a school bus of children rather than an object whose every ounce reflects its capacity to devastate other persons and places.

This was the first time that I had ever seen a weapon advertised in a major

Images outpace the critiques that can be made of them.

journal, simply laid quietly into the lavish midst of Swiss watches, Mercedes Benzes, the banks so sedate they could only be represented with verbal rather than visual images. So I called the *Economist* to express my bewilderment over the image. The person in the aerospace division of the advertising department suggested that the image would become legible if one recalled the readership of the *Economist*. It is 87.2 percent male. The average income of 1989 subscribers was $150,000. Seventy-nine percent are in business, and 38 percent of that total are in top management, either as presidents or as chief executive officers. Significantly, only 1.1 percent of the subscribers are in the army (hence directly at risk of ever being in an F/A-18), and only 3.7 percent are in the government (hence in any position to authorize a flight).[20] The direct address of the "you" in this advertisement becomes, as the knowledgeable spokesperson at the *Economist* had promised, more clear. The advertisement enlists the reader into an act of self-recognition. Both the McDonnell Douglas aircraft and the reader are "proven performers," dedicated to "*Performance Above And Beyond*"; both are in the language of the text, "dependable" and "fearsome." The advertisement is addressed to shareholders. Rather than inaugurating a new genre of advertisement, it reactivates a familiar one, for the F/A-18 is a new version of an old object, the Executive Vehicle: no wonder it fits comfortably into the midst of the Mercedes and the Lear executive jets.[21]

The text breaks over the nose of the plane, across the face of the spectator. The buyer of shares is not at risk. He is not at risk because he is in a plane that is proven performer. His is also not at risk because he is not actually in the plane. He is there only as a spectator. The advertisement lets us see that the structure of lost military and civil responsibility consists not of two but of three axioms: either (one) we are inattentive to military matters, or (two), if we are attentive, our attention has no power of authorization, or (three), if ever we are in an authorizing or financing position, it carries no risk and therefore distorts and disables the authorizing act. Elsewhere I have written about the way wartime language retracts sentience from live persons and then confers it on the weapons themselves. The Gulf War—with its emphasis on smart bombs sensing their way to nonsentient targets and its percipient

missiles carrying perceptual apparatus that invites us to see from the weapon's "point of view"—is an extreme example of that general tendency.

The disappearance of the injurable bodies of the enemy citizenry has as counterpart, in almost any war, the magnification of the injury that the enemy can inflict. In the U.S.-Iraq war, this magnification took two main forms. One of them was the nuclear blackmail urged by the president: Iraq was within months of creating a nuclear weapon, never mind the fact that we had (and continue to have) thousands of such weapons. So deep is our double standard about the legality of our own nuclear weapons and the criminality of any southern country's nuclear weapons that even Iraq's potential acquisition could serve as a basis for urgent military intervention.[22]

The second form of magnification was the verbal and visual depiction of Iraq's invasion of Kuwait, a depiction analyzed in a brilliant forthcoming book written by Mark Crispin Miller entitled *Spectacle: Operation Desert Storm and the Triumph of Illusion*. As one might anticipate from Miller's pieces in the *New Republic*, it is a stunning nalysis of the sequences of televised images that were put in front of us during what he calls "the atrocity campaign." His project is a relatively solitary one since it is more difficult to critique with tact and rigor the overrepresentation of bodily injury than its underrepresentation. Though it is not possible to rapidly summarize his analysis of the newscast footage, it is possible to recite the background facts that he culls from many sources and vividly elucidates. In August 1990 the Citizens for a Free Kuwait (CFK)—whose membership consisted of only thirteen people—hired "the giant PR firm of Hill & Knowlton, Inc." for a barrage of television news images. They also sponsored "Kuwait Student Information Day" on twenty different campuses in September; the impact of each "information day" in turn snowballed, since in many instances the campus event was covered on the local news station.[23] It was Hill & Knowlton that created the "525-page document of Iraqi abuses" in Kuwait that was distributed to every member of Congress before the hearings.[24] Between September and December CFK paid Hill & Knowlton $5.64 million, which is said by the *Washington Post* to be among the highest paid single PR jobs on record.[25] Mark Miller writes that "Indeed, throughout these crucial months [September to December] there was, on TV,

no other footage of or about Kuwait: every single documentary image that was telecast had been prepared by Hill & Knowlton."[26] According to the *Wall Street Journal*, two particular reels "garnered the highest viewing of any PR video for 1990's second half." One was on the occupation of Kuwait and the other was on human rights abuses there.[27]

Let me end by stressing what I see as the best defense against our present infantalized position. The only defense is to regain the actual powers of military and civil deliberation that were the population's to begin with. Our major energies should be directed toward this outcome. Short of that, the only interim defense is the project of dismantling images to which many of the writings about spectacle have been devoted. The best general accounts of the way spectacle can either instigate or instead immobilize deliberation and decision making are by Bertolt Brecht and Antonin Artaud: their writings on the theater provide graphic accounts of the disabling power of images as well as concrete strategies for dismantling those images.

The interim solution of dismantlement is, however, a limited one. Three things should make us skeptical about merely counting on our ability to dismantle images. First of all, although the kinds of accounts we now read about the Gulf War are particularly rich and often brilliant, many of those dismantling strategies were already practiced on the floor of Congress during the war debates.[28] The question is, why didn't they work then? And if they didn't work then to impede the war, why should we assume that any good can come of these practices at this later date? The second danger is that the mental habit of dismantling images can lead to an ironic stance that does not necessarily do anything to stop the actual injury to other populations, but just lets us dwell in the comfort of our own "knowingness." The third problem is perhaps the most important and has to be underscored: dismantling does not always lead to good. We have seen in the period of these other critiques a courtroom critique of the film clip showing the hurt inflicted on Rodney King: what had earlier appeared the only possible reading was dismantled, taken apart, reassembled, and reversed. It is not the case that the dismantling of these seductive images itself always leads to an outcome that is good, right, or true. Earlier I cited the liberal dismantling of Carter's rights vocabulary: I

would see that phenomenon in exactly the same way, as a terrible misuse of the dismantling apparatus.

In the absence of solutions, let me end by reiterating the three major axioms that describe our present position. First, we do not ordinarily as a population watch or attend to grave matters of military and political import. Instead, we permit our attention to be deflected onto inconsequential matters over which we then perform a mimesis of deliberation. Second, when we do attend to issues of great consequence, we do so without being in a position of authorization. Third, when we do authorize, we do so without being ourselves at risk. Deliberative decisions separated from the site of risk are dangerous to those who *are* at risk, namely, other populations. In the long run, this erosion of our military and civic authority will, I believe, be fatal to our own country as well.

NOTES

1. The incompatibility between the country's present military arrangements and these two constitutional provisions is documented at greater length in Elaine Scarry, "Declaration of War: Constitutional and Unconstitutional Violence," in *Law's Violence*, eds. Austin Sarat and Thomas R. Kearns (University of Michigan, 1992), 23–76; and in Scarry, "War and the Social Contract: The Right to Bear Arms," *University of Pennsylvania Law Review* 139 (May 1991): 1257–1316.

2. See *Senate Comm. on the Judiciary, Report on Lowering the Voting Age to 18*, Senate Report no. 26, 92nd Cong., 1st Sess. (1971), 3, 4, 5, 7, 8; *House Comm. on the Judiciary, Report on Lowering the Voting Age to 18*, H.R. Report no. 37, 92nd Cong., 1st Sess. (1971), 5; and *Lowering the Voting Age to 18: Hearings before the Subcomm. on Constitutional Amendments of the Senate Comm. on the Judiciary*, 91st Cong., 2nd Sess. (1970), 132–33, 157.

3. See, for example, *Congressional Globe*, 40th Cong., 3rd Sess. (1869), 691, and Appendix, 92.

4. Abraham Lincoln, *The [Emancipation] Proclamation* in *The Liberator*, Jan. 2, 1863, reprinted in *The Antislavery Argument*, W. Pease and J. Pease, eds. (Indianapolis: Bobbs-Merrill, 1965), 481, 482.

5. See H. MacKaye, Susan B. Anthony, *A Chronicle Pageant*, in *The Suffragist*, Dec. 11, 1915, 7, 8.

6. See G. Middleton, *Back of the Ballot* (1915); A. Miller, *Unauthorized Interviews* (1917);

G. Rugg, *The New Woman* (1896); M. Winsor, *A Suffrage Rummage Sale* (1913), reprinted in *On to Victory: Propaganda Plays of the Woman Suffrage Movement*, ed. Bettina Friedl (Boston: Northeastern University Press, 1987), 325, 363, 130, 243.

7. See, for example, "War and Freedom," *The Suffragist*, Dec. 11, 1915, 6.

8. Jules Lobel, "Emergency Power and the Decline of Liberalism" *Yale Law Journal* 98 (May 1989): 1385, summarizing the *Miami Herald*, July 5, 1987, 1, col. 1. Lobel explicitly contrasts the public response to the two *Miami Herald* stories.

9. Jacobo Timerman, *Prisoner Without a Name, Cell Without a Number*, trans. Toby Talbot (New York: Vintage, 1981).

10. "Une alerte pour l'Amérique latine," *Le Monde,* July 19, 1980, p. 1., col. 1. See also "Amérique Latine: la politique des droits de l'homme au musée?", *Le Monde,* Nov. 7, 1980, p. 5, col. 1, which includes passages such as the following: "La politique dite des 'droits de l'homme' practiquée par M. Carter . . . a crée un vent de panique chez les tyranneaux que accablent la majorité des pays situés au sud du rio Grande."

Only after Carter's November 1980 election defeat did the U.S. press begin, on occasion, to describe the effect of Carter's rights policies with a gravity approching that available earlier in *Le Monde* (for two unusual pieces, see William Greider, "The Foreign Policy We Didn't Really Try," *Washington Post,* Nov. 16, 1980, L1; and Stephen S. Rosenfeld, "On the Rights Track," *Washington Post,* Dec. 5, 1980, A17.). Until that time, the actual impact on the people of other countries was ignored and the policies themselves were often trivialized by an inappropriate level of diction such as "Carter's much-ballyhooed concern for human rights" and Carter's "goo goo principles," idioms so widespread they even made their way into otherwise thoughtful pieces (*Washington Post,* Oct. 13, 1979, E41; and Dec. 5, 1980, L3).

11. "Excerpts from President's News Conference on Crisis in Gulf," *New York Times,* Dec. 1, 1990, 6.

12. The war in Korea is the most striking example. Another instance is the Taiwan Straits Crisis. Formerly classified presidential papers for this period reveal that President Eisenhower and his advisers worried about waging a war that had no congressional declaration; but they also discussed whether a U.N. authorization could relieve them of the necessity of having to secure a congressional declaration (U.S. Department of State, "Memorandum of Discussion at the 214th Meeting of the National Security Council, Denver, September 12, 1954," *Foreign Relations of the United States, 1952–54,* 14: 618, 620, 621).

Authorization from an international body such as the U.N. is wholly desirable if it comes after, and in addition to, a rigorous adherence to our own internal constitutional safeguards.

13. W. J. T. Mitchell, "Culture Wars," *London Review of Books,* Apr. 23, 1992, 7.

14. Andrew Ross, "The Ecology of Images," *South Atlantic Quarterly* 91 (Winter 1992): 216.

15. Six paths by which bodily injury disappears during war are described by Elaine Scarry, *The Body in Pain* (New York: Oxford University Press, 1985), 63–81. In two of the six—omission and redescription—the body disappears altogether. In the remaining four, the body, though still visible, is made marginal by its designation as a by-product, as an accidental entailment, as a cost, or as an extension of a benign activity.

For an analysis of these paths in the specific context of the Gulf War, see Hugh Gusterson, "Nuclear War, the Gulf War, and the Disappearing Body," in *Journal of Urban and Cultural Studies* 2 (1991): 1–8.

16. Mitchell citing Major General Perry Smith, "Culture Wars," 7.

17. Jonathan Goldberg, "Sodomitries," English Institute, Cambridge, Mass., Aug. 24, 1991. On the conversion of an army into a monolithic single combatant in strategic and historical writings, see Scarry, *The Body in Pain*, 70–72, 99–102.

18. Ross, "The Ecology of Images," 218.

19. *Economist*, May 2, 1992, 93.

20. Sarah Holmes, telephone interview, May 14, 1991 (the parentheses are my own). The McDonnell Douglas advertisement, according to Holmes, belongs with a sequence of similar ads. Included in the *Economist*'s 1991 aircraft-defense file (made up of some manufacturers who make only domestic craft and others who make both domestic and military) are Astrobusiness Jets, Boeing, British Aerospace, Lear, Lockheed, EOSAT, and Matra.

21. Following my public presentation of this essay (May 1992), Professor Mary Gaylord sent me a remarkable advertisement from the Neiman Marcus 1991 Christmas catalogue for the LTV Hummer, an executive vehicle used in Operation Desert Storm: "Operation Desert Storm was a breeze for this seasoned veteran of military service." Available in "sand, red, or white" and equipped with (among many other things) a "Neiman Marcus signature plaque," the jeep is presented in a two-page spread whose headline reads: "The Hummer— first time out of uniform. HIS AND HERS." The last three words are printed in red, white, and blue.

Equally remarkable (though they place less emphasis on the genre of the executive vehicle) are two advertisements brought to my attention by Marshall Brown. One shows two Lockheed stealth fighters poised in the clouds like levitating pyramids. The text celebrates Lockheed's sequence of technological "firsts," including "the first sub-launched ballistic missile" (*New York Times*, June 3, 1992, 21). A two-page Boeing advertisement shows a baffling transparent stocking surrounding the globe, either being zipped or unzipped. One hopes it is being unzipped so that the world can be released from this mysterious encirclement, but the text suggests otherwise since it speaks continually of

contraction: "Boeing Defense & Space Group is smaller, tighter, leaner . . ." (*New Republic*, June 15, 1992, 24, 25).

22. During the congressional debate on the Gulf War, both Senator Al Gore and Senator Joseph Biden criticized the Bush administration's invocation of a nuclear threat (Jan. 12, 1991, PBS Broadcast). Gore's disapproval had earlier been cited by journalists who directly challenged the president during his Dec. 1, 1990 news conference ("Excerpts from President's News Conference," 6).

Whether the United States leadership at any point contemplated the possibility of itself using nuclear weapons has not, to my knowledge, been publicly discussed. One war resister, Dr. Yolanda Huet Vaughn (a captain in the Army reserve) went AWOL because of "her belief that nuclear weapons would be used in the gulf" (Katherine Bishop, "Turning against the Military Life They Once Chose," *New York Times*, Jan. 14, 1991, 12).

Unlike troop movements, the movements of U.S. submarines are not reported to Congress or to the public. Neither are presidential deliberations about the use of nuclear weapons made public until long after the incident: for example, formerly classified conversations about atomic weapons by Eisenhower (1954 Taiwan Straits Crisis; 1959 Berlin Crisis) and by Kennedy (Cuban Missile Crisis) are now, after many years, available for public reading, but more recent conversations remain classified. The *New York Times* cites Nov. 4, 1992, the day following the presidential election, as the first time one of our nuclear submarines entered the Persian Gulf: its mission was to assess the "acoustic properties" of gulf waters. Michael Gordon, "U.S. Sub Checks Gulf's Waters with Iran in Mind," *New York Times*, Nov. 5, 1992, A-3.

23. Mark Miller, *Spectacle: Operation Desert Storm and the Triumph of Illusion* (New York: Poseidon Press, 1994), manuscript, 60 n.9.

24. Ibid., 62.

25. Ibid., 64.

26. Ibid., 63.

27. "Video News Release," *Wall Street Journal*, Feb. 12, 1991 in Miller, *Spectacle*, 63.

28. W. J. T. Mitchell's observation, for example, about the displacement of the term "body bags" by the designation "human remains pouches" ("Culture Wars," 7) had been made by Senator Mark Hatfield during the final day of congressional debate (Jan. 12, 1992, PBS Broadcast); just as my own concern about nuclear blackmail was expressed by Senators Al Gore and Joseph Biden (see note 23 above). These are two among many examples.

Watching Borders

5

"No Bad Nigger": Blacks as the Ethical Principle in the Movies

K. Anthony Appiah

Our topic is American spectacle: and no family photograph of the United States would be visible if it did not come in black *and* white. But reading "race" in our culture—high or low, popular or elite—is a large and difficult enterprise (as it is, of course, in any culture). I am going to pick at a tiny part of the issue, as it arises in the reading of some of our more spectacular movies; and I am going to suggest that in our reading of these spectacles it is as well to keep in mind the complexities of the relationships between representation and represented, particularly given the enormous ethical freight of race in our current practice of reading.

That changes in the representation of blacks do not ipso facto lead to changes in their treatment is not, by any means, a new thought: it is certainly older in American letters than Huck Finn. But a passage from that popular classic, toward the end, should remind us that Twain knew this as well as anybody.

> . . . then the old doctor . . . says: "Don't be no rougher on him than you're obleeged to, because he ain't a bad nigger. . . . I never see a nigger that was a better nuss or faithfuller, and yet he was resking his freedom to do it. . . . I liked the nigger for that; I tell you, gentlemen, a nigger like that is worth a thousand dollars—and kind treatment, too. . . . He ain't no bad nigger, gentlemen; that's what I think about him."
>
> Somebody says: "Well, it sounds very good, doctor, I'm obleeged to say."
>
> Then the others softened up a little, too. . . . Then they all agreed that Jim had acted very well, and was deserving to have some notice took of it, and

reward. So every one of them promised, right out and hearty, that they wouldn't cuss him no more.

Then they come out and locked him up. I hoped they was going to say he could have one or two of the chains took off, . . . or could have meat and greens with his bread and water, but they didn't think of it. . . .[1]

So much by way of advertising my theme. Let us turn, as is our custom, to the texts.

In the first of a series of extended fantasies in Robert Townsend's movie *Hollywood Shuffle* (1987), the character Townsend plays imagines himself as a Stepin' Fetchit slave butler worrying about why he should run away from the plantation. Then a voice yells "Cut" and Townsend steps out of this character and into that of Robert Taylor (the name flashes on the screen as he introduces himself in what I have learned to call not an English but a British accent, one that is almost as good as mine).

TAYLOR: My name is Robert Taylor and I'm a black actor. I had to learn to play these slave parts and now you can too at Hollywood's first black acting school.

Taylor then introduces us to a sequence of moments in the life of the school. Here is white instructor Bob Stevens (his name flashes up too) teaching a black actor who just doesn't get it:

STEVENS: Be cool. [Grabs his balls and continues] Jive turkey motherfucker.

Next we meet a class being taught by tall, blonde Mike. He's trying to teach a young black actor to walk. "No rhythm," Mike mutters and he steps out like the best blaxploitation street punk as a blaxploitation music track fills the air.

Then there's Advance [*sic*] Student Willie Jones rehearsing his standard lines:

JONES: I didn't steal that TV. It just happened to be under my coat. I don't know nothin' police woman, Kojak, Ironside. Yeah, I'm a gang leader. I'm in the War Lords, the Vice Lords, the Onion Heads.

Finally we meet Ricky Taylor, who's an alumnus from three years ago.

RICKY TAYLOR: Well, Robert, I've played nine crooks, four gang leaders, two dope addicts. I've played a rapist twice. That was fun. Currently I'm filming a prison movie. I play this tough convict. Tries to fuck this new inmate.

ROBERT TAYLOR: That sounds wonderful.

The ad ends (after Taylor has told us that only darkskinned blacks need apply, since only they make good servants) with the message that classes are enrolling now.

VOICE-OVER: Learn to play TV pimps, Movie Muggers, Street Punks. Classes include Jive Talk 101. Shuffling 200. Epic Slaves 400. Dial 1-800-555-COON.

ENSEMBLE: Don't try to be cool. Call Hollywood's first black acting school.

Townsend's movie's implicit argument is that these are the roles available for black actors in today's movies. In contemporary settings: crooks, thugs, muggers, whores (with or without golden hearts), servants (the latter sometimes the friendly nurturing descendants of Mammy). In costume drama: slaves (though these can be heroic as well as craven). The movie starts with Townsend and his younger brother rehearsing an audition script in the bathroom of their comfortable home. Townsend moves back from a burlesque of black speech, with "I'se" and "what you be doin's"—as he rehearses his lines—into his own "natural" speech. Thirty seconds into the movie, we can figure out that Hollywood wants its blacks to sound like parodies of street punks.

What's interesting, of course, is that this is less than half the story. There are still plenty of roles around for black punks, especially on television. But the new black directors have created a genre of "black" movies in which the major protagonists are mostly black and there are good guys and bad guys, strong black women as well as whores. In this essay, though, I'll stick mostly with black characters in "white" Hollywood movies (movies, that is, that we understand, in the complex way we construct the authors of movies, as authored by whites); for reasons you'll see later, black authorship gets in the way of the arguments I want to make.

Let me begin, then, by identifying some other slots into which black actors

are now fitted, some of them important enough to have affected, as I would argue, the grammar of the medium.

Take, for example, the black police chief. In scores of movies, the police chief is black. He's tough; he's a bit of a stickler for the rules; he knows how to deal with the mayor; and he's never corrupt. You know the type. In fact, unless he's a major character, you can almost guarantee that any black policeman will not be corrupt; something that, as you know, Hollywood (which is, after all, in a major American city) does not normally assume about cops in general. So naturalized has this convention become, that in Roger Donaldson's *White Sands* (1992), the script actually plays on our assumption that a black FBI field officer must be honest. Only when we're faced with *two* black FBI agents with different stories do we have to acknowledge the possibility that one of them may actually be corrupt. Which one? We're led, at first, to the assumption that it's the lower-ranking one, the one, in short, who's least like the police chief we know and love. It came as something of a relief to me when the senior agent turned out to be the villain: here, finally, the necessities of the plot overcome the desire to provide yet another exemplary Negro.

No doubt this character is some kind of reflection of changing realities. There really are black police chiefs nowadays in the big cities where crime movies live and move and have their being. But, in case there should be any doubt about it, I should remind you that black police chiefs remain the exception in the world outside Hollywood. Should we, therefore, read these movies as in this respect antiracist? For the moment, I want to resist answering this question.

So consider a second type: the noble good-hearted black man or woman, friendly to whites, working-class but better educated than most working class Americans, and oh so decent. This manifestation of the good Negro can be found, for example, in Lawrence Kasdan's *Grand Canyon* (1991), where he's Simon, played by Danny Glover. "It ain't supposed to be this way. Everything's supposed to be different from what it is," Simon says of the inner city with its predatory gangs. As he touches each white life he heals. Simon, I thought,

as I dozed off in *Grand Canyon*, Simon Peter. On whom I will build my church. Not the savior but the greatest apostle. Simple Simon.

In a movie in which everybody else has some quirks or kinks, only Simon and the—inevitably black—woman he meets and starts dating seem simply decent. And when one white character, played by Kevin Kline, is going through a crisis, it's the good sense of this black saint that pulls him through. Simon provides him not so much a buddy as a father figure. Their bonding experience is to shoot some hoops, a moment that we know from the Steve Martin remake of Charles Shyer's *Father of the Bride* (1991), is the ultimate father-child bonding scene. As with Sidney and Billy (Wesley Snipes and Woody Harrelsen) in Ron Shelton's *White Men Can't Jump* (1992), intimacy develops under the basket. And if you think about it, what else can a couple of straight men, one black, one white, plausibly do to bond? It can't be squash or tennis—these mean yuppy (which rules out Danny Glover) and country club (which rules out Danny Glover *with* Kevin Kline). And without a bar to lean on, or a game to watch, they can't just talk . . . because they're straight American men.

There is something of the Simon type—lets call it the Saint—in other roles that Danny Glover has played.[2] The Saint's macho incarnation is there, too, for example, in Richard Donne's *Lethal Weapon* movies (1987, 1989); in each of them it's the white cop who's crazy.[3]

When I first started thinking about the Saint as a black movie type, I thought of the psychic played by Whoopie Goldberg in Jerry Zucker's *Ghost* (1990). But she is a petty con woman, which means we can't say that she's exactly perfect. Still, I think she's a variation on the theme: she may be prone to dishonesty in small matters, but her fundamental decency is always on display. All saints have flaws of personality: but Whoopie makes up for hers by having, like Simon, but more literally, that other essential mark of sanctity, the capacity to perform miracles.[4]

You might argue that what is going on here is a universal phenomenon, part of the grammar of stardom. Stars, with few exceptions, don't play people the audience doesn't like. (Their agents don't like it.) Become a star (even a

dim one) and you have to be *likable*.[5] Morgan Freeman is perhaps the ultimate example of the black actor who goes from the bad nigger to the Saint. He started as a pimp in Jerry Schatzberg's *Street Smart* (1986). But by the time we get to the movie bell hooks calls "Driving Me Crazy," (*Driving Miss Daisy*, Bruce Beresford, 1989) where he played Hoke, Jessica Tandy's loyal and saintly chauffeur, fate has made him a star: which means, as a black actor, that he goes on to play the loyal and saintly Saracen in *Robin Hood* (1991) and the loyal and saintly South African convict in *The Power of One* (1992).[6] Even the embarrassing speech he gave as the judge in his cameo at the end of *Bonfire of the Vanities* lecturing a multiracial audience about racial decency would have been improved by borrowing Simon's lines:

> "It ain't supposed to be this way. Everything's supposed to be different from what it is."

But, of course, saying that Freeman has to be *likable* doesn't explain why he has to play the Saint. White stars don't have to play the Saint to be likable.

The Saint is a crucial type, because, in the last five or six years, where blacks had first and second-rank roles in what I've been calling "white" movies, they were, by and large, if not Saints, then, to varying degrees, on the side of the angels. The exceptions, too, are interesting. For the black villains we remember from the later 1980s are both bizarre and foreign, doubly alien: indeed, the recipe for getting a job as a black actor in the late 1980s was to practice throwing bones and muttering voodoo curses. The strange cult leader from the Sudan in John Schlesinger's 1987 *The Believers*; Screwface, Stephen Seagal's adversary, in his *Marked for Death* (Dwight Little, 1990); the voodoo Prince King Willie in Stephen Hopkins's 1990 movie *Predator II* (who used to "run with Seaga until he got too big"): all these black men are foreign, talk funny, and have (the trope is puzzling) blue eyes (i.e., contact lenses) to mark them off as not-quite-of-this-world. Outside Mario Van Peebles's *New Jack City* (1991) (which doesn't count, once more, since it's a "black" movie), if the drug trade is run by blacks they belong to the Jamaican posse. The bottom line is that, if they were not foreign or secondary, blacks were good.

Where does the Saint come from? Is it the return of Poitier in Stanley

Kramer's *Guess Who's Coming to Dinner* (1967), the black man who is too good to be true, because only a truly superior black man could turn the possibility of marriage to Hepburn and Tracy's daughter into a genuine ethical dilemma? (Poitier certainly took the Saint to brilliant extremes; in James Goldstone's *Brother John* (1971), he literally plays an angel.)

Or does the Saint draw on the tradition of the superior virtue of the oppressed? Is there, in fact, somewhere in the Saint's background a theodicy that draws on the Christian notion that suffering is ennobling? So that the black person who represents undeserved suffering in the American imagination can also, therefore, represent moral nobility? Does the Saint exist to address the guilt of white audiences, afraid that black people are angry at them, wanting to be forgiven, seeking a black person who is not only admirable and lovable, but who loves white people back? Or is it simply that Hollywood has decided, after decades of lobbying by the NAACP's Hollywood chapter that, outside crime movies, blacks had better project good images, characters who can win the NAACP's "image awards"?

These questions, like the ones I deferred earlier about the lower-key type of the black police chief, are questions about how we should *read* these movies. And they should be the occasion for asking what readings of movies are supposed to do.

Readings at the sort of popular level that I have been operating at, which ask the question "Is it racist or antiracist?" like the questions about the homophobia of *JFK*, discussed elsewhere in this volume, seem often to confound many different issues. Sometimes we say a film is racist or homophobic or misogynistic, because, roughly, we think of it as reflecting these things in the people that produced it. (A film may reflect the racism of its culture by *portraying* that racism: which would mark it, usually, not as racist but as antiracist. We only call it racist if the racism that's reflected is that of its producers, of the imaginary author we construct for it.) There can be many signs of this sort in a film, as in any cultural artifact, ranging a great deal in explicitness. A film may seem to intend to endorse these attitudes (as D. W. Griffith's *Birth of a Nation* (1915) endorses racism); or it may reflect it without seeming to intend

to endorse it (as in the so-called symbolic annihilation that kept black people and gays invisible through many film genres until the 1960s). It's because we assume that most blacks aren't, by and large, antiblack racists, and because we think of the new black movies as authored by blacks, that we're unlikely to suspect them of racism in this sense; which is why I have kept away from discussing them.

But it doesn't follow from the fact that a film is racist or homophobic or misogynistic in this sense that it succeeds in reinforcing or in naturalizing those attitudes: Leni Riefenstahl's *Triumph des Willen*, which is certainly deeply chauvinist in the sense of reflecting the chauvinist culture that produced it, strikes me as a film whose effect now is not to encourage Nazism but to chill the blood. *Guess Who's Coming to Dinner* is quaint in part because it seems to defer too much to racist assumptions, so that, by our standards, it simply cannot succeed in the cultural work it mapped out for itself as an argument against prejudice. But it can hardly be thought that its being in this sense racist—laced with evidences of the racial condescension of its cultural producers and the audiences they imagined—establishes that it will encourage racism now.

In much popular cultural discussion of the movies, these issues are seen through an even cruder notion: a film is seen as racist or homophobic if it represents people of color or gay people as bad. For years the NAACP has given "image awards" in Hollywood, to actors who have portrayed good Negroes. This is another matter again, since you can play a good Negro in a movie that reflects, in subtle or less subtle ways, the racism of its producers; and there's no guarantee, *pace* the NAACP, that a score of movies with good Negroes in them will change the mind of a single bigot. (I leave aside the simpler mistake of assuming that every black in every movie stands for all blacks.)

GLAAD gave an award to Jon Avnet's movie *Fried Green Tomatoes* (1991) because it involved a positive portrayal of a lesbian relationship. Somebody wrote in to one of the magazines (*Entertainment Weekly*, I think) to say that it was disgusting that they did so because it represented as lesbian a wholesome relationship between two women that plainly wasn't sexual. Jon Avnet, the

director, responded that they had decided (in making the film from a book in which the lesbianism is explicit) that it should be done so that you could make of it what you wanted. Conclusion: this was a case where the real achievement was to make a movie that *allowed* of a gay interpretation. This may make us feel good, but it won't change any homophobic minds, since the movie is designed to allow also the "straight" reading that will suggest itself to homophobes.

These crude distinctions are important because to call a film racist or homophobic suggests that there is something wrong with it, in the way that there is something wrong with a person who is racist. Like it or not, terms like "racist" and "homophobic" are moralizing. But we need to be clear about *what* the wrong is. If the film reflects a racist or homophobic culture, then what's wrong is that the culture is racist or homophobic: the film's just a symptom and boycotting it is like blowing the smoke when we should be dousing the fire. If a film reinforces racism, then what's wrong is that it makes the culture more racist than it would have been otherwise. A film that's racist or homophobic in *that* way is worth boycotting. But while a film with positive gay characters may make some of us feel good, it may still both reflect the homophobia of its makers, and leave homophobia in the culture exactly where it was.

Actually, so it seems to me, on the all-important question of how crucial a role movies play in shaping consciousness, and, in particular, in perpetuating the nastier forms of hatred, there is less good evidence than one might like.

Of course, if we really care about this question, somebody ought to go out and ask people all around the world how they read media texts. What (little) work *has* been done seems to suggest, in the words of John Tomlinson's work *Cultural Imperialism,* that "people generally . . . are less deceived" (i.e., less manipulable) "than critical media theorists had supposed."[7] The reason is not far to seek: most of these approaches forget that culture (in the broadest sense of that multivocal term) is not only acted upon by the media but acts upon them. As Tomlinson also points out, in discussing one of the few transnational studies of audience response to television, the Palestinian family watching Dallas convinced that Sue Ellen is escaping from her husband back to her

father's home (and not, as the script intends, the home of a former lover and *his* father) is understanding her response in terms of their beliefs about family life.[8] Culture shapes media even as media shape culture.

Such thoughts seems apropos in consideration of the Saint and the Good Cop, whose significance for the wider culture, I am inclined to doubt. In the sphere of racism, the good Negro, in real life as in the movies, usually functions as the exception rather than refining the rule. The cultural assumptions of the consumer are all important.[9]

In early 1992 we witnessed these issues being played out in discussions of the supposed homophobia of Paul Verhoeven's *Basic Instinct*. Richard Goldstein wrote in the *Village Voice*:

> It's no coincidence in the age of ACT UP,[10] the Gay Villain is having a revival in Hollywood. Films that show gays as corrupt conspirators (*JFK*), inverts who harbor murderous misogyny (*The Silence of the Lambs*), and man-haters with ice-pick dicks (*Basic Instinct*) may actually quiet the anxieties of heterosexuals. Each of these clichés affirms that queers are as socially destructive as Pat Buchanan says, yet each is a product of Hollywood's liberal establishment.[11]

But it just isn't clear that *Basic Instinct* is, indeed, so wicked. There are, I will concede *arguendo*, "man-haters with ice-pick dicks" in *Basic Instinct*, but what makes them stand for *all* lesbians?[12]

Indeed, in a latter issue of the same *Village Voice*, both C. Carr and Amy Taubin have rejected the mass of largely male attackers who have spoken of *Basic Instinct*'s homophobia. C. Carr even announced that she "simply got a kick out of" the movie and Taubin says that "had [these men] consulted some women, . . . they might have discovered that a lot of us (lesbians, bis, and straights) thought it was a gas to see a woman on the screen in a powerful enough position to kill and let it all hang out and *not* be punished in the end."

This contest of readings brings me round to an issue of more direct professional concern to *us*, namely what the connection is between the more sophisticated readings of culture exemplified in other essays in this volume—starting with Rogin's post-Freudian reading of *JFK* and Edelman's Lacanian reading of

bushusuru and going on from there—and these readings that subsist outside the academy.

There are confusions, I have suggested, in the world of popular reading, between reading as treating the object as a cultural sign, reading as seeing the sign as a cultural agent, reading as reporting how and what the work represents. But there are contests, too, if not confusions in our professional accounts of reading. What is it, for us, that a reading is supposed to give a correct account of? "The quick answer," as I have written elsewhere,

> one that, as we shall immediately see, tells us less than it pretends to—is, of course, "the text." But the text exists as linguistic, as historical, as commercial, as political event; and while each of these ways of conceiving the very same object provides opportunities for pedagogy, each provides different opportunities: opportunities between which we must choose. We are inclined at the moment to talk about this choice as if the purposes by which it is guided were, in some sense, given. But . . . the concept of a "literary reading," like the concept of "literature" is what W. B. Gallie used to call an "essentially contested concept." To understand what a reading is, is to understand that what counts as a reading is always up for grabs.[13]

In our business, the aims of reading are essentially contested. But they are driven, as this passage implies, by the needs of our teaching, our concern to bring texts to the classroom to teach. The readings of film in popular culture I have been discussing are driven, by contrast, by an urge to shape the perception and the production of film outside the classroom: and, to the extent that film does change consciousness, these are both crucial political tasks. (This opposition is not offered as an absolute one: changing the reception of texts in the classroom has clearly been part of shaping their reception outside.)

In the normal peripeteia of our professional "readings," we identify the obvious interpretation of a text and then produce a series of new ones, each of which contradicts, dare I say "subverts" its predecessors. (This is what the *New York Times* means by deconstruction.) The process is Hegelian. Superficially the Saint is antiracist (thesis). In fact, however, below the surface

it is racist, in acceding to racist cultural presuppositions by refusing black particularity (antithesis). You know the moves: I will leave the *Aufhebung* to your imaginations. But the shift from one of these readings to the next does not establish a change in the text's effects outside the little world of our readers.

We need, in other words, to be careful in this political project not to conflate the representation of sin with sin; not to assume that the representation of sin causes further sinfulness; not to assume that representations that are neither stereotyped nor prejudicial ipso facto diminish stereotyping and prejudice. I know that representations are also real, but we still need to keep a clear grip on the distinction between representations and the reality they represent. Goldstein buys into one kind of confusion between representation and reality at the end of his piece on movie homophobia when he suggests that, because "[t]he real goal of gay liberation must be to open up space for gay particularity," we do not need to insist on films that are gay-positive. For this presupposes that what matters in achieving gay liberation depends on how gays are represented in the movies; it presupposes what the NAACP assumes in handing out its image awards. Peter Biskind in the June 1992 issue of *Premiere* writes:

> Movies do matter: they have enormous impact on how people perceive the world. In an era in which Patrick Buchanan—who has said, "Our promiscuous homosexuals appear literally hell-bent on satanism and suicide"—can get 37% of the Republican vote in New Hampshire, demonizing homosexuals or other power-impaired groups is not exactly the height of social responsibility.[14]

I am all against demonizing, but what is the evidence that *Basic Instinct* has had an "enormous impact" in "demonizing" gay people?

What would happen, in fact, if ever GLAAD achieved what we may suppose has been achieved by the NAACP: a world in which most gays in the movies were ultradecent, never villains? What if lesbians and gays were so reliably good that you could build up suspense by having the occasional gay villain?

The evidence here from the case of blacks is not good. There's some truth in the assumption implicit in Michael Douglas's response to the criticism of

Basic Instinct. "Should WASPS be the only villains?" he complained in *Premiere* in April, joining the chorus of whining elite white men identified in Professor Rogin's essay. "I mean, no Italians, no blacks—if there are no minorities that can be socially deviant. . . . I don't get it." Even though there's a ludicrous overstatement here, we can concede that it really is harder these days for white filmmakers to represent black villains. But if blacks had come as far in life as they have in the movies, Rodney King might still be a petty criminal, but he wouldn't have been a punching bag, and the streets where he lives would not have been the scene of devastation they are today. In the battle over signifiers, let's remember that there is politics to be conducted in the world of what is signified. That, for what it is worth, is the point made by my early quotation from *Huckleberry Finn.* Nigger Jim may no longer be seen as a "bad nigger" after the doctor's speech. The world of representations has changed; it has, in Huck's phrase, "softened up a little." But Jim is still in prison and in chains.

NOTES

1. Chapter 42 of Mark Twain's *The Adventures of Huckleberry Finn* (London: J. M. Dent 1991) 428–429. *Huckleberry Finn* here functions like Shakespeare in Marge Garber's account in this volume, adding the weight of authority and the taste of truth to our cultural nostrums; Twain has the advantage that many of us may actually have read the whole original text.

2. In Peter Weir's *Witness* (1985) Glover plays a bad guy. But, once again this exception confirms the rule: it is because of the Saint convention that our recognition that he is a bad cop is so successfully deferred. (Robert Ludlum's *The Chancellor Manuscript* [New York: Bantam Books, 1977] is surely one of the more masterful modern loci of this device, where the one villian you never suspect is the black civil rights lawyer and Supreme Court justice.)

3. On the other hand, in "black" movies (movies written by or based on texts written by African Americans), like *The Color Purple* (Steven Spielberg, 1985) and Charles Burnett's *To Sleep with Anger* (1990), Glover is allowed to be sinister. It is an issue to take up, this; but here I am sticking to "white" turf.

4. Of which, as Jann Matlock has suggested to me, the most spectacular is her ability to make love in full view of an American audience to a woman.

5. The typical Jack Nicholson character, for example, isn't "nice," of course, but he *is* a likable crazy or villain.

6. Freeman also joined a veritable heavenly chorus of loyal saints in the movie *Glory* (Edward Zwick 1989).

7. John Tomlinson *Cultural Imperialism* (Baltimore: Johns Hopkins University Press, 1991), 57. To say that there's little work is not to say that there's been *none*. I think a fine model of how to do the ethnography of reception is in Janice Radway's *Reading the romance: Women, Patriarchy, and Popular Literature* (Chapel Hill: University of North Carolina Press, 1984, 1991). And Todd Gitlin has edited *Watching Television: A Pantheon Guide to Popular Culture* (New York: Pantheon Books, 1986), which contains some useful ideas. But it remains true that what little empirical study there is of film audiences in the United States (and *a fortiori* elsewhere) has been done by film marketers, who are likely, by and large, to agree with William Goldman's *Adventures in the Screen Trade: A Personal View of Hollywood and Screenwriting* (New York: Warner Books, 1983), that "Nobody knows anything."

8. Tomlinson, *Cultural Imperialism*, 48.

9. An anecdote: I once watched the Ira Levin mystery *Deathtrap* (Sidney Lumet, 1982) in a cinema in the inner suburbs of New Haven. This is a film in which Michael Caine kisses, smooches, to speak only slightly less delicately, in the French manner, with Christopher Reeve. (This is a scene that Michael Caine has revealed was so hard for him to do that he had to get drunk first.) The New Haven audience would have offered Caine its sympathy. When Alfie Frenched Superman there was a gasp of shock and a hiss of hostility. Plainly, the naturalness of the gesture in the world of the movie did not help naturalize it in the minds of those whose culture had prepared them for something else.

10. "It's no coincidence that . . ." is better, I suppose, than "Can it be a coincidence that . . .?" but it's worth thinking a moment about what is being insinuated here. If it's no coincidence, is there some kind of causality? Is it that these films are made *in order to* relax threatened heterosexuals; or *by* threatened heterosexuals? And if *by* them, do they know this is why they are doing it? Or is it that the threatened heterosexuals like the movie for this reason, so that what isn't a coincidence is that it is a success? And, if so, do these audiences know that they are responding for this reason? Or is the film's lack of coincidence simply a kind of meaningful synchronicity? So that we can read the wider needs of straight culture off the narrow strip of the film? And if so, what warrants this reading? The trouble with "no coincidence" claims is that they invite the response in Ernest Gellner's riff on Wittgenstein. He said: "That which one would insinuate, thereof one must speak." (*Words and Things* (London, Penguin Books, 1968) 296.

11. Richard Goldstein, *Village Voice,* April 14 1992.

12. This may "affirm" that "queers are . . . socially destructive," if to "affirm" a movie commonplace is not to contradict it: but by this logic the film also affirms that all psychiatrists are crazy.

13. K. Anthony Appiah, "Out of Africa: Topologies of Nativism," *Yale Journal of Criticism* 2, 1 (1988), 153–78.

14. Peter Biskind, *Premiere,* June 1992, 59.

6

Cortez in the Courts: The Traps of Translation from Newsprint to Film

Doris Sommer

On May 5, 1992, the day after children came back to school in lacerated Los Angeles, a front page center article in the *New York Times* showed a dark child drawing houses aflame and people assaulted. They were his memories of the still smoldering riots that followed a local court's acquittal of four white policemen who brutalized Rodney King. On the same front page, at the far right, another legal decision made the news. The Supreme Court had decided to overturn the guarantees for fair hearings established by the 1966 amendment to habeas corpus. Acknowledging the possibilities of error, ignorance, or bias, that amendment used to entitle state prisoners to a retrial at the federal level, if "the material facts were not adequately developed at the state-court hearing." Refining the law enhanced it dramatically: "Of the 400 habeas corpus petitions granted each year, more than 40% of all the death penalty cases were overturned."[1] The new decision of May 4, 1992, *Keeney v. Tamayo-Reyes*, ruled out those guarantees when it found no reason to retry a Cuban convict of manslaughter, even though his lawyer had failed to offer crucial evidence. Instead he offered Tamayo-Reyes a no contest plea, so badly translated that the defendant did not understand what he was signing.

The article might have, but did not, editorialize on a connection between the Washington ruling and West Coast unruliness. In both cases, justice parodied its own ideal of indifference. The Los Angeles judges chose to be blind to the videotaped violence of white authority against a single black man; and a week later, our highest court decided to be deaf to the demand for translatable justice: if English is a problem for subjects of the law, it is *their* problem, not one that the law should consider. Blind and deaf, but not dumb, the country's courts

continue to promulgate rules that resent intrusive minorities, as if discouraging blacks and Hispanics from expecting real equity were a guarantee of white privilege and property. While the angel of vengeance ravaged the city named for more benign messengers, and while one metropolis after another girded itself against that angel's potential scourge, Supreme Court judges were counting the nickels and dimes of legal proceedings, cutting the short-term costs of retrials, not the long-term material and social costs of injustice.[2]

Sometimes a life is lost in translation. Mistranslation (or visual underexposure) can even misfire in a series of casualties, including a ricochet effect back onto the benighted or befuddled source. These are the dangers suggested in the juxtaposed articles of May 5. Errors can be fatal enough, even when intentions are sound. But the high court's indifference to error is high arrogance. It says, in effect, that English is the only legally binding language. The decision will probably not foster a utopian, inclusive polity that speaks one socially binding single language; instead it is likely to have the opposite effect: it will inflict legal binds on virtually indefensible "outsiders."

A melting pot fantasy that dissolves the differences it might celebrate is a double bind familiar to American law.[3] Rather than trace the twists of that history here, I want to fix on a particular scene of contradiction (and of misfired translations), a scene that has been played and replayed since Gregorio Cortez shot the sheriff in Karnes County, Texas, on June 12, 1901 and then escaped a small army of Rangers for ten days.[4]

The first English versions were newspaper articles about the killing and the characters. The San Antonio *Express* of June 23 reported that Cortez had until then respected the law during the eleven years he and his brother lived in Karnes County. And two days later, alongside indignant complaints that Cortez wasn't lynched as soon as he was brought to San Antonio, the same paper ran a front-page piece on the Mexican's good looks and confident manner:

> He is tall, slender, and lithe, with the lean muscular appearance of one who has passed through a trying physical ordeal. . . . His hands and feet are small

and well shaped. His head is large and of good shape. It is covered with hair, of which any society "exquisite" might be envious—black as night and tumbling in heavy curls all over his head. His face is long and aquiline, all the features being regular. . . . The eyes are brown and bright, but not fierce or unduly prominent in repose. . . . his teeth are regular and white. . . . He was easy in his manner and showed no embarrassment. . . . it was apparent that Cortez understood English, and later demonstrated that he could speak it. . . . he cooly proceeded to give the officers a detailed statement . . . He talked unaffectedly and was at pains to make himself clear, often repeated statements over and over to make himself understood. Where his statements seemed at variance with the facts as known by the officers, he argued the point and usually succeeded in removing the doubt.[5]

The ambivalence of the Anglo public is patent, but it goes as unacknowledged and uncommented in the *Express* as does the pattern of legal blindness and deafness in the recent *Times*. Demands for the Mexican's blood competed with calls for brotherhood, because some outsiders cast Cortez as a darkskinned demon while others read him as romantic victim of their own monolingual limitations. The subsequent story of trials, appeals, and retrials—lasting a dozen years until Governor Colquitt finally pardoned Cortez on July 14, 1913, would bear out the romantic reading. As early as an *Express* article of October 10, 1901—where much is made of the murderous mistranslations that led to the shooting—followed up by a reversal of the guilty verdict at the Texas Court of Criminal Appeals January 15, 1902, English speakers have had occasion to pause over the decisive details that we'll review here. But the Anglo-American reaction to Cortez's release retained the initial ambivalence about the case; one local paper ran a restrained review of the history, while another editorialized on the "dangerous murderer pardoned."[6] In English the story kept shuttling between an account of criminality and unaccountable victimization.

But in Spanish it stayed at a pitch of epic heroism. First *El Regidor* and then *El Imparcial*, both of San Antonio, published the news, along with appeals for justice, for funds, and for reliable lawyers. As far away as Mexico City, *El*

Popular repeated the plea for fairness and funds.[7] And the news ran ahead of the papers through the corridos about Cortez. In Texas, at the turn of the century, news could circulate in Spanish corridos, a popular, usually anonymous, ballad that sung the news, commemorated history, or lamented lost loves. Called "the people's newspaper,"[8] the corrido often begins by precisely dating, and usually locating, the event to be sung.[9] Still a popular practice in Mexico and on its frontiers, singing corridos is as close to medieval "trovar" as it's possible to be in the twentieth century. Its composers/singers are literally called *trovadores ambulantes*, travelling troubadours.[10] And few ballads have travelled as wide, as long, or in as many variants as the "Corrido de Gregorio Cortez." This staple of border balladry takes advantage of the news to repeat postures of resistance that were already legendary, as if the facts were a confirmation of fabled Mexican courage and capacity, rather than news to be assimilated.[11] The earliest extant version, the "Mexico City Broadside," became a regular in the minstrels' repertoire; it begins, classically, by timing and placing a verifiable event:

Como decimos, así es,	Like it is, as our story says,
en mil novecientos uno,	in nineteen hundred and one
el día veintidós de junio	on the twenty-second of June
fue capturado Cortés.	they finally captured Cortez.
En junio día veintidós	Through the telegraph box
por telégrafo supieron	on June the twenty-second
que a Cortés lo aprehendieron	they knew Cortez was arrested
entre el Sauz y Palafox.	between Sauz and Palafox.[12]

Many versions followed, as did debates about the accuracy of detail, both symptoms of the ballad's vitality. A 1929 recording ends in tragedy, as when Christlike Cortez allows himself to be betrayed; another sets him free after eight years in prison.[13] These and other corridos were collected by Américo Paredes, a man whose interlocking careers as singer, poet, journalist, and folklorist bring home the generic connections between reporting the news and recording (in both senses) corridos. In a 1958 book that predated and helped to establish what we now call Chicano studies, Paredes framed his

own resistance to Anglo-American bigotry by retelling the story of a legendary resister to a linguistically limited and apparently humorless academy. There, influential interpreters of border tensions, such as J. Frank Dobie and Walter Prescott Webb, had been arguing the superiority of Anglo Texans over allegedly degenerate Mexicans. Paredes outperformed, or outgunned, them. *"With His Pistol in His Hand": A Border Ballad and Its Hero* is a book whose title derives from the phallic posturing of a selected verse from the Cortez corrido, and ably aimed at the new Texas Rangers on patrol in academic walkways. When it appeared, after some concern for reprisals directed at the press, an ex-Texas Ranger actually threatened to "shoot the sonofabitch who wrote that book."[14]

More than merely an inspiration for a 1983 film, the book was an important source for *The Ballad of Gregorio Cortez*, starring Edward Olmos (of *Zoot Suit* and *Miami Vice* fame), directed by Robert Young, and produced by Moctesuma Esparza through the National Council of La Raza. The movie is significantly named for the corrido, rather than for the bald events, and so announces itself in the line of repeatable and enduring popular revisions of history. This version opens on a locomotive belching smoke as it transports Cortez from one prison to the next, we later learn, while the sound track mixes train whistles with Paredes's own voice singing two verses from the corrido, his "Variant X."[15] The popular cinematic medium for this update of the ballad is meant for Anglo audiences as well as Hispanic. For both, it dramatizes more than injustice and defiance; it also stages the vagaries and the violence of bad translation. By focusing on the film in what follows, we will have an opportunity to linger over the differences between this extended fiction and the contemporary reports in papers and in popular ballads. The fiction, we will see, forces facts into the unmistakable motifs of a fractured polity. After seeing and hearing the movie, it would be hard to miss connections between repeated refusals to translate justice into practical terms, between, for example, the right and the center of the *Times* front page.

Fiction provides other opportunities for thematizing newsworthy problems of translation. One striking instance is Mario Vargas Llosa's gloss on his own journalism with a novel. In newspaper articles of 1983 he had confronted Indians' cultural intransigence as an obstacle to Peru's national unity; but five

95

years later, *The Storyteller* (1987) would circle in slowly and self-consciously on the cultural devastations visited on Indians by the voracious desire for unity. The care and the graceful pace of Vargas Llosa's ponderings will merit another essay.[16] But here I mention his success in moving from "objective" reportage to self-implicating fiction because it speaks to the same kind of contemplative openings that the film offers to the news about Cortez.

Developed beyond other versions of the Cortez legend, the movie is a meditation on the presumptive arrogance of English speaking law enforcers. Histories tell the same story, notably the detailed history that Paredes offers, complete with misfired translations and unfortunately better aimed bullets; and the versified variants had been repeating the story for years. But only the film elicits a particular effect from the audience, a guilt-provoking effect of self-conscious collusion, or in the least case, the effect of acknowledged nescience. For all the deadpan humor that Paredes brings to his text, and that Renato Rosaldo applauds on his reading,[17] the written version splices in ironies of linguistic ignorance as the story unfolds. It doesn't withhold the punch line, and so it welcomes English language readers as intimates of the misunderstood Mexicans. But the movie reserves reliable translation, and intimacy. Although its ideal audience includes all border people (all of us, by extension in this increasingly Hispanicized country), those of us who live on the line in English alone will see the film very differently from the bilingual straddlers.

Put a bit provocatively, *The Ballad* sets a trap for its Anglo viewers and eludes their efforts to grasp it until the end, when reasons for the initial violence and for the hour-long chase scenes are finally cleared up in court. Meaning escapes monolinguals for as long as Cortez manages to escape his pursuers. It is as if the film were repeating the Mexican's regional mastery, so embarrassingly superior to that of 600 Texas Rangers, at the expense of a similarly embarrassed Anglo audience. The movie, in other words, makes us worry about more than what we watch; it corners us into considering who watches and from what position on the language divide. And for all the incongruities of interpretation possible on either side, this film—like other resistant texts— performs the necessary gesture of highlighting an overwhelming incongruity between sides.[18]

Let us listen to the scene of initial conflict, as Boone Choate presumes to negotiate the divide. The sheriff took him along to Cortez's ranch, Choate explains later to a reporter from the *Express*, because "I talk Mexican. I been around 'em most of my life." Then the film cuts back to translator Choate and Sheriff Morris driving up in a surrey as Gregorio sits on the porch stoop, arms around knees, while his brother Romaldo stands in the foreground. The surrey drives in, Gregorio stands up, thrusts hands in pockets, leans against a post, and listens.

Choate: Buenes tardees.
Romaldo: Buenas tardes.
Morris: Ask him his name.
Choate: Como ste . . . como seyames?
Romaldo: Romaldo.
Morris: Ask old Romaldo if he knows Gregorio Cortez.
Choate: El cherife quiere hablar con Gregorio Cortez.
Romaldo [looking back]: Te quieren.
Gregorio: Gregorio Cortez, a sus órdenes, ¿en qué les puedo ayudar?
Choate [to Morris]: He didn't tell him you wanted to talk to him. He told him you wanted him.
Morris: Ask him if he's traded in a horse lately.
Choate: El cherife quiere saber si has cambiado un caballo ahora.
Gregorio: No. Un caballo, no.
Choate: He says he hasn't traded a horse.
Morris: I understand "no," Boone. Uh, tell him another fellow said he did.
Choate: El cherife . . . dici. . . que. . . ya hablamos con. . . con el otro, que no hay que mentir.
[Gregorio walks off the porch, toward Romaldo who turns around toward him.]
Romaldo: Vinieron por el cambio . . . esos rinches.
Gregorio [To Romaldo]: Sí. [To Morris] No estamos mintiendo. No cambiamos un caballo, era una yegua [Romaldo laughs], pero hace dos días.
Choate: They ain't gonna tell you nothing.
Morris: Well, you habla him that he's under arrest [gets down from surrey].

Choate [with sly smile toward Gregorio]: *El cherife dici que te va a arestar.*
Gregorio: *¿Por qué? No hemos hecho nada. No nos puede arrestar por nada.*
Choate: *Nooo?* [Morris faces him for clarification] He says no man can arrest him.
Morris: Boy [he cocks his gun toward Gregorio], get back in that surrey.
[Morris shoots Romaldo to stop his run, and Gregorio shoots Morris, walks up close to his writhing body and shoots again, with a long stare of contempt and defiance.]

An Anglo audience is no doubt upset by the violence of an American sheriff who shoots a Mexican for helping his brother resist arrest, perhaps on some trumped up charge. And the uneasy feeling is probably compounded by the fury Morris triggers in Cortez. But a bilingual audience also knows enough to laugh with Romaldo and to wince over Choate's ominous incompetence, enough to feel the violence more poignantly, as a tragedy of humorless arrogance in translation.

Bilinguals will notice immediately after Choate's boastful "I speak Mexican," that he can hardly speak at all. From the mispronounced greeting to the last and fatal mistranslation, he is both funny and infuriating. Here are the same exchanges as insiders hear them:

Choate: *Gid afternood.*
Romaldo: *Good afternoon.*
Morris: Ask him his name.
Choate: *What yer . . . what's yer named?*
Romaldo: Romaldo.
Morris: Ask old Romaldo if he knows Gregorio Cortez.
Choate: *The sheriff wants to talk to Gregorio Cortez.*
Romaldo [looking back]: *They want to talk to you.*
Gregorio: *Gregorio Cortez, at your service. How may I help you?*
Choate [to Morris]: He didn't tell him you wanted to talk to him. He told him you wanted him.
Morris: Ask him if he's traded in a horse lately.
Choate: *The sheriff wants to know if you traded a horse now.*

Gregorio: *No, not a horse/stallion.*
Choate: He says he hasn't traded a horse.
Morris: I understand "no," Boone. Uh, tell him another fellow said he did.
Choate: *The sheriff . . . says . . . that . . . we already talked to the other guy . . . that you shouldn't lie.*
[Gregorio walks off the porch, toward Romaldo who turns around toward him.]
Romaldo: *They came about the trade . . . those Rangers.*
Gregorio [To Romaldo]: *Right.* [To Morris] *We are not lying. We didn't trade a horse/stallion. It was a mare* [Romaldo laughs]. *But it was two days ago.*
Choate: They ain't gonna tell you nothing.
Morris: Well you habla him that he's under arrest [gets down from surrey].
Choate [with sly smile toward Gregorio]: *The sheriff says he's gonna arrest you.*
Gregorio: *Why? We haven't done anything. He can't arrest us for nothing.*
Choate: Nooo? [Morris faces him for clarification] He says no man can arrest him.
Morris: Boy [he cocks his gun toward Gregorio], get back in that surrey.

One deadly joke is on the sheriff, of course, who gets shot for thinking that "no" effectively summarizes a much longer sentence. He presumes that the object of his inspection can answer only yes or no, that Cortez is too simple to engage in word games or to master wit through language. But the force of the fatal humor falls mostly on Choate, the subject who presumes to know and to translate. By extension it falls on those of us who follow the false leads of his translations. To Gregorio's dignified courtesy (a sus órdenes, ¿en qué les puedo ayudar?), Choate counters with innuendo about Romaldo's alleged misrepresentation. Then the sheriff's suggestion about contradictory reports escalates to a charge of lying. And Cortez's informative banter about the mare who slips away from the limits of Choate's masculine signifier, along with more information about the precise timing of the admitted trade, is reduced to a report of intransigence. Finally, *nada* is confused with *nadie* to twist Gregorio's legal logic about grounds for arrest into unnuanced resistance.

It would be impractical to object to the inevitable linguistic dismemberment suffered in translation's move from one language to another, literally

from one side to the other. To hear quotes misplaced or misused is hardly surprising, given what deconstructionists have been telling us about the iterable quality of language, its decontextualized life, and the attendant problem of shifty signifyers.[19] My move here is merely to notice the points at which the sides are inscribed or circumscribed, to discover when translation pays tolls or is forced to stop. Instead of bringing us to the other side, Choate's translations derail understanding. Patient reconstruction of the linguistic detours that lost their way finally do rescue comprehension, at the cost of twelve years of defensive struggle and of Cortez's imprisoned, shattered health. But the final outcome makes one theme of the story and the movie seem clear: the fight was worth the effort. Anglos have had to acknowledge the potential universality of their own law, and they will have to assume the burden of halting, tentative translation that stops at the toll booth of doubt, to modestly admit ignorance, before it shoots toward the other side. From this promising perspective, the desire of the film is to produce competent viewers and interlocutors from an English-speaking audience that is, by definition, not ideal.

A different desire, though, may exceed the "happy" ending. It derives from another perspective that hesitates before welcoming Anglo understanding, and interferance. Truer to the heroic spirit of the corridos than to the extended and exonerating history of legalities, this more prickly perspective prefers to keep resistance alive. Instead of encouraging correct translations from the local language into imperious univerals, the film's alternative desire is to refuse collaboration, to paint a fresh coat of local color on the stop signs in translation's way. Why else, the viewer may wonder, does Cortez strike the unmistakably proud and unyielding posture that Edward Olmos repeats in the movie? Hands stuck in his pockets, leaning with theatrical ease on the post of his porch, Olmos's Cortez is a studied model of pride and courtesy, as if those attributes played on the courtly etymology of his name. Why else would he concede to the artifice of translation, if he knew English, except to keep the sides distinct? And why does he speak in a conspicuously Mexican singsong, underscored by Romaldo's milder register, except to claim pride of place as a proper Mexican on his own property? Politeness and pride are his displays of superiority, gestures of formal hospitality to strangers in the land.

From this perspective, then, even the correctly translated cooperation that Anglo viewers will appreciate after patient reconstruction may turn out to be a kind of intransigence after all. Distances survive translation. We know that presumption and ignorance are finally indicted in court, as the bandit hero of the corridos is convicted, retried, reindicted, shuffled from one prison to the next, and finally pardoned. But after almost a century, his audience remains divided. Part of it continues to sing and to hear his ballad, and to be immediately *in* on the film's jokes. Another part stands as far outside the humor of codes in collision as did the legal system that gradually admitted its own limitations. The difference is hardly forgettable, especially now that the Supreme Court has shamelessly admitted that its limitations don't much matter.

English, it will be understood, is different from Spanish; it can ignore the distinction between male and female horses and seem laughably simple to a Mexican victim of moving borders. Cortez resists the language and the lawlessness of those who robbed half of Mexico's territory in the 1840s war. The Republic of Texas, we know, is a particular case of national banditry. It had seceded from Mexico in 1836, after Anglo Americans settled there and outnumbered the Mexicans ten to one. Mexican Tejanos fought for independence alongside the newcomers, but then found that they had merely traded one master for another. By 1845 the United States annexed Texas, as the first gobble of territorial gluttony, and two years later Mexico was half its original size.[20] With characteristic ambivalence, the war was unpopular for many Anglo Americans who saw little justification for annexing the dusty land, and just as little gain. The effort was driven by an expansive army and hawked by ideologues who meant to save Mexicans from their own benighted habits (perhaps with the same kind of confidence in universally valid law and language that motivates our current high court). Walt Whitman was one such hawk, to the horror of his friends. Remembering Whitman here is almost inevitable on both sides of the shifty border; he is the enduring voice of America's liberal embrace.[21] Benignly, we sometimes celebrate him for equating progress and democracy with America, but translated to Mexico the enthusiasm reads differently. In *Walt Whitman: Racista, imperialista, antimexicano* (1971), Mauricio González de la Garza collects some of the bard's

newspaper editorials to show the belligerence of that equation. In one, Whitman celebrates Taylor's victory in Monterrey as "another clinching proof of the indomitable energy of the Anlo-Saxon character," (*Brooklyn Eagle*, October 13, 1846).[22] Nevertheless, "Democratic Vistas" (1871) shows an apparently more accommodating Whitman, less worried about ethnic and linguistic differences, because American nationalism was "melting everything else with resistless heat, and solving all lesser and definite distinctions in vast, indefinite spiritual . . . power."

Gregorio Cortez (the man, the myth, and the movie) resists the heat. And his exemplary performance of polite intransigence hints at an entire range of balancing acts that I will allude to through books, and that should resonate elsewhere. His proud pose, the moviemakers seem to say, should prepare for meaningful communication with those who wield more power, by trapping presumptive interlocutors in their ignorance. Texts like *The Ballad of Gregorio Cortez* resist the privileged English-dominant public, intentionally. Cool before the Whitmanian warmth that would melt down difference, unyielding works strike confident postures and paint signposts alerting the travelers to impassable terrain. These are not the ethnically marked books that invite empathy and that can turn out to be translations or imitations of the real thing, as Henry Louis Gates Jr. shows in " 'Authenticity,' or the Lesson of Little Tree." His critique hovers around the always suspect claim of authenticity, since imitations are often indistinguishable from more presumptive fictions. Therefore Gates concludes that "No human culture is inaccessible to someone who makes the effort to understand, to learn, to inhabit another world."[23] But resistant texts don't seem to fret over the snare of transparent authenticity which can reveal visible inventions. They are determined to offer opacity, not to make it evaporate. Resistent texts thematize what is lost in translation. They raise questions of access or welcome to produce a kind of readerly "incompetence" that more reading will not overcome. I am not talking about the impossibility of exhausting always ambiguous art through interpretation. Ambiguity, unlike the resistance that interests me here, has been for some time a flattering theme for professional readers. It blunts interpretive efforts,

and thereby invites more labor, so that ambiguity allows us to offset frustrated mastery with a liberating license to continue endlessly.[24]

Years of privileged training, understandably, add up to a kind of entitlement to know a text. The more difficult, the better. Difficulty is a challenge, an opportunity to struggle and to win, to overcome resistance, uncover the codes, to get on top of the text and then to call it ours. We sit through the incomprehensible dialogue of *The Ballad* sure that we do, or will, understand enough to establish appropriat(iv)e empathy. Films and books want to be understood, don't they, even when they are coy and evasive? Evasiveness and ambiguity are, as we know, familiar interpretive flags that audiences erect on the works they leave behind. Feeling grand and guiltless, we proceed to the next conquest.

"I am only interested in what does not belong to me. Law of Man. Law of the Cannibal," is the gluttonous way Oswald de Andrade inflected this desire to conquer difference. Appropriation of the other is what our New World cultures feed on, according to the Brazilian modernist, as long as the other offers the spice of struggle. Cannibals reject bland meat easily consumed, in this digestion of Montaigne's essay.[25] Europe, apparently, was also constituted by ingesting its others. And Andrade's point is, after all, that cannibalism is what makes us all human.

The kind of incompetence I am advocating is obviously not what Alan Bloom laments as a failure of education, but rather a modest-making goal. It is the goal of respecting the distances and refusals that some texts have been broadcasting to our still deaf ears.[26] Here my language feels the lack of a transitive verb derived from "modesty." Its intransitivity may be no surprise for those of us who inhabit carefree, or careless, interpretive languages and who can easily name the contrary movement: to approach, explore, understand, empathize, legislate, assimilate, conquer.

Announcing limited access is the point, not whether or not some information is really withheld. Cortez, after all, withholds nothing. Resistance does not necessarily signal an authentic impasse; it is enough that the impasse is performed in this ethico-esthetic strategy to position the reader, the sheriff

and the judges, within limits.[27] The question, finally, is not what "insiders" can know as opposed to "outsiders"; it is how those positions are being constructed as incommensurate or conflictive. If Cortez did, in fact, know English, he refused to let on, or to let the sheriff in. And professional readers who may share some social space with Cortezlike performers or protagonists, enough to claim privileged understanding and explanatory powers, may hastily fill in the gaps their texts would demarcate.

I want to call attention to the habitually overlooked markings that would construct this kind of incompetence, because privileged audiences are unaccustomed to rebuffs, so unaccustomed and ill prepared that slights may go unattended.[28] As textual markers of inassimilable difference, these slights are critical for obvious political as well as aesthetic reasons. But signs of resistance that lack identifiable forms remain obscure and unexpected, as unremarked and invisible for privileged reading as ethnicity or gender can be. One partial remedy is to anticipate the calculated rebuff through a range of patterns and tropes for strategic (not paradoxical) invitations to exclusion.[29]

Sometimes the signs will be easy to read. But recognizing polite evasiveness or defensive distractions will take both practice and the sensitivity that comes along with expectation. Zora Neale Hurston gives this lesson to would-be collectors of Afro-American folklore, and very possibly to readers of Afro-American literature as well.

> They are most reluctant at times to reveal that which the soul lives by. And the Negro, in spite of his open-faced laughter, his seeming acquiescence, is particularly evasive. You see, we are a polite people and we do not say to our questioner, "Get out of here!" We smile and tell him or her something that satisfies the white person because, knowing so little about us, he doesn't know what he is missing. The Indian resists curiosity by a stony silence. The Negro offers a feather-bed resistance. That is, we let the probe enter, but it never comes out. It gets smothered under a lot of laughter and pleasantries.

She'll add that the theory behind the tactic is, "The white man is always trying to know somebody else's business. All right. I'll set something outside the door of my mind for him to play with and handle. . . . he will seize it and go

away. Then I'll say my say and sing my song."[30] But we might also notice the triumph of her seduction, as the phallic intrusion is lost in the warm folds that arrest it. Possessiveness leads to its own defeat in Hurston's invaginated maneuvers.

Her strategies may sound like so many textual defense mechanisms. And the label is hardly misplaced, as long as defense carries its military and strategic meanings. Hurston may be suggesting that the defense works *because* it's unperceived, loathe to provoke a dogged insistence. Yet Hurston herself calls attention to the tactic, saying, in effect, that whites can never know blacks except through mediations, such as her book.[31] Is self-defensiveness here simply self-advertising? Is it a friendly caution against useless prying? Or is it a characteristically polite hint that the "knowledge" used by whites against blacks is hopelessly naive? If she is indeed saying that we cannot know all the while that she is telling us how we might go about it, the only responsible reading would be to acknowledge the rhetorical maneuver that positions us as outsiders. The purpose of announcing an epistemological dead end, I imagine, is to stop short our presumption that knowledge and the power it implies are attainable.

Outsider, it will be objected, is not a fixed or impermeable category, as Mexicans knew from living on an unstable border. And Frederick Douglas knew it too, as he accounted for different understandings of slavery through unequal experience, not through essential differences between blacks and whites. Remembering Douglas in this context suggests that responsible incompetence and degrees of readerly underachievement may teach us to remark the resistent signs in other texts that knew how to distance "ideal" abolitionist readers. Writing often at the unrefusable request of white allies and supporters, slave narrators may logically have foregone uncooperative gestures. Yet many readers will recall how Harriet Jacobs interrupts her otherwise intimate confessions of *Incidents in the Life of a Slave Girl* (1861) to stop her white readers from presuming to judge her. You "whose purity has been sheltered from childhood, who have been free to choose the objects of your affection, whose homes are protected by law, do not judge the poor desolate slave girl too severely!"[32] And some readers may find it significant that Cuba's Juan Francisco

Manzano changed his mind about what to write for abolitionist Domingo del Monte. The slave had agreed to record his memoirs, but a second letter explained that candor about certain incidents would be impossible. Too painful to narrate, perhaps protected from the liberal's cheap empathy, the scenes are announced and then silenced.[33] Frederick Douglas's general point—about the locus of enunciation—would surely evoke more remembered refusals to identify with readers, if we learn to recognize a rhetoric of refusal.

To notice the unstable boundaries between the self who speaks and the other who listens is not to vitiate the opposition. It is merely to repeat what every military strategist knows: that the lines of battle change and the conflict continues. Subject positions, we know, are not fixed through time. But in the war of positions that reading so often is, historically specific stances matter, as we saw in Cortez's courteous Mexican mastery.[34] If we are used to assuming the virtues of overstepping the frontier between self and other, or to confusing deconstruction with assimilation, we may need to consider the differential effects of liberal and universalist principles when the other is magnanimously absorbed into the greater self. This condescendingly generous gesture in court, or in, for example, Todorov's *The Conquest of America*, has characteristically evoked very different responses. One is guilt-ridden sympathy (for victims of monolingual law, for Aztecs whose worldview and technology could not compete with the more realistic Spaniards). Another is outrage at the invidious comparisons that lament the tragedies by explaining their inevitability. Like Mexico's first Jesuit chroniclers and catechists, Todorov assumes that the catholic or universal Self already inhabits the particularist pagan other, and that history is a process of accommodations that need not be so violent.[35]

It may surprise some well-meaning witnesses to find that particularists are not always accommodating, that assimilation rhymes more with cultural annihilation than with progressive *Aufhebung*. The ecumenical gestures to reduce otherness to sameness, as Whitman embraced variety to stamp it with his own ideal image, suggest that difference is a superable problem rather than a source of pride or simply the way we are in the world.[36] Unyielding responses to the liberal embrace, the responses that I am tracking here, range from offering up a surrogate self whose absorption is no real loss, the

"featherbed resistance," to striking the pose of an intransigent, unaccommodat-
ing self from the place "competent" readers have associated with the other.
This "strategically essentialist"[37] pose (as on Cortez's porch) need not construct
a stable, "authentic" speaking subject whom readers, after all, could then
presume to know and to represent. The purpose of intransigence and refusal
is to cast doubt on our capacity to know, without allowing incapacity to float
into the comforting, unmanageable mists of ambiguity. It is to say that some
texts decline the intimately possessive knowledge that passes for love.

I remember Edward Said interrupting a question about the possibilities
for curing the blindness he denounced in *Orientalism.* "How should we achieve
a better understanding of the Arab world?" the sincere colleague was asking.
"How we can avoid the mistakes, get closer to the truth, and . . . ?" Said
interrupted to ask why Westerners suppose that the "Orient" wants to be
understood correctly. Why did we assume that our interest in the "Orient"
was reciprocated? Did we imagine that the desire was mutual, or that we were
irresistible? Could we consider, along with the dangerous spiral of knowledge
and power decried in his book, the possibility that our interest was not
returned? This doubt about our own desirability is one lesson to be learned
from the kind of textual resistance I am describing here.

Rigoberta Menchú has been teaching it to me. It was her 1983 testimonial
account of Guatemala's genocidal war on Indians that tipped me off about the
function of vociferous silences and publicly refused intimacy.[38] Menchú's
quincentennial experience with Spanish speaking conquerors of the indige-
nous Maya Quiché had warned her not to share secrets with ill-prepared, and
unreliable, readers who "cannot [and should not] know" them.[39] After a dozen
declarations of silence throughout her testimonial, her very last words are,
"Not even anthropologists, nor any intellectuals, no matter how many books
he may have read, can know all our secrets."[40] But the almost 400 foregoing
pages are full of information. About Rigoberta herself, her community, tradi-
tional practices, the armed struggle, strategic decisions.

Therefore, a reader may wonder what "cannot know [our secrets]" means,
and why so much attention is being called to our insufficiency as readers.
Does it mean that the knowledge is impossible or that it is forbidden? Is she

saying that we are *incapable* of knowing, or that we *ought* not to know? Her withholding, on my reading, is a calculated investment in diversification, much like the passages in Toni Morrison's *Beloved* where the story stops short, seems reluctant. Perhaps one woman's telling restraint can help to say something about another's.

Now, Rigoberta's audible silence is apparently a response to an anthropologist's questioning. If she were not being interrogated, there would be no reason to refuse answers. And of course, Morrison's display of reticence seems equally explicable by a familiar narrative logic that makes delayed information goad curiosity and build suspense. But this readerly reasoning doesn't really explain why Rigoberta's refusal to tell secrets remains on the page after the editing job is done, nor why Morrison bothers to perform an insistent refusal of her genre's demand for intimacy, all the while divulging more and more unkept secrets. Certain habits of reading may therefore overstep the trench that both performances dig between competency and satisfaction.

Some readers actually manage to embrace Rigoberta in an autobiographical reflex that presumes identification with the writer, despite her reluctance to be fully comprehended. (Some of Cortez's jailers offered him friendship as well.) The projections of presence and authenticity are hardly generous here. Instead, they allow for an unproblematized appropriation that disregards the text's insistence on the political value of keeping us at a distance. And I wonder whether Morrison's narrative evasions may give as little pause to readers who process suspended or guarded information as simply building intrigue. They miss Morrison's intriguing double bind: To tell Sethe's story and arouse sympathy for her is also to reveal so much pain that telling threatens to reinscribe the terror and humiliation she escaped. "Paul D. had only begun, what he was telling her was only the beginning when her fingers on his knee, soft and reassuring, stopped him. Just as well. Just as well. Saying more might push them both to a place they couldn't get back from."[41] (I am reminded also of a young German scholar who wondered out loud why we children of Jewish survivors prefer to elicit that "Just as well" from parents who stop telling war stories, as if it were difficult for him to intuit that the hunger for memory might be sated or even spoiled by unchildish recollections of a

displaced persons' camp, recurring parental nightmares, occassional unsolic-ited details.) Yet not to tell would leave Sethe, Paul D., and an entire society of survivors without the history that binds them, leave them unwritten like the displaced postwar blacks who were "Silent, except for social courtesies, when they met one another[;] they neither described nor asked about the sorrow that drove them from one place to another" (53). It is Denver's broken silence, after all, that makes her mother available for the sympathy that effects a collective absolution. Morrison is both bound to tell and to claim she is not telling. "It was not a story to pass on," repeats the double-binding epilogue about this story just passed on to us. Morrison's novel makes us worry too, about how much can or should be known, as if the testimony and the fiction were both media for producing this readerly circumspection.

How else are we to take Menchú's or Morrison's, protestations of silence as each continues to talk? Are there really many secrets that Rigoberta is not divulging, in which case her restraint would be "true" and real? Or is she performing a kind of rhetorical seduction that lets the fringe of a hidden text show in order to tease us into thinking that the fabric must be extraordinarily complicated and beautiful, even though there may not be much more than fringe to show? Conversely, is fictional seduction all we get in *Beloved*, or do disturbingly historical details tease us into wanting more? It may be useful to notice that the refusal is performative; it constructs metaleptically the desire to know.

This is to say that resistant texts are necessarily provocative too. They seem calculated to produce desire in order to restrain or to frustrate it. A challenge for Menchú, for Morrison, and for Olmos's Cortez is, logically, how to be interesting without promising the dividends of ownerwhip. It is to produce enough desire for refusal to be felt, because the objective here is to engage unfamiliar, perhaps unfriendly, publics, not to be ignored by them. Their stories will aggressively claim power, if only the power to exclude, to say no to master's (dividend bearing) interest. Before they can refuse attention, they have to elicit it. And they do so by a slight to our vanity. Smarting from the snub by the humble likes of a Guatemalan Indian, a border farmhand like Cortez, or the Mexican washwoman in Elena Poniatowska's testimonial

novel,[42] from the reserve of the black novelist and a Chicano conservative like Richard Rodriguez,[43] we may wonder what kind of superiority in the Other accounts for our interpretive demotion.

Their tactic is neither to chastise our egotism nor to implore our ethical self-effacement, as Emmanuel Levinas does.[44] They do not insist or plead for recognition by creating individual subjectivities associated with empowered men. A limitation or boomerang effect of these strategies is that they assume the primacy of the privileged reader, the one who can choose to be modest or who can learn to share his fully human status with others. Instead, the artists I want to privilege here assume that their own positionality is primary and that access to it is limited. That is why I have focused on culturally specific strategies of representation rather than on newsworthy facts, on *The Ballad of Gregorio Cortez*, a guarded Guatemalan testimony, an embittered if assimilationist autobiography, rather than on events themselves. The front page of the *New York Times* may be no place for such toying with the reader, but in the absence of playfully transgressive readings between articles, competent tidiness may miss the deadpan (or deadly) humor that blurs the borders between, say, truncated translations and riotous reprisals. To make the connections we may need to learn some irritating lessons offered by resistant texts, in telling asides about the reader's difference from the narrator, in the ignorance effect of abridged allusions and purposeful incomprehensibility. The translations these texts both demand and permit, between stop signs and warnings against trespassing, teach a faltering, self-doubting step in the direction of fairness, but too lame for conquest.

Notes

1. I am grateful to Prof. Bonnie Honig at Harvard for suggesting the connection between this decision and Cortez's case, and for leading me to the following information: The broad definition of habeas corpus followed a 1963 decision, Townsend v. Sain, written by Chief Justice Earl Warren. The substantial statistic represents cases heard from July 1976 to May 1991. See Linda Greenhouse, "High Court Votes to Further Limit the Appeals of State Inmates," *New York Times*, May 5, 1992, front page and B10, col. 2. See also the reference in 60 US Law Week 4339, 1992; and in American Law Reports 2d, 540 vol. 89, a publication by lawyers about constitutionally important cases.

2. Justice White, who wrote the recent decision, reasoned that "it is hardly a good use of scarce judicial resources to duplicate fact finding in Federal court merely because a petitioner has negligently failed to take advantage of opportunities in state-court proceedings." See Greenhouse, "High Court," B10, col. 4.

3. Consider, for example, *Hernández v. New York* [111 Supreme Court 1859 (1991)], where Judge Anthony Kennedy wrote the decision that exonerated the Court from charges of racism, raised because there were no Hispanics on the jury. The two possible Hispanic jurors had been disqualified because they would be hearing the testimony orally, while the others would refer to the transcripts.

4. Américo Paredes explains that the shooting took place in Karnes County, Texas. But since that transliterates into "Carnes," or "meats," the names soon adjusted to "El Carmen." See *"With His Pistol in His Hand": A Border Ballad and Its Hero* (Austin: University of Texas Press, 1958), 210.

5. Paredes, *"With His Pistol,"* 57; quoted from the San Antonio *Express,* June 25, 1901, 1.

6. Paredes, *"With His Pistol,"* 100–102. The respective papers are the Beeville *Picayune,* August 7, 1913, 1, and the Beeville *Bee,* August 15, 1913, 4.

7. Paredes, *"With His Pistol,"* 88.

8. Andrés Henestrosa, selección Prólogo y notas *Espuma y flor de corridos mexicanos* (Mexico City: Porrúa, 1977), 10 (2d. par. of intro.). "El corrido es el vehículo de que el pueblo se vale no sólo para expresarse: es también su órgano periodístico. Y esto de un modo natural, pues por ahí empiezan las literaturas todas por la épica. . . . Un corrido se hace de un día para otro, igual que una gacetilla de periódico, pues, como está dicho, tiene un fin informativo, es medio de propagar noticias."

9. Higinio Vázquez Santa Ana, ed., *Canciones, Cantares, y Corridos Mexicanos,* Prólogo de D. Luis González Obregón (Mexico City: Ediciones León Sánchez, n.d). Although no year is indicated, the corridos date the book after 1924, the year given in the "Corrido de Vargas Vila" (253). It was evidently published between then and 1926, when Harvard acquired the book. Paredes dates it in 1925.

Most of the corridos printed here, and patiently transcribed from oral performances, give precise dates.

10. Vázquez Santa Ana, *Canciones,* 240.

11. Thanks to Prof. John Womack for his leads on the historical literature of the area. See Robert Rosenbaum, *Mexicano Resistance in the South West* (Austin: University of Texas Press, 1981), 49, where he refers to a point by Américo Paredes, 125.

12. Vázquez Santa Ana, *Canciones,* 173 (my trans.); also quoted in Paredes, *"With His Pistol,"* 151.

13. Paredes's book transcribes several variants. And even James Nicolopulos's forthcom-

ing book on Texas-Mexican singer Lydia Mendoza includes three different renditions, not because she sang all three, but because " 'Gregorio Cortez' is one of the oldest, most durable, and certainly the most well-documented *corridos* of the Texas border region." Ms. p. 629, note 33.

The first version he offers was recorded by the Hermanas Mendoza, Lydia and Juanita, in 1967 (597–99); the next, by "Los Trovadores Regionales" (Pedro Rocha and Lupe Martínez), is from 1929 (599–604); and finally, Salomé Gutiérrez, composer, singer, and record producer, "felt compelled to write down his own version . . . [of the eight-year imprisonment] because he felt that the transcriptions and translations that he had seen in the pamphlet to Folkloric 9004 and Paredes's books did not tell the whole story or told it inaccurately." Ms. p. 605.

14. José Limón reports this in "The Return of the Mexican Ballad: Américo Paredes and His Anthropological Text as Persuasive Political Performance," SCCR Working Paper no. 16 (Stanford, Calif.: Stanford Center for Chicano Research, 1986), 29. See also José Limón, "Américo Paredes: A Man from the Border," *Revista Chicano-Riqueña* 8 (1980): 1–5.

15. Paredes, *"With His Pistol,"* 154.
 En el condado de Carnes
 miren lo que ha sucedido,
 murió el Cherife Mayor
 quedando Román herido. . . .

 Se anduvieron informando
 como media hora después,
 supieron que el malhechor
 era Gregorio Cortez.

16. That future essay, and this current one, are part of a book-length project on resistant texts and resisted readers.

17. Renato Rosaldo, "Politics, Patriarchs, and Laughter" in *The Nature and Context of Minority Discourse,* ed. Abdul R. Jan Mohamed and David Lloyd (New York: Oxford University Press, 1990), 124–45. I am grateful to Lora Romero for pointing out this essay.

18. See Stuart Hall, "Deconstructing the Popular," on the "double movement of containment and resistance that transpires on the battlefield of popular culture."

19. See for example, Jacques Derrida, "Signature, Event, Context," in *A Derrida Reader: Between the Blinds,* ed., Peggy Kamut, (N.Y.: Columbia University Press, 1991).

20. David J. Wever, *Myth and History of the Hispanic Southwest* (Albuquerque: University of New Mexico Press, 1988), 106, 141–48.

21. See Doris Sommer, "Supplying Demand: Walt Whitman as the Liberal Self," in

Reinventing the Americas, ed. Gari LaGuardia and Bell Chevigny (New York: Cambridge University Press, 1985). This article also appeared in *New Political Science* 15 (Summer 1986). See also Sommer, "Whitman: The Bard of Both Americas," *Approaches to Teaching Whitman's Leaves of Grass,* ed. Donald D. Kummings (New York: Modern Language Association, 1991).

22. Mauricio González de la Garza, *Walt Whitman: Racista, imperialista, anti-mexicano* (Mexico City: 1971).

23. Henry Louis Gates, Jr., " 'Authenticity,' or the Lesson of Little Tree," *New York Times Book Review,* 11 November, 1991, 1, 26–30; this cite from p. 30.

24. According to Gérard Genette, *Figures of Literary Discourse,* trans. Alan Sheridan (New York Columbia University Press, 1982), 10, Roman Jakobson is associated with the lapidary, and by now generally accepted, statements about ambiguity being inherent in poetry and in literature more generally. Specifically, for example, reader-response criticism begins from assuming the negotiable ambiguity of a text.

25. "Manifesto Antropofago" of 1928. I thank Heloisa Buarque de Hollanda for pointing this out. It has been translated by Leslie Bary as "Cannibalist Manifesto," in *Latin American Literary Review* 19, 38 July–Dec. 1991): 35–47.

26. In an apparently pioneering essay, Reed Way Dasenbrock argues that, "the meaningfulness of multicultural works is in large measure a function of their unintelligibility." Therefore, and paradoxically, intelligibility cannot be considered the sole criterion for understanding this literature. See his "Intelligibility and Meaningfulness in Multicultural Literature in English," *PMLA* 102, 1 (1987): 10–19; this cite from p. 14. Also quoted in Marta Sánchez, "Hispanic- and Anglo-American Discourse in Edward Rivera's *Family Installments,*" *American Literary History* 1, 4 (Winter 1989): 853–871, on p. 858.

27. Among other critics concerned with related issues, see Tobin Siebers, *The Ethics of Criticism* (Ithaca: Cornell University Press, 1988). In general, this is an almost shrill rejection of contemporary criticism, from New Criticism to poststructuralism, on the grounds that it assumes that decisions in reading literature are necessarily oppressive, totalitarian, and unethical.

28. The success of literary figures depends in part on a reader's awareness of them. Genette, *Figures,* 54. See also Peter J. Rabinowitz, *Before Reading: Narrative Conventions and the Politics of Interpretation* (Ithaca: Cornell University Press, 1987), 27, and Jonathan Culler, *The Pursuit of Signs* (Ithaca: Cornell University Press, 1981), 121.

29. Mikhail Bakhtin probably has some leads on this in his "discourse typologies"; see Bakhtin, *Speech Genres and Other Late Essays,* trans. Vern W. McGee (Austin: University of Texas Press, 1986). His discussion of "reaccentuation" is suggestive for theorizing this kind of constitutive resistance. A text (or author) is constituted by the process of reaccentuating other discourses, by the manipulation of speech genres. For example, a particular perspec-

tive, such as a liberal espousal of ethnic identification, can be a reaccentuation of a discourse working against itself. I owe these observations to George Yúdice.

30. Zora Neale Hurston, *Mules and Men* (1935; rpt. Westport, Conn.: Negro University Press, 1969), 18.

31. For Edward Said, in "Representing the Colonized: Anthropology's Interlocutors," *Critical Inquiry* 15, 2 (Winter 1989): 205–25, divulging the mechanisms tends to vitiate them. This is his criticism of James C. Scott's otherwise admirable *Weapons of the Weak: Everyday Forms of Peasant Resistance* (New Haven: Yale University Press, 1985). Said comments, "And although Scott presents a brilliant empirical as well as theoretical account of everyday resistances to hegemony, he too undercuts the very resistance he admires and respects by in a sense revealing the secrets of its strength" (220).

32. Linda Brent, *Incidents in the Life of a Slave Girl,* intro. and notes by Walter Teller (New York, Harcourt Brace, 1973), 54.

33. Quoted in Susan Willis, who is disappointed with the stops in her "Crushed Geraniums: Juan Francisco Manzano and the Language of Slavery," in *The Slave's Narrative,* Charles T. Davis and Henry Louis Gates, Jr. eds. (New York: Oxford University Press, 1985), 199–224; 208. Willis attributes them to narrative convention that is "artificial" in the "full, vivid detail" of his story (209).

34. I borrow the term loosely from Antonio Gramsci, for whom the war of position is a process of ideological disarticulation (of bourgeois hegemony) and rearticulation (of a workers' hegemonic bloc). It is the ideological struggle between the fundamental classes over elements that could serve either one, a struggle that precedes military confrontation. See his *Selections from the Prison Notebooks,* ed. and trans. by Quintin Hoare and Geoffrey Nowell Smith (New York: International Publishers, 1971), 238–39. See also Chantal Mouffe, "Hegemony and Ideology in Gramsci," in *Gramsci and Marxist Theory,* ed. Chantal Mouffe (London: Routledge and Kegan Paul, 1979), 168–204.

35. See, for example, Fernando Coronil, "Mastery by Signs, Signs of Mastery," Vol. 2, no 2, a review essay in *Plantation Society,* 2 (Dec. 1986): 201–207; and José Piedra, "The Game of Critical Arrival," *Diacritics* (Spring 1989): 34–61. Consider also Gayatri Spivak's general indictment of "the ferocious standardizing benevolence of most U.S. and Western European human-scientific radicalism ("recognition by assimilation"), "Can the Subaltern Speak?" in Cary Nelson and Lawrence Grossberg, *Marxism and the Interpretation of Culture* (Bloomington: University of Illinois Press, 1988), 294.

36. For the collusion between the apparently opposite projects of universalizing (saming) and subordination of the "other" (othering) see Naomi Schor, "This Essentialism Which Is Not One: Coming to Grips with Irigaray," *Differences* 1, 3 (Summer 1989): 38–58. Comparing Beauvoir's call for equality with men to Irigaray's celebration of female difference, Schor observes the limitations of both. "If othering involves attributing to the

objectified other a difference that serves to legitimate her oppression, saming denies the objectified other the right to her difference, submitting the other to the laws of phallic specularity. If othering assumes that the other is knowable, saming precludes any knowledge of the other in her otherness.

37. Gayatri Spivak's work is associated with this idea, although Robert Scholes suggests that John Locke came upon it some time ago. He apparently distinguished between real and nominal essences, the former being the Aristotelian irreducible and unchanging core of a thing, and the latter merely a linguistic convenience, a classificatory fiction. Scholes, "Reading Like a Man," *Men in Feminism*, ed. Alice Jardine and Paul Smith (New York: Methuen, 1987), 204–18; this cite from p. 208. See also Locke, *An Essay Concerning Human Understanding* (London: Elizabeth Hold for Thomas Bassett, 1690), especially passages 2.31, 3.3, 3.6, 3.10, 4.6, and 4.12.

For Spivak's formulation, see Spivak, "Subaltern Studies: Deconstructing Historiography," *In Other Words* (New York and London: Methuen, 1987), 197–221, where she doesn't dismiss the essentialism; it's "a *strategic* use of positivistic essentialism in a scrupulously visible political interest" (205). Allying themselves with the subaltern is an "interventionist strategy" (207). For a more cautious consideration, "within a personalist culture" where essentialism can be smuggled in again to serve the powerful, see her interview with Ellen Rooney in the special issue of *Differences* entitled *"The Essential Difference: Another Look at Essentialism"* (1, 2 [Summer 1989]: "In a Word. Interview," 124–56, 128–29. In the same issue, Diana Fuss, "Reading like a Feminist," 77–92, anticipates some of Spivak's concerns. One thing is for the subaltern to use essentialism, another is for the hegemonic group to use it. "The question of the permissibility [of essentialism] . . . is therefore framed and determined by the subject-positions from which one speaks" (86).

38. Rigoberta Menchú, *Me llamo Rigoberta Menchú, y así nació mi conciencia* (Havana: Casa de las Américas, 1983), 42. See also the translation by Ann Wright, *I, Rigoberta Menchú: An Indian Woman in Guatemala* (London: Verso, 1984), 20: "We Indians have always hidden our identity and kept our secrets to ourselves."

39. See Doris Sommer, "No Secrets: Rigoberta's Guarded Truth," *Women's Studies*, Tulsa, and Sommer, "Rigoberta's Secrets," *Latin American Perspectives*.

40. Menchú, *Me llamo* . . . , 377; *I, Rigoberta* . . . : "Nevertheless, I'm still keeping my Indian identity a secret. I'm still keeping secret what I think no-one should know. Not even anthropologists or intellectuals, no matter how many books they have, can find out all our secrets" (247).

41. Toni Morrison, *Beloved* (New York: New American Library, 1988), 72.

42. Elena Poniatowska, *Hasta no verte Jesus mio* (Mexico City: Era, 1968).

43. I am referring to Richard Rodriguez, *Hunger of Memory* (New York: Bantam Books, 1982).

44. For a powerful and balanced approach to enlisting Levinas for literary criticism, see Adam Zachary Newton, *Narrative Ethics: The Intersubjective Claim of Fiction* (Ph.D. diss., Harvard, 1992). It holds out promising readings against, for example, Derrida's critique of Levinas for not acknowledging a war of positionality between subject and other in "Violence and Metaphysics: An Essay on the Thought of Emmanuel Levinas," in *Writing and Difference*, trans. Alan Bass (Chicago: University of Chicago Press, 1978), 113.

7

Power Shortages: The Soviet Coup and Hurricane Bob

Svetlana Boym

In the summer of 1989 I went back to Leningrad, my native city, nine years after my emigration. My friends asked me what I thought was a trivial question: "How long are you staying?"

> "Two weeks," I said.
> "I'm afraid you'll only be able to stay one week."
> "Why?" I asked.
> "Next week we're expecting the end of the world."

I knew I was in Russia, the country where nobody observes conventions of small talk, where every banal daily incident is seen as a sign of Russia's messianic apocalypse and the discussion of apocalypse has itself become banal.

In July 1991, when I visited the Soviet Union again, the apocalyptic mood seem to be passé, yet only ten days after my departure the much awaited disaster, that had become so proverbial no one believed in it any longer, finally happened. On the morning of August 19 I watched CNN in Boston where news of Hurricane Bob—one of the most swift-moving and unpredictable hurricanes in New England history—alternated with the images of tanks on the Red Square. Commonplaces of fin-de-siècle apocalyptic imagination proliferated in the headlines of the papers: "the end of the era," "catastrophe," "fear for the future." As Mikhail Gorbachev was reported "ousted out of power" by his own men and Boris Yeltsin was climbing the tank, Hurricane Bob blew by and "left millions of New Englanders without power."[1] As Soviet tanks were reported "storming television and radio stations" and blocking harbors,

the New England vacationers caught suntanning in their bathing suits "were riding out the storm." In fact, *vacation interruptus* seemed to be the major traumatic trope of the season; Bush and Gorbachev, New Englanders and Russians, were forced to take a break from their vacations. "Emergency measures" were taken in both countries. Stores ran out of candles.

As the tanks on Moscow's Manezh Square chewed up the new pavement that was laid especially for Bush's visit a month earlier, I, too, experienced a "shortage of power." This time I knew I was in the United States where disasters are supposed to be "natural." In American media lingo the cliché expression "power shortage" has no political, social, or metaphysical connotation. It refers merely to practical inconveniences: for instance, one can no longer watch TV.

The two "states of emergency," two disasters—natural in the United States and political in the Soviet Union—were competing for television time as long as the television was working. But the natural and political clichés started to cross the borders as rapidly as the new means of communication. In Brighton, where many Soviet émigrés live, customers began to stock up on groceries "due to the expected shortages" and no one could tell whether it was due to power shortages or to shortages in the Soviet Union. Meanwhile, in the barricaded Moscow the only program not disconnected was the ubiquitous CNN that was transmitted to Russia via satellite as a part of the peaceful gesture of the "end of the cold war." And CNN, which for Russians was the only source of information about Russian events, masterfully intercut the images of Yeltsin on top of a tank with the threatening announcement of Hurricane Bob and advice on emergency measures. The rumor spread on the barricades that a horrendous destructive hurricane was raging from Florida to Siberia and would soon reach its peak. In the breaks of transmission the optimistic and comforting message of CNN commercials about "home, kids, and fun" was lost and Hurricane Bob turned into an ominous apocalyptic hero approaching Moscow, ready for ultimate destruction. Thus Vice President Yanaev was only a banal fictitious devil who could not "possess" the country, but the true hero was Bob, the pale horseman of the apocalypse with an American first name.

Natural and political disasters make more visible disasters in interpretation. It appears that the uncomfortable Russian-American post–Cold War romance reproduces many cultural mistranslations of the Cold War and reveals the traps of cross-cultural spectatorship. Fast-moving fin-de siècle disasters invite us to question the relationship between spectacle and event, media and catastrophe, catastrophe and the everyday. After watching the coup through Soviet and American media we will try to figure out what kind of event happened on August 19–21, 1991, and what access to we have to it—by way of diverse framing devices, commercial interruptions, and theoretical digressions. How does a disaster become a spectacle? How is it inscribed into the everyday framework, naturalized or politicized by the media and spectators? And on the other hand, how does it defamiliarize the common-places of everyday life? Comforting and disturbing effects of the media will be explored here, as well as the tensions between defamiliarization and familiar-ization, disruptive theatricality and self-perpetuating simulation. We will look at the coup from different points of view: first, as spectators on the Soviet and American sides, then as a cultural critic in exile, and, at the end, from the point of view of the participants of the events, particularly some (then) Soviet "postmodern" artists and critics (in their own self-definition) who helped to build barricades on August 20, 1991. What is the role of spectators and critics? Can a spectator be "dissident," or, to rephrase a common critical expression, can a "dissident" be a mere spectator? If so, how does the understanding of both dissidence and postmodernism depend on the cultural context? What is the relationship between the two words—"dissident" and "spectator"? Is it an oxymoron, since one hardly becomes a dissident by being a spectator and once a dissident, one can no longer continue to be a spectator? Is it an irony of the postmodern condition? Or is it an embarrassment of our cultural situation? Finally, we will approach the impossible question of what happened on August 19–21 in the Soviet Union, whether history indeed turned into a simulacrum or whether it was revealed that a certain kind of postmodernist irony could be compatible with political action.

Interestingly, Russians and Americans appear to compete for the title of pioneer in two seemingly unrelated fields—apocalypse and postmodernism.[2]

Jean Baudrillard sees America as an exemplary "land of simulacra" where there are no longer images and referents, events and information, but only chains of perpetual, "banal" simulation.[3] The new Russian theorists came to a patriotic reinterpretation of Baudrillardian "evil demons of images" (Baudrillard being one of the most well-known and oft-quoted "Western" postmodern theorists in Russia) and declared that Russians—not Americans—were the first to live through the era of simulacra. In this view, the Socialist Realist culture had nearly nothing to do with external "reality" and was a kind of postmodernism *avant la lettre* that came literally after the official destruction of Russian modernism, but inheriting some of its utopian claims.[4] The condition of simulation makes it particularly difficult to think about historical change, crisis, and disaster. In the view of Baudrillard, in the age of media culture, the "disruptive event" can no longer happen. "The war would not take place," wrote Baudrillard in his essay in *Libération* a week before the Gulf War.[5] According to Baudrillard, in an era of TV domination we live always already *après le coup*, and always already "after the orgy"—in the age of global indifference, with a permanent power shortage.

It turns out that the conceptions of disaster and catastrophe, as well as the separation between natural and political, is different in the two cultures. While at the time of the coup some of my Soviet friends—journalists—were laughing at the American preoccupation with health and their fear of natural disasters, the American press was somewhat ironic about the Soviet mania for "political" catastrophes. In fact, on August 17 the *New York Times* characterized the warning issued by Alexander Yakovlev, one of Gorbach ev's old friends and a founder of the policy of *glasnost'*, about the impending military coup as a "melodramatic flourish." Unfortunately what appeared as melodrama to the *New York Times* journalist and typically Russian apocalyptic prediction came to be the actual historical dénouement. Melodrama and black comedy, or sometimes black tragicomedy, appear to be the dominant genres of Soviet history. To give a third-party perspective on the political forecast on August 19, 1991, we can consider Radio Beijing, which did not offer much information about the events of the coup in the Soviet Union, but instead gave a detailed

report of the "major storms in the United States" depicted as contributing to the country's economic crisis.

One is tempted to see in the mere temporal coincidence of the two events, the political crisis in Russia and the natural disaster in the Northeastern United States, a kind of cruel poetic justice, since the two events help to illustrate some crucial cultural differences. In Russian cultural mythology, as was observed both by philosophers of "the Russian idea" and Soviet semioticians of culture, where certain syncretic, quasi-religious, holistic structures predominate, there is a great disbelief in "natural disasters" or mere "accidents," which are seen rather as a part of a larger Russian or Soviet historical predicament; hence there is a greater tendency to politicize a given event or to regard it metaphysically. In American cultural mythology there is a tendency toward "naturalization" of all resident and nonresident "aliens" and alien elements— to use a metaphor from the bureaucratic speak of the US Immigration Office— and hence to depoliticize. Andrew Ross speaks about American "weatherification of the everyday."[6] Of course this "naturalization," especially the way it is exercised by the media, is not the same as the confrontation with nature as other, as something beyond individual mastery and at the limits of human understanding. Rather, there is a strategy to domesticate, to tame, to make familiar and unthreatening nature, culture, and politics by employing the same conventional rhythm of televisual editing. (In fact, the word "politics" has a negative connotation in media reporting, as was demonstrated during the Clarence Thomas hearings when the accusation of "political motivation" was supposed to obfuscate rather than reveal the truth of judgments.)

The word "disaster," of Greek origins, refers to the "evil influence of the celestial body," while the word "catastrophe," which in modern American English is seen as a disaster with a "sense of tragic outcome with irreparable loss," actually originates in the Greek theater.[7] Catastrophe, from *cata*, over, and *strephein*, to turn, an overturning, refered to the dénouement in a classical Greek tragedy. As Mary Ann Doane remarks, "catastrophe is on the cusp of the dramatic and the referential, and this is indeed, part of its fascination."[8] The theatrical origins of "catastrophe" are replayed in every representation of

a natural or political disaster. Catastrophe disrupts the everyday flow of existence, introduces radical discontinuity into a seemingly continuous system, discontinuity that cannot be explained by existing conventions. Catastrophe can effect a radical paradigm shift; those who have experienced it could claim a privileged access to the elusive and ephemeral "real" of the human existence. Yet the actual experience of catastrophe is superceded by the memory of catastrophe, its everyday effects and traces; the radical character of the catastrophic is quickly assimilated for the sake of the survival of both the human species and the media. Mary Ann Doane points at the striking paradox associated with the attempt to conceptualize televisual catastrophe: "for while catastrophe is designated as discontinuity within an otherwise continuous system, television is most frequently theorized as a system of discontinuities, emphasizing heterogeneity."[9] This will be true not for television in general, but more specifically for American commercial television, which feeds on disasters, catastrophes, and crises. Disaster sells, but only a carefully prefabricated and packaged disaster, wrapped in TV conventions. For a foreigner, the "discontinuity" and "heterogeneity" of American commercial television often appears homogeneous, even continuous, if only in its rhythm, pace of editing, and the attention span demanded from the viewer. If American television thrives on disasters and domesticates them, Soviet television before *glasnost'* simply erased them. Soviet television used to be a virtually disaster-free environment: "discontinuities" were relegated to the past and to the lands of the capitalist evil, while Soviet viewers, instead of commercial interruptions, enjoyed "nature breaks" that showed gentle Russian waterfalls with Piotr Tchaikovsky's patriotic music in the background. Most of the serials of pre*glasnost'* Soviet TV— with seemingly apolitical titles like "*Siberiade*," "By the Lake," or "Seventeen Moments of Spring"—were either political histories of the Soviet families or spy stories. The events of August 1991 revealed many paradoxes and unconventional disruptions in both the Soviet media and everyday life, as well as some conventions of discontinuity in the American reporting of the crisis. Instead of going further into patriotic and antipatriotic debates as to who pioneered postmodern and apocalyptic vision, we will turn—to the extent it is possible—to the actual disasters.

This is how my Soviet friends report their reaction to the Soviet television broadcasts of August 19. One of my friends was awakened by her mother who told her that tanks were coming to Moscow. She thought at first that it was a bad joke, a banal example of Soviet paranoia. She turned on the TV. All channels were transmitting Tchaikovsky's ballet *Swan Lake*. It was then that she realized that something terrible had occurred. (Similarly, during the massacre in Timisoara the Romanian TV transmitted folk dances.) *Swan Lake*, a dull spectacle of classical goodness, deemed safe and the least upsetting both for the Soviet people and for the members of the Emergency Committee, signaled the return of the old commonplaces of stagnation silently naturalized and internalized by the people. Here one has to understand the classical Russian ballet performance of *Swan Lake* not as an autonomous work of art, but as a Soviet media spectacle. *Swan Lake*, a story of the victory of good over evil conveniently personified by white and black swans, is an icon of Russian and Soviet traditionalism. It preserves the tsarist luxury and nostalgia for classical art, old-fashioned virtuosity, and order. It was one of Stalin's favorite ballets; in Brezhnev's time it assumed the high style of developed socialism and became the most desirable Soviet commodity for the West, a kind of official package of nostalgic Russian exotica. Recently *Swan Lake* has been performed in Boston in order to raise funds for post-Soviet Russia. Interestingly, in Susan Sontag's view, the love for *Swan Lake* defines one as belonging to the elite aesthetic "camp" with epicene sensibility and affection for "bad taste" and all things outmoded.[10] Perhaps the word camp is as untranslatable from American into Russian as *Swan Lake* is from Russian into American. In any case, in Soviet Russia very few people would choose to be voluntarily "in the camp." The mark of self-imposed aesthetic exclusionism turns into its opposite—a memory of enforced political isolation—when it crosses the American-Russian border. Though some elements of refined aestheticism can be found in late Soviet and post-Soviet Russian art, the new generation of Russian aesthetes might prefer *Terminator 2* to *Swan Lake*.

Thus the way the Russian audiences understood that the disaster had happened, before they went outside or were able to get CNN, was not through what was reported on TV but through what was not reported. Moreover, it

was not the actual programs that mattered but their tone and style, belonging to a different epoch. The great Russian ballet that supplanted the variety of *glasnost'* programs, as well as the familiar restrained tone of the TV announcers, with measured intervals of official gloom and official optimism, made people experience again the time of Brezhnev's stagnation and the old practices of reading official texts. On August 19 when the Emergency Committee took over some of the TV channels, people had to use their old skills to read the media again between the censored lines, paying more attention to the tone and style and to minor iconographic deviations of the clichés than to the actual contents of the message. This was called reading in the Aesopian language—in the name of the ancient fabulist who taught people to read not for the plot but for the subtle allegories between the lines. In the early stages of *glasnost'* when freedom of the press was first realized, people were oversaturated with direct information "without a subtext." Many poets and artists, ironically, complained about the abolition of censorship, claiming that the old Soviet ways of reading between the lines made people appreciate good metaphors and helped to make poets the unofficial leaders of human hearts in Russia. At the time of the coup, however, the need for reading between the lines and between the elegant classical leaps of the little swan's skirts provoked a trauma of recognition.

The style of the coup was not that of the Stalinist or old KGB brutality; rather it was a mild Brezhnevite compromise with an old Soviet-style pretense at legality. The Emergency Committee hoped to appeal to people's inertia, to the miraculous power of the meaningless simulacrum discourse of the Brezhnev times with a few buzz words and promises of better food service and a war on crime, secured by the presence of the tanks. (The era of stagnation was an era of gentle enforcement of the Soviet commonplaces without revolutionary enthusiasm but also without direct Stalinist oppression, an era of indirection and stagnation, without zeal yet also without the hope that was characteristic for the thaw generation. Generalissimus Brezhnev appeared immortal, the commonplaces of Soviet order immutable, and people's powerlessness was taken for granted. It was at this time that the term "dissident" is used in the Soviet context. Dissi-

dents are not those who read between the lines—this was a common exercise out of necessity—but rather who dissented from using the riddles of the Aesopian language, went for an open confrontation with authority, and paid for that in camps and prisons, with their deaths and exiles.[11] "Dissident," from the Soviet point of view, is a term from the time of the Cold War, a term belonging to the previous era. In what can be called "postmodern" Soviet cinema and literature the term "dissident" and the appeal to dissident courage, appears as a cliché of the somewhat self-righteous and moralizing discourse of the early years of *glasnost*). Of course, once the Emergency Committee usurped media power, the commonplaces of the Brezhnev time uncannily returned; the dissident discourse also made a powerful comeback and had a direct impact on the people's behavior on the barricades.

The attempted coup revealed that the style of high Brezhnevism no longer framed Soviet politics, and that the postwar Soviet cultural myths of "people" and power, cemented by mutually compromising favors and fears, had become denaturalized for the past five years. The speech of the Emergency Committee itself was full of old-fashioned clichés: it was addressed to "the Soviet people" as if such a concept continued to exist in the singular. In speech the Soviet clichés were used together with the apocalyptic rhetoric of the Russian nationalist Right: a mythical enemy was disrupting law and order and making the country "unrulable," bringing it to the edge of complete chaos. The apocalyptic rhetoric of the Emergency Committee, however, was deprived of emotional strife—which characterizes the apocalyptic rhetoric of the neo-Slavophile nationalism that often takes the form of prophetic religious preaching. Bleak, uninspired language, lack of humor, and lack of energy made the manifesto of the Emergency Committee into a sort of parody on Soviet discourse and its decadence. The anchorman on Soviet TV who read the speech of the Emergency Committee kept stumbling over the clichés, mixing them up and revealing quasi-Freudian slips into cultural unconsciousness: instead of "continuing" (*prodolzhenie*) the reforms they announce their "overcoming" (*preodolenie*); instead of warning about the danger of "bloodshed" (*krovoprolitie*) they warned about the danger of "bloodpolitics" (*krovopolitika*).

In the alternative Russian press, officially forbidden by the Emergency Committee, subversive language games and self-conscious ironic play with clichés began the next day, aiming at necessary comic relief and distance from the new power.[12] The newspaper *Smena* (literally, "change" or "shift") started the humorous competition to come up with the best deciphering of the abbreviation for the State Emergency Committee (GKChP in Russian) and since the response was overwhelming the newspaper jokingly concluded "our apologies to those who couldn't reach us in time; we have to wait for another coup and then we will announce a new competition."[13] Gorbachev was reported to have used obscene language when he found out about the invitation to support the activities of the Emergency Committee: "what shitheads you all are" ("*nu i mudaki zhe vy vse*"). Whether Gorbachev actually said it or whether this is merely popular apocrypha, the very violation of "good taste" and hierarchies of style appeared authentic and signifying. This was a mark of his resistance to the old Brezhnevite clichés and the assertion of the eclectic discourse of *glasnost'*.

Now if we turn to the American media, at CNN it was business as usual. On the one hand, a few courageous reporters were at the Moscow barricades, bringing images back to the Russians, and as some participants testify, ensuring them that communication with the outside world was not broken, that the world was watching. On the other hand, for the foreign viewers the events were conveniently framed by a bright new logo—"crisis in the Soviet Union"—and on the bottom of the image, simultaneous with the documentary footage, went information about stocks, which was the way the Soviet crisis was made relevant to some Americans. If in the 1960s on American television news headlines interrupted commercial broadcasting, here the stock market information "translated" Soviet political upheavals into their own ciphers. Meanwhile, comforting commercial interruptions brought the American viewer back to the "natural" American everyday. Images of Russian soldiers on tanks alternated with images of American body builders and "Soloflex" exercise machines, which help to eroticize strong men and their paramilitary machines, to make them more "healthy and natural." Among the other most frequent commercials were those touting heartburn relief and health food ads for "eggs

without a flaw," followed by happy multiracial pictures of the American family. So spectators were receiving a nonlinear multiple narrative: between the lines of tanks, as between the lines of a text, the commercials were offering us another, more "natural" drama with a happy ending, a *bildungsroman* of personal improvement where even eggs could be without a flaw, to say nothing about bodies, and where the burn in the heart can be relieved with a smile and a spoonful of Mylanta. The programming was indeed discontinuous and "heterogeneous," but this kind of TV discontinuity only helped to cover up the potential catastrophe. At the end it was "all in the family."[14] It might have been the pace of American television, the rhythm of cutting and alternating the subject matter, that in this case did not allow for the transmittal of the Soviet TV experience to American audiences. The Soviet anchorman's speech was interpreted at "face value," in the American TV way, paying attention to what was said rather than *how* it was said; hence all the suggestive slips remained overlooked.[15]

It appears, however, that not only the conception of the disaster, but even the conception of banality as well as of postmodernism and the role of the commericals is culturally specific, and it is up to us to make an effort to see or to be blind to those differences. The use of commercials during the coup reveals some old and new clichés of American-Soviet relationships. Independent Soviet entrepreneurs, under the pretext of a new advertisement for Stolichnaya Vodka, smuggled to the West on the day of the coup the photograph of the crowds protesting the coup on Palace Square with the caption "Stolichnaya Vodka: Proud to be Russian." This in many ways paradoxical incident uncovers old underground political tactics in the commercial framing, demonstrating that Soviet and post-Soviet "commercialism" has to be first understood in the Soviet ideological context, and only later in the context of a global economy. During the 1992 May Day celebration the first commercial was placed on Red Square: "Visit the Canary Islands!" This commerical is certainly completely surreal on Red Square: its addressee is unknown, since hardly anybody can afford going to the Canary Islands and those who can, do not need advertisements. It functions as a fairy-tale statement in just the same way as a political slogan had that was hung there before: "Long live the

unbreakable friendship of all the people of the Soviet Union!" We know what happened to that unbreakable friendship and to the Soviet Union itself. The post-Soviet advertisement, which almost never promotes any product that could be purchased by an average consumer, has nothing to do with the actual situation of communication geared toward the sale that can be found in most American advertisements. Post-Soviet advertisements, like former political slogans, are read between the lines—or not read at all but only glimpsed as elements of the new urban ornament. Those who protested the appearance of the advertisement for the Canary Islands came to Red Square carrying portraits of Lenin and Stalin, with the slogans "down with Judeo-Masonic conspiracy!" and huge banners on which the Nazi swastika was equated to the Star of David and the sign for the American dollar. As in a Russian proverb where one chooses not between good and evil but between two evils—I am afraid I would have to go for the Canary Islands.

After much theoretical suspense and imaginary traveling, we are finally approaching the impossible question: what actually happened on August 19–20, 1991 in Russia while the population of New England was smitten by Hurricane Bob? What are the limits to the spectacular and speculative character of the disaster? I will make a last naive attempt at approaching this rhetorical question empirically by asking another question: What did Soviet postmodernist theorists do on the day of the coup? Did they remain Western-style "dissident spectators" and critics of the media, or did they become scared, embarrassed, and yet enthusiastic participants on the historical scene?

The journal *Seance*, several months after the coup, posed a question to a group of young art historians about their behavior during the coup. To the surprise of their no less postmodern interviewer, they "did not go to the miraculously open international airport and leave the country like good yuppies but instead went out to the streets."[15] "What the hell did you go to the barricades for?" was the next question. Here is the answer of Viktor Misiano, a curator of contemporary avant-garde art and a postmodern critic:

> The experience was "pure art," and a gigantic performance. The most striking metaphor of the events was the barricade near the subway called "Barricade

Station." Our barricade was built on top of the barricades of the monument to the revolution of 1905. It was built in such a way that it did not defend anything. But from the semantic point of view there was a great contradiction in cultural symbols, since the new revolution was defended in the name of ideals opposite to those of the old revolution. This was a typical post-modern revolution. By the way, during the coup I was writing the article "Art and Politics" so I was interested in the events from a professional point of view. And I was not alone there on the streets. Everyone was there. It is not a secret that had the coup succeeded both the racketeers and the avant-garde artists would be the victims.[16]

It appears as if the building of the barricades was only another kind of Moscow party. Yet when I pressed Viktor during our meeting to speak beyond his professional interest in art and politics, he confessed that there were two moments of "authenticity." The first was when he saw Gorbachev on TV reading the text given to him by his captors and the former Soviet leader looked aged and scared; his intonation—again his intonation, and not his message—betrayed fear visible even on television. And the second moment of authenticity was when the people on the symbolic barricades heard the shots and started to run—only to realize that they were running precisely in the direction of the tanks and that they were in fact surrounded. Perhaps irony and fear, aesthetic self-reflexivity and disruptive experiences, can go hand in hand. There is often no time to choose between them.

The artist Konstantin Zvezdochetov, who in fact was arrested by the KGB and called to serve in the Soviet army only some five or six years ago, confessed that he was "a sentimental kind of guy" and that he "dreamed of that experience all [his] life."[17] The experience in his view was not just a carnival but a combination of "carnival and corrida." One of the most amazing ironies of the coup's aesthetics was the fact that the Russian flag that flew over the White House in Moscow during the events of the coup—the tricolor, as opposed to the one-color-of-blood Soviet flag—was actually made by Konstantin Zvezdochetov and Andrei Filippov for their new artistic installation. Zvezdochetov took the flag with him when he went to the barricades to the Russian White House on August

19 to protect him from the wind and was happy to donate it for a good cause. This pragmatic political use of the aesthetic object, that in itself mimes the political symbol, goes against the grain of both contemporary American conceptions of pop art and the new conservative censorship supposedly aimed at preventing the "defamation of the American flag." It would be hard to imagine Jasper Johns's American flag flying over the White House in Washington.

The experience of the coup had some aesthetic *trompe-l'oeil* effects. In fact, the day before the events, Soviet TV transmitted an adaptation of *Nonreturner*, Alexander Kabakov's apocalyptic science-fiction novel that predicts a victorious military coup in the mid-1990s. But occasionally life only pretends to imitate art and in fact cheats on it. The apocalypses that would certainly have made for a stunning aesthetic dénouement did not take place and the coup did not succeed. Even the most ironic intellectuals happened to lose their distance as well as the internalized conscience of a perpetual simulation that it is not in their power to affect. Many people told me that it was a kind of cathartic experience, a celebration of loss of fear, a redemption of the years of silence and anger. The others reported that it was a kind of carnival, with lots of food delivered for free by the new cooperative restaurants, with music and tanks—and nobody was completely sure which side those tanks were on at any particular moment.

So did the coup really take place? Ironically, in the Russian context this Baudrillardian question would only have been possible had the coup succeeded. In fact, this belief in a perpetual ideological simulacrum, the chain of self-reflective words internalized by the people, was what the coup organizers hoped for. In other words, had the coup succeeded one could have said that it had never happened, that it was merely a restoration of order and not a disruptive event. But at that moment banality was not fatal; the everyday behavior of people changed, as well as the new clichés of responses to power. In the moment of extremity, the cathartic theatricality of the events effected a crucial "power shortage" in the internalized structure of the vicious circle of simulations. The disruptive event disrupts narcissistic theorizing and certain kinds of self-generating intellectual paradoxes.

And what can be better than disasters with a happy ending! Hurricane Bob

was a modern hurricane that was swift, surprising, and somewhat unpredictable: it anticipated the media itself and thus angered it. The Soviet coup was also a modern coup—the quickest of the failed Russian revolutions. The fictional messianic apocalypse turned into a petty, badly organized and unspectacular melodrama that failed not only in its military tactics and strategies but also in its style. It was at the moment of the coup that people realized—paraphrasing Marx—that they had nothing to lose, except their chains of simulacra.

But everyday life after the coup happened to be much less spectacular than the coup itself. The Russian satirist Mishin compared Russia to the celebrated folkloric hero Ivan the Fool who does nothing but lie on the warm furnace bed and sleep. He wakes up and immediately commits heroic feats but does not know what to do after or between them. It is that *byt*—the Russian daily grind (the word that, according to Roman Jakobson, could not be culturally translated into any European language)[18]—that people do not know how to survive. Some ironic Russian journalists have suggested that the abolition of the Soviet Union was a theatrical necessity: people who participated in building the barricades began to be bored and disenchanted with their daily grind, and the new exciting risky event was uplifting for their imagination. So in the Russian case, perhaps, the problem is not that people live "always already after the coup," or "after the orgy," but that they live always in anticipation of it, almost wishing some kind of public orgy to happen so as not to confront their unspectacular *dailiness*. "The fortresses of byt" described by Vladimir Mayakovsky and Roman Jakobson seem harder to overcome than the revolutionary or antirevolutionary barricades.

Meanwhile in the United States, the end of the Cold War was exploited in the commercials almost as much as the Cold War itself. Nobody wished to take the blame for starting the Cold War, but many wish to take the credit for its ending, while the Russian-American cross-cultural illiteracy and blindness continues. The United States for Russia and Russia for the United States constituted a necessary cultural other, the mythical limit or a peculiar "end of the world" that could be alternatively imagined as hell or paradise, the land of permanent disaster or the land of the ideal. Like many long-term relationships, this one presents a peculiar double bind of love and hatred. In the early

1960s, Nikita Khrushchev called the United States an "imperialist evil"—words that, twenty years later, would be plagiarized by Ronald Reagan, who named the Soviet Union "the evil empire." Russian *Amerika*—which in Russian, like in Kafka, is spelled with a "k"—has its own fantastic geography from ultimate modern hell to capitalist paradise. In Dosteovsky's *Crime and Punishment*, "going to America" is a euphemistic expression for committing suicide, while for some Left revolutionary artists, America signified a new way of life in which Leninism and Fordism went together. (Some even opted for "Americanization" of personality for the new Soviet men and women.) One could only hope that the new wave of unreflected "Americanization" would not end up being a particularly Russian Kafkaesque experience. "Amerika" in Russian and Soviet cultural history has more to do with Russia itself and its imagination of cultural otherness than with acutal understanding or knowledge of the United States. The same will be true for the United States. Russia, for many Americans, is also an imaginary country that ranges from Dostoevskyland (a sort of Russian Disneyland), dreamed between the lines of a half-finished novel, to the Gorky Park on the borders of cartoonville inhabited by Boris, Natasha, Ninochka, or some other Russian woman-spy looking like Greta Garbo or Michele Pfeiffer. Others wish to go "back to the USSR" of the Beatles where "Georgia girls" and "Ukraine girls" still walked together "leaving the West behind," to go back to that romantic country of never-realized revolutionary dreams. Natural and political disasters reveal the powers of global media and call for cross-cultural mediation. One can only hope these disasters will help to disrupt the cultural claustrophobia, the self- absorption, and the deluded belief in the uniqueness of one's own historical mission that for different reasons has characterized both Russia and the United States. Otherwise, the romance between the two cultures will never outgrow the infantile stage of misunderstood codependency.

Notes

1. *Boston Globe*, Aug. 20, 1991.
2. H. M. Abrams claims that "the nation possessed of the most thoroughly and enduringly millenial ideology is . . . America." ("Apocalypse: Theme and Variations," in

Abrams, *Apocalypse in English Renaissance Thought and Literature*, ed. C. A. Patrides and Joseph Witreich (Ithaca: Cornell University Press, 1984), 342–68.) At the same time many Russian philosopher-Slavophiles, from Khomiakov to Berdiaev, insisted that Russia was the only nation that truly comprehended the Book of Revelation and was ready to fulfill its messianic mission to save the West.

3. Jean Baudrillard, *America*, trans. Chris Turner (London: Verso, 1988).

4. A good example of this approach is Mikhail Epstein's paper, presented at the MLA conference in San Francisco, December 1991, which regards the era of Brezhnev's stagnation was the final "decadent stage of Soviet empire-style postmodernism. This approach, although it takes Baudrillard's theory out of context and treats it somewhat uncritically, gives us a revealing insight into cross-cultural translations of the apocalyptic tradition. Perhaps it is not by chance that, among new Russian theorists, Jean Baudrillard appears to be one of the main "loudspeakers" of postmodernism. The Baudrillardian authoritarian theoretical voice and totalizing apocalyptic vision, exemplified in the very choice of quasi-religious metaphors (like "evil demons of images"), his reduction of everyday culture to fatal "banality" is much more appealing to a Russian thinker than the playful indeterminacy and attention to singularity characteristic of someone like Derrida or Lyotard. Baudrillard plays directly into Russian apocalyptic thinking, in both its traditional and postmodern versions.

5. Jean Baudrillard, "La Guerre n' aurait pas lieu, in *Libération*, Jan. 4, 1991. I am grateful to Martin Roberts for bringing this article to my attention.

6. Andrew Ross, *Strange Weather: Culture, Science and Technology in the Age of Limits*, (New York and London: Verso, 1991), 242.

7. *The American Heritage Dictionary*, Second College Edition (Boston: Houghton Mifflin, 1985), 401 and 249.

8. Mary Ann Doane, "Information, Crisis, Catastrophe," in *Logics of Television*, ed. Patricia Mellencamp (Bloomington: Indiana University Press; London: BFI, 1990). Several other essays in this excellent collection are relevant to my topic: Stephen Heath, "Representing Telelvision"; Margaret Morse, "An Anthology of Everyday Distraction: The Freeway, the Mall, and Television"; Meagan Morris, "Banality in Cultural Studies"; and Patricia Mellencamp, "TV Time and Catastrophe, or Beyond the Pleasure Principle." For more on the theory of disaster see the journal *Disaster*; for catastrophe see René Thom, *Structural Stability and Morphogenesis: An Outline of a General Theory of Models)* (Readin Mass.: W. A. Benjamin, 1975).

Strictly speaking, the events of August 1991 would qualify as as a "disaster" since luckily they did not have a tragic outcome. However, at the early stages, the word "catastrophe" was frequently invoked by the media to add dramatic flavor to the events. Perhaps one can truly distinguish between the two only retrospectively.

9. Mary Ann Doane, "Information, Crisis, Catastrophe," p 228.

10. Susan Sontag, "Notes on Camp," in *Against Interpretation* (New York: Doubleday, 1990, pp. 275–292. For a cross-cultural discussion of "Kitsch," "camp" and banality see my book *Common Places: Mythologies* of *Russian Everyday Life*, forthcoming in Harvard University Press, 1994.

11. Of course, I am giving here the Soviet cultural history of the word "dissident" and I by no means presume that the specific historical and political signification should be privileged over more metaphoric uses of the word.

12. On the afternoon of August 19 people went out to Nevsky with a slogan: "Congratulations with the Fascist putsch, dear St. Petersburgians!" The slogan, an excellent example of a quite courageous black humor, offers a clash of styles and discourses: in fact "St. Petersburgians" (the prerevolutionary name of the city favored by the democrats and not by the coup organizers) and "Fascist coup" could hardly coexist even in one sentence.

13. *Smena*, Leningrad, Aug. 20 and Aug. 24, 1991. The translation is mine.

14. Also in one of CNN's special reports, the Soviet anchorman who made several suggestive slips of the tongue was actually featured. But only the very brief segment of his speech that could fit neatly before the commercial was transmitted. One might argue that I am imposing order and creating a signifying narrative out of accidental fragments merely metonymically put together, but in this case the "commercial accident" is also one of the myths naturalized by the media that wishes to make us believe that the choice of channels equals the choice of news coverage or the choice in the style of programming. Maybe it is my own cultural overdeterminism that forces me to overread.

15. Alexey Tarkhanov, "How the Post-Modernist Revolution Has Built Art-Historical Barricades," *Seance* 5 (1991), St. Petersburg, 9–10. I am grateful to my Leningrad and Moscow friends for sharing their coup experiences with me while I shared with them my CNN worries: Viktor Misiano, Sergey Sholokhov, Liubov' Arcus, Joseph Bakstein, Tatiana Arzamasova, Leonid Gozman, Nadezhda Azhgikhina, Daniil Dondurei, Zara Abdullaeva, Nina and Oleg Il'insky.

16. Ibid, 10. The translation of the quotations is mine.

17. Ibid.

18. Roman Jakobson, "On the Generation That Squandered Its Poets," trans. Edward Brown, in *Language and Literature*, ed. Krystyna Pomorska and Stephen Rudy (Cambridge, Mass.: Harvard University Press, 1987). The essay was written on the occasion of Vladimir Mayakovskys suicide.

Watching Sex

Patricia Bowman, testifying, covered by "blob."
(AP/Wide World Photos)

8

Scandals of Naming: The Blue Blob, Identity, and Gender in the William Kennedy Smith Case[1]

Jann Matlock

"The Most Famous Woman Never Seen," ran the headline of the *People* magazine story that appeared December 17, 1991, two days after the William Kennedy Smith rape trial ended in acquittal. "Even after the verdict," read the subtitle, "Will Smith's accuser remains an enigma." Within a week, that enigma had "gone public," interviewed on ABC's *PrimeTime*, leaving behind the anonymity that had become a central issue of the trial. "Do you want to introduce yourself?" asked Diane Sawyer on December 19, assenting to the single precondition of the interview that her interlocutor be the one to speak her own name. "I thank you for giving me that honor," answered the woman who chose to show her face for the first name: "Out of everyone who's used my name, for once it's an honor to say that I am Patricia Bowman. . . . I'm not a blue blob. I'm a person."[2]

Naming herself, Bowman also affixed a name to the electronic cover that had protected her identity on national television during her testimony. The blue blob she cited was what television personnel called a "soft-edge circle wipe," a computerized mask given her by Courtroom Television Network, first in the form of what the press called "a grey dot," then, after the mask slipped accidentally from her face as she testified, as what one newspaper called a blue "splotch."[3] Naming the computer mask a blob, Bowman also summoned the 1958 science fiction film and its subsequent remakes that had fueled sexist humor during the trial. For Bowman to refuse to be a blue blob, then, represented a refusal of a series of identities foisted upon her by a rampaging press.

While the media depicted Bowman as trading in her anonymity for the

name she gave Sawyer, that anonymity had long ago been surrendered—not by Bowman but by a Florida tabloid, NBC News and the *New York Times*.[4] The media's identification of her, which occurred in April, 1991, shortly after Bowman reported she had been raped, unleashed fervent debate over identifying victims of rape and sexual abuse. Naming herself publicly, Bowman gave up not just her putative *namelessness*, but that enigmatic status on which *People* magazine capitalized the day after the verdict:

> Her hair was visible, thick and brown and cut in a pageboy. You could see her hands, her left wiping away her tears, her right pressed over her heart—just as it had been, she said, when Smith allegedly raped her. . . . But only those in court could see anything more. All that millions watching elsewhere got to see was a fuzzy blue dot or a computerized blur on their TV screens.[5]

The woman behind the mask had become an empty signifier onto which every imaginable identity might be projected. Bowman was, she stated, exchanging one identity—"the blob"—for another she sought to determine by speaking in her own voice without electronic cover. She would, according to her interview, substitute for the scandals of naming that had transpired since March 30, the identity *she* wished to assume and the story *she* chose to give that identity meaning.

This essay explores transactions over names and identity between April and December 1991 in the press coverage and trial of William Kennedy Smith for sexual battery. It begins with the premise that the story of naming here is a crucial one, not only for those experiencing or witnessing traumatic events, but also for understanding the identity politics pertinent to gender, class, race, and sexual preference. I want to argue that the hinge issues of this trial were naming and identity, and that those issues—both in the outcome of the trial and in the press coverage—turned on perceptions of gender.

Because the woman who riveted viewers was herself not *identified* during the trial, this case provides an ideal surface on which to explore a central question of this volume—the relationship between who is looking and what is being watched. Who was watching mattered little here. How the accuser

"I'm not a blue blob. I'm a person."
(AP/Wide World Photos)

was named by the press, by Smith's lawyers, and by Smith himself relays a much more significant story of media spectacles and their disruptive capacities. Whether named in pretrial media lashings or covered by blue computer graphics, Bowman's identity was fixed in one disturbingly inflexible way as gendered. Onto a body she depicted as violated by nonconsensual sex, a series of identities were projected that stripped her of the story she came to tell.

While the problematics of naming provide a useful lens through which to review this trial, my concerns here go beyond the trial itself to a debate over the relationship of gender to identity. In her influential book *Gender Trouble*, Judith Butler has argued that gender is one act among many, regulating and stylizing bodies, always available for manipulation.[6] In the William Kennedy Smith case, I wish to contend, gender became far more than a "style of the flesh,"[7] but rather the irreducible term for which even anonymity functioned as a foil. It became the one name that Bowman could not replace with her own. Like the "blob" itself—which imported into the trial an array of sci-fi referents about aliens and monstrosity, gender had too many old stories for it to peel away with her account of the trial. Bowman indeed made "gender trouble," but not for any reasons that she seemed able to control. Rather, she emerged as a spectacular body identified only as female. Like the humans destroyed by the science fiction "blob," Bowman dissolved into the stories others could tell about her. The scandal of this case was that it reduced her to flesh, without the ability to name with propriety—herself or anyone else.

Science fiction and horror films have long taught their teenage target audiences that sex, with or without consent, means trouble. That the creature of the original 1958 *The Blob* crashes to earth just as its teenage heroine (Aneta Corseaut) rejects the advances of the male protagonist (Steve McQueen) situates the film in a genre that gleefully relates adolescent sexuality to monstrosities, horror, danger, and death.[8] Particularly intriguing, however, is the "naming trouble" that accompanies the Blob's arrival on screen. After whimsical opening credits accompanied by a catchy song about what to call the blob, the film cuts to two teenagers embracing at a parking spot in the woods. After a brief kiss, the girl pulls away:

She: No.

He: But it was a shooting star.

She: I thought you were supposed to *wish* on shooting stars.

He: But I did.

She: But we only saw one.

He: But you see a lot of 'em up here at night. . . . Oh, no, no, that's not what
 I mean. I mean you can see 'em better up here.

She: I know what you mean, Steve.

He: No, no, it's not what you think, Janie-girl.

She: My name is Jane, just Jane.

Naming herself, the heroine of *The Blob* refuses all the positions her date
would put her in—both his sexual demands *and* his reduction of her to
gender. Her name, she insists, is "just Jane," not "Janie-girl," and she has said
"no."

Although none of the *Blob* films had any explicit relation to the Smith trial,
press references to Bowman's cover sufficiently invoked the sci-fi monsters to
justify our asking what else the classic horror film might have in common
with the scandal-ridden rape trial. That the 1958 movie turns on a sequence
involving consent as well as misnomers emerges as an uncanny intertext for
a trial that too easily approximated science fiction. In testimony every major
American newspaper highlighted as crucial to his defense, Smith gave *his*
account of sex and naming:

> We were moving together on the lawn and I got more excited and I thought
> I was maybe gonna ejaculate inside of her. . . . I held her very tightly and I
> stopped moving and I told her to stop it and I called her "Cathy." She sort
> of—she sort of snapped. She got very, very upset and she told me to get the
> hell off her and she hit me with her hand.[9]

That Smith called Bowman a wrong name became a central issue not only for
the press the day after his testimony, but for Sawyer in the televised interview:
"Mr. Smith's case . . . was . . . that he had . . . annoyed and irritated and
inflamed you up on the lawn during sex, calling you by the wrong name."
According to Bowman, the only thing Smith called her on the lawn was

"bitch"[10]—when she protested that she did not want to have sex. Whatever Smith may indeed have called Bowman, these conflicting accounts of naming, like the opening scene of *The Blob*, codify expectations about the workings of proper names.

Both the defense and Bowman's press critics depend on an account of naming that would have Bowman deeply troubled by a *misnomer*. Why does such an account of naming work so powerfully here? What enables the 1958 film to relay its heroine's refusal of the protagonist's advances in metaphoric terms with precisely the same kind of account of an unsettling *misnomer*? "My name is not Janie-girl" here has become the equivalent of a rejection of sexual advances. In both cases, however, the refusal of sex ("She told me to get the hell off her" and Jane's "no") generates yet another explosion—in the film, the crashing of the meteor containing the blob, and in the trial testimony, the rape accusation. "She sort of snapped," read the headline the day after Smith's testimony.[11] Misnaming her Cathy, he contended, led her to assault him with what he called "a damnable lie."[12] His slipped signifier, he argued, brought vengeful duplicity not just at the level of language but also in terms of police action. She called him "Michael," Smith contended on the witness stand. Once he had misnamed her in the throes of passion, *she* couldn't get *his* name right. She even asked for his ID card, and when shown it, he claimed, continued to insist his name was "Michael." "You don't even want me. And Michael raped me," supposedly she said.[13] All Bowman seemed to know, according to Smith's testimony, was that he was a Kennedy.

"No one will believe you," she claimed he told her when she confronted him. To prove she had really been in this mansion belonging to a family whose name resonated far beyond Palm Beach society, Bowman took an urn and a notepad. In the days following her accusation, Bowman was initially represented by Kennedy family spokesmen as a common criminal who may have fabricated the rape claim to cover her theft of family possessions.[14] Called by Patrick Kennedy "a sort of fatal attraction you couldn't get rid of" and "a girl" who was "really whacked out,"[15] Bowman was evoked as a madwoman who took things from their rightful places and who had lost any sense of what names rightfully belonged to people. After all, Smith and his defense attorneys

142

would argue during the trial, this was a woman who could not even name the man with whom she had just had sex.

On *Larry King Live* after the verdict, Smith's defense attorney Roy Black announced: "I would have looked into her obvious mental problems and the reasons why she brought this. We know that this woman has had a difficult life, that she's disturbed."[16] Displayed before the press as in trouble with the proper relations of names and things to their owners, Bowman became, in turn, a woman in trouble with propriety in a more gendered and sexual sense. "Cathy," Smith would contend, was the name of his ex-girlfriend, an understandable lapse, hardly improper—if anything an allusion to a kind of sexual relationship proper to a man of 30—a long-term monogamous relationship.[17] Michael, the name Smith said Bowman called her after his lapse on the lawn, was given much more insidious overtones by defense attorneys who suggested that "when [she] called Smith 'Michael,' . . . she subconsciously was calling out for her stepfather, whose name is Michael." Though Bowman's mother testified she called her husband "Jerry" and her daughter called him "Boomer," the defense's insinuations carried over into press speculations about Bowman's past and motives.[18] Black claimed he could win his case simply by demonstrating that she "blindly accused Smith, calling him Michael."[19] Somehow, in this economy of slippery signs, a woman's failure to get a man's name right became evidence that she was, in Black's words, "disturbed," capable of anything, including "blind accusations."[20] A *man's* failure, however, to properly name the woman with whom he was having sex, in this same economy of signification, procured value for his version of the story. The other epithet Smith supposedly used, according to Bowman's version, was displaced, like her account of the rape itself: " 'Shut up, bitch,' " Diane Sawyer reminded TV audiences of Bowman's testimony before pressing her about their different stories: "But he said what upset you so was that he called you by another woman's name." "I don't know any other woman by that name," retorted Bowman.[21]

"A man commits rape when he engages in intercourse . . . with a woman not his wife; by force or threat of force; against her will and without her consent,"

Susan Estrich explains the "traditional, common-law definition of rape."[22] Central to consent is the assumption that "no" means "no" and not "yes," and that "no" is readable within the codes available to both parties. Nevertheless, as Frances Ferguson has pointed out, rape law is racked by fundamental paradoxes related to its earliest manifestations as a method of protecting young women from relations not befitting their fathers' plans.[23] There, in the laws governing statutory rape, we find that an "under-age" girl's "yes" is legally interpreted as nonconsent, and that her will has no meaning. The possibility of a "category of consent that is not consent and intention that is not intention"[24] suggests a paradox repeatedly played out in rape trials. Proving rape, and especially date rape, beyond a reasonable doubt turns on interpretive dilemmas in which one individual names a sex act as non-consensual, and another names the same act as consensual. For Smith to have been found guilty, then, required not only that Bowman properly name her desire but that Bowman's "no" be perceived by Smith as "no."

"The emergence of symbolic thought must have required that women, like words, should be things that were exchanged," claimed anthropologist Claude Lévi-Strauss."[25] Proper use of such female signs would have them "communicated"—married properly according to cultural codes. Rape, like incest, would emerge as an improper use of those signs, a misfiring of codes that could only end in what the anthropologist views as barbarian disasters. The fantasy in traditional definitions of rape that the signs of consent are always readable to all parties seems inherently linked to this fantasy that women's bodies might have proper uses.[26] Inscribable within the language of kinship, women's appropriation of the signs relating to rape seems inherently precarious. In the eighteenth century, for example, influential Italian criminologist and penal code expert Cesare de Beccaria argued that women had no reason to lie since they did not exist as legal subjects.[27] But such arguments have just as frequently translated into gendered equations of femininity and duplicity. Bowman, argued the most slanderous press, had every reason to lie. Described in the scandalmongering *New York Times* article of April 17 as "having a little wild streak," Bowman was cited as liking "to drink and have fun with the ne'er-do-wells in café society." Small wonder that Smith's defense would echo the

views of an observer in the café the night of March 30: "Ms. Montgomery said that she saw Ms. Bowman at the Kennedys' table and that she was not surprised when Ms. Bowman left with Mr. Smith. 'How many times a night does that happen in Palm Beach?' she observed."[28] Small wonder, then, that according to Smith's testimony, *she seduced him.*[29]

Rape law, as Bowman and others like her have discovered, displaces the story of proper use of codes onto the body of the accuser. The crime itself, as Ferguson suggests, seems to disappear, leaving behind the body of the woman who accuses, that very body now entered into evidence as "the text that bespeaks not only her intention not to have consented but also the perpetrator's intention to have overridden that refusal to consent."[30] Reading that body requires an inquiry into her ability to name what has been transacted through it. Her mental state, says the law, must be read.[31] For a woman to demonstrate that "no" means "no" requires that she prove herself capable of properly naming things: sex acts, consent, intentions. Woe to the woman shown in trouble with signs.

Every date, Camille Paglia has observed, "by definition is a sexual situation. Each person is giving signals and every signal can be misinterpreted."[32] Paglia's insistence that "it's fair to blame the victim if she fails to protect herself"[33] is a commonplace of misogynistic readings of the systems of signs that govern rape. Like Neil Gilbert, author of an article entitled, "The Phantom Epidemic of Sexual Assault" who has argued that "feminists have exaggerated date-rape numbers to pursue their own political agenda," Paglia blames the rape victim for believing sign systems might work.[34]

Perhaps the paradox of rape trials is that one wants a sign system to work effectively enough that a "no" can be readable as "no," yet at the same time, one would demand a system of signification in which *different* perceptions of the same event might nevertheless emerge without *her* "no" becoming in any way diminished by *his* belief that it meant "yes." We want signifiers to have proper significations (no as no) but we also want consequences when no is nevertheless erroneously read as yes. How do we exchange a system where a woman's word is distrusted simply because she's female without substituting a system where her word is believed simply because she is female? How might

we allow for possible readings of the signs without sacrificing women's rights to be heard, properly naming their desires?

That William, or more specifically Will, is one of the proper names through which debates over the meaning of names have been transacted—by philosophers of language, literary critics, and of course, inevitably, Shakespeare himself—gives uncanny resonance to whatever account of naming and identity we bring to the William Kennedy Smith trial. Testifying to the knotting of issues of sexuality, power, and language, Shakespeare and Shakespearean critics have reveled in the vibrant double entendres that made "will" a name, a desire, a power, and both male and female genitalia.[35] To imagine that the story one might need to tell about "Will" Smith is a story about the manipulation of proper names has a certain ironic subtext that nevertheless telescopes the power struggles underlying the Smith trial itself and the debates over naming it engendered. Naming, Joel Fineman suggested, procures inevitable testimony about loss.[36] It reminds us of the impropriety of language because no name ever means what it names: even Ernest, that ideal name of the Oscar Wilde universe, is racked by duplicity, for no one can expect a man named Ernest to be, indeed, as earnest as all that. As much as we want to believe that names are somehow attached to the people, places, and things they identify, all our etymological efforts pay off with only the loosest elaborations of originary fictions: as John Stuart Mill argued, Dartmouth may have been a place in England at the mouth of the river Dart, but when the river changed course, the place remained properly called Dartmouth even though it had no further relationship to its earlier connotative meaning.[37] Aristotle is understood to name a Greek philosopher because, as John Searle argues, we share descriptions associated with that name that function like "pegs on which to hang descriptions."[38] Two people pointing to a city in England, as Saul Kripke points out, can each believe they are naming the same place, but one will call it properly London and the other Londres.[39] Will Smith may logically belong to a set of individuals described by the media as Kennedys, but his own first name no more means that he has power than it positions him in a string of

146

bawdy puns. Named Will, this man is neither properly signified by his name nor is he reduced to the field of disjecta membra.

Smith's own first name nevertheless became the subject of as many debates as the misnomer he claimed Bowman used. The press seemed constantly uncertain how to name the accused—as Will, Willie, or William, as Kennedy Smith (as if the name were hyphenated), or as simply, almost namelessly, Smith. The first *Boston Globe* story cited his college roommate claiming, " 'He was Willie Smith, not William Kennedy Smith. He was a regular guy.'"[40] Just after the accusation reached the press, the *Globe* wrote him into a story that made his middle name the modifier for the story in which he figured: "Kennedy twist to an old plot."[41] Kennedy lawyers claimed the press was attacking the family through the cousin. Stories even surfaced about the alleged victim's stepfather's long-held dislike of the Kennedys.[42] By May, major newspapers no longer needed the family name to point to the identity of the arrested rape defendent. "Smith charged with rape, freed on bail" announced the *Globe* on May 12.[43] "Tests find Smith probably had sex with accuser," read a May 29 headline.[44] "Smith fiasco," read an op-ed headline the day after the verdict.[45]

Smith's own name was of course divisive because of scandals summoned by the mere announcement of his middle name. While Kennedy relatives and lawyers accused the press of creating a media circus because of their relation, members of the press admitted: "I am here because of the Kennedy name," Yvon Samuel of *France-Soir* was cited as explaining, "Willie Smith is a no-body."[46] Just what a somebody Smith had become emerged in the year-end *People* magazine where Smith had his own page among the "25 most intriguing people of 1991."[47] "William Smith" was no longer, claimed the article, just "an obscure Kennedy cousin," but "now a man whose deeds—good and bad—will never again escape public notice."[48] Despite such fantasies about William-just-Smith, no one during the trial forgot his middle name—to such an extent that it was imagined in a caricature of December 13 to displace the very accusation for which this scion of Camelot was being tried: "I don't care what the woman accused him of," an elderly woman was shown insisting to her husband. "I still think William Kennedy Smith deserves to be on the Supreme Court."[49]

That Smith himself was divided by press descriptions of his "regular guy" status and media associations of him with the Kennedys emerged as a central trope in the trial weeks. Prosecutor Moira Lasch tried to compel the defense to call him "Mr. Smith," while his attorneys successfully battled to call him the "softer 'Will.' "[50] Attorney Black managed to have it both ways: "Will" read as both a regular guy and potentially a Kennedy, someone who commanded respect through a resonance of power in a name that suddenly became *proper* to the needs of the defense. Using his "will" with propriety, then, William Kennedy Smith became a man who could have his way with women without much of an effort, and certainly without undue force. This "Will" was not one who used his sexuality improperly, but rather, just a guy a little in trouble with language. No one would be surprised that, divided by his Kennedy name, he was equally divided between his recollection of the woman in his arms, Patricia, and the woman left behind, Cathy. What one could know for sure, and all those "Wills" served an additional purpose of driving this home, was that this guy's name was not "Michael."[51] What the press knew about Bowman's name mattered less than the system of identity into which defense attorneys and the press inserted her story.

Jokes about Bowman took three forms during the trial: first, allusions to the reasons her face was covered by the blob; second, references to her lifestyle before the trial; and third, remarks about her identity resembling *Boston Globe* columnist Alex Beam's snipe after the verdict: "I seem to be the only person who doesn't know the alleged victim's name—it's not Cathy, I know that."[52] Small wonder, then, that Bowman asked to name herself, answer accusations about her previous involvement with drugs, alcohol, sex, and psychiatry, and reject the language of derision that surrounded the electronic mask she wore during the trial. "I'm not a blue blub" might well have represented a refusal of all the improprieties told about her from the devastating April *New York Times* article to press equivocations about the uses of the electronic masking techniques.

That the press did not know what to call the thing covering her face during her testimony was not surprising. This was the first time such a trial had been

nationally televised. Each slip of the electronic mask elicited discussions by the press about its usefulness.[53] Throughout the month of the trial, press commentators complained about the difficulty viewers had of knowing whether Bowman, masked by the blob, was telling the truth. Alternatively referring to it as a dot, a blur, a smudge, the press sounded like they had been listening to the theme song of the 1958 movie that joyfully warned "A splotch, a blotch, be careful of the blob!"

If the original *Blob* bore a resemblance to bodily excretions, its color gave a series of mixed messages—first mucouslike and clear, then increasingly red as it dissolved more and more human flesh. Bowman's blur, first grey, then blue, hardly resembled any of the mutations of those alien beasts. We might, though, need to read the mask's color for precisely what it was not. A *U.S. News and World Report* op-ed piece of December 23 remarked after the verdict that "the trial left a perfect visual coda for the sexual revolution: her face covered by a blue blotch. It's the video age's scarlet letter."[54] This article calls up the colors of that other blob, of the film fantasies of a creature that could dissolve (exclusively) male bodies in a single all-encompassing red gulp, but it also relays a strange story of female transgression. For the "blob" to be "the video age's scarlet letter," Bowman had to be imagined as engaging in improper sex—indeed, in an exchange of her body that would be read not only as illicit but as improperly negotiating the meanings of consent and intent.[55] Beneath her blue blob, Bowman was imagined by the press as offering up the greatest lessons "of all time for bringing home to people questions about burden of proof, how you establish guilt beyond a reasonable doubt and presumption of innocence."[56] Her concealment behind the blue smear left many commentators raging over "journalistic hypocrisy"[57] and complaining that they were unable to know if she was telling the truth because they could not see her face.[58] Wearing her so-called "scarlet letter" only for the American media,[59] the supposedly anonymous Bowman was unable to convince the jurors who did see her face of the veracity of her story. Within seventy-seven minutes, these four women and two men declared Smith "not guilty" beyond a reasonable doubt.

A shifting, blurred-edged blueness on a video screen, the blob that masked
Bowman was ultimately projected onto a surface that could be read as anything
but white. Supposedly screening her, it ultimately covered her with stories of
otherness, of derision, of duplicity. It made her, in the words of one columnist,
both "Everywoman [and] Nowoman,"[60] a woman of no importance whose
story could not transcend its shroud.

Thomas Laqueur has argued that "the power of culture represents itself in
bodies and forges them, as on an anvil." Gender is just such a power forging
bodies, we might argue.[61] Bowman's gender identity became indissoluble from
the blob, just as the blob left her with little besides her femaleness, her status
as victim of that stereotypically gendered trauma of rape. I have argued here
that the blob stood in for Bowman in ways that ultimately stripped her of her
name, but it could only do so because her gender identity remained an
indissoluble bedrock on which the trial attorneys inscribed their own stories.

Even named, Bowman remained a woman without a proper name, a
woman unable to give herself identity amidst the whirl of identities ascribed
to her. Even naming herself the week after the trial, she could not reclaim the
truth of a story that the acquittal had stripped of value. Her name had become
as wrapped in scandal as her anonymity. Her story had been transformed into
one of right and wrong names, equating in a single scandalous gesture the
impropriety of language and improper sexual behavior.

If, as I have argued here, Bowman could not even name herself once this
whirlwind of improprieties was set loose in the sparks of overinvested gender
identity, then what are we to make of the quandary over naming victims of
sexual abuse? How are we to imagine that any woman might claim the right
to an identity she chooses, a series of referents like a proper name to which
she gives a story? "The voice of the shuttle is ours," Patricia Joplin claims as
she reappropriates the weaving power of the raped Philomela to speak even
without the tongue cut out by her accuser.[62] As compelling as this metaphor
may be for survivors of sexual abuse, I would like to suggest that we need
more than voices. Patricia Bowman *had* a voice, plaintive, chilling even, with
which she retorted to defense attorney Black in her last words on the stand,
"Your client raped me."[63] Refusing in this moment to name Smith, whether

as Will the regular guy, or William *Kennedy* Smith, seemed a powerful protest on Bowman's part of Black's references to his client as if he were her estranged lover. But it did not enable her to shake the plays of naming and identity so skillfully put in place by the defense. By refusing to name him, she ultimately reconfirmed the defense's projected belief in the power of names. Bowman's voice was not in itself enough.

Another moment from the 1958 *Blob* might be suggestive of the maneuvers of identity, naming, and gender that I would propose as alternatives to such a belief. Spunky Jane, whom we have earlier seen refusing teen heartthrob Steve's advances, is sneaking out to meet her boyfriend to save the world from the encroaching blob. Her little brother ambushes her on the stairs and demands to go along. "If you go to bed," she promises, "I might bring you a little dog all of your very own." "What's his name?" asks the child. "Oh, any name you want," replies his sister, eager to leave. "Can I name him William?" the boy demands. "Oh that's a fine name," his sister assures him. "Now you better run on up to bed." But the child has other motives for his naming. He stalls at the top of the stairs: "No, I don't like William."

What may well be a B-flick in-joke here (we might well ask, Is William a reference to the film's art director, William Jersey, or to someone's actual dog?) suggests a kind of belief in the power of names that is just as quickly erased by the film. "[William] is a fine name," says the girl who has only minutes earlier insisted that she is not "Janie-girl." In this world in which Janes insist on being called by their real names, fine names still exist. But this is also a world in which, in another register, we can like or dislike names. "No, I don't like William," reads like a strange nonsequitur for the child has only moments before proposed this name as seemingly ideal. William, like Will, or even Willie, in the trial we have been examining, serves as a lure. It would catch us looking for the propriety of names, imagining that in a perfect world, fine names give meaning to their holders and convey power to those who name. But the power of naming is just as great for those who choose names they like. Forswearing a belief in the properness of names might allow a space for desire.

Desire is precisely what is elided by rape, but it is also what is barred by

this insistence on the proper signifying potential of names. If we could imagine a world in which we could choose our own tropes, then Judith Butler's utopian project of manipulating identity might obviate our need to come to terms with gender as it was coded in the Smith case, or as it is coded by the spectacles of sexuality underlying such a case. This is not yet such a world. Coming to terms with gender, I would argue, requires giving a history to the debates over naming that have transected the bodies of the women in these cases. It requires imagining that the men whose bodies are not covered by blobs are themselves pinioned by the identities that make rapists stereotypically male and victims female. It necessitates giving terms we desire to the transactions of bodies. Most important, it requires that we be able to say—of names, of identity, of actions, of sexuality—"No, I don't like it," and be heard, properly, not for propriety, but for desire.

Notes

1. Research assistance for this article was provided by J. D. Connor and Sharon Haimov. Thanks also to Laura X and Jennifer of the National Clearinghouse on Marital and Date Rape in Berkeley, California, for use of their organization's extensive files of national press clippings. For insightful conversations on this case, I am most grateful to Margaret Carroll, Hannah Feldman, Paul Franklin, Naomi Hamburg, Anne Higonnet, Ewa Lajer-Burcharth, Katharine Park, Rebecca Spang and Rebecca Walkowitz. Judith Butler graciously provided invaluable counsel. Joel Fineman long ago challenged me to think about scandals of naming. He would know that to accept now his wise and witty provocations is my way of striking out for the real.

2. *PrimeTime Live*, Transcript 224, Dec. 19, 1991, 2–3. This was also ABC's teaser for *PrimeTime*. The appeal of Bowman's reason for going public was not lost on the press: "I'm not a blue blob," ran headlines in newspapers throughout the country. The headline of the *Palm Beach Post* the following day echoed her words. "The blue dot is retired," declared *USA Today* (Dec. 19, 1991). "DOT'S HER!" announced the *New York Post* (Dec. 19, 1991). Robert Goldberg, television columnist for the *Wall Street Journal*, headlined his story on *PrimeTime*: "Holiday Fare: Blue Blobs and Shepherds" (Dec. 23, 1991).

3. According to the *Palm Beach Post*, National Teleproductions' Bob Peterson operated the "blob . . . with a joystick called a 'positioner' from inside the media center a floor below the courtroom. He receives a live 'feed' from the CTN camera—the only one in the courtroom—then inserts the blob and sends that picture to hundreds of TV outlets. CTN

itself used a different time-delayed feed, in which the woman's face was covered with an electronic 'mosaic' that distorts her features with a kaleidoscope of out-of-focus blocks" (Dec. 5, 1991). On the differences between proper names and "general names," see Saul Kripke, *Naming and Necessity* (Cambridge: Harvard University Press, 1972), 127–28ff., and note 39 below.

4. The *Globe* tabloid, based in Boca Raton, Florida, was the first American newspaper to publish the alleged victim's name and photograph, following a London-based tabloid on April 7. The *New York Times* identified her in an extensive "portrait" on April 17, 1991, on p. 17A. Charges against the Florida tabloid were eventually dropped on grounds that an 80-year-old statute protecting the identities of sexual assault victims was unconstitutional (*Boston Globe*, 25 Oct. 1991, 80). See subsequent discussions in The *Boston Globe*, Apr. 17, 1991, 1, 17, and Apr. 19, 1991, 3. The ensuing debates on the staff of the *New York Times* are detailed in Nan Robertson, *The Girls in the Balcony: Women, Men, and the New York Times* (New York: Random House, 1992), 241–44, and in articles in The *New York Times* (Apr. 21, 1991, 4, and Apr. 26, 1991, 3, A14). *Newsweek* ran its cover story on "naming" on April 29, 1991, on pp. 26–32. Katha Pollitt, "Naming and Blaming: Media Goes Wilding in Palm Beach," *Nation*, June 24, 1991, extensively considered the contradictions in debates over naming rape victims in relation to other debates over "outing" of gay public figures and the publication of the names of arrested "johns." On CNN's *Larry King Live*, Bowman cited a national survey showing that subsequently some 25% of the national press named her (Transcript 548, Apr. 27, 1992, 3).

5. *People*, Dec. 23, 1991, 55.

6. Judith Butler, *Gender Trouble* (New York: Routledge, 1990), 140–41.

7. Butler, *Gender Trouble,* 139.

8. On the male target (and apparently also real) audiences of such horror films in the 1970s and 1980s, see Carol Clover, *Men, Women, and Chainsaws: Gender in the Modern Horror Film* (Princeton: Princeton University Press, 1992). Although Clover does not discuss any of the three *Blob* films (*The Blob* [directed by Irvin S. Yeaworth, Jr., 1958]; *Beware! The Blob* [directed by Larry Hagman, 1972]; and *The Blob* [directed by Chuck Russell, 1988]), much of what she has to say about horror films applies—except that in the *Blob* films, Clover's "Final Girl" is always accompanied by a "Final Boy." The connection between the science fiction genre to which the *Blob* films seem to belong and later horror films is clearly articulated in the 1988 *Blob*: the "Final Girl's" pre-pubescent brother and friend sneak into a movie theater without their parents' permission to see what they joyously refer to as a "slice and dice"—or slasher film. It is in the theater that the blob, grown into a huge amorphous monster with the intake of the blood and bones of its victims, overcomes the children of the town—and nearly gets the Final Girl's brother as well. The 1958 blob likewise overtakes the town movie theater during a midnight horror-

film showing, but much less is made of that midnight movie's excessive—and prohibited—nature. The 1988 remake also exacerbates the tensions surrounding sexual consent we have seen in the opening scene of the 1958 film: midway through the later *Blob*, a youth is shown in the woods mixing cocktails for his girlfriend who lapses into a drunken stupor just as the monster appears. When he begins undressing the apparently unconscious girl in the backseat of the car, the blob springs out of *her* body where it has been hiding while he planned something strikingly close to date-rape. In a moralistic commentary on teen sex—if not also alcohol consumption—the desired girl turns out already to *be* the "blob" that will devour the desiring boy.

9. *New York Post* transcription of trial testimony, Dec. 11, 1991, 5.

10. "Shut up, bitch," Smith supposedly said, according to Bowman's trial testimony. See *ABC PrimeTime Live* transcript, Dec. 19, 1991, 8.

11. *Boston Globe*, Dec. 11, 1991, 1. "She just snapped," read the headline of the *New York Post*, Dec. 11, 1991, 5. A similar headline ran in the *Colorado Springs Gazette Telegraph*, Dec. 11, 1991, 1.

12. Smith's first statement of denial cited in the *Boston Globe*, Apr. 12, 1991, 1.

13. *Boston Globe*, Dec. 11, 1991, 38.

14. *Boston Globe*, Apr. 7, 1991, 13. Edward Kennedy told reporters after Smith's arrest that he had been slow in responding to police inquiries because he thought investigators were seeking him to discuss the "Possible theft of an urn, about which he knew nothing" and not any wrongdoing on the part of his nephew (*Globe*, May 16, 1991, 15). Smith lawyers later contended Bowman took property "as revenge" (*Globe*, Nov. 5, 1991, 14).

15. *Boston Globe*, May 15, 1991, 6.

16. *Larry King Live,* CNN, also shown on *PrimeTime*, 19 Dec. 1991 transcript, 2. Black made similar statements in documents filed before the hearing and trial (*Boston Globe*, Aug. 10, 1991, 3, and Oct. 16, 1991, 3).

17. And not only that, but the real "Cathy," "Kathie Aime," appeared in the flesh, to support the man who seemed to claim in his testimony that all the sex he had was related to her, covered by an umbrella that had her name on it. "Kathie wanted to come down and be with him," a Smith spokeswoman was quoted by the *Boston Globe* (Dec. 3, 1991). "They still are good friends, they just are not romantic."

18. The *Chicago Tribune* reported "The 'Michael' question never has been resolved. The woman acknowledges calling Smith by that name once but says she does not know why. In his opening statement, Black hinted at some dark psychological motive, noting the woman's stepfather was named Michael" (Dec. 11, 1991). Black's efforts to smear Smith's accuser by means of her medical and psychological history began in August as statements were released about the woman's childhood sexual abuse by a caretaker (*Boston Globe*, Aug. 10, 1991, 3).

19. According to an interview summarized by the *Boston Globe* in pretrial moments, Black claimed he would "prove his case by showing how the woman called a casual acquaintance to pick her up at the Kennedy estate rather than the police or her relatives, how she remained in the Kennedy compound after she supposedly had been brutalized and how she started blindly accusing Smith, calling him Michael" (Dec. 3, 1991, 16).

20. *Boston Globe*, Dec. 3, 1991, 16.

21. *ABC PrimeTime Live* transcript, 8. In trial testimony, Bowman said "I was screaming. . . . I was struggling and he told me to 'Stop it, bitch' " (*Boston Globe* trial excerpts, Dec. 5, 1991, 36).

22. Susan Estrich, *Real Rape* (Cambridge: Harvard University Press, 1987), 8.

23. Frances Ferguson, "Rape and the Rise of the Novel," in *Misogyny, Misandry, and Misanthropy*, ed. R. Howard Bloch and Frances Ferguson (Berkeley: University of California Press, 1989), 95–96. See also Roy Porter, "Rape—Does It Have a Historical Meaning?" in *Rape*, ed. Sylvia Tomaselli and Roy Porter (Oxford: Basil Blackwell, 1986), 216–36.

24. Ferguson, "Rape and the Rise," 95.

25. Claude Lévi-Strauss, *Elementary Structures of Kinship* (Boston: Beacon Press, 1969), 496, cited in Patricia Klindienst Joplin, "The Voice of the Shuttle Is Ours," in *Rape and Representation*, ed. Lynn A. Higgins and Brenda R. Silver (New York: Columbia University Press, 1991), 41–42.

26. This fantasy is as much that of Lévi-Strauss as that of the societies he studies, as Joplin points out in "The Voice of the Shuttle," 42.

27. Cesare de Beccaria, *An Essay on Crimes and Punishments* (1764; Albany, N.Y., 1872), 47–48, cited in Ferguson, "Rape and the Rise," 97. Caroline Ford's "The Seduction of Emily Loveday" (ms. given to me by the author) considers nineteenth-century French women's difficulty of speaking as legal subjects in relation to the problematic charge of *"séduction."*

28. *New York Times*, Apr. 17, 1991, 17A.

29. Smith testified that he was "picked up" (*Washington Post*, Dec. 11, 1991, A11. The *New York Post* reduced Smith's trial testimony to a "tale of seduction" (Dec. 11, 1991, 4). See also Smith's trial testimony cited in the *Boston Globe*, Dec. 11, 1991, 37.

30. Ferguson, "Rape and the Rise," 92.

31. Ferguson, "Rape and the Rise," 92. See also Estrich, "Real Rape," 38–56. In a fascinating article that appeared after this essay was written, Sharon Marcus argues for reading rape as a "linguistic fact," asking how the "violence of rape is enabled by narratives, complexes and institutions which derive their strength not from outright, immutable, unbeatable force but rather from their power to structure our lives as imposing cultural scripts" ("Fighting Bodies, Fighting Words," in *Feminists Theorize the Political*, ed. Judith Butler and Joan W. Scott [New York: Routledge, 1992], 388–89). Like Marcus, I am

convinced we must reconsider the ways "rape is structured like a language" (390), but I am equally convinced that we must study the scripts that have given the term "rape" meaninglessness as well as meaning if we are to, in her words, "conceive of female sexuality . . . as an intelligible process whose individual instances can be reinterpreted and renamed over time" (400).

32. Interview cited in *Newsweek*, Dec. 16, 1991, 23. Paglia develops this argument in "Rape and Modern Sex War," and "The Rape Debate, Continued," in *Sex, Art, and American Culture* (New York: Vintage, 1992), esp. 70, 74. The first of these chapters was originally published in *New York Newsday*, Jan. 27, 1991; the second, which includes Paglia's comments on the Smith trial, is an amalgam of letters to editors, and segments of interviews from 1991. Paglia's unsympathetic comments on Bowman appear on pp. 58, 69 and 73. Central to Paglia's arguments here and elsewhere is an opposition she draws between "real rape" (53, 69), or "actual rape" (58), and the experiences of women who participate in what she calls "date-rape propaganda" (69). Paglia declares that Bowman's experience "is not rape" "because everyone knows that Kennedy is spelled S-E-X" (58).

33. Paglia cited in *Newsweek*, Dec. 16, 1991. Similar statements appear in Paglia, *Sex, Art* 51, 56.

34. "The problem," U.C. Berkeley social welfare professor Gilbert supposedly claimed, "was one of definition," cited in *Newsweek*, Dec. 16, 1991. His article was published in *The Public Interest* in Spring 1991. See Paglia, *Sex, Art* 49–74, esp. 52, 58, 70–71, and 74.

35. See Sonnets 135–36, though they likewise give accounts of nonconsensual sex involving the man's will: "If thy soul check thee that I come so near, / Swear to thy blind soul that I was thy will" (Sonnet 136.1–2). See Stephen Booth's commentary on Sonnet 136 in his edition of *Shakespeare's Sonnets* (New Haven: Yale University Press, 1977), 466–67. This poem begins with a coaxing of the dark lady to consent, and concludes with a plea that the poet be named as "thy love" because his "name is Will." The suggestions that in naming himself as "will," he has also used more than language to seduce remain as overtones in a poem that puns delightfully on the power of naming and the lust it might engender. See Booth, 466–73. That the other significant locus of Shakespeare's punning on "will" occurs in *The Rape of Lucrece* offers even more powerful evidence of the dark undertones of such plays on words and sexuality. See Joel Fineman, "Shakespeare's *Will*: The Temporality of Rape," in Ferguson, *Misogyny, Misandry, and Misanthropy*, 25–76, reprinted in *The Subjectivity Effect in Western Literary Tradition* (Boston: MIT Press, 1991), 165–221. Fineman's unfinished book was to have been called *Shakespeare's Will* and would have explored, among other things, the way (in Greenblatt's words) "the name is itself the sign of a loss" (*The Subjectivity Effect*, xvi).

36. Stephen Fineman suggested this in relation to Shakespeare's plays on naming in a seminar in Spring 1991. See also Greenblatt's introduction to *The Subjectivity Effect*, p. xvi.

37. Cf. Kripke discussing Mill's *System of Logic* in *Naming and Necessity*, 26.

38. John R. Searle, "Proper Names," in *Speech Acts: An Essay in the Philosophy of Language* (Cambridge: Cambridge University Press, 1969), 172.

39. Saul A. Kripke, "A Puzzle about Belief," in *Meaning and Use*, ed. A. Margalit (Dordrecht: D. Reidel, 1979), 239–83. Such arguments enable Kripke, first in *Naming and Necessity*, 127ff., to draw firm analogies between the workings of *proper* names and those of "common names," or "terms for natural kinds" like "cow," "tiger," "gold," and "water." Mill argued, Kripke explains, that such "general names" had connotation while proper names lacked it (*Naming*, 134–35). Even such names, argues Kripke, have only an "illusion of necessity" (*Naming*, 139): they are always possibly missing their mark in a process of identification. This is why, in the course of this essay, I have allowed the problematics of "proper names" as such to blur with the problems of "naming," or giving terms to people, things, and acts. See also Nathan U. Salmon's discussion of the problems of sense and names in his review of Leonard Linsky, *Names and Descriptions*, *The Journal of Philosophy* 76, 8 (1979): 436–52. In his critique of Kripke, "The Causal Theory of Names," in *Naming, Necessity, and Natural Kinds*, ed. Stephen P. Schwartz (Ithaca: Cornell University Press, 1977), Gareth Evans makes a remark worth rereading into the puzzles about belief, naming, and terminology implied by Kripke's account of bilingual descriptions of London: "Although standardly we use expressions with the intention of conforming with the general use made of them by the community, sometimes we use them with the *over-riding* intention to conform to the use made of them by some other person or persons. In that case I shall say that we use the expression *deferentially* (with respect to that other person or group of persons). This is true of some general terms too: 'viol,' 'minuet' would be examples" (212). The "general" term "viol," translated out of its musical English context into French, names quite another story of conformity to use—precisely the one at stake, I have been arguing here, in the problems of naming: rape.

40. *Boston Globe*, Apr. 6, 1991, 6.

41. *Boston Globe*, Apr. 7, 1991, 1.

42. *Boston Globe*, Nov. 27, 1991, 8, reported that Smith's attorneys argued that "the right-wing political activism that dominated the 30-year-old Jupiter, Fla. woman's family could be an ulterior motive or persecution of the Kennedys, first family of liberal Democrats." See also *Globe*, Dec. 6, 1991, 22.

43. *Boston Globe*, May 12, 1991, 2.

44. *Boston Globe*, May 29, 1991, 3.

45. David Nyhan, *Boston Globe*, Dec. 16, 1991, A27.

46. *Time magazine*'s headline, Dec. 16, 1991, referred to "what was in a middle name."

47. The scandal, according to the article's subtitle, continued to revolve around his middle name: "William Kennedy Smith beat a charge of rape, but his famous family may

never be the same again." "Kennedy watchers," the article informed readers who might themselves fit this category "were passing judgment not only on William, but on the family." As if to demonstrate the insignificance of the "famous family name" on Smith's future, however, this intriguing person was three times named as just "William Smith" (*People*, Dec. 30, 1991–Jan. 6, 1992, 52).

48. *People*, Dec. 1991, 52.

49. *Boston Globe*, Dec. 13, 1991, 17.

50. *Newsweek*, Dec. 9, 1991, 26.

51. Smith and his lawyers' insistence on the divisive powers of names remained powerful well beyond trial testimony about Bowman's misidentification of him as Michael. "Yukking it up with reporters," *Newsweek* claimed as the trial began, "Smith answered a question about being called 'Will' Kennedy by defense attorney Black, 'I want to clarify this for everybody, . . . My name is Jerry Rivers [once rumored to be trash-TV king Geraldo Rivera's real name]. This is my mother Mrs. Rivers. You can call me Jerry' " (Dec. 9, 1991, 27). Not only was Smith's joke here dependent on an allusion to Geraldo Rivera's supposed masquerade as ethnic, a slur on the tabloid media his lawyers claim saw as exploiting the Kennedy name to smear their client, but it required that listeners view Rivera's change of name from the Americanized Jerry Rivers to the Hispanic Geraldo as somehow a violation of propriety. What kind of propriety did Smith and his lawyers expect names to have? And why could Patricia Bowman not convey her account within the same system of naming and identity that they managed to use to frame this case?

52. "Another Chapter in 'The Kennedys Play to Win,' " *Boston Globe*, Dec. 16, 1991, 11.

53. Ed Siegel, "Testimony from Smith Accuser Makes for Powerful Television," *Boston Globe* television column, Dec. 5, 1991, 86. "On CNN, Bigger Spot to Block the Spotlight," *Boston Globe*, Dec. 6, 1991, 22.

54. *U.S. News and World Report*, Dec. 23, 1991.

55. The married woman, of course, like the victim of statutory rape, may say "yes" to a man who is not her husband, but the law imposes upon her a "no" that brooks no desire. See Estrich, *Real Rape*, 72–79.

56. Steven Brill, president of Courtroom Television Network, and founder of *The American Lawyer*, cited in the *Boston Globe*, July 18, 1991, 3.

57. David A. Kaplan, "Remove That Blue Dot," *Newsweek*, Dec. 16, 1991, 26. Alan Dershowitz, "TV Should Show Smith's Accuser," *Boston Herald*, Dec. 9, 1991.

58. Ed Siegel, television critic for the *Boston Globe*, Dec. 5, 1991, 86.

59. Bowman's face and identity were not protected on television broadcast in other countries supposedly "because of the complications of satellite-fed TV signals" (San Francisco *Chronicle*, Dec. 10, 1991).

60. Ellen Goodman, "Sex, Consent and That Trial," *Boston Globe*, Dec. 8, 1991, 27A.

61. Thomas W. Laqueur, "Amor Veneris, Vel Dulcedo Appeletur," "Fragments for a History of the Human Body," *Zone*, 5, pp. 102–103.

62. I have made similar arguments in "Masquerading Women, Pathologized Men: Cross-dressing, Fetishism, and the Theory of Perversion, 1885–1930" (in *Fetishism: Essays in the History and Critique of a Cultural Discourse*, ed. Emily Apter and William Pietz [Ithaca: Cornell University Press, 1993]).

63. Joplin, "The Voice of the Shuttle," 35–64, esp. 55.

64. *Time*, Dec. 16, 1991, 31.

9

Lesbian Spectacles: Reading *Sula*, *Passing*, *Thelma and Louise*, and *The Accused*

Barbara Johnson

When I proposed this topic for a paper in this collection, my intention was to push myself to try something I have never done before: to read explicitly as a lesbian, to take account of my particular desire structure in reading rather than try to make generalizations about desire as such, even lesbian desire "as such." Much has been said about the theoretical and political issues involved in what Nancy Miller calls "reading *as a.*"[1] On the one hand, to the extent that dominant discourses have used the fiction of universality to ground their authority and to silence other voices, it is important for the voices thus silenced to speak for and as themselves. But, on the other hand, just because something has been silenced doesn't mean it possesses "an" identity, knowable and stable. Speaking "as a" plunges the speaker into new questions of reliable representativity and identity, as Nancy Miller suggests. If I tried to "speak as a lesbian," wouldn't I be processing my understanding of myself through media-induced images of what a lesbian is or through my own idealizations of what a lesbian *should* be? Wouldn't I be treating as *known* the very predicate I was trying to discover? I needed a way of catching myself in the act of reading as a lesbian without having intended to.

To accomplish this, I decided to look at novels or films that did *not* present themselves explicitly as "lesbian," but that could, through interpretation, be said to have a crypto-lesbian plot. I took my inspiration for such a textual category from two readings of literary texts: Barbara Smith's reading of Toni Morrison's *Sula* and Deborah McDowell's reading of Nella Larsen's novel *Passing*. I cite these critics not because they offer me examples of the act of "reading as a lesbian" (Smith does; McDowell does not) but because of the

nature of the texts they read. "Despite the apparent heterosexuality of the female characters," Smith writes of *Sula*, "I discovered in rereading *Sula* that it works as a lesbian novel not only because of the passionate friendship between Sula and Nel but because of Morrison's consistently critical stance toward the heterosexual institutions of male-female relationships, marriage, and the family."[2] She grounds her reading of *Sula* in the text's description of the shared fantasies of the friends, the erotic nature of some of their games, and the ways in which the text describes them as two halves of one whole.

Deborah McDowell, who had criticized Smith's reading of *Sula* for pressing the novel into the service of a sexual persuasion, soon made her own foray into lesbian criticism, writing not as a lesbian but as a decoder of lesbian structures of desire in the text, in her reading of *Passing*.[3] After detailing the overwhelming evidence of the fact that the security-seeking, ostensibly black-identified Irene Redfield is consumed with an intense, repressed, erotic fascination with the transgressive Clare, who is passing for white even within her own marriage, McDowell concludes that the plot of racial passing is a cover for an exploration of the more dangerous question of female-female eroticism, that the sexual plot is itself "passing" as a racial plot.

In both *Passing* and *Sula*, the intensity of the relation between two women is broken by a fall into triangulation. In *Passing*, Irene imagines that her husband Brian is having an affair with the beautiful Clare. The idea comes to Irene as she looks at her husband in a mirror in which she can also see herself. That is, she projects onto Brian her own fascination with Clare. The novel ends when Clare falls, jumps, or is pushed by Irene to her death.

In contrast with *Passing*, in which there is never any proof of the affair between husband and best friend, Nel, in *Sula*, happens upon Jude and Sula in the act. She tries to howl in grief and rage but cannot until, seventy pages later, after Sula's death, she realizes that she mourns the loss of Sula, not Jude.

For me, despite Barbara Smith's excellent use of textual evidence, *Sula* does not work as a lesbian novel, while *Passing* does. My first task, then, was to explain to myself why I felt that way. Sula and Nel are certainly central to each other's lives. They achieve genuine intimacy and recognize each other's

value, and the novel ends by showing how the veil of compulsory heterosexuality blinds women to the possibility of seeing each other as anything other than sexual rivals. In *Passing*, the two women remain intensely ambivalent about each other, perhaps even murderously so. Why, then, does my inner lesbometer find *Passing* more erotic than *Sula*?

I think it has to do with two things: the description of the long stare between Clare and Irene when they first meet after many years of separation, and the way in which the text is structured by Irene's constantly vowing never to see Clare again, and repeatedly going back on that vow. It is erotic to me that Irene's "no" constantly becomes a yes. The relationship is therefore overinvested and underexplained. This is what creates the effect of irresistible magnetism that is precisely *not* grounded in friendship or esteem. In *Sula*, on the other hand, while the relationship is certainly overinvested, it is also abundantly explained. My identifying signs of a lesbian structure, then, involved protracted and intense eye contact and involuntary re-encounters ungrounded in conscious positive feelings.

To test these categories on another pair of texts, I turned to movies. I remembered my first reactions to two films, one of which has sometimes been discussed as a candidate for lesbianism, the other, to my knowledge, not. The two films are *Thelma and Louise* (Ridley Scott, 1991) and *The Accused* (Jonathan Kaplan, 1988). While *Sula* and *Passing* describe the female-female bond as existing *before* the fall into the triangulation through adultery, *Thelma and Louise* and *The Accused* both build their female-female intimacy around the consequences of rape. Because the image of the rapists is so vivid in both films, many viewers and reviewers of the films could see nothing in the films beyond a negative image of men. While I do not think that the films' critiques of male sexual violence and of patriarchal institutions are irrelevant to my attempt to view them through lesbian spectacles, I do think that to focus on what the films are saying about men is to focus on men, and thus (for me) to view the films heterosexually. Indeed, to see the films as being about the viability of heterosexuality is to make invisible the question of what is or is not happening between the women.

Thinking back to my initial reactions to the films, I remembered my very

strong sense that I experienced *The Accused* as a lesbian plot while *Thelma and Louise* promised one but, for me, failed to deliver. My first justifications for these reactions might run as follows: Thelma (Geena Davis) and Louise (Susan Sarandon) hardly ever stop to look at each other—they are either looking straight down the road or Thelma's eyes are wandering toward sexually interesting men and Louise is attempting to keep Thelma's sexual appetite contained. Their intense exchange of looks and a kiss at the end comes too late to count—it is the adrenaline of death, not of desire. Their friendship is a given at the beginning, therefore there is no structure of involuntary return. My first impulse was therefore to say that their relationship was neither overinvested nor underexplained. But actually, it *is* underexplained. What are these two women doing hitting the road together? Why are they friends? What do they have in common? The point of departure of the road trip seemed to me psychologically incomprehensible, but not for that reason erotic.

In *The Accused*, on the other hand, from the moment deputy district attorney Kathryn Murphy (Kelly McGillis) picks up rape victim Sarah Tobias (Jodie Foster) in her car (and there is a lot of what Marge Garber calls "autoeroticism" in *both* films), the two women are intrigued by their differences, and cannot leave each other alone. The image of each woman bursting into the house of the other uninvited feels like an echo of the sexual violence around which the film is structured. That Murphy is centrally accused by Tobias of having silenced the victim she was supposed to be defending places her in a male role she has to spend the remainder of the film redeeming herself from. The long looks between the two women are looks across class, education, profession, and size. They fill each other's screen as objects of fascination, ambivalence, and transformation.

After I had finished the first draft of this paper, I looked through the literature to see whether there had not, in fact, been other lesbian interpretations of *The Accused*. The essay that sounded most promising, entitled "Up against the Looking Glass! Heterosexual Rape as Homosexual Epiphany in *The Accused*,"[4] turned out to be a reading of the film as an indictment of heterosexuality and a confrontation for the *male* spectator with the homosexual nature of *male* spectatorship in the film. But I also found out more than I

Jodie Foster and Kelly McGillis in The Accused. (AP/Wide World Photos)

Susan Sarandon and Geena Davis in Thelma and Louise. (AP/Wide World Photos)

bargained for, and I'm not sure what to do with it. It seems there were rumors of an alleged affair between Kelly McGillis and Jodie Foster during the filming of *The Accused*. Was this what I was seeing in the electricity between the two actresses? Or was their alleged affair itself an *interpretation* of what was happening on the screen? In a film that from the beginning blurred the relation between art and life—McGillis herself had been raped, and Foster pursued by a psychotic literalizer of one of her previous films—it is hard to pin down the origins of a reading effect.

However these overdeterminations may be factored in, what does it mean to say that for me *The Accused* "works" better as a lesbian film than *Thelma and Louise*? On some level, this reading does not make sense. For while Thelma and Louise eventually really get beyond any return to legal patriarchal heterosexual pseudoprotections, *The Accused* ends up validating the legal system, and Murphy and Tobias separate at the end, presumably never to meet again, each returning to a life of presumptive heterosexuality. What is lesbian about this? Isn't Murphy in the place of the one good cop in *Thelma and Louise*, the tragic consciousness that sees the limitations of an institution to which in the end he nevertheless remains loyal? Certainly the relationship between Thelma and Louise is progressively more real than any relationship that is set up between Murphy and Tobias. If I do nevertheless feel that *The Accused* presents me with a plot that corresponds to my own fantasies, I have to acknowledge the role of the patriarchal institution not in impeding those fantasies but in enabling them. Murphy is attractive to me because she is a powerful woman turning her full attention toward another woman precisely *within* the patriarchal institution. It is transference onto the phallic mother, the woman whose appeal arises from her position in a power structure, that infuses my reading of the film, simple as that.

So much for reading with the unconscious.

I thus have to conclude that the project of making my own erotic unconscious participate in my reading process, far from guaranteeing some sort of radical or liberating breakthrough, brings me face to face with the political incorrectness of my own fantasy life. In a post-Foucauldian world it is perhaps

more embarrassing to admit to the attraction of power than it is to confess to the appeal of violence in the era of Kitty MacKinnon. Any attempt to go on from this reading to theorize (my) lesbian desire would therefore have to confront the possibility of a real disjunction between my political ideals and my libidinal investments. But if the unconscious is structured by repetition and the political by the desire for change, there is nothing surprising about this. The question, still, would remain one of knowing what the unconscious changes, and what politics repeats.

NOTES

1. See Nancy K. Miller, *Getting Personal* (New York: Routledge, 1991).

2. Barbara Smith, "Toward a Black Feminist Criticism," in Gloria T. Hull, Patricia Bell Scott, and Barbara Smith, eds., *All the Women Are White, All the Blacks Are Men, But Some of Us Are Brave* (Old Westbury, N.Y.: The Feminist Press, 1982), 165.

3. Deborah E. McDowell, introduction to Nella Larsen, *Quicksand and Passing* (New Brunswick, N.J.: Rutgers University Press, 1986).

4. By Larry W. Riggs and Paula Willoquet, *Film Quarterly* 4 (1989).

10

Throwing Up/Going Down:
Bushusuru; or, the Fall of the West

Lee Edelman

If the narrative contexts available to account for the presence, let alone the activity, of one man's head in another man's lap seem to offer us only the binary alternatives of prurience or sentimentality—the alternatives, as one might put it, of giving head or giving succor—the ideological lenses that polarize these ways of coloring such a scene may blind us to the process whereby the insistence on one can filter out the effects and operations of the other. Thus in January of 1992 when audiences in Japan and America watched with horror and fascination as their televisions repeatedly presented them with images of President Bush throwing up on Prime Minister Miyazawa before collapsing into his lap, the machinery of the news media on both sides of the Pacific was obliged to construct a context in which to construe this unusual relation of ministerial lap to presidential head. The on-scene reporter for the *New York Times*, after noting, for example, that videotape of this episode "was repeatedly shown on television both here in Japan and in the United States," went on to observe immediately thereafter that "the President's host, Prime Minister Kiichi Miyazawa, cradled his head for some minutes until Mr. Bush was strong enough to get up on his own."[1] The verb of choice, "to cradle," which secures the necessary relation of sentimentality in defining the affect proper to this disturbing interaction, appeared as well in the translation of an article from Tokyo's *Nihon Keizai Shimbun*—a translation that extended the reach of this verb by invoking a related figure from its tropological penumbra: "The tape of Miyazawa cradling Bush's head after the president collapsed at a state banquet in Japan was shown over and over again on American television, and the sight was etched into American people's minds.

The scene was pregnant with symbolism of America's current need for help from Japan."[2]

The notorious promiscuity of figurative language may account for the reversal of cause and effect as the spectacle of one man cradling another impregnates the scene itself, but when the pastoralizing resonance of "cradling" starts to vibrate to the frequency of impregnation, the prurience of the spectatorial investment in this representation of two men and a cradling acquires an added charge from its pointedly heterosexual mediation. Indeed, to the extent that this scene must be registered as "pregnant with symbolism" in Japan and the West, the register of the symbolic has to labor, as it were, and to labor all the more manfully, to evacuate the unregenerate physicality of the body that the insistently regenerative trope of pregnancy might otherwise push to the fore. We are not meant, that is, to conceive of a body when we read the phrase "pregnant with symbolism," since the point, after all, of characterizing the scene as pregnant with symbolism in the first place, is to interpose between our gaze and the physicality of the body the very screen that enables us to register the body as symbolic. As the logic of trope in the deployment of the phrase replaces the emptied-out belly of a man with its allusion, made ghostly by convention, to the swollen belly of a woman, so the fullness of meaning with which the symbolic reading interprets this scene as "pregnant" must similarly displace the material substance of the president's emptied-out stomach; and if the circuit of figural exchange here requires that the commerce of the symbolic be routed through the substitution of one body for another, it is obviously not without meaning for the symbolic order of meaning itself that this substitution exchanges the embarrassment of two male bodies situated in painfully discomfiting intimacy with each other for the signifier—"pregnant"—that gestures not only toward an intimacy between bodies of different sexes, but also toward the redemption of heterosexual intimacy from the taint of the merely prurient, which is to say, from the taint of the material body as such, through its invocation of the spiritualizing work of reproduction. Pregnancy itself here, in other words, names the sentimentalization of prurience that can be seen to allegorize the birth of the symbolic out of a real that is thereby both evacuated and made visible at once.

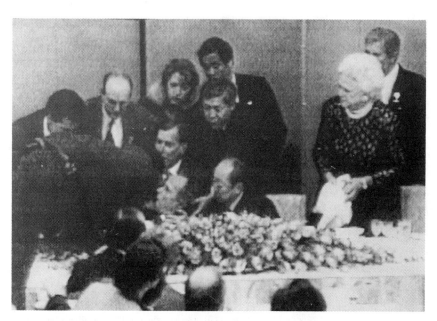

President Bush (center left) being "cradled" by Prime Minister Miyazawa (center right).
(AP/Wide World Photos)

If the real can be understood as that excess of the thing that refuses assimilation or containment within the network of the signifier, if it is, as Lacan describes it, "beyond the . . . insistence of the signs,"[3] my reading, it goes without saying, can offer no access to the real of this scene; it can only repeat in a different way the gesture that empties it out. For to read this scene at all is necessarily to read it as "pregnant with symbolism," even if that reading insists on defining the event as "a simple case of the flu"[4] and imbuing it, in so doing, with the symbolic meaning that constitutes the particular discursive prerogative of contemporary medical science. Any reading or representation of Bush's vomiting and subsequent physical collapse will inevitably reenact the projective evacuation of the unassimilability of the real, an evacuation that doubles or allegorizes Bush's own disgorging or evacuation of some unassimilable material substance. But while reading, to the extent that it translates the real into something apprehensible, must perceive it as "pregnant with symbolism," my own reading wants to attend to the relation between the occlusion of the real by the symbolic and the occlusion—though occlusion precisely of what remains, perhaps, to be seen—performed by defining through figures of heterosexual productivity the inherence of meaning in this particular scene whose centerpiece, literally occluded or cut from the videotapes that were shown to the public, is the intimate transfer of bodily fluids from one man to another.

To provide a framework within which to allow us to think about this scene, I want to turn to a passage from Lacan that will have the effect of bringing us back to the representations of Bush's collapse. "When diplomats are addressing one another," Lacan writes,

> they are supposed to represent something whose signification, while constantly changing, is, beyond their own persons, France, Britain, etc. In the very exchange of views, each must record only what the other transmits in his function as signifier, he must not take into account what the other is, *qua* presence, as a man who is likable to a greater or lesser degree. Interpersonal psychology is an impurity in this exchange.[5]

LEE EDELMAN.

This passage can be read as glossing Lacan's meditations on the subject's constitutive subjection to his status as a signifier, as an instance of the fading of being into meaning on which the symbolic depends. The real, in this context, is the excess for which the signifier cannot account, evoked here, in language that borders, but only borders, on the positivistic, as "what the other is, *qua* presence." What the other "is" and "presence" are not identical in this phrase; it is only "*qua*" presence that what the other "is" can in any way be known. For Lacan as for Wallace Stevens, we might say, "is" is only made available to us as "as" in the symbolic order. The displacement of being by meaning, therefore, that produces the split between the diplomat and the man likable to a greater or lesser degree produces an analogous split between the man who is likable and the real of what he "is." To the extent that this passage can allegorize the relation of the signifier, in this case the diplomat, to the real, or "what is, *qua* presence," within the workings of a symbolic economy, it is striking that the threat to this economy, "the impurity in this exchange," finds representation through a disturbance effected in the system of diplomatic interaction by taking into account the affection, or even the desire, that translates a diplomat into a man who cannot ignore the fact that he finds another man "likable to a greater or lesser degree." This is not to say that same-sex desire is somehow, in itself, the real, or that same-sex desire is unrepresentable within the network of the signifier, but rather that a symbolic order that rests on the regime of heterosexuality figuratively aligns the "impurity" that threatens to interrupt the production of meaning with the latency in the body—and the male body in particular—of an excess that threatens to expose as illusory the symbolic reality of the subject. The real, in other words, itself unrepresentable within the order of the signifier, is allegorized and displaced fantasmatically into a condition of latency in the body of the male. The anxiety produced by that latency must be answered by the technology of representation working to reinsert the body into the dominant matrix of heterosexual signification—the matrix that generates the symbolic by inscribing the body with the social meaning that renders it intelligible. The effect is a compulsory hystericization of the male body within the symbolic order in an effort to make it conform to the signifying imperatives that constitute the

171

subject—a normative hystericization within a heterosexual order of meaning that achieves a spectacular embodiment in the person of George Bush.

In returning from Lacanian theory to the spectacle of George Bush's collapse in Japan (which produced a neologism among the Japanese: *bushusuru*, "to throw up, to do a Bush"), I want to align the threat to the symbolic, the impurity that disrupts the diplomatic exchange, with the occulted moment of impurity cast out of the videotapes as publicly released: the impurity, to be less oblique, of seeing President Bush in the process of throwing up, in the process, that is, of casting out impurity as he lapses into, or better yet, is appropriated by, the unconscious, and enacts in his body a lapsus, so to speak, by going down in the prime minister's lap. Watching the videotape responsible as much for producing as for chronicling this scene, we can recognize the moment of rupture where, for reasons of "taste," of course, what can be seen (that is, what can be shown) is only the absence in the videotape where there is something that *cannot* be seen. That gap in the symbolic construction of this episode commemorates, and paradoxically makes visible, the moment of impurity that is stigmatized for bearing the figural burden of the body's implication in a presymbolic materiality. Drawn down into the condition of unreadable matter, the body, as if gravitationally falling away from its standing in relation to the subject, is allowed to point only metonymically in the videotape toward the repudiated impurity of the real through its framing as the object whose deathly bulk would seem, on the face of it, to topple the fiction that it could possibly submit to being cradled. The unwieldiness, the heft of the body that the president's men and Prime Minister Miyazawa so strenuously struggle to support, testifies to the fact that a president, no less than a king, is also a thing. And yet the iconographic force of these images in the sequence as edited and shown, the force that made these tapes so compelling for East and West alike, consists in the apparent redemption of the body from the fatal pull of the real by its figural resurrection into meaning through the very machinery of representation. By this I mean to call attention to the visual citation, in the videotapes and in the photograph that was printed in magazines and newspapers around the world, that construes in the relationship of Bush and Miyazawa the lineaments of a secular pietà—a citation that

prepares the way in the videotape for the quick cut to President Bush shown back on his feet again, attempting to reaffirm, however sheepishly, authority over his body and the spectrum of its meanings.

Now the subliminal iconography of the pietà comports with the heterosexual elaborations of this scene through figurations of pregnancy and cradling; indeed, it reasserts the emergence of the subject as the cultural work of the symbolic family. But the figural surround that would insert this moment into narrative structures that are predicated on a reading of narrative itself as an articulation of the law of heterosexuality, can only, once outed, make clear the necessity of containing or managing acts of physical intimacy between or among the bodies of men that threaten, however fantasmatic the threat, an obtrusion of the real. The fascination for me of this incident, then, which is nothing in itself, lies precisely in the way it automatically provokes the energies of containment that are central to the dominant representational regime that micromanages perception from moment to moment in everyday life. Without any need to posit a consciousness alert to the possibility that the president's nausea and subsequent collapse into the prime minister's lap might draw on the time-honored heterosexual fantasy of a gay male sexuality being shoved down its gagging throat; without any need, that is, to imagine a mobilized awareness in relation to this scene of how the scene itself reverses that fantasy's protestation that the notion of a man going down must "naturally," as if somatically, precipitate the violence of throwing up, reverses it to allow for the recognition instead that throwing up might provide—through illness or in fantasy—an excuse for a scene of going down; without any need to propose, in sum, that same-sex desire was at any moment visible to anyone in the representational construction of this scene, we can see that the framing nonetheless works precisely, and all the more precisely for working automatically, to assure the invisibility of the spectacle of male-male intimacy or desire that was never at any point considered by any consciousness as having been there to be seen at all.

It is not, therefore, remarked upon, or properly speaking remarkable, that the embarrassment of a scene that improperly foregrounds the bodily relations of two men must be organized into a narrative that celebrates the redemptive

presence of a woman. "Saved by the Grace of Barbara Bush," a headline in the *New York Times* declared, and an article in the *Times* of London observed:

> While America groaned yesterday at the humiliating end to George Bush's attempt to play the tough trade enforcer in Japan, the country drew some consolation from the extraordinary performance by his wife, Barbara. . . . In a few brief words, delivered amid uncertainty over her husband's true condition, she managed to counter the damaging images of presidential frailty and shore up the notion of his authority.[6]

What, one might disingenuously ask, is a wife for, after all, if not to shore up the authority of the heterosexual symbolic, the Name-of-the-Father, by rescuing it from the humiliating eruption of that excess resistant to containment in the organizing narratives that cradle us all as subjects?

Let us notice, then, in this regard, that in the videotape documenting the president's collapse, a collapse that immediately preceded his scheduled delivery of a ceremonial toast, we never hear the president's voice. Even after his recovery we only see him gesture in dumb show, as if the embarrassment of the body in figural proximity to the unincorporable, unarticulated matter or stuff of the real deprived him of voice in the symbolic, disallowed him access to language. Once the president, or the president's body, however, is safely removed from our sight, we are given in his place both the image and the voice of Barbara Bush instead, who, as the *Times* of London put it, "after her limp husband had staggered out of the room . . . managed to crack a joke"—a joke, as we might have anticipated, immediately represented as "loaded with symbolism."[7] The joke in question was Mrs. Bush's diagnosis of her husband's unprecedented nausea and fainting spell as responses to his unaccustomed loss that afternoon to the emperor and crown prince of Japan in what was billed as a friendly game of tennis. The symbolic force to which the reporter refers would lie in the willful reconstruction through the joke of her husband's body as athletic and his manly resolve as unyieldingly firm. But rather than suggest that this joke is symbolic, might we not say that the implicit narrative through which this whole incident gains representation has, like the symbolic order itself, the structure of a joke insofar as its operation

produces meaning out of nonsense, making what is extraneous, what is materially in excess of signification, signify? So viewed, the joke lies not so much in what Barbara Bush has to say as it does in the representational necessity of producing her in the place from which she can say it.

The substitution, that is, of her body for the evacuated body of her husband, performing that social economy that the *Times* of London defined as "face-saving," serves to associate her face with his and thus to affirm the narrative logic that configures heterosexuality with the presence and the reproduction of meaning. Yet by offering her face in place of his, such representations also make evident that face here necessarily serves as a figure, a substitution of one thing for another, and that if diplomacy, like the symbolic, insists that one face can stand for another, effacing the impurity of the body's specificity as a relation to the real, that insistence doubles the process whereby the signifier "face" itself can misname through synecdochic totalization the body conscripted into the order of social meaning and regulation. That the face of Barbara Bush should be where the face of George Bush was, may reappropriate George Bush's body, then, for the heterosexual order of meaning, but it surely signals, at the same time, a more disruptive possibility as well. It reinforces what I referred to earlier as the normative hystericization of the male body obliged to represent on and as itself the "natural" authority of a symbolic system designed to occlude its own status as the historically-specific, and hence neither "natural" nor inescapable, machinery of representation. Barbara Bush, as the other face of George in the renderings of this episode, unveils, we might say, the extent to which George is just another face; standing in for her husband she exposes her husband as already a stand-in himself, as one whose frenetic stagings of his body attempt to obey, however unsuccessfully, the injunction to represent the discipline of masculinity as neither a discipline nor a process requiring the energies of representation at all. The joke, if you will, of Barbara Bush's enshrinement as the savior of her husband's face, then, is that in the process of substituting her face for his she gives his face away, calls attention to the fact that he has no face, that he is, instead, as this incident seems to underscore all too vividly, only a mouth in desperate pursuit of a face to call its own.

That the embarrassment in Japan could so readily assume its status as a defining image for both the Bush presidency and the nation he represented testifies to its peculiar capacity to instantiate the anxious orality that Bush publicly enacts in his efforts to make his body perform the symbolic work of masculinity. Can it be, after all, mere coincidence that Bush's vomiting in Japan seems an overly literal repetition of the single most memorable utterance of his presidential career, the phrase with which he will always be associated in the nation's memory: "read my lips"? That phrase, which uncannily ironizes not only the nausea, but also the dumb show that the videotape records, would register authority by suggesting that the meaning of any statement that passes those lips matters less than the fact of its enunciation by a body in control of its meanings. Crucially, though, that phrase, which speaks volumes about Bush's desire to represent himself as the embodied voice of the symbolic Other, is only, of course, an appropriation of the voice and body of someone else—of Clint Eastwood, who, like Ronald Reagan, possesses what Bush as a public figure so thoroughly lacks: the ability to embody, without visible effort, the natural assurance of phallic authority in the national imaginary. Bush, by contrast, makes even his acts of relaxation seem laborious insofar as they reveal his ghastly determination to mean what he cannot be, to incorporate into his own the masculine body as signifier of symbolic authority—a signifier beneath which his own body, like the surfeit of the real, is only able to slide by making a disconcertingly eroticized spectacle of itself and its desire. That incorporative fantasy, persistently paraded in the anxious efforts to keep it concealed, identifies Bush, in the national imaginary, with homophobically abjectified drives toward oral and anal gratification. Famous for what the *New York Times* called his "well-known problems with syntax,"[8] skewered by Ann Richards, in a celebrated quip, as having been "born with a silver foot in his mouth," Bush, even before he said "read my lips," and long before he threw up in Japan, had been defined by the inappropriate things that both went into and came out of his mouth. And this too figures, though figures to no one, to no consciousness that ever discerned it, in the energies of representation deployed to contain the embarrassing contiguity of the president's mouth and

the prime minister's lap. Consider after all, in relation to this highly fraught axis of mouth and lap, the terms with which George Bush characterized his prepresidential niche in the consciousness of his country: "take the word 'Quayle' and insert the word 'Bush' wherever it appears, and that's the crap I took for eight years. Wimp. Sycophant. Lap dog. Poop. Lightweight. Boob. Squirrel. Asshole."[9] It requires no finely tuned ear to detect the hysteria informing this catalogue of the ways the Bush body fails in its efforts to register as adequately masculine—and fails, indeed, through the very excess of its desire so to be registered. The *Times* of London thus put it just right in remarking on Bush's inability "to play the tough trade enforcer with Japan," for Bush's gaping mouth becomes the emblem of heterosexual masculinity's impossible desire to perform an identification with, and an appropriation of, the symbolic male body that is never its own without making visible the inscription of that process in the register of desire.

In order to conclude these remarks on the representational economies engaged in the symbolic construction of the scene of the president's collapse, it remains to consider the particular inflection produced when the quondam "lap dog," become the leader of the Western world, winds up going down with his face in the lap of the prime minister of a particular country: Japan. To the extent, after all, that this scene recapitulates the president's own impossible desire to occupy the place of the Other, the name by which the Other goes in this scene is, precisely, Japan. If, therefore, the management of this scene must control the explosive excess of meanings that it registers in terms of the body, and if such efforts to control that excess are entangled with larger questions of representation in the symbolic order, the framings of this scene cannot fail to record some trace of the racial fantasies that inform the social relations of the body and the accounts of its desires. In this context the difference between the Western enactment of the male body's normative hysteria within a heterosexual symbolic order and the Western fantasmatic of the Japanese body could hardly be more pronounced. In the racial imaginary of white America and much of Western Europe as well, Japanese bodies are construed as interchangeable, as constituted less by their individuality than

by their participation in a social mass. While this, historically, has contributed to the Western ascription of passivity and effeminacy to the Japanese male, following upon the triumphant expansion of Japan's postwar economy, the Japanese body increasingly appears in the racial imagination of the West as indistinguishable from the high-tech machinery that has provided the engine for economic success. Fantasized as mechanistic, efficient, and barely differentiable from the robotics with which it finds itself metonymically associated, the Japanese body becomes the token of a regulated economy of desire and it acquires thereby the capacity to figure the smooth, uninterrupted workings of the machinery of the symbolic: the unproblematic disappearance of the subject beneath the signifier without any disturbing excess of bodily specificity, without any insistent inscription of bodily desire. Japan, in this context, becomes the fantasmatic site of the very mechanics of representation, a veritable empire of signs, and thus it becomes, both literally and figuratively, the camera through which the West, in this scene of embarrassment, is required to see itself. As such it changes places with the West in the active/passive binarism, acquiring, in the fantasmatics of cultural identity, the cachet of aggressive potency that has decisively shaped the self-image of an America that construes itself now, homophobically, as "getting screwed" by Japan—a construction that expresses its desire to take in, to incorporate, the authority of a symbolic economy that "Japan" has come to name. "Japan," then, figures the place of the gaze from which the symbolic looks at us, the place that we, like Bush, try to occupy by returning repeatedly to the scene of this fall as if by properly taking it in we might somehow cast out what disturbs us about it and redeem it through a symbolic reading that not only would make it a fortunate fall, but also, in the commerce of the symbolic, would cancel the deficit in our trade with Japan.

Postscript

As if to confirm the logic of hysterical orality that this essay perceives in the unspoken erotics (representable only as "disgust")[10] informing President Bush's experience of throwing up and going down in Japan, the *New York Times* printed, three months after this essay was originally delivered, the

following account of an anecdote Bush included in a campaign speech warning America against Bill Clinton, his Democratic opponent in the 1992 presidential race: "The story," as the reporter for the *Times* described it, "ended up painting Mr. Bush as a gladiator, buried up to his neck in sand, and Mr. Clinton as the lion attacking him. 'As he did the gladiator reached up and took a very ferocious bite in a very sensitive place in the lion's anatomy,' Mr. Bush said."[11] To this spectacularly self-revealing anecdote there is little a critic need add: only, perhaps, that when viewed in the context of his ill-fated trip to Japan, it makes vivid that where Bush and the complex relations entangling the male body are concerned, what the Western symbolic insists on casting out is the representation or expression of desire for what it insists, at the same time, that the subject must incorporate or take in; and thus, as Bush's disarmingly graphic self-portrait from the campaign trail suggests, his "barf" is not only not worse than, but also not different from, his bite.

Notes

1. Michael Wines, "Bush Collapses at State Dinner with the Japanese," *New York Times*, January 9, 1992, 1.

2. Yashuhiro Tase, Tamura Hideo, and Takeyuki Kumamura, "Trade Tension," translation from the *Nihon Keizai Shimbun* published in the *World Press Review*, April 1992, 11.

3. Jacques Lacan, "Tuché and Automaton," in *Ecrits: A Selection*, trans. Alan Sheridan (New York: Norton, 1977), 53–54.

4. This is the characterization offered by the White House Spokesman, Marlin Fitzwater, in the *New York Times* (Michael Wines, "Bush Collapses," 1).

5. Jacques Lacan, "The Subject and the Other: Aphanisis," in *The Four Fundamental Concepts of Psycho-Analysis*, ed. Jacques-Alain Miller, trans. Alan Sheridan (New York: Norton, 1981), 220.

6. "Saved by the Grace of Barbara Bush," *New York Times*, January 9, 1992, A8; Charles Bremmer, "Charm, a Joke, and Damage Control Lesson," *Times* (London), January 9, 1992, 6.

7. Charles Bremmer, "Charm, a Joke, and Damage Control Lesson," 6.

8. Lawrence K. Altman, "The Doctor's World," *New York Times*, February 18, 1992, C3.

9. This quotation was cited by Senator Alan Simpson and printed in *Newsweek*'s "Overheard" column on January 20, 1992, 13.

10. For a cogent analysis of the phenomenon of "disgust" see Joseph Litvak, "Delicacy and Disgust, Mourning and Melancholia, Privilege and Perversity: *Pride and Prejudice*," forthcoming in *qui parle*.

11. "Bush Says Rival Would 'Pull a Fast One' over Taxes," *New York Times*, August 7, 1992, A14.

11

Monsters of Perversion: Jeffrey Dahmer and *The Silence of the Lambs*

Diana Fuss

[H]uman life is still bestially concentrated in the mouth.
—Georges Bataille, *Visions of Excess*[1]

If, in the popular imaginary, gay male sexuality can be said to have an erotogenic zone of its own, its corporeal "repository" may well be the spectacularized site of the anus. Currently, some of the most provocative readings of male sexuality focus on interrogating the cultural priority attributed to the anus across a spectrum of iconographic representations of homosexuality— representations that variously eroticize, hystericize, and demonize the orifice behind. D. A. Miller, for instance, in a dazzling reading of Hitchcock's *Rope* (entitled, appropriately, "Anal *Rope*") uncovers a phobic terror of the eroticized backside "wound" as the very spur to Hitchcock's fantasy of a film without cuts, a movie without a single "penetratable hole in the celluloid film body."[2] Lee Edelman's "Seeing Things: Representation, the Scene of Surveillance, and the Spectacle of Gay Male Sex" is an elegantly nuanced reading of the idea of "behindsight" in Freud's analysis of the Wolf Man and the role the anus plays in inciting castration anxiety; as a site of penetration, the anus operates for men as a "phobically charged" orifice that Freud suggests must be actively repudiated if the male subject is to submit to the law of castration and to the imperative of heterosexualization.[3] And Leo Bersani, in an ambitious exposé of anal politics, reminds us in his essay called "Is the Rectum a Grave?" that even "in cultures that do not regard sexual relations between men as unnatural or sinful, the line is drawn at 'passive' anal sex."[4] Bersani's immediate concern

is with contemporary public discourse about AIDS, specifically the abjectification of the rectum as a site of criminality and certain fatality—a contaminated, contaminating vessel. The anus routinely figures as the overdetermined cultural localization of male homoerotic desire, thanks in large part to Freud's insistence that it is specifically the body orifice of the bowels that plays a major role in strengthening the "passive trend" necessary for the development of a "homosexual" object-choice.[5]

I would like to suggest that alongside the scene of intercourse *per anum* between men, modernist culture offers quite another spectacle of male homosexuality, one based on oral, rather than anal, eroticism. This other sodomitical scene, organized around the sexual practice of fellatio, does not displace so much as *extend* and *stretch* the priority accorded to anality in symbolic configurations of male homosexuality. Notions of anal incorporation cannot help but to invoke tropes of orality; the anus operates in many ways as a kind of displaced mouth or second oral cavity, an organ that can take in as well as eject, just as the mouth can expel as well as receive. Mouth substitutes for anus, and anus for mouth, as each comes to symbolize the gaping, grasping hole that cannibalistically swallows the other. I will be discussing in this essay two recent media spectacles that create public terror in large part by summoning this archaic definition of gay sexuality as oral insatiability. Jonathan Demme's 1991 Oscar-winning horror film, *The Silence of the Lambs*, and the sensational story of Milwaukee serial killer Jeffrey Dahmer ("a real-life *Silence of the Lambs*," in the words of *People* magazine)[6] together demonstrate how the advent of a new public fear of cannibal murder and the intensification of an old and especially virulent form of homosexual panic can converge in a potent, explosive, and dangerous way to brand homosexuality itself as "serial killing." Before turning directly to the subject of serial killing, I would like to take a closer look at the psychoanalytic narratives of oral eroticism and sexual perversion that give these contemporary stories of human monstrosity their peculiar representational power. In the history of Western psychoanalytic representations of the ravenously hungry, insatiably promiscuous male invert, *gay sex has always been cannibal murder.*

Heads or Tails?

Like the wing of stamin (death), the membranous partition [*cloison*] that is
called the soft palate, fixed by its upper edge to the limit of the vault,
freely *floats*, at its lower edge, over the base of the tongue. Its two lateral
edges (it has four sides) are called "pillars." In the middle of the floating
edge, at the entrance to the throat, hangs the fleshy appendix of the uvula
[*luette*], like a small grape.

 —Jacques Derrida, *Glas*[7]

The most archaic of the sexual organs and the least developed of the libidinal
zones, the sensitive mucuous membrane of the mouth provides us with our
earliest sexual experience: "sucking at the mother's breast is the starting-point
of the whole of sexual life, the unmatched prototype of every later sexual
satisfaction, to which phantasy often enough recurs. . . ."[8] Each of Freud's
oral, anal, and phallic phases of infantile sexuality corresponds to a different
bodily function, with the satisfaction the child obtains from eating preceding
the pleasure it later derives from either rectal stimulation or phallic masturba-
tion. But despite the originary status accorded to the mouth in this develop-
mental hierarchy of erotogenic zones, Freud's theoretical "discovery" of the
anal phase precedes that of the oral phase by a full two years, and that of the
phallic phase by almost a decade. Freud's famous theory of the three partial
drives makes its dramatic entry onto the psychoanalytic stage *arse backwards*;
the anus comes first, in the context of his 1913 work on male homosexuality
and the critical role its repression plays in the obsessional neuroses. Not until
the third edition of *Three Essays on the Theory of Sexuality* in 1915 does Freud
finally distinguish between the "oral or cannibalistic phase" and the "sadistic
anal phase," adding the "phallic phase" much later in a 1923 rethinking of
the question of "the infantile genital organization."[9]

 In the adult subject, the libidinal impulses are themselves coterminous,
simultaneously active as each sexual drive fights to achieve dominance over
the other. Commentators on Freud's theory of the drives tend to emphasize
their dynamism and porousness: "oral fantasies about assimilating objects

through the mouth will be connected with anal fantasies about assimilation through the anus, and similarly anal fantasies about defecating will correspondingly be associated with phallic fantasies about losing the penis."[10] The mouth, in other words, provides at least as much castration anxiety as the anus, with the latter once again assuming the properties of a second oral orifice. Mouth and anus, both fated in this sexual allegory to yield to the dominion of the phallus, are less opposite than analogous, and, as such, infinitely substitutable. The intimate relations between these two orifices may well explain their conspicuous absence from those catalogues of symbolic polarities that cultural theorists identify as upholding normative sexual behavior. For instance, Eve Sedgwick's self-described "bravely showy list of binarized cultural nexuses,"[11] totaling nearly forty pairs, includes active/passive, private/public, health/illness, natural/unnatural, subject/object, in/out, and masculine/feminine (to name just a handful)—but not oral/anal. And rightly so: the mouth/anus opposition was never really part of a symmetrical pair to begin with, perhaps because the shadow of the phallus already loomed large in Freud's corpus as a potential third term, permanently disorganizing the equation. Freud, while refining his theory of succession to acknowledge that each early phase persists alongside of and behind the later configurations, nonetheless insists that as organs of sexual desire, mouth and anus must be "abandoned"[12] in favor of the genitalia if the subject is to attain sexual maturity. Failure to relinquish these "primitive" and "primordial" zones accounts for the appearance of what Freud calls the human sexual perversions.

Perversion is fundamentally a question of how organs are used and with what degree of "exclusiveness" and "fixation."[13] These two latter criteria are the distinguishing features that separate "normal" from "perverse" sexual acts, *even if these acts are structurally identical*. Oral and anal eroticism, in this account, are not in themselves perverse; Freud attempts to clarify in *Three Essays on the Theory of Sexuality* that the "differences separating the normal from the abnormal can lie only in the relative strength of the individual components of the sexual instinct and in the use to which they are put in the course of development" (205). Thus Freud can assert, with no apparent

fear of contradiction, that "preference" for anal intercourse "is in no way characteristic of inverted feeling": "on the contrary, it seems that *paedicatio* with a male owes its origins to an analogy with a similar act performed with a woman" (152). And looking back on the fantasy of fellatio in the Dora case (a fantasy that arguably is more Freud's than Dora's), Freud can reassure us that "there was no need to be too much horrified at finding in a woman the idea of sucking at a male organ," for after all this "repellent impulse" has "a most innocent origin, since it was derived from sucking at the mother's breast."[14] Only when mouth and anus become the *exclusive* sites of sexual activity does the subject who performs these acts cross the invisible border into the lawless terrain of the perversions. It appears that Freud, in the end, wants to have his phallus and eat it too.

Initially, intercourse *per anum* seems to constitute for Freud the central defining feature of a homosexual erotics for men. Anal fixation is offered as the key to unlocking the secret of the Wolf Man's fear of being eaten by a wolf and the Rat Man's terror of rats boring into his rectum—two animal phobias Freud associates in his clinical writings with unresolved homosexual desire for the penetrating, castrating, devouring father. Anal eroticism also plays a bit part in Little Hans's fantasy of babies born through the anus, and a more central role in Schreber's transvestic desire to become a woman and to be penetrated by the rays of God.[15] However, all of these analysands are merely "contingent" inverts in Freud's sexual typology, men who engage in homosexual acts only "under certain external conditions."[16] Freud's first extended discussion of a "manifest" homosexual—his psychoanalytic biography of Leonardo da Vinci—isolates oral rather than anal eroticism as the principal residual drive that organizes and sustains the homosexual identity formation. In Freud's enthusiastic estimation, Leonardo was the "rarest and most perfect" homosexual type, the "ideal" homosexual[17]—ideal because he sublimated his homoeroticism into acts of adventurous intellect and breathtaking artistry. "Ideal" homosexuality can only be achieved, paradoxically, through its own ruthless repression. The artist's "frigidity" and "abstinence" (69–70) serve as the very precondition of his genius; Leonardo embodies for Freud "the cool

repudiation of sexuality" (69), a man whose every passionate impulse has been rerouted into an "insatiable and indefatigable thirst for knowledge" (75). How then, on the basis of his subject's presumed lifelong chastity (70), does Freud retrospectively arrive at the thesis of Leonardo's *manifest* homosexuality?

Freud bases his reading of Leonardo's "manifest, if ideal [sublimated] homosexuality" (98) on the single memory from infancy recounted in the artist's notebooks—a memory, not insignificantly, of orality: "It seems that I was always destined to be so deeply concerned with vultures; for I recall as one of my very earliest memories that while I was in my cradle a vulture came down to me, and opened my mouth with its tail, and struck me many times with its tail against my lips" (82). The "memory" of the vulture's tail beating about inside the child's mouth, Freud goes on to explain, actually corresponds to a later homosexual fantasy of fellatio transposed back into a childhood memory of suckling at the mother's breast. By reading the bird's tail as a figure for both penis and breast (elsewhere Freud describes the penis as the "heir of the mother's nipple"),[18] Freud thinks he has uncovered the psychical connection between homosexuality and the maternal, the symbolic link that makes every act of fellatio a reexperiencing or reenactment of the preoedipal nursing phase. The symbolic importance of the vulture—in Christian legend a female bird and in Egyptian hieroglyphs a symbol for motherhood—is the sole evidence supporting Freud's hypothesis that fellatio is no more than an emotional relic of the oral-cannibalistic phase. For his historically belated analysis of this oral fantasy, however, Freud relies upon a faulty German translation of Leonardo's scientific notebooks. The Italian *"nibbio"* refers not to a magnificent vulture, with all its rich mythological, religious, and cultural associations, but to an ordinary *kite*, a small or medium-sized bird of the falcon family with a weak bill and a forked tail. We also know that Freud was informed of his mistake by Pfister as early as 1923 but refused (uncharacteristically) to make any significant revisions in the Leonardo paper, a work that he believed, in an act of unconscious identification with his artistically gifted subject, to be "the only beautiful thing" he had ever written.[19]

Is it any coincidence that 1923, during which Freud learned of his embar-

rassing gaffe, is the same year he discloses the importance of the phallic phase in infantile sexuality and the very same year he is diagnosed with cancer of the mouth? By spring of this eventful annum, the throbbing pain in his mouth, from a malignant growth on the palate too swollen to be ignored, finally convinced Freud to submit to the surgeon's knife in a botched operation where the injured doctor-patient nearly bled to death on the operating table. Little wonder that the mouth became for Freud a traumatized site, a zone where physical and psychical pain were centrally concentrated in the sore, tender, and afflicted mucous membrane of the oral cavity.[20] Could it be that the decidedly phallic protuberance on his palate pushing down into the throat left more than a slight taste of fellatio in Freud's mouth? And what are we to make of the fact that if something did stick in his throat, its removal—the cut of castration—nearly proved fatal?

To pose one final question before turning to two more contemporary narratives of oral cannibalism, how does this psychoanalytic model account for a homosexuality that is *not* fully sublimated into acts of high intellectual or artistic achievement—that is, for a "manifest" homosexuality truly deserving of the name? What happens when the oral and anal erotogenic zones are not "abandoned" but enjoyed, not "relinquished" but accommodated, not "repressed" but gratified? For Freudian psychoanalysis, there is another "class of perverts" who, "in their multiplicity and strangeness . . . can only be compared to the grotesque monsters painted by Breughel." This group of "monsters" includes (in this precise order): those who "replace the vulva, for instance, by the mouth or anus"; those who eroticize "the excretory functions"; those who desire part objects and can properly be called "fetishists"; and finally, the most heinous group of all, those who "require the whole object indeed, but make quite definite demands of it—strange or horrible—even that it must have become a defenceless corpse, and who, using criminal violence, make it into one so that they may enjoy it. But enough of this kind of horror!"[21] That oral and anal sex, which inevitably carry with them the "taint" of homosexuality, find themselves on the same list as necrophilic murder, with only coprophilia (abnormal obsession with excrements) and

fetishism between them, suggests a "slippery-slidey slope" model for the so-called sexual perversions. This startling juxtaposition is not the only occasion homosexuality finds itself in such unsavory company; casual asides such as "whether a man is a homosexual or a necrophilic . . ."[22] are commonplace in the psychoanalytic literature and speak powerfully to a careless conflation of two terms assumed to be not exactly identical, but not significantly different either. The psychoanalytic morbidification of homosexuality upholds and lends scientific legitimacy to a wider cultural view of gay sexual practices as inherently necrophilic.

In the psychoanalytic model of sexual perversion I have been discussing, male homosexuality is represented as fixated at the earliest stage of the libidinal organization—the oral-cannibalistic stage—in which the recalcitrant subject refuses to give up its first object (the maternal breast and all its phallic substitutes). Instead, the male homosexual *ingests* the (m)other, "puts himself in her place, identifies himself with her, and takes his own person as a model in whose likeness he chooses the new objects of his love."[23] Oral-cannibalistic incorporation of the mother not only permits a homosexual object choice but unleashes sadistic impulses. All aggression in sexuality is "a relic of cannibalistic desires,"[24] an expression of the subject's primal urge to avenge itself on the object by sinking its teeth into and devouring it. Violence, mutilation, and disfigurement are structurally internal to the psychical act of identification. In order to analyze more carefully the critical role identification plays in establishing this symbolic association between homosexuality and cannibalism, I turn first to a film that offers us not one but two different versions of the oral sadist as sexual deviant. I conclude with a brief coda on the Jeffrey Dahmer coverage—another cultural narrative of identification gone horribly awry—which revives some of the same metaphors of orality, perversion, and morbidity that impel its cinematic predecessor. Freud's definition of identification as "the oral-cannibalistic incorporation of the other person"[25] comes centrally to define a film like *The Silence of the Lambs* where the psychiatrist, whose very profession is based on the proper reading of identifications, perversely literalizes the act, orally incorporating his victims with "favva beans and a nice Chianti."

Serial Killing, Close Up

[I]n his unconscious he was homosexual, and in his neurosis he was at the
level of cannibalism.

—Sigmund Freud, *From the History of an Infantile Neurosis*[26]

Film has always been a technology of dismemberment and fragmentation.
The contemporary horror film recalls cinema not only to its violent historical
beginnings but to the abject materiality of its very form.[27] In the famous
shower sequence of *Psycho*, Alfred Hitchcock films the murder of Marion
Crane in a manner designed to create the impression of "a knife slashing, as
if tearing at the very screen, ripping the film."[28] Film, after all, is no more than
dead matter, bits and pieces of perforated celluloid slashed, spliced, and taped
together. A system of "cuts" and "sutures," film borrows much of its technical
vocabulary from the discourses of surgical medicine and pathology. The
"cut-in," the "cut-away," the "splice," "dissecting editing"—all suggest the
capabilities of filmmakers to investigate the human body with the same
kind of accuracy, precision, and close scrutiny that pathologists call upon
to perform human autopsies. This formal correspondence between medical
pathology and film production may explain why, in narratives of serial killing,
the film director has virtually become a cliché, second only to another stock
character of the genre, the psychiatric doctor, who generally stands first in
the line up of potential murder suspects.[29] In films like Michael Powell's
Peeping Tom (1960), Michael Mann's *Manhunter* (1986), or John McNaugh-
ton's *Henry: Portrait of a Serial Killer* (1986/1990), the killers are often amateur
filmmakers, filming their kills so they can watch them over and over again,
trying to recapture, through cinematic replay, the experience of the actual
kill. Serial killing is in many ways a self-reflexive topic for the cinema, as this
satirical one-liner, which circulated after the opening of Demme's film, wittily
confirms: "I was cast as a victim of a serial killer in *The Silence of the Lambs*,
but my body parts ended up on the cutting room floor."

The violence encoded in cinematic form finds its most dramatic articulation
with the historical invention of the close-up. Lillian Gish recalls in her autobiog-

raphy that when D. W. Griffith first moved the camera closer to an actor in order better to capture his facial expression, the studio managers were enraged, prompting one executive to exclaim: "We pay for the whole actor, Mr. Griffith. We want to see *all of him*."[30] Another anecdote, recounted by Noël Burch, paints the association between cinematic form and bodily dismemberment even more plainly: "a woman who went to see a film shortly after the introduction of close-ups emerged completely traumatized by what she thought of as a horror film: 'All those severed hands and heads!' "[31] Film technology at first appears to offer a mirror stage reflection of the body as a fully intact entity; it promises the symbolization of a coherent corporeal image that will assist the spectator in shoring up his or her own precarious identity through a series of secondary identifications with the screen image. However, film can only satisfy the spectator's infantile desire to see the body whole and up close by cutting up the body and presenting it piecemeal. In point of fact, the filmic experience is less a reprisal of the infant's mirror stage encounter with the fantasy of a totalized ego than it is a reproduction of the infant's pre-mirror stage assimilation of the body as a collection of discrete part objects. Film technology always bears traces of this early traumatic event, the occasion of the child's own retroactive experience of itself as a body-in-pieces.

A film like Jonathan Demme's *The Silence of the Lambs* exploits the potentiality of dissecting editing to create terror in the spectator by shooting the scenes between Special Agent Clarice Starling (Jodie Foster) and Doctor Hannibal Lecter (Anthony Hopkins) almost entirely in close-up and tight shot/reverse shot sequence. Unlike cutting on movement, which tends to decrease the visibility of the cuts,[32] the cutting in these claustrophobic jail cell scenes happen when the two figures are immobilized or stationary, making the dissecting editing sharper and more visible. The relentless shot/reverse shot movement of these intimate face-offs, the sustained back-and-forth rhythm of the camera's head-on, level gaze, creates a structure of symbolic exchange whereby the two heads eventually become interchangeable, substitutable, switchable. The grotesquely embalmed head of Benjamin Raspail discovered in the storage garage of Miss Hester Mofet (Lecter's anagram for "Miss the rest

of me") stands as the film's iconic reminder of the detachability of human body parts and the cut of castration: no exchange without detachment; no identification without disfiguration. The technique of the cinematic close-up, which Demme relies upon so heavily to figure the identification between Lecter and Starling, in effect decapitates the subject, reducing it in scale to the level plane of the face by simultaneously enlarging the face to fill the screen's entire visual field. The face, the surface upon which subjectivity is figured, is also the zone of bestiality and primordial hunger, the overinvested corporeal site of not just an ocular but an oral identification.

The Silence of the Lambs, viewed close up, is a film all about the horrors of identification—identification as self-mutilation, identification as decapitation, identification as oral-cannibalistic incorporation. The psychiatrist and the detective, the law breaker and the law enforcer, the male mentor and the female student are the classic transferential couple. Both skilled in the art of playing head games, both trained in the exercise of inference, deduction, and detection, the psychiatrist and the detective do, in fact, take on one another's identities as Lecter becomes an assistant to the FBI and Starling becomes an amateur shrink. We can even mark exactly where the switch takes hold: in the third encounter between Lecter and Starling immediately following the discovery of death's head moths in two of the victim's heads, the scene in which Starling officially enlists Doctor Lecter's help in the search for Buffalo Bill. During the discussion of transsexuality in this scene's climactic moment, Starling's and Lecter's weirdly disembodied heads swim dangerously close together, Lecter's face reflected on the glass behind which Starling's own face stares at us intensely. The reflection, however, is neither an exact superimposition nor a dissolve; instead, Lecter's visage hovers slightly to the side and to the back of Starling's, creating the trick illusion that he is sitting directly behind her, like a psychoanalyst positioned behind a patient on a couch. The film's jail cell mise-en-scène simulates an analytic session, with analysand Starling learning to think like her evil mentor if she is to catch her quarry. Success in solving the case is wholly dependent upon the novice's ability to identify fully with the killer, to learn (like any good detective of the genre) to

desire what the other desires, to inhabit the place of the other's identifications. In narrative terms, identification is as much a plot device as anything else; identification both sets this drama of serial killing in motion and provides its ultimate resolution.

Identification is itself an act of serial killing. Viewed through the lens of psychoanalysis, "seriality" and "killing" denote the defining poles of the identificatory process. As we have seen, Freud theorizes psychical identification throughout his work in terms of bodily appetite. The following passage from *Group Psychology and the Analysis of the Ego* (1921) might serve as a representative example:

> Identification, in fact, is ambivalent from the very first; it can turn into an expression of tenderness as easily as into a wish for someone's removal. It behaves like a derivative of the first, *oral* phase of the organization of the libido, in which the object that we long for and prize is assimilated by eating and is in that way annihilated as such. The cannibal, as we know, has remained at this standpoint; he has a devouring affection for his enemies and only devours people of whom he is fond.[33]

At the base of every identification lies a murderous wish: the subject's desire to cannibalize the other who inhabits the place it longs to occupy. But as Freud also reminds us, identifications are at best "partial" and "extremely limited" (107); they must be continually renewed and serially reenacted, for the ego's appetite is voracious and unappeasable. Identification is an endless process of killing off and consuming the rival in whom the subject sees itself reflected. In the words of Mikkel Borch-Jacobsen, "the other-me is never anything but a rival, all the more detested for being admired, all the more violently negated for being amorously incorporated."[34] When Borch-Jacobsen speaks of the two "faces" of identification, he means to invoke (*pace* Freud) both the unconscious superego that prohibits identification ("Do not be like me") and the conscious ego-ideal that encourages identification ("Be like me") (36). These two faces represent the difference between good totemic and bad totemic identifications, normative and neurotic identifications, socializing

and desocializing identifications (40–41). They distinguish between a lawful identification, which inserts the subject into the symbolic order, and a tabooed identification, which disturbs the very foundations of the law. But what a serial killer film like *The Silence of the Lambs* insists upon is that sometimes it is simply impossible to tell the difference. This film's two faces of identification, Clarice Starling's good totemic identification with her mentor/father policemen, and Hannibal Lecter's bad totemic identification with his student/rival surrogates, are separated by no more than a transparently thin boundary that Lecter succeeds in crossing by putting on the very face of the law, flaying the policeman and wearing his features as if identification were no more than "a limit or a sack: a sack of skin."[35]

The notion of wearing another's skin—as Jame Gumb (Ted Levine) does quite literally in fashioning for himself a suit made of real women—also invokes the earliest form of identification, primary or narcissistic identification, in which a boundary between inside and outside, while sustained through the activity of introjection (the assimilation of an object), is *initially* formed through the mechanism of projection (the externalization of the object).[36] Jame Gumb's sexuality, rather than localized in a single organ, is spread out across the body. For him, the entire corporeal surface is a potential area of excitation; skin is "the erotogenic zone *par excellence*."[37] Are we to believe that in wearing the skin of the women he kills Jame Gumb becomes, in fantasy, the object he both fears and desires most? In classic psychoanalytic terms, tearing, eating, sucking, and biting specifically signal the ambivalent infantile relation to the mother. Oral sadism operates as a defense against the child's early fear that he will be eaten or flayed by the figure whom he is himself entirely dependent upon for nourishment.[38]

Why is Freud's theory of primary identification so important for a reading of *The Silence of the Lambs*? Because if the characterization of Jame Gumb is "homophobic,"[39] the force of this charge derives from more than a cursory representation of the serial killer as a woman-identified, woman-hating, cross-dressing, disco-dancing, poodle lover. The film's camerawork (its own projection apparatus) labors to call up and to strengthen the classic psychoanalytic

association of homosexuality with the morbidity, orality, and boundary confusion that define primary identification. Demme reserves nearly all of his *extreme* close-ups in the film for shots of Buffalo Bill, so named by police investigators for the professional way in which he flays his victims. The extreme close-up functions in the cinema as a technological analogue for primary identification. Film's capability to represent the human body as a disparate collection of part objects corresponds to the subject's earliest attempts at oral incorporation. From our first introduction to Gumb wearing night vision glasses to the controversial scene in which he crosses over to the other side of the lens and dances narcissistically in front of a videocamera, more than ten extreme close-ups fetishize different parts of Gumb's body: eyes, hands, neck, nipples, and lips (variously adorned with makeup, tattoos, and jewelry). In the presentation of Jame Gumb, the camera is at its cruelest— and its most cutting; Gumb is optically dismembered as savagely as he is known to have mutilated his victims. Only one kind of body can sustain such thorough inspection or close scrutiny from the camera: the corpse. Autopsy pictures and crime photographs of dead bodies provide the only other instances of extreme close-up in the film. This identical camerawork makes it impossible not to acknowledge in the end a certain insidious equation established in *The Silence of the Lambs* between homosexuality and pathology, between perversion and death.

Even so seemingly inconsequential a detail as the name "Mrs. Lippman" (in whose home Starling eventually stumbles upon her killer) draws attention to the camera's fetishization of Jame Gumb's painted mouth, one of the film's privileged signifiers of transvestic identification ("lip man"). Tight close-ups of Gumb's lips recall an earlier instance of technonecrophilia in the autopsy scene: the shot of the pathologist's protruding camera invasively entering the corpse's mouth. The disembodied eye of the camera is associated throughout the film with dead matter, with decaying corpses and with flayed skin, while the orifice of the mouth, with its lethal incisors, is associated with both castration and oral/sexual gratification. The paradigmatic model of orality, the infant feeding at the mother's breast, is explicitly invoked by Lecter when he

delivers his most merciless line to the film's sole mother character, Senator Ruth Martin, comparing the removal of the nursing child to the "tickling" sensation an amputee might feel after the loss of his leg. While under physical restraint, Lecter's oral-sadistic impulses seem to find temporary outlet in the psychiatrist's biting tongue and cutting intellectual acuity; Lecter, after all, is capable of a rhetorical savagery powerful enough to induce a man to swallow his own tongue. *The Silence of the Lambs* is a film obsessed with orality—with mouths, lips, teeth, tongues, and, of course, "gumbs."

Oral sadism provides perhaps too tame an epithet for the behavior of the film's most terrifying character, a figure whose ferocious orality and perverse appetite make him the very incarnation of the fairy tale ogre. Although more erudite and sophisticated than his former patient Jame Gumb, Hannibal Lecter nonetheless acts out the most instinctual and primitive of libidinal impulses, coding him within the filmic narrative as yet another dangerous pervert whose sexual desire is sublimated into compulsive acts of aggressive identification. Curiously, little critical attention has been paid to Hannibal Lecter's enigmatic sexuality in the film, with the noteworthy exception of Adrienne Donald's characterization of the aristocratic psychiatrist as a "gay dandy" and Elizabeth Young's equally suggestive description of Lecter as a mannered aesthete with a "near-camp delivery."[40] Even without any such denotative signs of a "gay identity," the specter of a perverse and monstrous homosexuality would still haunt the representation of Hannibal Lecter as an insatiable oral sadist. It is Lecter who "eats tongue" in the movie's most horrifying and, not uncoincidentally, most homoerotic scene; cupping Sergeant Pembry's face in his hands, Lecter bestows upon the man whose insides he intends to devour (and whose skin he later wears) the very kiss of death. "Hannibal the Cannibal" covets and feeds on human flesh in one of the most serious transgressions against the social prohibition separating the inedible from the edible, the human from the animal, the cultural from the natural. Hannibal Lecter's violation of cultural food interdictions admits him into the "homosexual brotherhood"[41] of Freud's "cannibal savages" who, out of fear and envy, murder and ingest the father to strengthen their identification with him. In Freud's myth of cultural origins,

outlined in his pseudoanthropological work *Totem and Taboo*, the feeding frenzy that follows the parricidal deed permits the lawless brothers to assimilate the father's strength and power. Like the story of incest and oedipal desire to which it is closely related, the primal scene of identification (a scene in which the sexual is still indistinguishable from the alimentary) is founded by a criminal act—an act of carnal desire and corporeal violence.

In this context, it seems entirely appropriate to read Hannibal Lecter as the "high priest" of human sacrifice and cannibalism as "communion made literal."[42] Freud himself understands the Christian Eucharist, the ritual consumption of the flesh and blood of the deity (the "lamb" of Christ), as an important revival of the ancient totemic meal.[43] However, equally compelling is a reading of Hannibal Lecter as not the jealous son of *Totem and Taboo* but the omnipotent father of the Wolf Man's childhood nightmares—the parent who, in a form of "affectionate abuse," threatens to gobble up and wolf down the child. Cannibal son or ogre father, Hannibal the Cannibal frightens by the way he literalizes our sexual colloquialisms. "Permanent marks" (teeth marks?) have been left by the oral phase of sexuality, Freud observes, and so it is not uncommon in everyday language to speak of "an 'appetizing' love object" or to refer to the person we love as "sweet."[44] Pulled from the darkest corners of the unconscious, the eerily bloodless Doctor Hannibal Lecter is a nightmare figure of terrifying mythic proportions.

Coda: "The Milwaukee Anthropophagite"

He was spiritually dead, but had become a vampire, a kind of walking dead who existed only to prey on his next victim. He was the closest thing to a *nosferatu*.

—Joel Norris, *Jeffrey Dahmer*[45]

The psychoanalytic narrative of the central role oral eroticism plays in the formation of gay male desire reveals more about the *cultural* determinations at work in the revival of a late nineteenth-century, early modern notion of the lawless and lustful sexual "invert" than about any timeless organization of

psychosexual libidinal desires. The trope of orality circulated as a privileged sign of social abnormality in fin-de-siècle science, figuring perhaps most prominently in anthropological discussions of the origin of criminality. For example, Cesare Lombroso, an Italian professor of criminal anthropology, identified a natural predisposition to orality as the cause of deviant behavior in what he termed the "born criminal"—"an atavistic being who reproduces in his person the ferocious instincts of primitive humanity" and who desires "not only to extinguish life in the victim, but to mutilate the corpse, tear its flesh, and drink its blood."[46] Significantly, both the Freudian invert and the Lombrosian criminal were figured as vampire/cannibals. It bears emphasizing that the Freudian conception of sexual deviance that we have inherited today was formulated in complex relation to other emerging historical discourses, including the new science of criminology. In fact, Robert Nye has persuasively argued that the medicalization of crime in the nineteenth century prepared the way for the pathologization of other social differences: "once it could be shown how criminals were in part biological anomalies, it proved a relatively simple matter to medicalize other kinds of deviance as well."[47] Sensational murder cases are often the trial arenas for reconfiguring, reconsolidating, and reinventing the cultural categories of criminality and deviance. In the specific case of Jeffrey Dahmer, the "homosexual-murderer-necrophilic-cannibal" equation has proved particularly fertile ground in the late twentieth century for activating old phobias and breeding new justifications for the recriminalization and repathologization of gay identity.

Frequently shot in close-up, photographs and drawings of Dahmer purport to image nothing less than the modern face of human monstrosity. Few graphic artists have been able to refrain from superimposing onto Dahmer's image the figure of the death's head, a vivid reminder of the human skulls that Dahmer preserved as totems from his killings. At the same time, these pictorial profiles present Dahmer's own head on a platter—decapitated, disembodied, mutilated, spectral, abject. The media feeds us images of our worst nightmare: Jeffrey Dahmer's gaze fixed menacingly, hypnotically, upon the spectator, as if to remind us that we are not only the subjects of identification,

but the objects as well—food for the other's insatiable oral appetite. Typically in these media representations, color, lighting, and graphics are used to fragment, over-expose, and disfigure Dahmer's face, framing his image much in the manner of a photographic negative or a medical x-ray. An *NYQ* cover image, for example, represents Dahmer as the object of a clinical gaze that mathematically sections his face into surface parts and colored grids.[48] Yet what this mock medical close-up reveals is a pair of less than scientific bloody fangs, a detail that inadvertently confuses the figure of the cannibal with that of the vampire. Dahmer's nighttime shift at the Ambrosia Chocolate Company and his earlier job as a blood taker at a local Milwaukee blood bank might seem to lend a certain playful logic to the transformation of Jeffrey Dahmer from human cannibal into supernatural vampire. Even the most responsible of Dahmer's biographers cannot resist describing him as "a kind of walking dead the closest thing to a *nosferatu*." But more than anything else, these misidentifications ultimately speak powerfully to the enduring cultural representation of the gay man as nocturnal oral predator and compulsive bloodsucker. As Ellis Hanson has commented in a powerful reading of the late Victorian vampirism at work in media constructions of AIDS, "to comprehend the vampire is to recognize that abjected space that gay men are obliged to inhabit; that space unspeakable or unnameable, itself defined as orifice, as a 'dark continent' men dare not penetrate. . . ."[49]

The *racialization* of the sexual orifice in psychoanalysis recalls us once again to the history of Western anthropology, this time in a more explicitly colonialist context. A *Newsweek* cover story on Jeffrey Dahmer, entitled "Secrets of a Serial Killer,"[50] is accompanied by an illustration that can only be described as a displaced Western fantasy of cannibalism. A flat cardboardlike cutout of Jeffrey Dahmer's head, severed at the neck and hanging suspended against a black backdrop, shows Dahmer again staring directly at the viewer with a mesmerizing intensity. Brightly colored lines swirling around his facial features like ceremonial paint, together with eight ghostly indistinct photographs (presumably of Dahmer's victims) stuck to his face with pins, are details intended to code the killer's atrocities as a secret and deadly form of African

voodoo. While the cultural category of cannibalism is emphatically an *anthropological invention*, and while even anthropologists have recently begun to question whether cannibalism *as a cultural system* has ever existed anywhere in the world,[51] the fiction of African cannibalism still persists in the West as the prevailing indicator of human savagery. Descriptions of Jeffrey Dahmer as "the Milwaukee anthropophagite"[52] bring the entire weight of Western anthropology to bear on the reading of one man's personal disorder, revealing little about Dahmer's psychological state of mind and quite a bit about continuing Western phobias of the man-eating savage. Representations of Jeffrey Dahmer as stereotypical African savage spectacularly repress the obvious fact in the Milwaukee case that a white man of German descent was the killer and that black, Asian, and Hispanic men were the principal victims.[53] While we may never know all the reasons why Dahmer killed outside his racial group, we do know that Dahmer's professed hatred of effeminate black men masked a deeper desire to appropriate the sexual threat they embodied. Dahmer's attempts to introject the *color* of his victims suggests a powerful unconscious identification with the racial other; the cannibal killings also mark specifically an aggressive identification based on a will to dominate and to humiliate sexually the object secretly coveted. Dahmer's sexual identifications work precisely as modes of racial imperialism.[54]

Real and fictional accounts of sexually motivated murderers who methodically stalk, torture, mutilate, and sometimes eat their victims have become as familiar to an American public as the popular serialized stories of famous criminals and outlaws were to a previous century's cultural imagination. Indeed, tales of serial killers in our newspapers have become our new serial literature, with regular installments, stock characters, behavioral profiles, and a fascinated loyal readership. To what degree is it possible that we could identify with a figure of abjection—with a Jame Gumb, a Hannibal Lecter, or a Jeffrey Dahmer? Could the tremendous popularity and appeal of the serial killing genre lie in the form's ability to discharge us of our own misogyny, homophobia, or racism by locating guilt in the killer alone? The success of America's new serial literature may well lie in its double, gratification/exculpa-

tion function. If we are all killers in our unconscious, as psychoanalysis would have it, then identification with a psychotic murderer provides gratification of a death wish against others while simultaneously ensuring exculpation through the projection of all guilt onto the self-same cultural anomaly: "the monster of perversion."[55]

NOTES

1. Georges Bataille, *Visions of Excess: Selected Writings, 1927–1939*, ed. Allan Stoekl (Minneapolis: University of Minnesota Press, 1985), 59.

2. D. A. Miller, "Anal *Rope*," in *Inside/Out: Lesbian Theories, Gay Theories*, ed. Diana Fuss (New York and London: Routledge, 1991), 134.

3. Lee Edelman, "Seeing Things: Representation, the Scene of Surveillance, and the Spectacle of Gay Male Sex," in Fuss, *Inside/Out*, 106.

4. Leo Bersani, "Is the Rectum a Grave?" in *Aids: Cultural Analysis, Cultural Activism*, ed. Douglas Crimp (Cambridge, Mass.: MIT Press, 1988), 212. For a reading of the anus as a culturally occluded site of *women's* active desire, see Eve Sedgwick's "A Poem Is Being Written," *Representations* 17 (Winter 1987): 110–43.

5. Freud goes so far as to locate the "origins" of male homosexuality in the passive anal stage, hypothesizing that in male inverts the considerable erotic importance attached to the anus was simply never relinquished: "a *stressing* of this anal eroticism in the pregenital stage of organization leaves *behind* a significant predisposition to homosexuality in men . . ." (emphasis mine). Sigmund Freud, "The Disposition to Obsessional Neurosis" (1913), *The Standard Edition of the Complete Psychological Works of Sigmund Freud*, trans. and ed. James Strachey, 24 vols. (London: Hogarth Press, 1953–74), 12:322.

6. "The Door of Evil," *People,* 36:5 August 12, 1991, 32–37. Citation from cover.

7. Jacques Derrida, *Glas*, trans. John P. Leavey, Jr., and Richard Rand (Lincoln and London: University of Nebraska Press, 1986), 142.

8. Freud, *General Theory of the Neuroses* (1917), *Standard Edition*, 16:314.

9. See, respectively, Freud, "The Disposition to Obsessional Neurosis" (1913), *Standard Edition*, 12:311–26; *Three Essays on the Theory of Sexuality* (1905), 7:123–245; and "The Infantile Genital Organization" (1923), 19:139–45.

10. Ole Andkjaer Olsen and Simo Køppe, *Freud's Theory of Psychoanalysis*, trans. Jean-Christian Delay and Carl Pedersen (New York and London: New York University Press, 1988), 275.

11. Eve Sedgwick, *Epistemology of the Closet* (Berkeley: University of California Press, 1990), 12.

12. Freud, *Extracts from the Fliess Papers* (1892–1899), *Standard Edition*, 1:269. See also *New Introductory Lectures on Psycho-Analysis* (1933), 22:100.

13. Freud, *Three Essays*, 161.

14. Freud, *Analysis of a Phobia in a Five-Year-Old Boy* (1909), *Standard Edition*, 10:7. For Freud's reading of Dora's cough and sore throat as somatic symptoms of an unconscious fellatio fantasy, see *Fragment of an Analysis of a Case of Hysteria* (1905), 7:51–52. Although Freud is concerned here with distinguishing what we might call "normal" perversions (heterosexual oral sex) from "abnormal" perversions (homosexual oral sex), the Dora analysis makes clear that the one is always "contaminated" by the other, that no performance of fellatio can escape the stigma of male homosexuality.

15. See, respectively, Freud's *From the History of an Infantile Neurosis* (1918), *Standard Edition*, 17:1–123; *Notes Upon a Case of Obsessional Neurosis* (1909), 10:151–320; *Analysis of a Phobia*; and *Psycho-Analytic Notes on an Autobiographical Account of a Case of Paranoia (Dementia Paranoides)* (1911), 12:1–82.

16. Freud, *Three Essays*, 137.

17. Freud, *Leonardo Da Vinci and a Memory of His Childhood* (1910), *Standard Edition*, 11:80.

18. Freud, *New Introductory Lectures*, 101.

19. For more on Freud's famous mistake, see Peter Gay, *Freud: A Life for Our Time* (New York: Anchor Books, 1989), 267–74.

20. Ibid., chapter 9. See also Avital Ronell's "Goethezeit," in *Taking Chances: Derrida, Psychoanalysis, and Literature*, ed. Joseph H. Smith and William Kerrigan (Baltimore and London: Johns Hopkins University Press, 1984) for an excellent reading of the naming and renaming of this traumatized oral cavity.

21. Freud, *General Theory of the Neuroses*, 305–6.

22. Freud, *New Introductory Lectures*, 141.

23. Freud, *Leonardo*, 100. Jean Laplanche thus sees a double displacement at work in Freud's theorization of male homosexuality: "the homosexual situates himself in his mother's place, and his 'object' in the place of the child he once was." Laplanche, *Life and Death in Psychoanalysis*, trans. Jeffrey Mehlman (Baltimore and London: Johns Hopkins University Press, 1976), 75. Simultaneously playing the roles of both mother and child, the male homosexual allegedly embodies the collapse in boundaries said to characterize the child's preoedipal state of nondifferentiation from the mother. In this way, Freud identifies primary identification as the constitutive element, the *sine qua non*, of male homosexuality, linking it indissociably to narcissism, perversion, and oral eroticism.

24. Freud, *Three Essays*, 159.

25. Freud, *New Introductory Lectures*, 63.

26. *From the History of an Infantile Neurosis*, 64.

27. Contemporary serial killer films represent not so much the emergence of a new or mutant cinematic form as the revival of an old or dormant one. These films return us to the earliest stages of the cinema and to the medium's fascination with the mutilation, fragmentation, and reconstitution of body parts. Amputations, decapitations, and other forms of bodily disfigurement were commonplace in early cinema; indeed they were one of the stock themes of the trick shorts by Edison, Biograph, Méliès, and Pathé.

28. Quoted in Donald Spoto, *The Dark Side of Genius: The Life of Alfred Hitchcock* (New York: Ballantine, 1983), 419.

29. Brian De Palma's *Dressed to Kill* (1980) provides the best example of this subgenre in the cinema. In the growing body of fictional works that take serial killing as their theme, several include filmmakers and/or psychiatrists as recurrent suspects: David Lindsey, *Mercy* (New York: Bantam, 1990); William Bayer, *Switch* (New York: Signet, 1984); Mary Higgins Clark, *Loves Music, Loves to Dance* (New York: Simon and Schuster, 1991), and Ira Levin, *Sliver* (New York: Bantam, 1991).

30. Lillian Gish, *The Movies, Mr. Griffith, and Me* (London: W. H. Allen, 1969), 59–60. Also cited in Stephen Heath, *Questions of Cinema* (Bloomington: Indiana University Press, 1981), 184. Contrary to anecdotal history, Griffith did not invent the close-up. Examples of the true film close-up can be found as early as "Fred Ott's Sneeze" (Edison, 1894). See Noël Burch, *Life to Those Shadows*, trans. and ed. Ben Brewster (Berkeley and Los Angeles: University of California Press, 1990), 41.

31. Burch, *Life*, 269.

32. Mary Ann Doane, *Femme Fatale: Feminism, Film Theory, Psychoanalysis* (New York and London: Routledge, 1991), 146.

33. Freud, *Group Psychology and the Analysis of the Ego* (1921), *Standard Edition*, 18:105. See also *Totem and Taboo* (1913), 13:1–162; "Mourning and Melancholia" (1917), 14:237–58; and *New Introductory Lectures*.

34. Mikkel Borch-Jacobsen, *Lacan: The Absolute Master*, trans. Douglas Brick (Stanford, Calif.: Stanford University Press, 1991), 32.

35. Laplanche, *Life*, 81.

36. "The ego is ultimately derived from bodily sensations, chiefly those springing from the surface of the body. It may thus be regarded as a mental projection of the surface of the body. . . ." Freud, *The Ego and the Id* (1923), *Standard Edition*, 19:26.

37. *Three Essays*, 169.

38. The theory of oral sadism belongs properly to Karl Abraham who splits Freud's

first phase of libidinal development into two stages—early oral (sucking) and oral-sadistic (biting). Melanie Klein refines the theory of oral sadism further, rejecting Abraham's distinction and hypothesizing instead that infantile aggression always characterizes the infant's relation to the maternal breast. See Abraham, "A Short Study of the Development of the Libido, Viewed in the Light of Mental Disorders" (1924), in *Selected Papers* (London: Hogarth Press, 1927), and Klein, "Some Theoretical Conclusions Regarding the Emotional Life of the Infant" (1952), in *Developments in Psycho-Analysis* (London: Hogarth Press, 1952).

39. See, for example, the lively commentaries by nine writers in the *Village Voice*, March 5, 1991; 49, 56, 58–59.

40. Adrienne Donald, "Working for Oneself: Labor and Love in *The Silence of the Lambs*," *Michigan Quarterly Review* 31, 3 (Summer 1992): 347–60, and Elizabeth Young, "*The Silence of the Lambs* and the Flaying of Feminist Theory," *Camera Obscura* 27 (September 1991): 5–35. Judith Halberstam, in another perceptive reading of this film, joins Young in cleverly identifying the root of Lecter's pathology as an unresolved "edible complex." See Halberstam's "Skin-Flick: Posthuman Gender in Jonathan Demme's *The Silence of the Lambs*," *Camera Obscura* 27 (September 1991): 37–52.

41. In Freud's mythological formulation of the basis of culture, homosociality *replaces* homosexuality as the founding repression of the law. The brothers, while outside the primal horde, base their organization on homosexual acts; once the father has been usurped, and the exchange of women has been established, homosocial acts govern the group. See *Totem and Taboo.*

42. Kathleen Murphy, "Communion," *Film Comment* 27, 1 (January-February 1991): 31–32.

43. See Freud's *Totem and Taboo*, 154, and *Moses and Monotheism: Three Essays* (1939), *Standard Edition*, 23:83–84.

44. Freud, *From the History of an Infantile Neurosis*, 106–7.

45. Joel Norris, *Jeffrey Dahmer* (New York: Pinnacle Books, 1992), 39.

46. Cesare Lombroso, introduction to Gina Lombroso-Ferrero, *Criminal Man According to the Classification of Cesare Lombroso* (New York: G. P. Putnam's Sons, 1911), xiv–xvi.

47. Robert Nye, *Crime, Madness, and Politics in Modern France: The Medical Concept of National Decline* (Princeton, N.J.: Princeton University Press, 1984), 99.

48. *NYQ*, (February 16, 1992).

49. Ellis Hanson, "Undead," in Fuss, *Inside/Out*, 325.

50. "Secrets of a Serial Killer," *Newsweek*, February 3, 1992, 44–49.

51. To my knowledge, the first researcher to expose the inadequacy of the anthropological documentation on cannibalism and to question whether cannibalism even exists, except

in rare cases of survivalism and psychotic behavior, was W. Arens in *The Man-Eating Myth: Anthropology and Anthropophagy* (New York: Oxford University Press, 1979). While some anthropologists think Arens overstates the case, few disagree that the charge of cannibalism has been leveled against virtually every culture in history and that it often functions as the rationale for genocide and national imperialism. For two sympathetic critiques and revisions of Arens's work, see Peggy Reeves Sanday, *Divine Hunger: Cannibalism as a Cultural System* (Cambridge: Cambridge University Press, 1986), and Gananath Obeyesekere, " 'British Cannibals': Contemplation of an Event in the Death and Resurrection of James Cook, Explorer," in *Critical Inquiry* 18, 4 (Summer 1992): 630–54.

52. "So Guilty They're Innocent," *National Review*, (March 2, 1992), 17. The persistent equation in Freud's thinking between "the homosexual" and "the primitive" is based on his assumption that both "types" are developmentally arrested in the oral-cannibalistic stage. We should perhaps not be surprised to discover that in anthropological research influenced by classical psychoanalysis, the explanation of human cannibalism sounds suspiciously like Freud's theory of male homosexuality. For example, in *Cannibalism: Human Aggression and Cultural Form* (New York: Harper Torch Books, 1974), Eli Sagan argues that cannibalism in tribal cultures is the result of absent fathers and overly protective mothers who nurse their children for prolonged periods of time instilling in them a tendency toward oral aggression.

53. The fact that all but two of Dahmer's seventeen victims were gay men of color from economically impoverished backgrounds prompted an indifferent and many have charged racist and homophobic Milwaukee police department to pay scant attention to the growing number of missing-persons reports and to overlook completely the obvious links among them.

54. At least one commentator on the Dahmer case has found the killer's ethnic background worthy of note. Andrew Holleran quips in *Christopher Street* that there is something "very *Sweeney Todd*" about the Dahmer story, something "very Grimm Brothers" in the details of Dahmer's German background, his army service in Baumholder, West Germany, his job in the chocolate factory. The more serious connection, which goes unspoken in Holleran's allusion to ethnic and racial conflict in the Dahmer case, is the Nazi experiments on Jews, homosexuals, and other "social undesirables" during the Holocaust, a historical precedent that provides a far more frightening context in which to read Dahmer's postmortem mutilations and his fascination with medical pathology. See Andrew Holleran's "Abandoned," *Christopher Street*, (June 22, 1992), 3.

55. Or, as Slavoj Žižek puts it, "Our desire is realized and we do not even have to pay the price for it." *Looking Awry: An Introduction to Jacques Lacan through Popular Culture* (Cambridge, Mass.: MIT Press, 1991), 59. Žižek's thesis that a need for a communal

discharge of guilt drives the detective novel works equally well with true crime narrative, which draws extensively on many of the same devices and themes as the classic detective genre: "the role of the detective is ... precisely to dissolve the impasse of this universalized, free-floating guilt by localizing it in a single subject and thus exculpating all others" (59).

Watching AIDS

12

Grafting David Cronenberg: Monstrosity, AIDS Media, National/ Sexual Difference

Andrew Parker

Q: What is the symbolism of the lesbian agents with penises grafted onto their faces, drinking spinal fluid?
A: Oh, just a bit of science fiction, really.
—William S. Burroughs, *The Job*

Nineteen sixty-five was the year that, traveling on vacation with my family from profoundly suburban New York to Montréal, I first crossed a border into a foreign country, a border I came to associate with sexual transgression. What remains impressed in my memory from this trip (a memory whose very force and clarity owes greatly, I suspect, to the Freudian logic of deferred action), was a spectacle I had never "witnessed" as an event before, the sight of two men amorously caressing each other on a city street. "Monstrous!" I recall my father storming in disgust: "This would never be permitted at home!" He meant, of course, the United States, though I also understood his use of "home" to have a narrower, more local application. Later that same day— hardly a coincidence—I discovered at an Anglophone bookstore a used copy of William Burroughs's *Naked Lunch*. I purchased the book and smuggled it back across the border without declaring it to my parents or *les douaniers*. Home again in the New York suburbs, I decided to let my hair grow long.

Nineteen sixty-five was also the year that the Anglo-Canadian filmmaker David Cronenberg interrupted his university studies to travel in Europe. We now know, through a series of remarkable interviews I'll be drawing on often, that Cronenberg was deeply absorbed at this time—hardly a coincidence— in the fiction of William Burroughs. He also was letting his hair grow long:

I came back [to Canada] with shoulder-length hair and a paisley shirt, which were very shocking at the University of Toronto. When you see my 1967 graduation photo, I look like an ugly girl! I grew my hair in Copenhagen because the girls all thought that if you spoke English you were a Rolling Stone. So it was very necessary to have long hair.[1]

Mutating his gendered appearance to meet what he imagined were the hetero-sexual expectations of Danish "girls" (for whom all versions of English suppos-edly sounded the same), Cronenberg returned home to Canada already clearly preoccupied with the volatile set of issues that would suffuse his extraordi-narily focused career. Perhaps the preeminent director working today in the genres of horror and science fiction—his films include *Scanners* (1980), *Videodrome* (1982), *The Dead Zone* (1983), *The Fly* (1986), *Dead Ringers* (1988), and most recently *Naked Lunch* (1991)—Cronenberg has consistently been drawn to the monstrous terrain where sexuality grafts itself onto nation, the same terrain the mass media have exploited since the advent of the AIDS crisis. I will be discussing below one of his earliest commercial films, *Rabid* (1976), in some extended detail.

Before doing so, however, I want to return one last time to 1965, the year Leslie A. Fiedler published an essay called "The New Mutants" in the *Partisan Review*.[2] Warning his readers of a monstrous threat to the tradition of Western reason, Fiedler likened the nascent student protests in the United States to the "emergence—to use the language of Science Fiction—of 'mutants' among us" (508). Motivated by "the myth of the end of man," a new generation of college students had begun to reject "the tradition of the human, as the West (understanding the West to extend from the United States to Russia) has defined it, Humanism itself, both in its bourgeois and Marxist forms; and more especially, the cult of reason" (509). If Fiedler was hardly the first to have linked the West, the human, and the rational, neither will he be the last to suggest that this linkage is in peril. Indeed, the question of what for Fiedler *counted* as the West resonates strikingly with contemporary attacks in the United States on the aims of multiculturalism. For despite his momentary and atypical broadening of its horizon to include Russia (an expansion calculated

solely, it would seem, to accommodate his anti-Communism), Fiedler re-
stricted himself in a "more parochial" way to "the Anglo-Saxon world" (516)—
the *telos* of a Western tradition that, in harboring the universal in its singularity,
remakes the world in its own self-image.[3] "We Are the World" is a song Fiedler
might later have hummed to himself, a "world" all but coterminous with one
imagination of the United States.

But Fiedler was not interested then in pursuing this seeming parodox of
the singular and the universal. He was concerned instead with a growing
monstrosity that, blurring the accepted limits between the same and the other,
threatened to undermine his West from within:

> I am thinking of the effort of young men in England and the United States to
> assimilate into themselves (or even to assimilate themselves into) that otherness,
> that sum total of rejected psychic elements which the middle-class heirs of the
> Renaissance have identified with "woman." To become new men, these children
> of the future seem to feel, they must not only become more Black than White
> but more female than male (516).

"Turning from *polis* to *thiasos*, from forms of social organization traditionally
thought of as male to the sort of passionate community attributed by the
ancients to females out of control," these mutant men (Fiedler irrepressibly
continued) "have embraced certain kinds of gesture and garb, certain accents
and tones traditionally associated with females or female impersonators"
(512,520). The very length of "the Beatle hairdo"—this alone, I think, explains
why Fiedler persisted in defining the West as *Anglo* America—belongs to

> a syndrome, of which high heels, jeans tight over the buttocks, etc., are
> other aspects, symptomatic of a larger retreat from masculine aggresiveness to
> feminine allure—in literature and the arts to the style called "camp." And fewer
> still have realized how that, though the invention of homosexuals, is now the
> possession of basically heterosexual males as well (520).

With gender binarism thus collapsing in the West, what followed for
Fiedler was the parallel collapse of any distinction between homo-and hetero-
sexuality. Unable to tell not just men from women but straight from gay (or

even, more to the point, straight from *basically* straight), he proceeded to "explain" the growing popularity of heroin (!) as yet another "attempt to arrogate to the male certain traditional privileges of the female. What could be more womanly . . . than permitting the penetration of the body by a foreign object which not only stirs delight but even (possibly) creates new life?" (522). It was not, of course, by chance that an imagined quality of foreignness underwrote this implied equation between drug use and gay sex. But neither was it coincidental that William Burroughs could thereby emerge as "the chief prophet of the post-male post-heroic world. . . . [*Naked Lunch* is] no mere essay in heroin-hallucinated homosexual pornography—but a nightmare anticipation (in Science Fiction form) of post-Humanist sexuality" (517).

For Fiedler, then, the crisis in Western reason presented itself as a crisis of the human as a crisis of masculinity as a crisis of heterosexuality as a crisis of drugs, all of which were figured through the monstrous example of William Burroughs. What makes this logic especially staggering is the way that it gathers nearly all the tangled threads passing through the German word *Geschlecht*: sex, nation, race, species, genus, gender, stock, generation, genealogy, community, blood.[4] To find nation and sexuality under common siege in Fiedler's account is to be reminded that they share, for "the West," elements of a common history—elements we will soon see redeployed in Cronenberg's work. For if modern philosophies of the nation have had to negotiate between the contradictory requirements of sameness and difference, of universalism and singularity,[5] these are also the (equally unstable) terms that have shaped modern conceptions of sexual orientation. Those of us from the North Atlantic especially inherit from the nineteenth century "a theory of sexuality which carves up humanity into two vast and immutable camps" distinguished by the gender—cross-sex or same-sex—of sexual object-choice.[6] This theory, however, does not simply replace but inscribes itself upon an earlier, still prevalent and competing conception in which same-sex desire refers not to restricted *categories* of people (identities) but to *acts* in which all persons may engage. Where the one approach emphasizes the singularity of object choices, "the diversity and mobility of sexual behaviour and identities *between* different

212

social groups," the other, universalizing viewpoint stresses "the diversity and mobility of sexual behaviour *within* individuals."[7]

What this has meant, over the past century in a certain West, is the simultaneous insistence of mutually exclusive conceptions of "homosexuality," of two epistemologies whose conflicting claims to truth no dialectic can hope to adjudicate. If gayness—at once identity and act, different and same, internal and external, singular and universal—thus divides itself conceptually from itself, then so must a heterosexuality that defines *itself* in simple opposition to a term intrinsically unstable. Indeed, as Eve Kosofsky Sedgwick has argued, the resultant precariousness of the homo/hetero dichotomy has had, as one of its consequences, a pervasive and devastating impact on the homosocial continuum that structures all forms of male-male relations, especially those that are not specifically gay:

> The historically shifting, and precisely the arbitrary and self-contradictory, nature of the way *homosexuality* (along with its predecessor terms) has been defined in relation to the rest of the male homosocial continuum has been an exceedingly potent and embattled locus of power over the entire range of male bonds, and perhaps especially over those that define themselves, not *as* homosexual, but as *against* the homosexual. Because the paths of male entitlement . . . required certain intense male bonds that were not readily distinguishable from the most reprobated bonds, an endemic and ineradicable state of what I am calling male homosexual panic became the normal condition of male heterosexual entitlement.

Since, in this structural panic, the line separating prescribed and proscribed male behaviors begins to look exceedingly tenuous, the "basically heterosexual" male remains faced with the task of mastering an unmasterable double bind, of proving what is by definition impossible to *prove*—"that he is not (that his bonds are not) homosexual."[8]

This double bind, Cronenberg will show and tell us, has had a specially pointed force for a country like Canada whose very boundaries, like those of "homosexuality," are similarly unstably both external and internal. For Can-

ada, of course, not only shares an outer border with the United States but also divides itself internally along national lines. As the Canadian cultural critic Robert Schwartzwald has remarked:

> During the years leading up to Québec's 1980 referendum on "sovereignty-association," a form of political independence from Canada, an oft-repeated argument for "national unity" was that without Québec, Canada would be indistinguishable from the United States! This double bind of calling on Québec's "distinctness" but being unwilling to acknowledge it within a new constitutional arrangement explains why many Québécois feel they are held hostage by English Canada which, unsure of its identity, "needs" Québec to prove its difference.[9]

Two double binds, then, structured by the identical necessity of proving what is impossible to prove. Though Cronenberg's *Rabid* may seem an unlikely vehicle to explore these panicked crises of national and sexual identity, the film may be read as an oblique meditation—"in Science Fiction form"—on the grafts through which they fuse.

Rabid opens with a motorcycle accident involving Hart and his girlfriend Rose, played respectively by Frank Moore and the porn superstar Marilyn Chambers.[10] While Hart has sustained only minor injuries in the crash, Rose is comatose, bleeding internally and near death. As the accident occurred near the gates of the Keloid Clinic (the projected first in a series of "franchised plastic surgery resorts"), Dr. Keloid—whose name puns on a surgical scar—saves Rose's life by experimentally grafting to her damaged intestines thigh tissue that has been rendered "morphogenically neutral." His method succeeds but with an unintended side effect: the new tissue inexplicably migrates from her intestines to her armpit, forming there a (vaginal or anal) opening from which emerges a phallic spike—a penis *dentatus* (or is it *dentatum*? or *dentata*? all of the above? the gender indeterminacy is precisely to the point). Using this new organ to drain life-sustaining blood from a variety of sources (who, in the first half of the film, include male and female patients at the clinic, a would-be rapist . . . and a cow), Rose attacks the suitably anxious Dr. Keloid who becomes infected as a result with a virulent strain of rabies. Delirious

214

The Underarm Penis-Syringe.

and oozing saliva, he bites several people, who in turn attack others, all of whom shortly die after passing on the disease.

Meanwhile, realizing she has become a vampire, Rose escapes from the clinic in search of fresh blood. Though the Keloid Clinic had been to this point wholly unmarked in its geographic location (it was situated in a completely nondescript rural area that could be anywhere in temperate North America), the movie suddenly and without any further explanation shifts to Montréal where Rose, now ensconced in her girlfriend's apartment, easily finds new victims in the local porno cinema. With the rabies epidemic raging out of control, Claude La Pointe (an official from the Québec Bureau of Health) explains to his television audience that the virus is transmitted through saliva dribbling into open wounds: "So don't let anyone bite you." As all efforts to stem the contagion prove useless, martial law is declared in Montréal and the director of the World Health Organization is called in to take charge. Hart, finally, tracks Rose down only to catch her in the act of siphoning blood from her girlfriend: "It's *you*! It's been *you* all along! You carry the plague! You've killed hundreds of people!" Unwilling to accept his account, Rose undertakes an experiment, locking herself into a room with one last victim in order to discover, after taking his blood, whether he indeed will turn rabid. He does, he bites her, and she dies. The film ends with health workers tossing her body into the back of a garbage truck.

Those previously unacquainted with *Rabid* may be most horrified that this film from 1976 includes nearly all the murderous details that would dominate the U.S. media's portrayal of AIDS. Not only will Marilyn Chambers's role soon be recast, "in real life," with a gay man—another promiscuous predator who wantonly infects his partners—but this gay man will also turn out to make his home in Québec: Gaëtan Dugas, the Patient Zero of AIDS, the Great Vampire whose exploits and death are sensationalized in Randy Shilts's *And the Band Played On.*[11] That Chambers's new sexual organ is also a syringe neatly condenses in one image several of the demographic categories (as opposed to behaviors) that the mainstream media have insisted on associating with AIDS. Indeed, among the so-called "high-risk groups" said to be most susceptible to HIV infection are intravenous drug users, hemophiliacs, recipi-

ents of blood transfusions, and sex workers. Trading on Chambers's cachet as a porn star, featuring a scene in a theater that could be screening one of her other, more popular films, *Rabid* grafts all of these categories onto its female lead. As Leo Bersani has noted, the media's iconography of HIV infection draws *its* life blood from the imagery of female prostitutes conveying disease to their "innocent" clients: this is "a fantasy of female sexuality as intrinsically diseased; and promiscuity, in this fantasy, far from merely increasing the risk of the infection, is the *sign of infection*. Women and gay men spread their legs with an unquenchable appetite for destruction."[12] (Chambers would go on to star in the films *Insatiable* and *Insatiable II*.) With the film's introduction of mandatory screening and identity cards—the Québec government's prophylactic measures exceeding in brutality William F. Buckley's own "modest proposals"[13]—the remaining pieces of the media's classic narrative have fallen into place: "The victims of the disease are beyond medical help," avers the head of the WHO; "shooting down the victims is as good a way of handling them as we have got." Even the final sequence of the film is chillingly proleptic: "The 'homosexual body,' which is also that of the 'AIDS victim,' must be publicly seen to be humiliated, thrown around in zip-up plastic bags, fumigated, denied burial. . . . The 'homosexual body' is 'disposed of,' like so much rubbish, like the trash it was in life."[14]

What are we to make, then, of these extended resemblances linking *Rabid* with the discourse surrounding a medical condition that, in 1976, had not yet been "discovered"? Should we infer that Cronenberg was unconsciously prophetic, that he "knew" in advance how AIDS will have been constructed? I am, of course, hardly claiming that. The point, rather, runs in the opposite direction, for the mainstream media response to AIDS has taken its representational bearings from preexisting, culturally pervasive "narrative systems along whose tracks events seem to glide quite naturally, whether in news reports, movie plots or everyday conversations."[15] As Simon Watney and others have argued, the most prominent by far of these narrative systems is the horror genre: "The 'AIDS carrier' story belongs to a cluster of similar stories, well known from popular fiction and film, about vampires, mysterious killer-diseases, dangerous strangers, illicit sex."[16] To portray AIDS consistently in

media reports as "a killer disease" is to draw actively on these generic conventions; to imagine Science (as did Randy Shilts) "closing in on the viral culprit that bred international death" is similarly to recall "the typical dénouement of a B-movie horror narrative."[17] The mass media and horror films have truly shared one script, mobilizing the same lethal fantasies in their common efforts to deny the incoherence of a series of binary contrasts: the human and the monstrous, the natural and the artificial, mind and body, masculine and feminine, straight and gay, health and sickness, innocence and depravity, victim and perpetrator, purity and pollution, redemption and retribution, public and private, self and other, same and different, inside and outside, singular and universal, national and alien. In horror film as in network AIDS reporting, the plot revolves around an identical danger, the inability to tell ("until too late") who is Not One of Us. And in both instances, this danger will be surmounted with the identification, isolation, and extermination of the monster, as the founding binary order, at great though "necessary" cost to human life, is restored once more to its original integrity.[18]

I dwelled earlier on Fiedler's evocation of monstrosity in part because his essay—even with its sustained and elusive coyness, a tonality (say) quite unlike my father's—clearly feeds off these same misogynist and homophobic impulses. *Rabid* does so, too—as must any work in a genre constitutively preoccupied, from at least as early as *Frankenstein*, with the origins of gendered and sexual differences.[19] But *Rabid* also shares with the most interesting of such works a tendency to acknowledge, analyze, or partially suspend these motivating energies; many aspects of its diegesis intersect at odd angles with the genre's most characteristic features.[20] For example, even though Chambers appears in the film often clad—with little narrative "motivation"—only in her underpants, her body is not thereby highly eroticized. In fact no one's body is, whether female or male, whether before or after the outbreak of disease. The film has surprisingly little affective investment in any of its characters (it has neither true villains nor heros); nor does it seem to care greatly about the institutions it depicts. Where the media's typical AIDS narrative is "a moralizing etiology of disease" designed to ward off threats to religious, familial, and civic values, there's nothing remotely like moralization in this film—indeed,

218

there's no church at all, and neither of the two families it briefly portrays is even minimally idealized. It is also unclear what Rose means when, after Hart interrupts her with her girlfriend, she charges *him* with being the origin of the epidemic ("It's *your* fault! It's all *your* fault!")—as if, perhaps, the disease itself were the monogamous heterosexuality he comes to represent, what in other horror films would be offered as the final cure. The public health officials hardly fill the moral vacuum: Claude La Pointe is attacked by rabid crazies, and the director of the WHO, intoxicated with his own powers, is clearly a monster himself. The film insists, moreover, that our access to these medical authorities is always strictly mediated; their televised reports are framed within the frame as if the viewer is being asked to contemplate their status as news. *Rabid* remains throughout peculiarly distanced, dispassionate, disinterested, estranged from what it portrays: less ironic than aloof, perhaps too coolly detached to be properly phobic, it seems fascinated only with the unfolding of its narrative logic. Looked at retrospectively, *this* may be the most monstrous aspect of the film—that its relationship to the epidemic it depicts remains neutral, apolitical, "academic."

If this coolness is proverbially Canadian, what seems much less characteristic (if the AIDS crisis serves as a model) is the public hysteria and state repression depicted in the film, the Québec government's actions resembling instead American patterns of quarantine and persecution.[21] But *Rabid* has little overt interest in such questions of national difference. Infection passes through blood and saliva, but these fail to represent what such fluids typically embody: the medium of racial, ethnic, or national differences.[22] While the carriers of the virus are portrayed as dangers to civil society, the disease itself is never allegorized specifically as a threat to *national* values. We might, indeed, expect that a film situated for half of its length in mid-1970s Montréal would reflect in some way the Québecois nationalism then reaching a high point, but Montréal appears to function only as a Typical North American City where not one word of French is overheard (Claude La Pointe speaks to us in his televised reports in heavily accented English). If *Rabid*'s Canadian provenance thus remains at best implicit, this illustrates what one critic has defined as a characteristic of Cronenberg's work: "His films suffer from a vague sense of

location. They all seem set in the same chilly-gray Everycity."[23] Everycity is populated with Everymen rather than distinctive national subjects, which helps to explain why Cronenberg characteristically resists thinking of his later remake of *The Fly* as "an AIDS movie": "It's an examination of what is universal about human existence. . . . AIDS is tragic. But, beyond it all, I'm digging deeper. We've all got the disease—the disease of being finite" (128). AIDS, for Cronenberg, thus only affects particular populations; finitude, by contrast, is Global Truth: "If AIDS hadn't been around, I still would have made *The Fly*, and I did make *Shivers* and *Rabid*. In retrospect, people say 'My God, this is prophecy,' but I just think it's being aware of what we are" (127).[24]

But this universalizing idiom is itself the reflection of Canada's position in the capitalist world system: a Canadian filmmaker whose primary market is the United States may think himself *compelled* to efface in his work all signs of national difference.[25] This conflict between the universal and the singular cuts deeply throughout Cronenberg's career. Thinking of his early days as a filmmaker, he describes how "it was different in Canada, as always. We wanted to by-pass the Hollywood system because it wasn't ours. We didn't have access to it. It wasn't because we hated it, but because we didn't have an equivalent, and we didn't have the thing itself" (15). To promote this *ding an sich*, Cronenberg on the one hand "still lives in the city of his birth, and to date has not made a movie outside Canada" (1).[26] On the other hand—the hand that gestures toward "what is universal about human existence" (and toward the market to the south)—he refuses to restrict himself to narrowly "Canadian" themes, which continually provokes the criticism of his more nationalist colleagues who take his films to be "living proof of the Americanization of our industry."[27] This contradiction between the claims of (Canadian) singularity and (American) universality is sharply crystallized early in *Rabid* as Dr. Keloid and his partner Murray plan their series of franchised resorts: "I just sure as hell don't want to be known as the Colonel Sanders of plastic surgery," objects the doctor. "Sounds great to me!" is Murray's exuberant reply.

Inhabiting both of these positions at once, Cronenberg almost blithely describes being caught in a double bind:

Thus the attraction of Canadians to things American, but also the repulsion?
That's right. It's definitely a love-hate relationship.
And where do you find yourself in that nexus as a Canadian filmmaker whose largest audience is American?
Right in the middle. It's a very interesting place to be. It's a *Canadian* place to be.[28]

Though this place is described as distinctively Canadian, it is also and by the very same token *less* than fully distinctive—as if being "right in the middle" means to be on the edge:

> My sensibility is Canadian, whatever that is. But it's there, and I think Americans feel it. There was a man who called me up from Santiago, and he said: "The fact that you make your films in Canada makes them even more eerie and dreamlike, because it's like America, but it's not. The streets look American, but they're not, and the accents are American, but not quite. Everything's a little off-kilter; it's sort of like a dream image of America."[29]

If Canada differs here at all from the United States, it does so solely in terms of its diminished, derivative, dreamlike ontology.

In another respect, however, Canada *is* wholly different, for Québec can always be adduced as "proof" of national distinctiveness. *Rabid* and the earlier *Shivers* are unique in Cronenberg's corpus in their explicitly Québecois settings. The decision to film in Montréal was dictated in part by the location of Cinepix, the Québecois production company that backed Cronenberg in the hope of finding "something that would break them into the American market" (37).[30] Cronenberg describes his initial experience of the city in tellingly sexual terms:

> By the time I contacted Cinepix, they had made a couple of other films too: very sweet, gentle, lush softcore films with a lot of tits—great tits actually. . . . This was unheard of in English Canada. This was really my first introduction to the fierce nationalism of Québec, and how well it worked in terms of a culture that could excite itself. It was very hard for English-Canadian culture to excite English Canadians. They were excited by Americana. (36)

Where English Canada needs the United States for its stimulation, Québec gets it on by itself—which English Canada *also* likes to watch. Montréal surrenders here its putative Everycity quality in fulfilling its singular, sexualized role in the Anglo-Canadian imaginary. Indeed, far from being Cronenberg's invention, Québec has long assumed the part of English Canada's Mediterranean. As Robert K. Martin argues: "The exotic, the Southern, the Latin—all existed next door in Québec. And so English Canadian writers who have wished to attack their own culture for its Victorianism, its Puritanism, its moral rigidity have turned to Québec." If, in this traditional scenario, "Canada is the man," Montréal finds itself cast (no surpise) as "the mysterious woman." But Montréal is also, and just as venerably, the mysterious *man* on whom is projected "the homosexual fantasies of the proper English Canadian":

> Located next door, Québec has remained the metaphor for that which is at the same time within and without. Québec is a metaphor for homosexuality, since homosexuality is the forbidden land of lustful desires; and homosexuality is a metaphor for Québec, since it is a state within, an inner subversion.[31]

If Québec is what makes Canada different, it thus may also be, for Cronenberg, *too* different, not "universal" enough. For to set *Rabid* in Montréal is to imply both dimensions of this national/sexual fantasy, grafting them together on a porn star's body whose represented predatoriness and indeterminate gender stand in, as well, for a different sexuality. Cronenberg surely recognizes this implication given the heat with which he attempts to deflect it:

> *You have a kind of—I don't know if we want to say—"repressed homosexuality" in a lot of your work. The first two films you did—"Stereo" and "Crimes of the Future"—your lead actor certainly had a gay presence; then you gave Marilyn Chambers an underarm phallus in "Rabid"—*
>
> But I gave her a vagina; I gave her a cunt, too! First there's the cunt, and then the phallus—it's both, you got everything! I gave her everything![32]

To give Chambers "everything" is not, Cronenberg insists, to link her metonymically with a singular gayness but to endow her with aspects of both genders, thereby making her . . . universal: "There is a femaleness and a maleness. We partake of both in different proportions. . . . If you think of a female will, a

universal will, and a male will and purpose in life, that's beyond the bisexual question. A man can be a bisexual, but he's still a man. The same for a woman" (31). Where bisexuality thus delimits itself as irreducibly singular, the two genders are ubiquitous even or especially when they are lodged, "in different proportions," within an individual. This latter, for Cronenberg, is the universal condition—with which he unflinchingly aligns himself: "I'm male, and my fantasies and my unconscious are male. I think I give reasonable expression to the female part of me, but I still think I'm basically a heterosexual male" (98).

Gayness, of course, has often been thought in the West on this model of internalized gender inversion (e.g., Ulrichs's *anima muliebris virili corpore inclusa*), a model that preserves what is basic to heterosexuality: gender difference itself.[33] But Cronenberg never thinks of his inner femininity in continuity with gayness; he conceives of it, in fact, as different enough in kind to *replace* the "less universal" term. I certainly *don't* want to say that this substitutive preference is the reactive sign of a "repressed homosexuality," only that Cronenberg's singularization of the nonheterosexual has been so consistent over the course of his commercial career as to constitute something like a signature. His masterpiece *Dead Ringers*, for example, recounts the lives and deaths of Beverly and Elliot Mantle, identical-twin gynecologists who, jointly addicted to drugs, fatally "separate" themselves from each other using tools designed to operate on "mutant women."[34] The film is a fictionalized account of the "real life" Marcus twins, though changed in a major respect: where one of the original twins was gay, Elliot and Beverly are both portrayed as straight: "To me that just felt wrong. If one of them is gay and one of them is not, then already they are different in a very essential way, when the point of the whole story is how similar they are" (163). Gayness would have been a perverse singularity in a film that "has to do with that element of being human . . . with this ineffable sadness that is an element of human existence" (149). And to be human is not to be singular but to be multiply and conflictu-ally gendered: "In *Dead Ringers* the truth, anticipated by Beverly's parents— or whoever named him—was that he was the female part of the yin/yang whole. Elliot and Beverly are a couple, not complete in themselves. Both the

characters have a femaleness in them" (147). Predictably, Cronenberg discloses that he made *Dead Ringers* "out of the female part of myself" (147), a self that—though partially feminine—is basically straight overall.

But these sexual distinctions are finally no more coherent than Cronenberg's version of Canadian identity. For a universally conceived same-sex couple resembles nothing so much as its singular opposite—which is why Cronenberg takes such deliberate pains to portray his twins as basically straight. This "proof" of their heterosexuality will be less than definitive, however, since the plot entails that Beverly and Elliot share the *same* woman whose presence as an intermediary enables them to touch one another vicariously.[35] "Just do *me*," Elliot coaches his brother: "You haven't had an experience unless I've had it, too. You haven't fucked Claire Niveau till you tell me about it." As in the sequence in which Beverly dreams that he and Elliot are grafted together by a monstrous piece of flesh, what remains basic to their heterosexuality is this unstable fusion of cross-sex with same-sex desire, the difference between prescription and proscription having here been rendered all but moot. With the boundary between the universal and the singular now passing *through* the universal, Cronenberg acknowledges a crisis of national proportions: asked once more to "comment on the differences" between the United States and Canada, he confesses that

> it's obviously not so clear cut and that's always been a problem in Canada, in terms of our own identity. In fact, maybe we've stumbled onto the reason that the real subject of most of my films is identity. Because I'm a Canadian, you see, and we are much more like Beverly and Elliot here.[36]

This collapse of the singular/universal dichotomy repeats itself spectacularly in Cronenberg's recent adaptation of *Naked Lunch*. As with *Dead Ringers*, Cronenberg sought to distance his script from the gay thematics of the original.[37] "One of the barriers to my being totally 100 per cent with William Burroughs," he notes, "is that Burroughs's general sexuality is homosexual. It's very obvious in what he writes that his dark fantasies happen to be sodomizing young boys as they're hanging" (99). Though Cronenberg "can

actually relate to that to quite an extent," he still felt compelled to explain to Burroughs that "what I do is very different" (162):

> I did go to him, and we talked several times. One of the things I said to him was "You know, I'm not gay and so my sensibility, when it comes to the sexuality of the film, is going to be something else. I'm not afraid of the homosexuality, but it's not innate in me and I probably want women in the film." (162)

Yet "in order to bring something of *Naked Lunch* to the screen," Cronenberg discovered that he needed "to fuse myself with Burroughs" (161), thereby creating a monstrous graft between them:

> I started to write Burroughsian stuff, and almost felt for a moment, "Well, if Burroughs dies, I'll write his next book." Really not possible or true. But for that heady moment, when I transcribed word for word a sentence of description of the giant centipede, and then continued on with the next sentence to describe the scene in what I felt was a sentence Burroughs himself could have written, that was a fusion. (162)

I'm *not* gay, but when it comes to imagining monsters I'm inside him, or rather I *am* him: now *that* was a fusion! Really not possible or true—though Cronenberg also describes having been from his adolescence "possessed" by Burroughs. Interfering with the development of "my own voice" (23), Burroughs had been in his mouth already from the start.

"Without Burroughs," the film critic Mitch Tuchman has suggested, "Cronenberg may be without imagery." Tuchman points out that *Rabid*'s "morphogenically neutral skin graft" has itself been grafted from Burroughs's "undifferentiated tissue that can grow into any kind of flesh . . . sex organs sprout everywhere."[38] That Cronenberg transplants Burroughs's tissue to a wholly new context seems an appropriate act of homage given Burroughs's lifelong obsession with the effects of iterability. Indeed, in transferring the very principle of Burroughs's writing—the cut-up—to his own film medium, Cronenberg deploys in nearly all of his works a sustained Bourroughsian analogy between textual production and surgical technique.[39] In *Rabid* this analogy is routed

The Graft.

through the figure of Dr. Keloid, since he and Cronenberg operate with similarly plastic materials and share a language of cuts and sutures. In light of this resemblance, the film's central plot device—the graft fusing Marilyn Chambers's thigh tissue to her intestines, her outside to her inside—comes to be invested with tremendous textual weight. As the putative "origin" of the epidemic, the graft is all that would splice together the two halves of the film, the unmarked rural setting with the particularity of Montréal. Once more, however, any stable fusion of the universal with the singular stubbornly refuses to take:

> Cronenberg's tendency to cut to the bone during editing . . . did produce some
> confusion for the audience in *Rabid*. How exactly did Marilyn Chambers

226

develop that blood-sucking penis in her armpit? A short dialogue scene between radical plastic surgeon Dan Keloid and his patient had been removed because Cronenberg felt it broke the tension of the scene. . . . "That was a mistake. It would have provided a simple rationale for people to understand. Even those who like the movie have asked, 'But what was that thing?' " (57)[40]

Dr. Keloid's experiment and Cronenberg's film thus commonly go astray, for "that thing"—Chambers's monstrous *Geschlechtsteile*—obeys the logic of a different graft, (up)rooting itself in the way that *it* chooses. Rather than reconciling the singular with the universal—indeed, rather than explaining itself—the graft cuts another way, even cutting itself out from its own diegesis.

To find *Rabid* once more piercing its own borders is to identify, as well, the particular kind of interest I take in Cronenberg's work—and that he seems, at times, to take in it too: "When you begin to mix your blood with the characters in the film . . . you're mixing your own anxieties with the anxieties that are being played out in the film." Cronenberg characterizes this fusion as other than classically "cathartic,"[41] as the boundary between insides and outsides drenches itself in an exchange of bodily fluids. A risky practice, certainly, but one that both enables and delimits my own grafts with David Cronenberg. Growing up on different sides of a common border, he and I jointly came of age in Fiedler's generation of mutant men. Though neither of us were born *that way*, we both became mutants in the face of an impossible double double bind—the necessity of proving, in national and sexual terms, what exceeds the order of proof. But there are ways and there are ways of being that way, of acknowledging that impossibility, of inhabiting that monstrous borderland. Am I able to imagine a Cronenberg less homophobically inclined, less ready to portray himself as the universal case, less willing to deny that his work profits from its contiguity with the media's construction of AIDS? *Really not possible or true.*

Notes

An earlier draft of this essay was presented in May 1992 at the Harvard conference "Dissident Spectators, Disruptive Spectacles." This version was delivered the following July in France at

the Cerisy-la-Salle colloquium "Le Passage des frontières (autour de Jacques Derrida)." I thank the editors of the present volume for their latitude and criticisms, and a multitude of other friends for suggestions and technical assistance: Michèle Barale, Jack Cameron, Judy Frank, John Gunther, Sean Holland, Peggy Kamuf, David Kastan, Tom Keenan, Richard Klein, Sura Levine, Robert K. Martin, Michèle Melchionda, Catherine Portuges, Bruce Robbins, Karen Sánchez-Eppler, Eve Kosofsky Sedgwick, Sasha Torres. Robert Schwartzwald supplied the usual inspiration, and Mary Russo once more saved me from myself.

I am especially grateful to Ebe-Rita Leone and Cinepix Inc. for their kind permission to reproduce images from *Rabid*.

1. David Cronenberg, quoted in Chris Rodley, ed., *Cronenberg on Cronenberg* (London and Boston: Faber and Faber, 1992), 16. All further references will be cited parenthetically.

2. Leslie A. Fiedler, "The New Mutants," *Partisan Review* 32 (1965): 505–25.

3. Cf. Jacques Derrida, *The Other Heading*, trans. Pascale-Anne Brault and Michael B. Naas (Bloomington: Indiana University Press, 1992), 73: "No cultural identity presents itself as the opaque body of an untranslatable idiom, but always, on the contrary, as the irreplaceable *inscription* of the universal in the singular, the *unique testimony* to the human essence and what is proper to man."

4. See Jacques Derrida, "*Geschlecht*: Différence sexuelle, différence ontologique" and "La Main de Heidegger (*Geschlecht II*)," in *Psyché: Inventions de l'autre* (Paris: Galilée, 1987), 395–414 and 415–451 respectively.

5. See, among others, Benedict Anderson, *Imagined Communities: Reflections on the Origin and Spread of Nationalism*, rev. ed. (London: Verso, 1991); Étienne Balibar and Immanuel Wallerstein, *Race, Nation, Class: Ambiguous Identities* (London: Verso, 1991); Homi Bhabha, ed., *Nation and Narration* (New York: Routledge, 1990); Partha Chatterjee, *Nationalist Thought and the Colonial World: A Derivative Discourse?* (London: Zed Books, 1986); and Andrew Parker, Mary Russo, Doris Sommer, and Patricia Yaeger, eds., *Nationalisms and Sexualities* (New York: Routledge, 1992). As Gayatri Spivak has argued, this conflict between the singular and the universal defines as well the possibility conditions of international feminism; see "French Feminism Revisited," in Judith Butler and Joan W. Scott, eds., *Feminists Theorize the Political* (New York: Routledge, 1992), 54–85.

6. Simon Watney, *Policing Desire: Pornography, AIDS, and the Media*, 2nd ed. (Minneapolis: University of Minnesota Press, 1989), 24.

7. Ibid., xi.

8. Eve Kosofsky Sedgwick, *Epistemology of the Closet* (Berkeley: University of California Press, 1990), 184–85.

9. Robert Schwartzwald, "an/other Canada. another Canada? other Canadas," *Massachusetts Review* 31, 1 and 2 (Spring-Summer 1990): 18.

10. This was Chambers's first attempt to cross over from porn into mainstream cinema;

Cronenberg imagined Sissy Spacek in the role, but one of his producers insisted that Chambers would make the better draw (54).

11. Randy Shilts, *And the Band Played On* (New York: St. Martin's Press, 1987). On Shilts, see especially Douglas Crimp, "How to Have Promiscuity in an Epidemic," *October* 43 (Winter 1987): 237–71, and Ellis Hanson, "Undead," in Diana Fuss, ed., *Inside/Out: Lesbian Theories, Gay Theories* (New York: Routledge, 1991), 324–40.

12. Leo Bersani, "Is the Rectum a Grave?" *October* 43 (Winter 1987): 211.

13. "Everyone detected with AIDS should be tattooed in the upper fore-arm, to protect common-needle users, and on the buttocks, to prevent the victimization of other homosexuals." William F. Buckley, "Identify All the Carriers," *New York Times*, 18 March 1986, A27.

14. Simon Watney, "The Spectacle of AIDS," *October* 43 (Winter 1987): 80.

15. Judith Williamson, "Every Virus Tells a Story," in Erica Carter and Simon Watney, eds., *Taking Liberties: AIDS and Cultural Politics* (London: Serpent's Tail, 1989), 69–70.

16. Simon Watney, "Short-Term Companions: AIDS as Popular Entertainment," in Allan Klusacek and Ken Morrison, eds., *A Leap in the Dark: AIDS, Art and Contemporary Cultures* (Montréal: Véhicule Press, 1992), 153.

17. Williamson, "Every Virus Tells a Story," 73.

18. The confluence of these discourses has since acquired a ubiquitousness reflected in Pierre Chablier's running account in *Libération*, "Moi et mon sida": "J'ai parfois le sentiment que nous sommes ici, à Paris, quelques dizaines de milliers de *mutants parmi la foule*" (my emphasis); cited in Alexander García Düttmann, "Ce qu'on aura pu dire du sida," *Po&sie* 58 (Decembre 1991): 89.

19. See, for example, Noël Carroll, *The Philosophy of Horror, or Paradoxes of the Heart* (New York: Routledge, 1990), and Carol J. Clover, *Men, Women, and Chainsaws: Gender in the Modern Horror Film* (Princeton: Princeton University Press, 1992).

20. It would be risky, of course, to ascribe these oddities to Cronenberg's "intention" when they may simply reflect the limits of his technical competence at that time (*Rabid* was his second feature film). I would argue, however, that—beyond any question of conscious design—such tensions are readable in his subsequent (and often dazzlingly realized) films, thereby remaining consistent over the course of his career. Carroll, for example, points out that Cronenberg's *The Fly* "has all the trappings of a horror film, including a monster. But classifying it as a horror film as such, without qualification, seems not quite right. It fails to capture an essential difference between this film and the rest of the genre" (*The Philosophy of Horror*, 39). Or between Cronenberg's entire *oeuvre* and itself.

21. Cf. Watney, "Short-Term Companions," 165: "However bad the [AIDS] epidemic is in Canada or Britain or Australia, we in these countries at least have advantages that remain all but unthinkable in the U.S.A., whether in terms of socialized medicine, good

government-funded AIDS service organizations or regular access to network TV audiences on our own terms." This does not suggest, of course, that the Canadian government's policies have been at all adequate; on this topic see James Miller, ed., *Fluid Exchanges: Artists and Critics in the AIDS Crisis* (Toronto: University of Toronto Press, 1992).

22. See Cindy Patton, *Inventing AIDS* (New York: Routledge, 1991).

23. Owen Gleiberman, "Cronenberg's Double Meanings," *American Film* 14, 1 (October 1988): 40.

24. Cronenberg's interviews are filled to overflowing with these globalizing philosophemes: "Catharsis is the basis of all art. This is particularly true of horror films, because horror is so close to what's primal" (73). "Many of the peaks of philosophical thought revolve around the impossible duality of mind and body. Whether the mind is expressed as soul or spirit, it's still the old Cartesian absolute split between the two" (79). Descartes, of course, is not invoked here as a *French* philosopher.

25. See Fredric R. Jameson, "Totality as Conspiracy," in *The Geopolitical Aesthetic: Cinema and Space in the World System* (Bloomington: Indiana University Press, 1992).

26. *Naked Lunch* was to have been an exception to this practice: "Planned as Cronenberg's first foreign-location movie (most exteriors were originally to be shot in Tangiers), the production became yet another of the director's interior journeys when the Gulf War prevented filming in North Africa" (xxiv).

27. Pierre Véronneau, "Canadian Film: An Unexpected Emergence," trans. Jane Critchlow, *Massachusetts Review* 31, 1 and 2 (Spring-Summer 1990): 217–18.

28. David Breskin, "David Cronenberg," *Rolling Stone*, 6 February 1992, 68.

29. Anne Billson, "Cronenberg on Cronenberg: A Career in Stereo," *Monthly Film Bulletin* 660 (January 1989): 5.

30. "Cinepix was just André Link, a European Jew who spoke French, and John Dunning, who was totally WASP. For me to say that they represented French-Canadian filmmaking is very ironic, but they did" (36). To be content with describing one's ignorance as "ironic" is, to be sure, a highly symptomatic response. On the history of Québecois filmmaking, see, for example, Joseph I. Donohoe, Jr., ed., *Essays on Québec Cinema* (East Lansing: Michigan State University Press, 1992).

31. Robert K. Martin, "Two Days in Sodom, or How Anglo-Canadian Writers Invent Their Own Québec," *Body Politic* (July–August 1977): 28–30. For a contrasting account of the ways Québecois nationalists have projected "homosexuality" onto *English* Canada, see Robert Schwartzwald, "Fear of Federasty: Québec's Inverted Fictions," in Hortense J. Spillers, ed., *Comparative American Identities* (New York: Routledge, 1991), 175–95.

32. Breskin, "David Cronenberg," 70.

33. Cf. David M. Halperin, *One Hundred Years of Homosexuality* (New York: Routledge, 1990), 16: "That sexual object-choice might be wholly independent of such 'secondary'

characteristics as masculinity or femininity never seems to have entered anyone's head until Havelock Ellis waged a campaign to isolate object-choice from role-playing and Freud . . . clearly distinguished in the case of the libido between the sexual 'object' and the sexual 'aim.' "

34. On *Dead Ringers*, see especially Barbara Creed, "Phallic Panic: Male Hysteria and *Dead Ringers*," *Screen* 31, 2 (Summer 1990): 125–46; Marcie Frank, "The Camera and the Speculum: David Cronenberg's *Dead Ringers*," *PMLA* 106 (May 1991): 459–70; and Mary Russo, *The Female Grotesque* (New York: Routledge, forthcoming).

35. See Eve Kosofsky Sedgwick, *Between Men: English Literature and Male Homosocial Desire* (New York: Columbia University Press, 1985).

36. George Hickenlooper, "The Primal Energies of the Horror Film," *Cinéaste* 17, 2 (1989): 7.

37. And what a distance this turned out to cover: "Scrapping most of the novel and its frank depictions of gay sex, Cronenberg has made a pseudo-biography of Burroughs which, while retaining Burroughs's tone and wit, almost completely obscures his sexuality. Burroughs's ironic comment on the double lives many gay people lead, that 'homosexuality is the best all-around cover story an agent ever had,' is here transformed into an excuse to render his hero's homosexuality nearly invisible, and Cronenberg inexplicably invents a love affair between Burroughs's alter-ego and a character based on Jane Bowles, despite the fact that the real Jane Bowles was a lesbian. The most disturbing aspect of the film, however, is the invention of a character who does not appear in the novel, an effete, predatory homosexual (played by Julian Sands) who (recreating every straight man's worst nightmare about gay sex) murders a young man while fucking him." Al Weisel, "Bugging Out: David Cronenberg Exterminates Homosexuality," *QW*, 9 August 1992, 36.

38. Mitch Tuchman, "Fish Gotta Swim . . . ," *Monthly Film Bulletin* 51, 605 (June 1984): 192.

39. "I am being this clinician, this surgeon, and trying to examine the nature of sexuality. I'm doing it by creating characters I then dissect with my cinematic scalpels" (151). For more on this congruence between film production and medical pathology, see Diana Fuss's essay in this volume, and Pete Boss, "Vile Bodies and Bad Medicine," *Screen* 27, 1 (January–February 1986): 14–24. Critics have been quick to grasp the implications of Cronenberg's casting himself, in *The Fly*, as a gynecologist.

40. Cf. Lee Rolfe, "David Cronenberg on *Rabid*," *Cinéfantastique* 6/3 (1977): 26: "I think, though, we cut a bit too much out of the explanation of why the disease develops the way it does. It was in the original script, we shot it but it was taken out because the scene where that information was given was poorly paced." The precise nature of this "information" remains, to my knowledge, a mystery.

41. Breskin, "David Cronenberg," 68.

13

Kimberly Bergalis, AIDS, and the Plague Metaphor

Katharine Park

"Kim's Brave Journey": At 11:31 A.M. on Sept. 24, Amtrak's Silver Meteor pulled into Florida's Okeechobee station, just one of 30 stops on the train's daily run between Miami and New York City. Yet for one passenger boarding at Okeechobee, this was not just a train trip; it was a pilgrimage. As Kimberly Bergalis settled painfully into her tiny compartment, she was beginning an odyssey that some believe she had literally been living for.

Since the day a year before when she revealed that she was the first person known to have been infected with the AIDS virus by a health-care worker, Kim, now 23, had had but one quest: to prevent what happened to her from happening again.

Last June her cause won valuable support on Capitol Hill. California Congressman William Dannemeyer told the Bergalises that he was introducing a bill, named for Kim, calling for mandatory testing of health-care workers who perform invasive procedures. But Kim could only smile weakly at the news. Ravaged by the disease she had contracted 3½ years earlier from her Stuart, Fla., dentist, Dr. David Acer, she was unable to speak, stand or eat. Her weight had dropped below 70 lbs. She begged to die.

But then Kim's condition began to improve. Kim says her renewed strength to go on came from God. "He's saying to me, 'Go for it,'" she said. By August she was talking again and eating solid food. When it was announced that on Sept. 26 testimony would be heard relating to her namesake bill, Kim vowed to be there.

"I don't think she's going to leave [this world] until she sees mandatory testing of health-care providers and patients," said her mother, Anna, 47, a

public-health nurse, who cared for her on the long train ride north. "She's willing to suffer until she can get to Washington. . . ."

Kim was dressed when the train pulled into Washington's Union Station at 7 A.M. . . . [She] had hoped to walk into the hearing room the next morning but instead had to be pushed in a wheelchair. The packed room was hushed as she began to speak.

"I'd like to say that AIDS is a terrible disease which we must take seriously," she said in a slurred monotone. "I did nothing wrong, yet I am being made to suffer like this. My life has been taken away. Please enact legislation so that no other patient or health-care provider will have to go through the hell that I have. Thank you."[1]

Bergalis's fifteen-second testimony before the House Subcommittee on Health and the Environment, here atmospherically described by *People* magazine, was broadcast in full on all three major networks, while most U.S. newspapers carried front-page pictures of her the next day, slumped in her wheelchair or hunched over a microphone, flanked by mother Anna and father George. This lamentable spectacle marked the culmination of the Bergalises' campaign, which had begun in early September 1990 with a news conference where Kimberly announced a million-dollar malpractice suit against Acer's estate, and which ended in early December 1991 with her death. This campaign, taken up with enthusiasm by both electronic and print media, involved not only press conferences and Bergalis's dramatic congressional appearance but also an astounding number of interviews and appearances on local and national television talk shows. It seems to have been largely choreographed by two West Palm Beach professionals: Robert Montgomery, the lawyer in Kimberly's successful malpractice suit, and Dr. Sanford Kuvin, an infectious-disease specialist and crusader for mandatory testing for HIV and hepatitis B.[2] In its later stages, as *People* magazine indicated, the Bergalises were taken up by Representative Dannemeyer, an ardent opponent of gay and lesbian rights and sponsor of the Kimberly Bergalis Patient and Health Provider's Protection Act, in favor of which Kuvin, Kimberly, and George Bergalis all testified.

Kimberly took an active part in this campaign through April 1991, when

233

she became too ill for media appearances, and her rage at the dead man who had infected her seemed to grow as her health declined. ("I blame Dr. Acer and every single one of you bastards," read a letter of hers released to the press in late June.)[3] During the fall and winter, she intensified her initial advocacy of mandatory disclosure of the HIV status of infected dentists and surgeons into a furious insistence on mandatory testing—a shift I would attribute to the influence of Kuvin and later Dannemeyer, who seem to have fed her understandable feelings of bitterness and self-pity and exploited her episodes of AIDS-related dementia to further their own political goals.[4]

The Bergalis campaign had great impact. It catapulted the issue of AIDS back into the front sections of newspapers and onto the covers of magazines such as *People* and *Newsweek*,[5] where it stood at the core of an intense debate over the prevalence of iatrogenic AIDS, focused primarily on Dr. Acer's infection of Kimberly and four other patients (still the only case of its sort)[6] and over the advisability of universal mandatory HIV testing of doctors, nurses, and patients. At its height, in the spring and summer of 1991, this issue dominated the public discourse on AIDS. Between April and June 1991, for example, *USA Today* ran fifty-one pieces on AIDS, in comparison with the fourteen it had averaged for each of the preceding three quarters;[7] these included three entire editorial pages devoted to the debate over the safety of medical patients,[8] fifteen page-one stories, and four cover stories on the topic, the first of which was evocatively titled "AIDS: Guarding the Innocent."[9]

In the rest of this essay, I will be reflecting on coverage of the Kimberly Bergalis case in mass circulation print media, concentrating on *USA Today* and *People* magazine. I have chosen these two publications both because their large national circulations guaranteed the wide dissemination of the images they chose to promote,[10] and because their representative strategies around Bergalis reflect clearly and without particular subtlety the assumptions and interpretations that continue to structure much of the general media discourse on AIDS. The issue of HIV testing lies at the heart of cultural and political constructions of AIDS, since testing of the sort advocated by Dannemeyer and Bergalis—particularly in the continuing absence of any evidence of a statistically significant risk of transmission of HIV from health-care workers

to their patients—makes sense only as an attempt to police borders between the infected and the uninfected and to justify stigmatizing and discriminatory practices and attitudes.[11] In this connection, it is worth keeping in mind— sobering thought—that *USA Today*'s editorial stand against mandatory HIV testing of health-care workers put it in a markedly progressive position with respect to the 89% of the U.S. population who favored such testing in a 1991 Gallup poll.[12]

In general, the coverage of the Bergalis case in *USA Today* conforms closely to the patterns of AIDS reporting already identified and analyzed by Cindy Patton and Simon Watney, among others.[13] Throughout the period in question, the paper's writers and editors offered up a series of finely honed, if not particularly subtle, double messages. Thus they used editorials to warn against exaggerated fears of contagion, while simultaneously featuring a series of screaming headlines clearly designed to pander to exactly those fears, thereby promoting the sense of crisis that fueled the movement for mandatory testing they claimed to reject.[14] Similarly, they represented AIDS as primarily a sexually transmitted disease of gay men; even the so-called "new generation of victims" described in a 1991 cover-story retrospective on the epidemic turned out to be not IV drug users or Latinos and African Americans or women and children, but simply younger gay men.[15] Nonetheless, the "AIDS victims" they chose to feature in their news coverage (as opposed to the entertainment section) were overwhelmingly men and, especially, women and children infected through medical procedures: Bergalis, of course; Barbara Webb and Lisa Shoemaker, two other patients of Dr. Acer; Ryan White and Ricky Ray, both young hemophiliacs; and Martin Gaffney, an ex-Marine whose wife had contracted HIV from a transfusion.[16] All were white and all clearly represented as heterosexual, as in, for example, the page-two story devoted to the fourteen-year old Ray's marriage plans.[17]

These editorial choices had various implications. In the first place, they encouraged readers to focus on and identify with only the relatively small number of people infected in various ways by their doctors, rather than with the much larger number of people with AIDS who had contracted HIV through gay sex or needle sharing.[18] This textual strategy had a clear visual analogue:

USA Today, like *People*, consistently published large-scale photographs of its "innocent victims" of AIDS, often surrounded by family or friends, while relegating the gay doctors feared to have infected them to unsympathetic, postage-stamp-sized mug shots.[19]

In the second place, these publications consistently presented gay men as the reservoir of infection from which HIV (or AIDS, as the paper consistently chose to word it) continually threatened to spill over into what they often called "mainstream" America. Because the gay and heterosexual communities were assumed to be naturally distinct—the boundary guaranteed by a fanta-sized gulf between the "deviant" and the "normal" population—there were only two avenues through which this contamination could occur, once the blood supply had been secured by routine screening for HIV. One was what one particularly explicitly worded op-ed column called "gay men masquerad-ing as straight," who could infect unsuspecting female lovers.[20] The other was gay doctors, whose work brought them into intimate contact with their patients. The latter avenue of infection took on extraordinary importance in the pages of *USA Today*, both on its editorial page—as the paper's regular op-ed columnist on AIDS delicately put it, "most doctors and dentists are white males, the group in which AIDS has struck most often"[21]—and in its news section, which repeatedly featured stories about doctors with AIDS who hid or lied about their condition, continuing to practice with open sores on their hands.

The fact that their patients, like Kimberly Bergalis, were overwhelmingly represented as women and children suggests that the fear of the infected gay doctor encodes some of the same fear raised by the masquerading gay—the lying seducer who infects the vulnerable or gullible, and through them the primary population of heterosexual men. The first sentence of one of Danne-meyer's columns in favor of mandatory testing makes this connection clear: "Your wife, who is about to deliver a baby, is rushed to the hospital into the waiting arms of an obstetrician/gynecologist who is infected with the AIDS virus."[22] But the gay doctor poses a greater threat than the passing gay sexual adventurer, for while it is presumably possible for women of strong moral character to resist the blandishments of bisexual men, *everyone* has to go to

the doctor, who becomes—in a shocking reversal—the purveyor not of health but of disease.[23]

Finally, the reiterated contrast between the closeted and infected gay doctor and his unsuspecting patients also posed in particularly stark form the familiar distinction between guilty and innocent "victims" of AIDS. That this distinction lies at the heart of the Bergalis affair appears not only from Kimberly's congressional testimony ("I did nothing wrong, yet I am being made to suffer like this") but in every interview granted by her and other members of her family. " 'I just went to the dentist,' she would say," as reported in *People* magazine, " 'I didn't deserve this.' "[24] While according to her father, "her sickness would have been easier to accept if she'd been a slut or drug user. But she had done everything right."[25] The central moral issue for Bergalis and her supporters was not drug use or female promiscuity, however, but male homosexuality, as is clear not only from Dannemeyer's virulently homophobic writings—his book, *Shadow in the Land: Homosexuality in America* argues not only for mandatory HIV testing but also for the restoration of state sodomy laws in the name of "family values" and the "Judeo-Christian ethical and moral Tradition"—but also from George Bergalis' own congressional testimony in favor of mandatory testing, where he presented his credentials in the following terms: "I'm not a medical professional, I'm not a scientist, I'm not a politician, a civil libertarian, or a homosexual."[26]

The dialectic of guilt and innocence also explains some of the more striking features of Kimberly's image as it appeared in the print media: the obsessive emphasis on her chastity ("yes, she really was a virgin," in the words of *People* magazine);[27] the intensely gendered nature of the journalistic representations (the repeated references to her faded beauty, her poignant vanity, and the children she would never bear); and above all her constant infantilization. Thus *People*'s most striking photographs showed her huddled in a fetal position under a crocheted blanket or squatting on the floor with her dog.[28] *People*'s text echoed the same theme—the writer reporting that "just minutes after [Kimberly's] testimony, she told me that she felt 'relieved.' She said it with the sincerity of a child, and I realized that for Kim the trip was more than a mission. It was also a young girl's first train trip and first visit to Washington."[29]

(Bergalis was at this time a 23-year old college graduate.) In the hands of the *National Review* there was an explicit ulterior motive for this kind of description; it compared Bergalis to "a fetus under *Roe v. Wade*: a victim of the right to privacy."[30] But even in its more generic forms, the overall aim was clearly to represent her as a candid, young, female heterosexual virgin, foil to the deceitful, sexually promiscuous adult gay man responsible for the epidemic of AIDS.[31]

The prominent references to Bergalis' virginity also call attention to another striking feature of the media coverage—the constant use of Christian imagery, even by publications without an overtly religious orientation. It is not surprising to find this language in the mouths of the Bergalises—strict Lithuanian Catholics, they clearly used it both to argue their cause and to make sense of their misfortune—or of their promoters and sponsors; according to their lawyer Robert Montgomery, Kimberly "was chosen for this message," while Florida governor Lawton Chiles said that "spending fifteen minutes with her was like being in the presence of a saint."[32] More significant is the way in which presumably secular publications such as *People* or *USA Today* adopted the same rhetoric, with their accounts of Bergalis' "pilgrimage" to Washington—note the decision to send her on a strenuous nineteen-hour train ride, while her father and sisters took the plane—her "quest," her "mission," her "crusade," and the "miraculous" remission that allowed her to fulfil her "dying wish" to testify. Even the photographs of Kimberly, her previously long hair cropped short, evoke associations with that other virgin, Joan of Arc.[33]

These Christian resonances were intensified by another novel feature of the coverage—the journalists' meticulous description of the physical marks of Bergalis's illness: her emaciation, her hollow eyes, the thrush infection in her mouth, the herpes blisters on her lips. Such details never appeared in the euphemistic and antiseptic accounts of other people with AIDS—with the exception of the so-called "open sores" on the hands of infected dentists and doctors. What we have here, in other words, is a potent evocation of the Christian martyr, whose life took on meaning only through her suffering and death, and whose sanctity was painfully inscribed on her virgin body for the world to see. This representation further draws on the complex and highly

developed Christian theology of disease, which has long promoted a double meaning for physical illness, as both punishment for sin and sign of divine grace. It recalls in particular the double image in Christian tradition of the leper, whose disfigurement could be read either as divine castigation (on the model of Moses' sister Miriam, whom God smote with leprosy when she spoke falsely against her brother) or as a mark of salvation (on the model of Lazarus, later the patron saint of leprosy, compensated for his earthly sufferings by salvation in the afterlife).[34]

This association, I would argue, is far from accidental. As Sander Gilman has suggested, the iconography of AIDS in American culture lies squarely in the tradition of European representations of what were thought of as sexually transmitted diseases, which reaches back through syphilis in the early modern period to leprosy in the high and later Middle Ages.[35] Similarly, while Allan Brandt has pointed out the ways in which our culture's construction of AIDS is consistent with its earlier construction of syphilis, revealing its "underlying anxieties about contagion, contamination, and sexuality," the modern focus of his study prevented him from seeking the ultimate roots of that construction in medieval attitudes toward leprosy, which was represented in literary and clerical sources as a contagious, slowly mortal, and intensely disfiguring disease devised by God as punishment for lust.[36] Thus the AIDS policy initiatives of many latter-day Christians such as the Bergalises and their supporters, and more generally the American religious Right, recall the calls for denunciation, isolation, and confinement of the ill that we find first in twelfth-and thirteenth-century European Christian policies toward lepers. For the same reasons, the image of Kimberly Bergalis, the good leper, the female Lazarus, her sores the signs of sanctity, implicitly calls up the image of her inverted double: the gay man, the bad leper, justly suffering for his sin.

What is the point of dwelling on these admittedly rather distant associations? I would argue that there are two. The first is that we often forget the central role played by religious and ultimately theological commitments in American homophobia and the construction of AIDS in the United States, where 41 percent of people identify themselves as born-again Christians and 32 percent believe every word of the Bible to be literally true.[37] In my own

reading of the often remarkably high quality critical writing on AIDS, I have been struck by the absence of any real attempt to come to grips with this dimension of the problem.[38] It is easy (and in my opinion accurate) to see those religious commitments in part as strategies bolstering traditional hierarchies of gender and sexuality, and justifying entrenched patterns of discrimination. But the theology has its own force and must be analyzed and addressed as such; we write off the Christian Right to our peril, as the recent history of American social policy shows.

My second and more specific point is that by eliding the specific role played by the Christian tradition in our society's attitudes toward AIDS we run the risk of naturalizing those attitudes as in some way inevitable or universal, instead of recognizing them as the contingent products of a particular cultural and religious history. In the rest of this essay, I want to discuss what I consider a telling example of this tendency: the use of what Susan Sontag has called the "plague metaphor" by American writers on AIDS.

In *AIDS and Its Metaphors* (1989), Sontag has argued that " 'plague' is the principal metaphor by which AIDS is understood."[39] And in fact journalists commonly characterized the disease as the "gay" or "homosexual plague" at least as early as 1982,[40] although, as it became clear that the disease was not confined to gays, the modifier was generally dropped, except by writers of the Christian Right.[41] As Sontag reminds us, the word "plague" comes from the Latin *plangere*, meaning to beat or scourge; a biblical term, it encodes the idea of illness as divine judgment—something that both "reveals, and is a punishment for, moral laxity or turpitude."[42] Sontag points out correctly that before AIDS, the metaphor applied most neatly to leprosy and syphilis, although she, like most English-language writers, appears intermittently befuddled by the fact that English also uses the word "plague" to refer to the specific disease (bubonic plague: Latin *pestis*) that ravaged Europe and the Middle East in the fourteenth through seventeenth centuries.[43] In its epidemiology and constructed etiology, *that* kind of plague bore little resemblance to AIDS, leprosy, or syphilis and—at least in its earlier phases—engendered a wholly different kind of social and moral response, of which more below.

Such quibbles aside, however, where I principally differ from Sontag is in

the ahistoricity of her discussion of the attitudes encoded in the plague metaphor. She describes the stigmatizing reactions around AIDS, in the tradition of leprosy and syphilis, as "throwbacks" to a "premodern experience of illness" and incompatible with what she rather uncritically terms "modern—that is, effective—medicine."[44] This interpretation of the ideology of blame as a historical anachronism, the natural reaction of human beings without access to the powers and reassurances of modern scientific medicine, appears quite widely in the literature on AIDS; we can find it, for example, in William H. Foege's references to "social regression"[45] and David Richards' description of the idea of "moral plague" as a "conceptual anachronism." Echoing Sontag's scientism, Richards opines that "the lack of any reliable models of scientific causality or control led to the hegemonic dominance of the idea of moral plague . . . until quite recently in human history," noting ecumenically that "the idea of moral plague is as powerfully important an idea in the religion and literature of Western culture as any other culture."[46]

My point is that this attractive formulation is completely misguided. Rather than being an inescapable part of our social and biological heritage, its origins lost in the mists of human evolution, I would suggest that the idea of moral plague—disease as a punishment for individual moral, particularly sexual, misconduct—is peculiarly characteristic of European Christian culture; that it was largely constituted at a particular moment of European history, the eleventh, twelfth, and thirteenth centuries; and that it originally organized itself around the epidemic of leprosy, which reached its peak at precisely that time.[47]

In the early Middle Ages, as Jerome Kroll and Bernard Bachrach have argued recently, the idea of illness as divine punishment for sin played a relatively minor role even in European devotional and literary texts.[48] (Throughout the Middle Ages, medical texts appealed almost exclusively to natural causes.) Whereas clerical writers often used disease as a *metaphor* for sin, they did not tend to present it as the *effect* of sin unless they had a particular political or material grievance against the sick person in question, in which case it functioned as a standard rhetorical topos of divine retribution—one focused not on classes of people but on individuals. In general,

however, according to Kroll and Bachrach, early medieval sources portrayed "community concern and a sense of responsibility for those afflicted rather than a preoccupation with their putative sinfulness."[49] Even early discussions of leprosy tended to deemphasize this aspect of the disease,[50] and in any case, the relatively weak and decentralized structures of authority in early medieval society could not sustain large scale attempts at segregation.

This generally naturalistic attitude toward disease continued into the high Middle Ages. Beginning in the eleventh and twelfth centuries, however, we find in Christian popular and clerical writing an increasing association between leprosy and vice, particularly sexual vice, in the forms of sodomy and lust. At the same time, it became more common to segregate lepers from the rest of society, depriving them of legal and property rights and isolating them by either banning them from towns or confining them in leper hospitals. Initially, these practices seem to have been ritually and morally motivated, acquiring only later (in the thirteenth and early fourteenth centuries) a medical rationale based on an exaggerated fear of contagion.[51] The religious and moral stigmatization of the leper was never consistently or universally practiced in Western Christendom; it is signally absent, for example, in medieval medical (as opposed to literary or theological) discussions of the disease.[52] Nonetheless, it established a pattern for the treatment of certain categories of sick people—specifically those whose illness was interpreted as sexually transmitted—that was transferred to syphilitics, and much later, as Brandt and Gilman have suggested, to people with AIDS.[53]

It is important to emphasize that this moral interpretation of disease and this punitive reaction to leprosy were neither natural, inevitable, nor universal. Even within Christian culture, there were important strands that saw disease as an arbitrary misfortune or as a source of merit and sign of grace,[54] while other religious traditions admitted of even less punitive attitudes. Although also endemic in the medieval Islamic world, for example, leprosy does not seem to have been as strongly stigmatized as it was by medieval Christians.[55] In general, Muslim theologians tended to deny contagion and were more inclined to see illness in fatalistic terms, as a misfortune attributable to the unknowable will of God, rather than as a moral judgment—a contrast that

also appears when one compares Christian and Muslim reactions to the Black Death.[56]

To what can we attribute this development of a punitive attitude toward leprosy in Western Christendom? Clearly, one of its roots lies in one of the distinctive features of the Christian tradition: its tendency to sexualize human evil—to identify it, in the words of Peter Brown, "with specifically sexual desires, with unavowed sexual strategems, and . . . with the lingering power of sexual fantasy."[57] This tendency and its corollary, the development of a mystique of sexual continence symbolized most intensely in the body of the virgin girl,[58] have had a long afterlife, as the imagery around Kimberly Bergalis testifies. The Christian inclination to privilege sexuality as the archetypal expression of the corrupted human will conferred a special status on what were seen as venereal diseases and made them particularly suitable agents of divine punishment and moral blame.

But we must look further to explain why punitive attitudes and practices crystallized around leprosy in a particular period—the high Middle Ages. R. I. Moore has recently argued that this was not an isolated matter, but rather part of what he calls "the formation of a persecuting society." This phenomenon, which he has traced to the eleventh and twelfth centuries, marked (in Moore's own words)

> what has turned out to be a permanent change in Western society. Persecution became habitual. That is to say not simply that individuals were subject to violence, but that deliberate and socially sanctioned violence began to be directed, *through established governmental, judicial and social institutions*, against groups of people defined by general characteristics such as race, religion or way of life; and the membership of such groups in itself [came] to be regarded as justifying these attacks.[59]

Among those newly subject to such attacks were not only lepers, but Jews, heretics, and of course sodomites, primarily construed as male homosexuals, as John Boswell has also shown.[60] Clerical writers tended to identify these groups with one another in a circular and self-confirming rhetoric of blame and exclusion, depicting them all as sources of pollution and contagion—"a

single though many-headed threat" to the order of nature as ordained by the Christian God.[61] This rhetoric and these attitudes gradually became hegemonic, and it is they that in the most general sense still underpin the plague metaphor and structure much of the western reaction to AIDS. In Patrick Buchanan's famous dictum, "the poor homosexuals—they have declared war upon Nature, and now Nature is exacting an awful retribution," he speaks with an authentically twelfth-century voice.[62]

As I have already indicated, it is incorrect, as well as dangerous, to naturalize and universalize this reaction. There has long existed a large repertory of interpretations of disease. Some of these are nonjudgmental (illness as natural catastrophe or arbitrary misfortune) or even exculpatory (illness as a sign of special grace), while there is considerable variation even among those interpretations that have tried to make sense of disease in terms of moral blame. Even within Western Christendom, the tendency to blame the victim was only one—and not by any means the dominant—such strategy.[63] Other more common moves involved either blaming the community as a whole ("God is punishing *us*") or else elaborating conspiracy theories attributing the disease to the malicious actions of outsiders. Both of these last two strategies came into play, for example, in reactions to late medieval epidemics of plague (never, to my knowledge given a venereal etiology), where the vast and indiscriminate mortality made it impossible plausibly to blame the victims, and people looked inward for their own sins or outward for conspirators, notably the Jews.[64]

We can find an equally wide range of reactions to AIDS, if we are willing to look beyond Western Europe and the United States—or even within Western society, if we are willing to look beyond straight white culture. This expanded view would seem in fact to suggest that the most common (if not "natural") human reaction to epidemic disease is not to blame the victims within one's own community but to develop conspiracy theories involving outsiders and/or those in power. We can see this not only in non-Western interpretations of AIDS—Japanese blame foreigners, Africans blame westerners, or occasionally ethnic minorities in their own or neighboring countries, while many in Africa and southern Asia still subscribe to the theory that the

virus was created in the U.S. Army laboratory at Fort Detrick, Maryland[65]—but also in the reactions of non-hegemonic groups within our own society. Thus one 1990 poll showed that 35 percent of black church members thought that AIDS was a form of genocide, while another found that 10 percent of all African Americans believed that HIV was "deliberately created in a laboratory in order to infect black people."[66] These reactions echoed similar conspiracy theories that circulated widely in the gay press in the mid-1980s.[67]

It is much more difficult for the casual researcher to gather information about these kinds of reactions than to browse through last year's copies of *People* magazine or *USA Today*, both conveniently available through University Microfilm. Yet *People* and *USA Today*, both steeped in a culture of Christian images and an idea of moral plague, do not give an accurate sense of the range of possible interpretations of AIDS. The ideology encapsulated in the plague metaphor—the view of disease as a punishment for the transgression of moral or religious norms—is not a universal human reaction, or even a universal Christian reaction, but is rooted in a particular period of Western history. To naturalize it, as Sontag proposes, into the normal response to what she calls "the premodern experience of illness"—which for her clearly includes also the modern non-Western experience of illness—is to confer on it a legitimacy and universality it does not deserve. It also lends to this response a quality of inevitability, conjuring up apocalyptic scenarios of spiraling mortality and inexorable, if lamentable, increases in discrimination, which encourage us to imagine, and then hypothetically to accept, measures that are punitive and extreme.[68] Bergalis was a creature of the Christian Right, ideological home of her family and her sponsor Dannemeyer, and the ease with which even secular journalists adopted their rhetoric, if not their explicit political agenda, signals the continuing hegemony of such representations in United States culture. To historicize the assumptions about disease on which these representations are founded—to begin to think of them not as natural reactions, but as the contingent products of a distant time and place—serves a double purpose: it encourages the search for alternative conceptualizations, and it gives us some grounds for hope. After all, even *USA Today* came out against mandatory testing, and the Bergalis Bill never made it out of the House committee.

Notes

1. Bonnie Johnson and Meg Grant, "Kim's Brave Journey," *People*, Oct. 14, 1991, 44–45. I would like to thank J. D. Connor for his assistance in collecting media sources relating to the Bergalis case.

2. Kuvin's letterhead of June 1991 identifies him as vice chairman of the board of trustees of the National Foundation for Infectious Diseases (Bethesda, Md.) and vice chairman of the Kuvin Centre for the Study of Infectious and Tropical Diseases (Jerusalem, Israel, and Palm Beach, Fla.)

3. Full text in *Newsweek*, July 1, 1991, 52.

4. In Kimberly's initial press conference of September 1990, she called only for mandatory disclosure and did not mention mandatory testing; see Peter Applebome, "Dentist Dies of AIDS, Leaving Florida City Concerned but Calm," *New York Times*, Sept. 8, 1990, 10. On her dementia, see Meg Grant, "An Anguished Voice Falls Silent," *People*, Dec. 23, 1991, 117.

5. "The Dentist and the Patient: An AIDS Mystery," *People*, Oct. 22, 1990; "Doctors with AIDS," *Newsweek*, Oct. 14, 1990.

6. Although, as of February 1993, the Centers for Disease Control lists this as the only confirmed case of transmission of HIV by an infected doctor to a patient or patients through medical procedures, even that is now in question. Using new techniques of genetic analysis, another group of medical researchers has concluded that the evidence is in fact inconclusive; see "Dentist's Role in AIDS Challenged," *The Boston Globe*, February 25, 1993, 11, citing a letter to the editor by Ronald DeBry in *Nature*, February 25, 1993.

7. Statistics based on *USA Today Index*, vols. 9 and 10 (Ann Arbor: University Microfilms International, 1991–92).

8. "Protect Patients from Risk of AIDS," Apr. 17, 1991, A12; "Let's Act to Make Blood Supply Safer," May 21, 1991, A12; "Don't Test Doctors to Protect Patients," June 21, 1991, A10.

9. "AIDS: Guarding the Innocent," May 17, 1991, A1–2; "Is the Blood Supply Safe Enough?," May 21, 1991, A1–2; "10 Years of Horror," June 4, 1991, A1–2; Kim Painter and Kevin Johnson, "AMA Rejects Mandatory Testing," June 27, 1991, A1–2.

10. *USA Today*, with a paid circulation of over 1.4 million and an advertised readership of 6.6 million, is the most widely distributed daily newspaper in the United States; *People*'s circulation is 3.2 million, roughly equal to that of *Newsweek*. Figures from *Gale Directory of Publications and Broadcast Media*, 124th ed., 3 vols. plus update (Detroit/London: Gale Research, Inc., 1991).

11. See Cindy Patton, *Inventing AIDS* (New York and London: Routledge, 1990), esp. chap. 2. Patton argues that HIV antibody testing is a "tool for reproducing class, racial,

and sexual discrimination" (64), since "the 'risky behaviors' for which testing is essentially a confirmatory exercise are already connected in the public mind with gay men, prostitutes, drug users, and people of color" (41).

12. Kim Painter, "AIDS Testing has Wide Support," *USA Today,* Oct. 17, 1991, D1.

13. In particular, Patton, *Inventing AIDS*; Simon Watney, *Policing Desire: Pornography, AIDS, and the Media* (Minneapolis: University of Minnesota Press, 1989); Watney, "The Spectacle of AIDS," in Douglas Crimp, ed., *AIDS: Cultural Analysis/Cultural Activism* (Cambridge, Mass.: MIT Press, 1988), 71–86. See also Jan Zita Grover, "AIDS: Keywords," in ibid., 17–30; Grover, "Reading AIDS," in Peter Aggleton, Graham Hart, and Peter Davies, eds., *AIDS: Social Representations, Social Practices* (New York: Falmer Press, 1989), 252–63. For a more general and less critical and analytical treatment, see James Kinsella, *Covering the Plague: AIDS and the American Mind* (New Brunswick: Rutgers University Press, 1989).

14. Thus in addition to the Kimberly Bergalis stories, we find, for example, "Oregon Fear: Tainted Blood," Apr. 18, 1991, A1; "Woman Fears She Got AIDS from Pap Test," Apr. 24, 1991, A3; "Second Scare at Clinic in AIDS Suit," May 16, 1991, A1; "Kids Played with HIV Needle," May 21, 1991, A1; " 'Whisper' of AIDS Can Infect Heterosexuals," June 18, 1991, A1. None of the episodes reported led to a case of HIV infection. Cf. Watney, *Policing AIDS,* 39–40; Patton, *Inventing AIDS,* 107–8.

15. Kim Painter, "Denial Was Present from the Start," *USA Today,* June 4, 1991, A2.

16. The principal exception was of course Magic Johnson, whose announcement of his HIV-positive status in November 1991 seems to have opened space for a glimmer of sympathy for people infected through sex; thus on December 18, 1991, the paper finally ran a human-interest story on Ron Young, who had died of AIDS after having been infected "through sex with a man": Kim Painter, "Guilt, Innocence and AIDS," *USA Today,* December 18, 1991, D1–2. Before then the only gay men to be given a sympathetic voice—and there were very few—were Hollywood stars.

17. "AIDS Can't Deter Teen Love," *USA Today,* June 3, 1991, A2.

18. Watney, *Policing Desire,* 86.

19. See, for example, the photographs accompanying *People's* cover story on Bergalis, Oct. 22, 1990.

20. Barbara Reynolds, "Don't Get the Wrong Message from Magic," *USA Today,* Nov. 15, 1991, A11. Even more conservative commentators assume this boundary to be completely impermeable, so that "heterosexual AIDS," rather than an anxiety, becomes a "myth"; see, e.g., Michael Fumento, *The Myth of Heterosexual AIDS* (New York: Basic Books, 1990), and Don Feder, "Values the Answer to AIDS," *Human Events,* Aug. 18, 1990, 9: "Vis a vis the dread contagion, imploring a heterosexual couple to reach for a

condom before they have relations makes as much sense as telling them to wear crash helmets."

21. Harry Schwartz, "Test Doctors for AIDS to Protect Patients," *USA Today,* June 21, 1991, A10; he also points out that "both professions tend to have a disproportionate number of IV drug abusers because of their easy access to drugs."

22. William E. Dannemeyer, "Problem of AIDS, Health-Care Workers Coming to a Head," *Long Beach Press Telegram,* Sept. 27, 1991; his office distributes this column, which was syndicated through the Scripps Howard News Service, as part of their packet of information on the Bergalis Bill.

23. According to Lisa Shoemaker, another of Acer's infected patients, who "vowed to carry on Kimberly Bergalis' tireless fight" for mandatory testing, "you always think that doctors and dentists are . . . immune to diseases": *USA Today,* Dec. 10, 1991, A2. Or, in the words of a mother suing a Chicago hospital after her child had fished a used syringe out of the wastebasket of a clinic examining room, "I figure when you go to a hospital, that's the most secure place there is. . . . I want people to know that when you go to a hospital you have to be very careful." Linda Kanamine, "Disclosure a 'Two-Way Street'," *USA Today,* May 17, 1991, A1.

24. Grant, "An Anguished Voice," *People,* Dec. 23, 1991, 117. Even Grant had to admit that Bergalis "could also seem to lack empathy with other, more commonly infected, AIDS patients" (ibid).

25. Bonnie Johnson and Meg Grant, "A Life Stolen Early," *People,* Oct. 22, 1990, 77.

26. Quoted in Jacob Weisberg, "The Accuser," *New Republic,* Oct. 21, 1991, 13–14. William E. Dannemeyer, *Shadow in the Land: Homosexuality in America* (San Francisco: Ignatius Press, 1989), 217.

27. Grant, "An Anguished Voice," 114.

28. *People,* Oct. 22, 1990, 70–73.

29. Grant, "An Anguished Voice," 18.

30. "Private Grief," *National Review,* July 19, 1991, 15; the same article characterized Bergalis as combining "womanly virtue and childlike innocence" (14).

31. This was not Bergalis's only inverted double in the pages of *USA Today.* Less than a week after her congressional testimony, the paper published a long article on the so-called "Black Widow" of Dallas, an African-American woman with HIV who had "vow[ed] to sleep with as many men as she can—infecting them in revenge for one of them infecting her." Carolyn Pesce, "Dallas Fears AIDS Avenger," Sept. 30, 1991, A3. Both women were young and attractive, and both were driven by rage at the men who had infected them, according to the implicit comparison, but whereas Bergalis had contracted HIV "innocently" and devoted her remaining months to saving others from a similar fate, the Black Widow

had contracted it through sex and had launched a dying crusade to pass it on. The Black Widow was later exposed as a hoax; see Steve Marshall, "Dallas AIDS Avenger was Teen's Fabrication," Oct. 22, 1991, A3.

32. Lawton Chiles, quoted in Desda Moss, "AIDS Patient's Public Agony," *USA Today,* Sept. 12, 1991, A3.

33. E.g., *People,* Oct. 22, 1990, 78.

34. Numbers 12; Luke 16: 19–25. On the double image of the leper, see Richard Palmer, "The Church, Leprosy, and Plague in Medieval and Early Modern Europe," in W. J. Sheils, ed., *The Church and Healing* (Oxford: Blackwell, 1982), 82–85; Saul Brody, *The Disease of the Soul: Leprosy in Medieval Literature* (Ithaca and London: Cornell University Press, 1974), esp. chaps. 3–4. On the tradition of Lazarus, Peter Richards, *The Medieval Leper and His Northern Heirs* (Cambridge and Totowa, N.J.: D. S. Brewer, Rowan and Littlefield, 1977), 8.

35. Sander L. Gilman, "AIDS and Syphilis: The Iconography of Disease," in Crimp, *AIDS,* 87–107.

36. Allan Brandt, *No Magic Bullet: A Social History of Venereal Disease in the United States since 1880,* 2d ed. (New York and Oxford: Oxford University Press, 1987), 191–92; see also Brandt, "AIDS: From Social History to Social Policy," in Elizabeth Fee and Daniel M. Fox, *AIDS: The Burdens of History* (Berkeley: University of California Press, 1988), 147–71, and Fee, "Sin versus Science: Venereal Disease in Twenieth-Century Baltimore," in ibid., 121–46. The moralizing interpretation of leprosy was not necessarily shared by medieval medical writers, who took a more naturalist stance; see Luke Demaitre, "The Description and Diagnosis of Leprosy by Fourteenth-Century Physicians," *Bulletin of the History of Medicine* 59 (1985): 327–44.

37. George Gallup, Jr., *The Gallup Poll: Public Opinion 1991* (Wilmington, Del.: Scholarly Resources, 1992), 239.

38. Cindy Patton is the only writer I know to have analyzed the discourse of the New Right on this topic, although she does not engage the religious issues directly; see her *Sex and Germs: The Politics of AIDS* (Boston: South End Press, 1985), chap. 7. Also relevant is Jeffrey Weeks, "AIDS: The Intellectual Agenda," in Peter Aggleton et al., *AIDS: Social Representations, Social Practices,* 9–11.

39. Susan Sontag, *AIDS and Its Metaphors* (New York: Doubleday, 1989), 132 (published with *Illness as Metaphor*).

40. E.g., " 'Homosexual Plague' Strikes New Victims," *Newsweek,* Aug. 23, 1982, 10; "The Gay Plague," *New York,* May 31, 1982, 52. UPI popularized the term in the fall of 1982; see Kinsella, *Covering the Plague,* 54.

41. E.g., Lawrence E. Lockman, *The AIDS Epidemic: A Citizens' Guide to Protecting Your*

Family and Yourself from the Gay Plague (Ramona, Calif.: Vic Lockman, 1986). *USA Today* kept the phrase alive on its editorial pages devoted to mandatory testing in a typically backhanded manner, noting on two occasions that AIDS "isn't thought of as a 'gay plague' any more." Fern Schumer Chapman, "The Fight is on for Research Funds," Apr. 17, 1991, A12; cf. Chapman, "An Epidemic that Defies Stereotypes," Dec. 7, 1990, A12.

42. Sontag, *AIDS*, 132–51; quotation on p. 145. See also Dorothy Nelkin and Sander L. Gilman, "Placing Blame for Devastating Disease," in the special issue edited by Arien Mack, "In Time of Plague," of *Social Research* 55, 3 (Autumn 1988): 361–78.

43. Other European languages do not confuse these two concepts, as in the German *Plage* and *Pest*, or the Italian *piaga* and *peste*. This English idiosyncrasy has engendered a number of misguided and not particularly illuminating attempts to draw parallels between AIDS and the Black Death; see, e.g., Robert M. Swenson, "Plagues, History, and AIDS," *The American Scholar* 57 (1988): 183–200. The most useful comparisons lie in the area of medical ethics and concern the problem of occupational risk for physicians; see, e.g., Abigail Zuger and Steven H. Miles, "Physicians, AIDS, and Occupational Risk," *Journal of the American Medical Association* 258, 14: 1924–28, and Richard M. Ratzan and Henry Schneiderman, "AIDS, Autopsies, and Abandonment," ibid. 260, 23: 3466–69.

44. Sontag, *AIDS*, 122–23.

45. William H. Foege, "Plagues: Perceptions of Risk and Social Responses," in *Social Research* 55, 3 (Autumn 1988): 337–38.

46. David A. J. Richards, "Human Rights, Public Health, and the Idea of Moral Plague," in *Social Research* 55, 3 (Autumn 1988): 520. For an explicit statement of what appears to be the deeper agenda behind these kinds of statements, see Johan Goudsblom, "Public Health and the Civilizing Process," *Milbank Quarterly* 64 (1986): 186: "both the present concern about health and the authority of medicine also make it likely that, faced with the danger of AIDS, people will be inclined to adjust their conduct in a more reasonable fashion. . . . The increasing likelihood that the promise of a long and healthy life may be fulfilled has made it more sensible for people to accept medical authority and to arrange their lives according to the precepts of hygiene."

47. There is some debate as to whether the disease or diseases medieval doctors and laypeople identified as leprosy were confined to what we would today call leprosy (Hansen's disease). For evidence and opinions, see e.g. Richards, *Medieval Leper*, chap. 10; Demaitre, "Description and Diagnosis," 329–36; R. I. Moore, *The Formation of a Persecuting Society* (Oxford: Blackwell, 1987), 46–50 and 73–80.

48. Jerome Kroll and Bernard Bachrach, "Sin and the Etiology of Disease in Pre-Crusade Europe," *Journal of the History of Medicine and Allied Science* 41 (1986): 395–414. In their survey of pre-Crusade saints' lives and chronicles, Kroll and Bachrach found that

episodes of illness were attributed to sin in slightly less than a fifth of all cases; see Table 1 (402–3). See also Kroll and Bachrach, "Sin and Mental Illness in the Middle Ages," *Psychological Medicine* 14 (1988): 507–14.

49. Kroll and Bachrach, "Sin and the Etiology of Disease," 399 (quotation), 406–7; John T. McNeill, "Medicine for Sin as Prescribed in the Penitentials," *Church History* 1 (1932): 14–26. On the variety of early Christian attitudes toward health, disease, and healing, see in general Darrel W. Amundsen, "Medicine and Faith in Early Christianity," *Bulletin of the History of Medicine* 56 (1982): 326–50, and Vivian Nutton, "Murders and Miracles: Lay Attitudes towards Medicine in Classical Antiquity," in Roy Porter, ed., *Patients and Practitioners* (Cambridge: Cambridge University Press, 1985), 48–51.

50. Kroll and Bachrach, "Sin and the Etiology of Disease," 410, n. 34.

51. Richards, *Medieval Leper*, chap. 6, esp. 52–54; Moore, *Formation of a Persecuting Society*, 53–65. Further references in Katharine Park, "Medicine and Society in Medieval Europe, 500- 1500," in Andrew Wear, ed., *Medicine in Society: Historical Essays* (Cambridge: Cambridge University Press, 1992), 86–87. While acknowledging the parallels with attitudes around AIDS, I would contest David F. Musto's characterization of the segregation of lepers as "benign" because "softened by religious rituals"; see his "Quarantine and the Problem of AIDS," in Fee and Fox, *AIDS: The Burdens of History*, 70.

52. Demaitre, "Description and Diagnosis."

53. Owsei Temkin, "On the History of 'Morality and Syphilis,' " in his *The Double Face of Janus and Other Essays in the History of Medicine* (Baltimore: Johns Hopkins University Press, 1977), 472–84; Brandt, *No Magic Bullet*, esp. chap. 6; Sander L. Gilman, *Sexuality: An Illustrated History* (New York: John Wiley and Sons, 1989), passim. See also Fee, "Sin versus Science."

54. Palmer, "The Church, Leprosy, and Plague," 84–85.

55. Michael W. Dols, "The Leper in Medieval Islamic Society," *Speculum* 58 (1983): 891–916; H. D. Isaacs, "A Medieval Arab Medical Certificate," *Medical History* 35 (1991): 250–57. Thus, as Demaitre points out, medieval Christian medical (as opposed to clerical) writing on leprosy resembled much more closely its Islamic sources: Demaitre, "Description and Diagnosis"; cf. Dols, "Leprosy in Medieval Arabic Medicine," *Journal of the History of Medicine and Allied Sciences* 34 (1979): 314–33.

56. Michael W. Dols, "The Comparative Communal Responses to the Black Death in Muslim and Christian Societies," *Viator* 5 (1974): 269–87; and Dols, *The Black Death in the Middle East* (Princeton: Princeton University Press, 1977), chaps. 4 and 6.

57. Peter Brown, "Bodies and Minds: Sexuality and Renunciation in Early Christianity," in David M. Halperin, John J. Winkler, and Froma I. Zeitlin, eds., *Before Sexuality: The Construction of Erotic Experience in the Ancient Greek World* (Princeton: Princeton University

Press, 1990), 481; see in general Brown's *The Body and Society: Men, Women and Sexual Renunciation in Early Christianity* (New York: Columbia University Press, 1988).

58. Brown, "Bodies and Minds," 485.

59. Moore, *Formation of a Persecuting Society,* 5 (author's emphasis).

60. John Boswell, *Christianity, Social Tolerance, and Homosexuality: Gay People in Western Europe from the Beginning of the Christian Era to the Fourteenth Century,* Chicago: (Chicago University Press, 1980).

61. Moore, *Formation of a Persecuting Society,* 88.

62. *New York Post,* May 24, 1983, quoted in Brandt, "AIDS," 155. Cf., for example, Alain of Lille's famous poem *The Complaint of Nature,* which uses (albeit satirically) the same strategies to the same effect.

63. Most historians and sociologists of disease have tended to conflate all forms of blame as undifferentiated "scapegoating," ignoring the great differences between, say, a blame-the-victim theory and a conspiracy theory; see, for example, Treichler, "AIDS, Gender, and Biomedical Discours," in Fee and Fox, *AIDS,* 240–241, and footnote 17, and Richards, "Human Rights."

64. As an example of the former strategy, the notables of Florence interpreted the plague of 1417 as a divine judgment on the rich, for having neglected their charitable duties, and pledged special tax levies on themselves; documents in Gene Brucker, ed. and trans., *The Society of Renaissance Florence* (New York: Harper Torchbooks, 1971), 230–231. As an example of the latter, Christians in a number of towns in Spain, France, and Germany accused lepers and, especially, Jews of spreading plague by poisoning Christian wells; see Ernest Wickersheimer, "Les accusations d'empoisonnement portées contre les lépreux et les juifs: Leurs relations avec les épidémies de peste," in M. Tricot- Royer and M. Laignel-Lavastine, eds., *Comptes-rendus du 4e congrès international de médecine* (Antwerp: De Vlijt, 1927), 76–83, and Séraphine Guerchberg, "The Controversy over the Alleged Sowers of the Black Death in Contemporary Treatises on Plague," in Sylvia Thrupp, ed., *Change in Medieval Society: Europe North of the Alps, 1050–1500* (New York: Appleton-Century-Crofts, 1964), 208–24.

65. I have not yet found any good comparative studies of Western and non-Western interpretations of AIDS; those few Western writers who engage in comparisons tend to look no farther afield than the Protestant frog pond of the Baltic and North Atlantic. For some hints of a broader view, see Renée Sabatier et al., *Blaming Others: Prejudice, Race, and Worldwide AIDS,* ed. Jon Tinker (London: The Panos Institute, 1988), chap. 7. On the Fort Detrick theory, which apparently originated in India but was then disseminated by East German and Soviet writers, see ibid., 61–64, and Sander Gilman, "Seeing the AIDS Patient," in his *Disease and Representation: Images of Illness from Madness to AIDS* (Ithaca: Cornell University Press, 1988), 264–65.

66. "The AIDS 'Plot' against Blacks" (editorial), *New York Times,* May 12, 1992.

67. References in Dennis Altman, *AIDS in the Mind of America* (Garden City: Anchor Press/Doubleday, 1986), 43–53. Even Altman, generally skeptical of these reports, refused to dismiss them categorically; see 44.

68. E.g., Sontag, *AIDS,* 141, or Swenson, "Plagues, History, and AIDS," esp. 196–98. On the general danger of apocalyptic scenarios, see Watney, *Policing Desire,* 77–78.

Palouse High School Men's Basketball Team, Palouse, Washington, 1911. The author's grandfather, Thomas Hedley Dingle, stands first on the left.

Endicott High School Women's Basketball Team, Endicott, Washington, 1913. The author's grandmother, Clara Sarah Sherman, is second from the right.

14

Accommodating Magic

Douglas Crimp

We think, well, only gay people can get it—it's not going to happen to me.
And here I am saying that it can happen to anyone, even me, Magic
Johnson.
>—From the press conference at the Great Western Forum

Then came the news about Magic. In a way, that changes everything. He is
not them; Magic is us.
>—A *Daily News* column of a few days later[1]

Magic is here. Magic is now. Magic is us.
>—*Sports Illustrated*'s version of the same[2]

Now everyone knows someone who's infected.
>—The sportswriter's presumption

Where were you when you heard the news?
>—*Newsweek*, suggesting the Kennedy assassination analogy[3]

My grandfather was a basketball player, and so was my grandmother. I have
photographs of both of them proudly posing with their high school teammates.
My brother was a star basketball player and now coaches college women's
basketball, my sister married a high school basketball coach, my nephew went
to college on a basketball scholarship, and my twelve-year-old, already five-
foot-eight niece is a basketball prodigy (since she's too young for Magic, her

room is covered with Michael Jordan posters). During my adolescence in the small town where I grew up, people meeting me for the first time would note my height and the size of my hands—big enough to palm a basketball—and say, "You must be a basketball player." Admitting that I wasn't embarrassed me; it felt like divulging my sexuality. In fact I *did* play basketball throughout most of my childhood and adolescence, but being queer made me self-conscious in locker rooms, so I stayed away from organized sports. What I meant when I said I didn't play was only that I didn't turn out for the high school team. Like a lot of other queers, when I left my hometown and found out there were places where playing basketball wasn't the only measure of worth, I rarely played or watched a basketball game again. So on November 7, 1991, when I listened to Magic Johnson announcing his retirement from the Lakers because he'd tested HIV-positive, I had to ask, Who's Magic Johnson?

Of course I found out right away. By the time I watched *Nightline* that same night, I'd already learned enough about Magic to recoil at AIDS activist Larry Kramer's insensitivity when he declared Magic would become a pariah and die. I doubted Magic would become a pariah, and though I agreed that he'd probably die of AIDS, I knew it wasn't the right time to say it.

But I understand why Larry was so angry. People who have long been coping with this crisis, who have watched lovers, friends, and acquaintances die or are themselves infected or ill, are enraged by the constant repetitions. How many times do we have to hear "AIDS is not just a gay disease"? "The virus doesn't discriminate"? "Heterosexuals get AIDS, too"? "HIV is transmitted through heterosexual intercourse"? "Everyone is potentially at risk"? "AIDS is everybody's problem"? How much longer will the us/them rhetoric remain in place? How many people have to die or become infected for it to matter? Why is attention paid only when celebrities are infected, or diagnosed, or die?

Of course, we also know the answers to our questions, but it doesn't make the repetitions any easier. One answer was broadcast the very next night, when Magic appeared on the *Arsenio Hall Show*. At his press conference Magic had said that it didn't matter how he got the virus. It was a courageous gesture, but of course it wouldn't play. So he told Arsenio, "I'm far from being

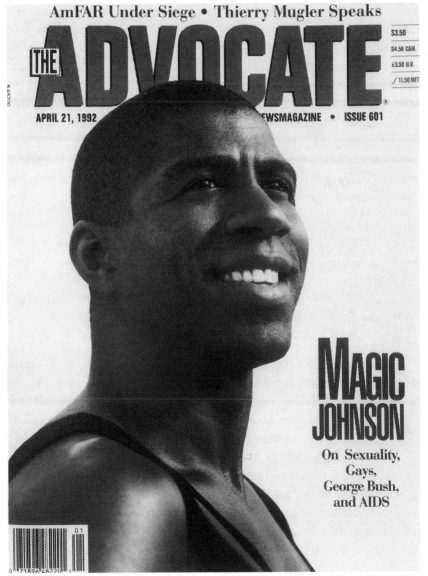

Cover of The Advocate, *April 21, 1992. Photo of Magic Johnson by Herb Ritts.*

homosexual. You know that. Everybody else who's close to me understands that." The crowd went berserk, cheering wildly for several minutes. What could Magic do but flash that smile?—"the most famous smile since the Mona Lisa" in *Newsweek*'s estimation.[4] The crowd evidently felt vindicated now that they were reassured they hadn't been duped into hero-worshipping a secret fag. Queers felt betrayed. We'd heard through the grapevine that Magic *was* a secret fag,[5] and I guess we hoped it was true. Not every queer stops playing basketball when he leaves home, and we'd like people to learn that, even if the hard way.

Writing a week later in *Sports Illustrated*, Magic repeated his denial of the rumors—"I have never had a homosexual encounter. Never"—and speculated on how he became infected.

> It's a matter of numbers. Before I was married, I truly lived the bachelor's life. I'm no Wilt Chamberlain, but as I traveled around NBA cities, I was never at a loss for female companionship. . . . There were just some bachelors almost every woman in L.A. wanted to be with: Eddie Murphy, Arsenio Hall, and Magic Johnson. I confess that after I arrived in L.A. in 1979, I did my best to accommodate as many women as I could—most of them through unprotected sex.[6]

Accommodate? "He was doing these women some kind of *favor?*" Barbara Harrison asked in *Mademoiselle*.[7] The arrogance and contempt Harrison recognized in the word choice were corroborated by Magic's friend Pamela McGee, who wrote in the *Los Angeles Times*, "Magic's closest friends always knew him as a major player and womanizer. He has had one-night stands with what he calls 'freaks' across America."[8] Like the denial of homosexuality, the misogyny does its work: promiscuity, which Johnson would come to regret and thus to condemn, was really the sin of others. Magic wasn't in active pursuit; he just acquiesced to fast women: "I know that we are pursued by women so much that it is easy to be weak. Maybe by getting the virus I'll make it easier for you guys to be strong."[9] Another repetition: women scapegoated as vectors of transmission; *their* risk—the greater risk of infection—is not the issue. And, as Martina Navratilova noted, the big-time double standard: if a woman athlete

confessed to so many sex partners, she wouldn't be seen as a superstar, but as "a whore and a slut."[10]

Moralizing about promiscuity has been and continues to be one of the most difficult rhetorics to combat for AIDS educators. Every queer remembers the incredulity, disdain, and disguised envy that met early accounts of gay men's numbers of sex partners. Now that the tables are turned, the envy comes out in the open, but it poses a new crisis. When the studio audience on the *Arsenio Hall Show* cheered so wildly, their homophobia was doubly displayed, for in their gloating that Magic was no fag, they could not but demonstrate that they would rather die than entertain the idea that he could be one. Had those "freaks" that Magic accommodated been men instead of women, Arsenio's loudly heterosexual audience *might* have wanted to heave a collective sigh of relief that they still aren't implicated in this terrible epidemic, as they've wanted to believe all along.

Playboy moved fast to accommodate Magic's news. Keeping sex safe, untroubled, unencumbered for heterosexual men is their up-front agenda, Michael Fumento's *Myth of Heterosexual AIDS* their treacherous guide.[11] More repetitions: safe anatomy—fragile anus versus rugged penis and vagina, "built," as *Playboy* put it, "to sustain the rigors of sex."[12] Safe (and racist) geography—AIDS in Africa is a different epidemic and sex in Africa is a different practice. More safe (and racist) geography—AIDS is contained in "communities"—"What will kill you in the South Bronx will make you a living legend in your home town."[13] And of course, heterosexual transmission as a deceit perpetrated by the "powerful gay lobby" to get more funding for "their" disease.

But there's still Magic. *Playboy* had some doubts: "Assuming that he did not contract the virus from his dentist (no one checked), another male (he denies the rumors), or intravenous drug use (steroids?), Magic is simply the newest member of a very small group of men who have contracted the AIDS virus through heterosexual contact."

Magic is an exceptional man. . . . He could accomplish more with a smile than you or I could in a year of sophisticated courtship. . . . He says he lived "the

259

bachelor's life," but that is like saying he could play a little ball. Just as he redefined the guard's position on the basketball court, he redefined the number of sexual conquests that it is possible for a bachelor to achieve off the court. All his passes were caught.[14]

Playboy's Magic is a whole new "myth of heterosexual AIDS." You'd think using a condom, like being a fag, was worse than death. Paradoxically, because *we* queers know it's not, and because nobody will ever ask *us*, we have to learn to accommodate Magic.

From the moment of the November 7 press conference, Magic began urging that "safe sex is the way to go,"[15] and he's remained steadfast under intense pressure to modify his position. He is accommodating enough to tell kids that "the safest sex is no sex," but he knows, just as the kids do, that the truism is also a lie: no sex may be safe, but it's not sex. As he told *Ebony*, "That's not the reality, and I'm trying to explain that to people too. Reality is young people . . . are going to have sex no matter what has happened to me. So if that's going to be the case, then they should practice safe sex."[16] Magic's realism about the necessity of teaching safe sex is no surprise, but the widespread acceptance of it is a significant breakthrough.

In spite of extraordinary success in slowing seroconversion rates for gay men, in spite of consensus among health educators about its efficacy, skepticism about safe sex has lingered, registered along a spectrum from "there's no such thing as safe sex" to the hedge-your-bets "r" tacked onto *safe*—not safe, but at least *safer* sex. But now, as if by magic, there really is such a thing as safe sex. And the reason can be discerned in the same *Ebony* article, as a moment painfully reminiscent of the Arsenio episode is recalled. Magic was speaking to students at Cardozo High School in Washington. "And when he told them 'I still kiss my wife a lot,' the place went nuts—you couldn't have heard a symphony of school bells for all the screams and applause."[17] Safe sex has become truly safe, you see, because Magic has to accommodate his wife Cookie. *Ebony's* cover article was devoted to Magic and Cookie's marriage, and was meant to allay some new tabloid rumors—that Cookie had moved to the maid's room, was so afraid of contracting HIV that she wouldn't let

Magic touch her. "All of those rumors are false," Cookie reassured, and, "As for their marriage, 'it has only gotten stronger, it's just fine. . . .' As Magic put it, 'We are still doing our thing.' "[18]

Accommodating Magic. I want to try to make it clear how difficult this is, for us queers. Behind the "there's no such thing as safe sex" line, which has been used mostly to prevent teenagers from getting safe sex education, there has always been a tacit assumption, applied equally to queers and teenagers (doubly to queer teens), that for such people sex is a luxury, an indulgence, an excess, a dissipation. We are told to give it up, desist, abstain. There has never been anything like an equivalence drawn between gay and straight sex, which is why gay men's success in stopping the spread of HIV infection with the adoption of safe sex practices has never been seen as an example to emulate. Now, though, Magic Johnson is infected with HIV, and he is blissfully married to Cookie, and so safe sex must be safe after all. Even *Playboy* will go this far: "If Magic can articulate the role of intimacy in his own life—the commitment that supersedes fear of infection—then we all stand to learn something. This is the real meaning of the marriage vow 'till death do us part.' This is the real face of love."[19] Accommodating Magic—for queers—means accommodating this contradiction: safe sex will be accepted, taught to teenagers, adopted by heterosexuals at risk, save lives—because of Magic, because it is necessary to protect the sanctity and prerogatives of his heterosexual union. Accommodating Magic—for queers—means accommodating the continued homophobic construction of AIDS discourse, apparently as unshakable today as it was when the new disease syndrome was named GRID, for Gay Related Immune Deficiency.

It is this homophobia that we endure every time we see Magic accomplish something we've worked for so tirelessly for years, to no avail. For years we tried to get the media to distinguish between HIV and AIDS; they finally found it necessary to comply in order to reassure Magic's fans that he was infected with HIV but did not have AIDS.[20] For years we asked the media for images of people with HIV disease living normal, productive lives. They gave us Magic playing the All-Star game. For years we badgered the *New York Times* to take a critical position on George Bush's do-nothing AIDS policies. They

wrote a scathing editorial headlined "Magic Johnson, as President."[21] We badgered Bush directly. He rebuked us, but admitted to Magic, "I haven't done enough about AIDS," and asked him to join his National Commission on AIDS.[22] Wherever Magic appears—the NAACP Image Awards, the American Music Awards, the Barcelona Olympics—there is adulation. His fellow players arranged a pre-All Star game ritual of bear hugs. The spectacle of someone who's HIV-positive being revered and physically embraced is deeply gratifying. But *our* gratification is diminished, because we know the boast to Arsenio makes it possible.

But we know something else, too. We gay men who have unequally borne the burden of AIDS in the United States know that that burden has also been unequally borne by people of color. In 1992, the *majority* of new AIDS cases in the United States was reported among people of color. Blacks account for 12 percent of the population, but more than 25 percent of total reported cases of full-blown AIDS. More than half of all women with AIDS are black. Three out of four women with AIDS are black or Hispanic. Nine out of ten children with AIDS and over half the teenagers with AIDS are black or Hispanic.[23] Magic admitted that he hadn't practiced safe sex during his bachelor years because, before receiving his test results, he still thought of AIDS as a gay disease. That astonishes me, but then I recall that, before he received his test results, I didn't know who Magic was, and that would probably astonish him. Now I know very well who Magic is, and he knows very well that AIDS is devastating America's black communities. His determination, from the outset, to "become a spokesman for the virus," is very good news for those communities, and for everyone else affected by AIDS. For an article in *TV Guide* about the production of *Nickelodeon*'s "Conversation with Magic" for kids, Linda Ellerbee called a friend who is HIV-positive.

> I wanted to know what my friend, a gay man, thought about the enormous attention Magic Johnson's announcement had brought to AIDS. After all, so many other good people have already died without most of us seeming to notice.
>
> "Yes," he said, "it's unfair. So what If it takes a Magic Johnson to see

that AIDS is everybody's problem, if he can use his fame to get the government to do more, if he can raise more money to fight the disease—to find a cure—what does fair matter?"[24]

Accommodating Magic. "Fair" *does* matter. "Fair" can also save lives. Magic wrote to George Bush that he now knows "more about HIV and AIDS than I ever wanted to."[25] But still, like Bush himself, Magic has so far adopted an accommodating stance: He wants to save the kids. In the AIDS epidemic, however, saving kids will mean knowing more than Magic has so far let on that he does:

—knowing, for example, that the availability of clean and free hypodermic needles for IV drug users will save not only their lives but those of their sex partners and children as well;

—knowing that the disproportionate number of black women with AIDS is due in part to women's greater risk of infection through heterosexual sex;

—knowing that the disproportionate number of AIDS cases among black people includes a disproportionate number of AIDS cases among gay black men;[26]

—knowing that black men who have sex with men often don't cop to being gay, might even say, if pressed, "I'm far from being homosexual";

—knowing that those men who have sex with men often also have sex with women;

—and knowing that kids, black kids, even the ones who play basketball, can be queer.

I said above that I agreed with Larry Kramer that Magic Johnson will probably die of AIDS. Buried in only one story that I read about Magic was the fact that he had a case of shingles in 1985.[27] For those of us all too familiar with the course of HIV disease, that is a very alarming fact. We haven't been told how impaired Magic's immune system is—no T-cell counts, no markers of any kind. Magic's workout regimen and optimistic outlook are all the press reports. Magic himself wrote,

I told the fellas that this is just another challenge for me. It's Maurice Cheeks in the NBA Finals in 1980 and '83 against the 76ers. It's Larry [Bird] and Dennis Johnson every time we stepped on the court against the Celtics. It's Isiah [Thomas] and Dennis Rodman in all those wars against the Pistons. It's Michael [Jordan]. It's because of all of those challenges that I'm able to face this newest challenge.[28]

But Magic's determination "to fight the virus," "to beat this thing," is for us probably the most demoralizing repetition of them all. We've heard it so many times. We've wanted so much to believe it. But we can't anymore. We've had to accommodate too much.

NOTES

1. Earl Caldwell, "Magic: When 'Them' Becomes Us," *New York Daily News*, November 11, 1991, 29.

2. Leigh Montville, "Like One of the Family," *Sports Illustrated*, November 18, 1991, 45.

3. Charles Leerhsen et. al., "Magic's Message," *Newsweek*, November 18, 1991, 58.

4. Jack Kroll, "Smile, though Our Hearts Are Breaking," *Newsweek*, November 18, 1991, 65.

5. Peter Vecsey, "Rumors Fly about Magic, but the Motives Are Selfish," *USA Today*, November 12, 1991, 6C.

6. Magic Johnson, with Roy S. Johnson, "I'll Deal with It," *Sports Illustrated*, November 18, 1991, 21–22. "Most" is something of an understatement. Johnson told the *Advocate* that he tried using condoms "just one time," but gave them up because he "didn't get the same feeling." Roger Brigham, "The Importance of Being Earvin," *Advocate*, April 21, 1992, 38. For Wilt Chamberlain's account of his own sexual conquests, see *A View from Above* (New York: Villard, 1991)

7. Barbara Harrison, "Do You Believe in Magic?" *Mademoiselle*, March 1992, 94.

8. Pamela McGee, "Friend: Magic Had Plenty of One-Night Stands," *New York Newsday*, November 10, 1991, 4.

9. Johnson, "I'll Deal with It," 22.

10. Martina Navratilova, interviewed in *the New York Times*, November 21, 1991, B16.

11. Michael Fumento's *The Myth of Heterosexual AIDS* (New York: Basic Books, 1990) argues that heterosexual transmission of HIV is enormously exaggerated by the media, by politicians, and by "the powerful gay lobby" as a means of increasing funding for a "gay

disease." For Fumento, virtually every case of heterosexual transmission, and especially female-to-male transmission, is a special case.

12. James R. Patersen, "The Playboy Forum: Magic," *Playboy*, March 1992, 43.

13. *Ibid.*

14. *Ibid.*, 41.

15. Quoted in Pico Iyer, " 'It Can Happen to Anybody. Even Magic Johnson,' " *Time*, November 18, 1991, 26.

16. "Magic Johnson's Full-Court Press against AIDS," *Ebony*, April 1992, 108.

17. *Ibid.*

18. Laura B. Randolph, "Magic and Cookie Johnson Speak Out for First Time on Love, Marriage and AIDS," *Ebony*, April 1992, 106.

19. Patersen, "The Playboy Forum," 45.

20. Johnson himself made it clear how badly the media had failed on this point: "Dr. Mellman quickly told me that I didn't have AIDS, that I was only infected with the virus that could someday lead to the disease. But I didn't really hear him. Like almost everyone else who has not paid attention to the growing AIDS epidemic in the U.S. and the rest of the world, I didn't know the difference between the virus and the disease. While my ears heard HIV-positive, my mind heard AIDS." Johnson, "I'll Deal with It," 18.

21. "Magic Johnson, as President," *New York Times*, November 9, 1991, 22.

22. On January 22, 1992, prior to his first meeting with Bush, Johnson wrote the president a forceful letter asking him to become the leader he had not yet been on AIDS. The letter included three demands for increased funding, to speed research, to fund the Ryan White CARE Bill fully, and to allow Medicaid to pay for people with HIV disease, not just AIDS. On July 14, *the New York Times* reported that Johnson had told CNN that he would probably resign from the National Commission on AIDS: "We need funding," Johnson said, "and every time we ask for more funding we get turned down by the President." "Magic Johnson Says He Is Likely to Quit Bush's AIDS Panel," A18. Johnson's resignation was officially announced on September 25, 1992.

23. Statistical information comes from the Centers for Disease Control in Atlanta as of April 1992.

24. Linda Ellerbee, "Magic TV and Kids," *TV Guide*, March 21–27, 1992, 10.

25. Letter from Earvin Johnson, Jr., to President George Bush, January 14, 1992.

26. Responding to Johnson's *Arsenio Hall Show* appearance, Charles Stewart, contributing editor of the black gay and lesbian newsmagazine *BLK*, wrote, "One of the largest and most invisible groups affected by the AIDS epidemic, black gay and bisexual men, just became even more invisible. So perhaps it is understandable why, as the Johnson AIDS saga unfolds, some black men are having to search themselves to locate sympathy for Magic. They have been burying friends by the dozens for half of the last decade. Testing

HIV-positive is normal in their world. Tragedy is not having the resources to do anything about it or a support base of family and friends you can count on, as Magic can, to love you literally to death." Charles Stewart, "Double Jeopardy: Black, Gay (and Invisible)," *New Republic*, December 2, 1991, 13.

27. Leerhsen et al., "Magic's Message," 62.

28. Johnson, "I'll Deal with It," 21.

Index

Contributors

K. ANTHONY APPIAH teaches Afro-American studies at Harvard. He's author of *In My Father's House: Africa in the Philosophy of Culture* (Oxford University Press, 1992), *Assertion and Conditionals* (Cambridge University Press, 1985), and *For Truth in Semantics* (Blackwell, 1986). In 1990, he published *Avenging Angel*, a novel, and he's now preparing the *Oxford Book of African Literature*. When not doing anything else, he goes to the movies.

SVETLANA BOYM is the author of *Death in Quotation Marks: Cultural Myths of the Modern Poet* (Harvard University Press, 1991), of a play *The Woman who Shot Lenin* and of a forthcoming book *Common Places: Mythologies of Everyday Life in Russia* (Harvard University Press, 1994). Her current project is *Post-Communist Landscape*. She teaches comparative literature at Harvard.

DOUGLAS CRIMP is currently Visiting Professor of Art History and Visual and Cultural Studies at the University of Rochester, and also teaches lesbian and gay studies at Sarah Lawrence College. He is editor of *AIDS: Cultural Analysis/Cultural Activism* (MIT Press, 1988), and the author with Adam Rolston of *AIDS Demo Graphics/* (Bay Press, 1990). A collection of his art critical writings, *On the Museum's Ruins*, will by published this year by MIT Press.

LEE EDELMAN is Associate Professor of English at Tufts University. He is the author of *Transmemberment of Song: Hart Crane's Anatomies of Rhetoric and Desire* (Stanford University Press, 1987) and *Homographesis: Essays in Gay Literary and Cultural Theory* (Routledge, 1993). He is currently working on *The Invisible Spectacle: The Body, Representation, and Gay Sexuality in Hollywood Cinema*.

DIANA FUSS is Assistant Professor of English at Princeton University. She is the author of *Essentially Speaking: Feminism, Nature and Difference* (Routledge, 1989) and editor of *Inside/Out: Lesbian Theories, Gay Theories* (Routledge, 1991).

MARJORIE GARBER is Professor of English and Director of the Center for Literary and Cultural Studies at Harvard University. She is the author of *Vested Interests: Cross-Dressing and Cultural Anxiety* (Routledge, 1992; paperback HarperCollins, 1993) and three books on Shakespeare: *Shakespeare's Ghost Writers: Literature as Uncanny Causality* (Methuen,

1987), *Coming of Age in Shakespeare* (Methuen, 1981), and *Dream in Shakespeare: From Metaphor to Metamorphosis* (Yale University Press, 1974).

BARBARA JOHNSON is Professor of English and Comparative Literature at Harvard University. She is author of *The Critical Difference* (Johns Hopkins University Press, 1980) and *A World of Difference* (Johns Hopkins University Press, 1987) and editor of *Consequences of Theory* (with Jonathan Arac, Johns Hopkins University Press, 1990) and *Freedom and Interpretation: Oxford Amnesty Lectures 1992* (Basic Books, 1993). She is currently finishing a short book entitled *The Wake of Deconstruction* to be published by Basil Blackwell.

JANN MATLOCK is the author of *Scenes of Seduction: Prostitution, Hysteria, and Reading Difference in Nineteenth-Century France* (Columbia University Press, 1993). Her current project, *Desires to Censor*, is a study of aesthetics and censorship. She is Assistant Professor of Romance Languages and Literatures at Harvard.

KATHARINE PARK teaches history at Wellesley College. She is the author of *Doctors and Medicine in Early Renaissance Florence* (Princeton University Press, 1985) and numerous articles on medicine and the life sciences in medieval and Renaissance Europe.

ANDREW PARKER is Associate Professor of English and Women's and Gender Studies at Amherst College. A Mellon Fellow in 1992–93 at the Stanford Humanities Center, he is most recently a co-editor of *Nationalisms and Sexualities* (Routledge, 1992).

MICHAEL ROGIN teaches political science at the University of California, Berkeley. His books include *The Intellectuals and McCarthy* (MIT Press, 1967), *Subversive Geneology: The Politics and Art of Herman Melville* (Knopf, 1983), and *Ronald Reagan, The Movie and Other Episodes in Political Demonology* (University of California Press, 1987).

ELAINE SCARRY is Professor of English at Harvard University. Her writing on war appears in *The Body in Pain* (Oxford University Press, 1985), several law journal articles, and a book now being completed entitled *A Matter of Consent*. She has also authored *Resisting Representation* (Oxford University Press, 1993) and edited *Literature and the Body* (Johns Hopkins University Press, 1987).

DORIS SOMMER is Professor of Latin American Literature at Harvard University. She is author of *Foundational Fictions: The National Romances of Latin America* (University of California Press, 1991) and *One Master for Another: Populism and Patriarchal Discourse in Dominican Novels* (1984), as well as coeditor of *Nationalisms and Sexualities* (Routledge, 1992). Her current work explores the ethical implications raised by traditionally "competent" readings of "resistant" minority texts.

REBECCA L. WALKOWITZ is a Marshall Scholar and graduate student in English literature at the University of Sussex. She was President of the *Harvard Crimson* in 1991, and her work has been published in the *Boston Globe*, the *Atlanta Journal-Constitution*, and the *New York Times*.

278